Jacob's Ladder

Jacob's Ladder

From the Bottom of the Warsaw Ghetto to the Top of New York's Art World

An Autobiography

Jacob Weintraub

Madison Books
Lanham • New York • London

Published by Madison Books
4720 Boston Way
Lanham, Maryland 20706

3 Henrietta Street
London WC2E 8LU England

Distributed by National Book Network

The paper used in this publication meets the minimum
requirements of American National Standard for
Information Sciences—Permanence of Paper for
Printed Library Materials, ANSI Z39.48–1984. ∞™
Manufactured in the United States of America.

Library of Congress Cataloging-in-Publication Data

Weintraub, Jacob.
Jacob's ladder: from the bottom of the Warsaw Ghetto
to the top of New York's art world: the autobiography
of Jacob Weintraub.
p. cm.
Includes index.
1. Weintraub, Jacob. 2. Art dealers—United States—
Biography.
I. Title.
N8660.W39A3 1994
709.'2—dc20 [B] 94-5265 CIP

ISBN 1-56833-035-9 (cloth: alk. paper)

Contents

This book is dedicated to my beautiful wife
BRONKA
for her help and patience.

Special thanks to:
Rabbi Ronald B. Sobel, Temple Emanu-El,
Edward Brodsky, Esq. and Philomena Gates, Esq.,
David Finn, Caroline Goldsmith and Michael Schubert,
Pamela Bernstein, Stephen Fenichell, Carl Levin, Tom Teicholz,
Lisa Jensen Bonham: my assistant and a wizard with computers.

Foreword

When Jacob Weintraub told me that he was in the process of publishing his memoirs, I was delighted. I knew that it would be an interesting story because he has had a remarkable career. From humble beginnings in his early years with the "New Art Center" on Lexington Avenue, his business has developed in a grand way as can be seen in his impressive Madison Avenue gallery. It has been a pleasure for me to be associated with him.

My first meeting with Jacob came about because of his long-time interest in the work of Henry Moore. I was excited to discover the breadth of his collection — both at home and in his gallery. In addition to works by Moore, he was displaying superb works by Calder, Arp, Giacometti, Marini and many other outstanding 20th century artists. I was very pleased when he expressed interest in my work and began to exhibit my sculpture in his gallery.

Over the years, my wife and I have come to know Jacob and his wife, Bronka, as good friends. We have always looked forward to spending time with them when they visit London, which has been quite frequent in recent years. I enjoy Jacob's straightforward, sometimes even blunt, way of expressing his opinions, and his warm feelings toward people he wants to help. His good business sense, which has been responsible for his success, is accompanied by what I have come to recognize as a generosity of spirit. I also admire his unerring eye for quality in art and his courage to back artists whose works he confidently believes will endure.

Jacob has a fascinating story to tell about his career as an art dealer as well as his early life in Poland and Germany. His amazing survival during the Holocaust explains how he developed the stamina and ingenuity to make his way in a new world and in a field which was unfamiliar to him. I always think of him as being European, and knowing something about his early life explains why.

Jacob has befriended many of the leading artists of our time as well as some of the great collectors of contemporary art. The stories he tells about his relationship with these personalities, and his views on the art market and the practices of buying and selling important works of art, provide many insights into and about the art world. His book is not only a chronicle of an individual life, from his survival in the Warsaw Ghetto to his remarkable success of almost fifty years as

an art dealer. It also provides a panoramic view of how the art world works, and Jacob's feelings of how it should work.

Not everybody will appreciate Jacob's outspoken observations, but those who like straight talk from an expert who has seen the best and the worst of the art world — indeed the world as a whole — will find his comments revealing as well as engaging. I feel that Jacob's autobiography is valuable, and I am grateful that he decided to write about his experiences in such vivid detail.

Bernard Meadows
May 1994

Introduction

For over forty years I have been a merchant and collector in the amazing world of art. While my professional activities have included all forms of art, my specialty has been sculpture.

In fact, I have in recent decades developed an international reputation for being one of the world's leading dealers in this art form. Modest, but not without a soupçon of ego, I am not prepared to dispute that assessment.

But I have not always been the recipient of unalloyed good fortune. In fact, in climbing what some of my friends have come to refer to as "Jacob's Ladder" I have never forgotten that I started my climb not at the lowest rung, but where there was no ladder — Poland in the Warsaw Ghetto during World War II, the slaughter of six million of my co-religionists including all of my family, and the miracle of my own survival.

It was only after enduring this, possibly the blackest period in human history, that I was able to put the past behind me, but not ever out of mind, and construct a new life in America—the "Promised Land."

As we relive this life together in these pages, you will find a period when Jacob Weintraub and his wife, Barbara, mysteriously disappeared from the embattled and soon-to-be liquidated Warsaw Ghetto, and reappeared on the Aryan side of the ghetto wall, as Tadeusz Winiawski, and his wife, Mentlak.

My career as "Citizen Winiawski" in Communist-dominated postwar Poland is an intricate part of this memoir. But, luckily, and not too long afterward, I escaped to the Free World and found myself starting to swim in the barracuda-infested waters of the art world—a murky world of shoal-filled waters, illusion and fantasy, inflated egos and polished and tarnished reputations.

My own ethical standards, forged in the harsh smithy of the Warsaw Ghetto, tested in the hellish cauldron of Poland under Nazi and Soviet occupation, are straightforward: if I am approached to buy a "bargain" Picasso, I set the seller straight: "If I think there is anything wrong with this work, I will not return it to you—I'll turn it over to the District Attorney."

I have often been asked what makes for success in the art world. As I look back now after almost fifty years, I realize that, in addition

to entrepreneurship and knowledge of art, the wisdom of one's friends, listened to, absorbed and adopted as guideposts, has to be acknowledged as a key ingredient.

In 1960, Colonel Samuel Berger, the managing director of a large insurance company, and a serious collector in his own right, invited me and my first wife, Barbara, to dinner at his lavish Park Avenue apartment in New York.

After escorting me around his extensive, lovingly assembled contemporary art collection, Berger, who often adopted a paternal attitude toward me, gently put his hand on my shoulder and said, "Jacob, you will never have any money." This prediction, I confess, stopped me dead in my tracks. I firmly believed that I would one day have money — not oodles or scads, or pots, or heaps, but enough money to be comfortable and for my wife not to have to work to support herself if I should predecease her. I was genuinely shocked by this awesome prophecy, and said so: "Why did you invite me all the way here and give me this lousy drink, just to give me this terrible news?" (Colonel Berger, like many a wealthy man I have socialized with before and since, was stingy with his best Scotch.) The colonel burst into gales of laughter, and patted me once or twice on the shoulder, before continuing:

"Jacob, I meant to say only that I have watched you look at the art in this room," pointing expansively to his Braques, Matisses and Kandinskys, "and I have seen the way your eyes open wide and your blood surges when you lay eyes on a good piece of art. You would stint your wife of jewelry in order to buy it."

On this point he was right: I have never grasped the value of buying expensive jewelry when you can buy expensive art. "But Colonel Berger," I protested, "why should this make me a poor man?"

"Because you'll never make any money buying and selling art, moving merchandise off the racks as fast as you can, like a shirt salesman." Over dinner, he warmed further to his theme. "You have to hold onto it. And the best way to hold onto it is, when the spirit strikes you, to select a piece of art that you really like, take it home, hang it up on the wall and hold on to it.

"People will pay more for a work of art from the dealer's private collection," he explained. "And if they can tell their friends that they went to your home and bought it right off your wall, they will pay even more for that privilege."

I nodded, absorbing his advice like art-world gospel. "Still, why wait to sell it?" Because, Berger explained, that was what made the painting valuable—that you intended to keep it. This was your savings account, your nest egg, your security blanket. And unlike bonds

lying dead in a bank vault, it also looked nice on your wall.

Shortly thereafter, a wealthy real estate man of my acquaintance encountered financial difficulties, and I bought part of his collection. We did the deal on a handshake over lunch. When the works arrived at the gallery a few days later, I unwrapped my new treasures in a state of high excitement. I decided to follow Colonel Berger's advice and tried to select a painting which would be the one I would bring home to start my private collection.

Opening a René Magritte oil first, I took a long moment to gaze at the front—the side with the paint on it. I saw two half-human figures, fashioned from what appeared to be ceramic jugs, sprouting hands. One figure held a glass of wine, the other leaves. Both figures, draped in pink shawls, stood before an open window, through which a cloudy gray sky could be seen.

The great Magritte expert, David Sylvester, once wrote of this painting that it represents "two figures, half-human, half man-made" which to Magritte symbolized "la vie véritable"—or "real life." Being a "real life" man myself from way back, I instinctively grasped what Magritte was driving at. From Sylvester: "They demonstrate a sense of warm companionship conspicuously absent from his human figures." But within that mood of happy companionship, a barely detectable "hint of menace" remained. "The two figures are trapped, not only within their human bodies, but within the oppressive and congested interior," Sylvester wrote. As a survivor of the Warsaw Ghetto, I could see that too. I have always been simultaneously attracted and repelled by paintings that reminded me of those experiences. "Oppressive and congested" were two words one could summon up if one were called upon to describe that horrible Ghetto.

But my real revelation, such as it was, was not yet at hand. This came when, after studying the front of the painting in awe and admiration for a pleasant few minutes, I finally turned the painting around to look at the back of the canvas, to examine its condition.

There, in French, was its title: "La Terre Promise." In English, "The Promised Land." That title, and the 1947 date, made me shudder. The words "Promised Land" have a very special meaning for me both as a Jew and as an immigrant American. Shortly before Magritte finished that painting, on May 20, 1946, I and several hundred other survivors of the Holocaust arrived in America, by special invitation from President Truman, aboard a converted troop ship called the *Marine Flasher*, chartered by the United States government to bring World War II survivors to this country.

My promised land was America and I couldn't help thinking, indeed couldn't help feeling, that Magritte had somehow painted my

personal experience, combining that sense of "warm companionship" with a hint of menace, of "oppression and congestion" of that dark claustrophobic interior of the memories of the Ghetto year which I could never fully escape.

So many years later, in April of 1991, when Joanna Drew, director of London's Hayward Gallery's touring exhibition department, wrote to me on stationery emblazoned with the logo "South Bank Centre," above a heading that read "Patron: Her Majesty the Queen," requesting the loan of my Magritte for the first major Magritte exhibition since the one organized by David Sylvester at the Tate Gallery in London in 1969, I took notice. "The selections of this exhibition have been made by David Sylvester and Sarah Whitfield, who are now completing the Magritte catalogue raisonné commissioned by the Menil Foundation." These, needless to say, are the foremost Magritte scholars in the world. "Their selections comprise paintings, works on paper, sculptures and objects and will include many of the finest works from the Menil collection and public and private collections in Europe and the U.S."

Not bad company in which to be included, I thought. "I am writing to request the loan of your painting 'La Terre Promise' for the four venues of the exhibition," she added. These, I noted, included three of the top museums in America: New York's Metropolitan Museum, Houston's Menil Collection, and Chicago's Art Institute plus London's Hayward Gallery. "We appreciate that to ask you to lend for four exhibitions is demanding a great deal, but the selectors consider the works requested as critical to the authoritative view of Magritte that they, and we, wish to present to the British and American publics."

I had difficulty making a decision. I loved my Magritte. I particularly loved coming home in the evening after a tiring day at the gallery to find it waiting for me, like a daily reminder of my good fortune at having survived to arrive in the Promised Land.

Part of me, the curmudgeon part, the part that is no great fan of the human race, cried out: "That Magritte is leaving my apartment over my dead body!" Ten, twenty years before, I almost definitely would not have lent it, because for the longest time after the war, I was not inclined to believe that the public deserved my philanthropy.

At the same time, in more recent years, starting around 1970, I had slowly but surely begun to grow out of my private prison, constructed out of my traumatized emotions. The idea of sharing my Magritte with the public now actually appealed to me. One reason was not so altruistic: many of my relatively unsophisticated friends often told me that they would only respect my private collection if

THE ART INSTITUTE OF CHICAGO

MICHIGAN AVENUE AT ADAMS STREET, CHICAGO, ILLINOIS 60603 · TELEPHONE: 312-443-3600 · FAX: 312-443-0849

June 15, 1993

Mr. and Mrs. Jacob D. Weintraub
988 Madison Avenue
New York, NY 10021

Dear Mr. and Mrs. Weintraub:

We were all sad when the Magritte retrospective closed at the end of May and
the objects were returned to generous lenders like yourselves. Seldom has an
exhibition at the Art Institute received such an enthusiastic response, from
viewers of every age. Most agree that Magritte looks like a more sophisticated
and magical artist than even his admirers could have remembered. During
the ten-week long presentation in Chicago 182,868 people came to enjoy the
exhibition and left with a new way of looking at art and at the world.

Your decision to lend made this exhibition unforgettable and we realize the
sacrifice it was to be without your work for so long.

With our sincere thanks.

Very best regards,

Charles F. Stuckey
Curator, Twentieth-Century
Painting, and Sculpture

R. VANTHOURNOUT-'TKINT Izegem, October 31, 1991

 WEINTRAUB GALLERY
 Attn. Mrs & Mr Jacob D. Weintraub
 988, Madison Avenue
 U.S.A.-New York, N.Y.10021

 Dear Bronka and Jacob,

 During our hectic stay in New York we visited one island where we
could come to rest and had a very pleasant talk with the local inhabi-
tants: your home. And there was one gallery where we could look at
masterworks and nothing else: your gallery.

 We thank you very much for your friendly welcome. The posters you
sent us have been delivered at the right address, and not in Poland.
They are indeed very beautiful.

 We certainly look forward to your next visit to Europe and invite
you to meet us here and see our collection.

 Yours sincerely,

 Josette & Roger Vanthournout

*A letter from a famous Magritte
collector whom I met at the
Verona Magritte exhibition.*

one of the works were shown at the Metropolitan. Here was my chance to show them.

As I pictured my treasured Magritte wending its way from New York to London, back to New York, Chicago and then to Houston, I became concerned for the painting's safety. I am a naturally anxious man, and my anxiety has all too often been confirmed by events. What if the plane went down? Or the boat sank? Or the train blew up? Or one of the museums was bombed by terrorists?

After a long week's anxious thought, I gave in. In this case, I was prepared to make an exception. The thought of having my Magritte admired by millions, or at least thousands, overwhelmed my trepidation.

"In principle, I agree to lend you my Magritte," I wrote Ms. Drew. But so as to allay my mounting anxiety, I asked for "more specific information as to who handles the insurance and shipping for this exhibition."

With fingers crossed, my heart in my throat, and breathing only with difficulty, I agreed to send my precious "Promised Land" across the vast ocean. Before the Hayward Gallery's exhibition was scheduled to open, I received a phone call from Charly Herscovici, executor of the Magritte estate, who was organizing his own large exhibition, scheduled to open in July of 1991, in Verona, Italy. Since I had already agreed, "in principle," to lend my Magritte for the somewhat later retrospective being organized by David Sylvester I could hardly say "no" to the executor of the Magritte estate. My Magritte was getting very popular.

My second wife, Bronka, and I departed for Europe on June 20, with plans to attend the lenders' reception in Verona, scheduled for three days before the official opening.

On July 3, someone called the Weintraub Gallery with the disturbing news that a friend in Warsaw, Jacek Szumlas, a film producer and distributor, had opened a crate of what he expected to be film sent from New York, and had been shocked to find a painting bearing the Weintraub Gallery label. Warsaw of all places!

My gallery manager immediately called the shipper, who in turn, promised to call the airline. After tracking Szumlas down in Warsaw, she received confirmation that he indeed had the painting and was exceedingly interested in determining its market value. My staff refused to release or discuss the $2,000,000 insured value, but repeatedly stressed the importance we placed on its timely arrival at its rightful destination: Verona.

While Bronka and I traveled through Europe in blissful ignorance of our wayward Magritte, Szumlas gave the shipper the runaround,

claiming that he had spoken to me personally, and that I had warned him not to release the painting to anyone not designated by me personally. I had never spoken to Szumlas.

On July 9, the gallery received a call from the shipping agent, who had received a telex from their Warsaw branch, advising them that on the advice of his lawyer, Szumlas was claiming a 10 percent finder's fee under Polish law.

When my staff finally reached me in Abano, Italy, with the news that my Magritte was now in Warsaw, I nearly had a heart attack. The country from which I had fled in 1945, which I had pledged never to revisit for the rest of my life, now held my Magritte hostage. The coincidence was terrifying. The American ambassador, Tony Perkins, was a great help. He met with Mr. Szumlas in person, only to find that Szumlas, no doubt on the advice of his lawyer, had turned the painting over to the National Museum in Warsaw for "safekeeping." Perkins advised me to retain a lawyer in Warsaw to negotiate directly with the museum. After a good deal of wrangling the Magritte was finally shipped to Verona, all in one piece.

Upon my return to New York, I called Szumlas, to whom I had avoided paying a "finder's fee." He announced in an offhand manner that this entire affair—which he referred to as "the Magritte Incident"—would make a great movie, and that his "close friend," Andreej Wajda, would be the perfect director.

When I finally shipped the Magritte out to meet up with the Magritte retrospective, I wrote requesting that the Magritte be given "special cover," a term-of-art in the insurance business guaranteeing "payment of the total amount for which the work is valued, in the event of any damage to the work while on loan." While the British government indemnity covered the costs of "expert restoration" if the painting was damaged, full compensation could not be guaranteed.

In February of 1992, a full year after the initial request, I received an urgent request from Martin Caiger-Smith, the exhibition organizer, that I release the Magritte with the coverage specified. "We hope very much that you will be able to reconsider, and that this most important work may still be included. Its omission at this late stage would be most damaging to the exhibition."

It was not omitted. In fact, seeing my Magritte at the Met, not to mention the Menil and the Art Institute of Chicago, was one of the great thrills of my life.

The Magritte incident shows the power of coincidence; it illustrates the genuine connection. Me to Magritte. Magritte to Warsaw. My own escape from Warsaw, mirrored in the trapping of the Magritte back in my miserable old home town. I, who had been held

a hostage of the Warsaw Ghetto as the Nazis dickered over how to implement their Partial Solution, which came before the Final Solution, bought a painting illustrative of my escape, of my freedom. After overcoming my anxiety, my fear, that something would happen to it, it too was in fact held hostage—in Warsaw of all places!

God, I often think, is a great scriptwriter. A great producer of true stories. The following is my own story, a true story, and I hope a compelling one. A story of art, and life, of entrapment and freedom, of striving for success and success. But above all, of welcome coincidence. And of fate fulfilled.

Part One:
Up the Ladder

Promised Land: Coming to America, Barbara and Me

The *Marine Flasher* concluded its calm, ten-day voyage out of the ruined German seaport of Bremerhaven, dropping anchor in New York harbor on the night of May 19, 1946. Of the 800 refugees and displace persons aboard scarcely one had slept a wink; we were all too excited at our first glimpse of the fabled Promised Land.

I'll never forget laying eyes for the first time on the beautiful sea-green Statue of Liberty. To me it seemed that she was extending a warm maternal embrace. As the sun rose over the slimly tapering skyscrapers of lower Manhattan, the city remained aglow with seemingly endless lights.

The passengers of the *Marine Flasher* were truly the tired, poor, and huddled masses of Emma Lazarus' immortal poem. The flags waved above us, snapping fiercely in the breeze, bringing tears to our eyes as the vessel eased slowly into her dock at Pier 64. "The sun flashed brilliantly through the clouds," wrote *The New York Post*, "as the victims of Nazi tyranny sang in faltering voices, "My country 'tis of thee, sweet land of liberty, Of thee I sing."

Through all those dark years of living like rats inside the Warsaw Ghetto, and the fearful hiding as gentiles under the name of Winiawski, we had wondered when the Americans would deliver us. Now, we were being delivered to America. On the pier below, nearly a thousand friends and relatives of the passengers were waiting for the ship to slide into her berth. As the gangplanks were lowered, a vast roar of welcome rose up to meet us. On shore excited greeters frantically waved placards and signs bearing the names of passengers. Barbara and I knew no one would be waiting to greet us. We had no one in the United States, possibly no one anywhere.

But Barbara and I had made one good friend on board the *Marine Flasher*: Bill Ungar, a kindly young man who had offered to take one of our valises under his quota. Bill was one of the fortunate ones who had relatives waiting for him at the dock. They embraced him

and swept him off in a waiting car, but not before he could invite us to lunch with his family in Riverdale, a place that sounded at least as exotic as Lvov might have to a New Yorker.

The cost of our passage on the *Marine Flasher*—just under $300 for the two of us—had been paid for by the American Joint Distribution Committee, which with the Hebrew Immigrant Aid Society (HIAS) relief agency and the United Nations Relief and Rehabilitation Agency (UNRRA) had hastily formed an ad hoc committee to take charge of us. We were the first wave of what would soon be a torrent of survivors of the Holocaust.

After spending a few nights at a small residential hotel near Pennsylvania Station—where two couples were billeted to a single room—I was briefly interviewed at the Joint's offices on Manhattan's Park Row, near City Hall. I explained my background in the film exhibition business, and that Barbara's family had had a relationship before the war with Paramount Pictures. We wanted eventually to explore the possibility of buying or building a movie house somewhere. But before that long-term prospect could materialize, one of us desperately needed a job, preferably two jobs. The ad hoc committees of UNRRA and HIAS, which were just testing the waters with their first arrivals, quickly found us more spacious quarters in a sprawling apartment at Madison Avenue and 98th Street.

Every day, for several months, I visited movie houses and film distribution companies to inquire about jobs. At nearly every location I visited, I was informed that I had come to the wrong place at the wrong time. Not through any particular fault of my own, they explained, but because industry insiders had become firmly convinced that the movie-house industry was soon to become obsolete, done in by that upstart poor cousin of radio called television.

That this gloomy scenario would not, in the end, take place hardly mattered. My skills and expertise, such as they were, were not needed. A "Labor Committee for Immigrants from Central Europe"—part of the Labor Division of the New World Club—had done what they could, by providing me with a "Dear Brother" letter addressed to the Motion Picture Studio Mechanics Local 52 in New York: "Weintraub commands extensive technical as well as commercial experience in the movie-picture line. He was actively engaged in the anti-Nazi underground movement so that the Allied Occupation Authority in Berlin gave him a certificate which he would be glad to provide you upon request."

Fortunately, I was later discreetly informed by one of my interviewers that this letter of reference might not be looked on with favor in certain quarters since, unknown to me, the New World Club

was a well-known Communist front organization. As a confirmed anti-Communist, I no longer felt comfortable using the letter. It hardly mattered. There were no jobs to be had for an immigrant would-be theater owner/manager with a thick accent and little ready cash. A few kindly souls suggested that we might look outside the city, in some small town, but that did not appeal to either of us even though New York frightened us. It also filled us with awe since, after our wartime deprivations, the mere sight of food on display in shops, restaurants and cafes, not to mention ordinary citizens' homes, could be enough to cause us to suspend our disbelief. We hadn't seen such beautiful provisions since well before the war.

The day we joined Ungar and his family at their elegant home in Riverdale, the Bronx, we were three-quarters of an hour late for lunch because we were afraid to take the express subway. The meal at this lovely home was a revelation. It was almost too much for us to absorb. It was as overwhelming as New York. We were wide-eyed at everything: the tall buildings, the insane traffic, even the traffic lights that flashed confusingly on and off and caused all motion to halt while they made up their minds whether to turn red or green.

We were taught a few tricks by other greenhorns: that if a shopkeeper told you that certain smaller oranges "were not for Jews" he meant "not for juice," and that this was not an anti-Semitic remark. That Ratner's delicatessen on the Lower East Side would be generous in supplying us with extra rolls and pickles with our soup, enough to take home to fill out a meager meal.

Occasionally I wondered what had gotten into me, to have turned down a recent opportunity tendered on behalf of the Allied Occupation government to repossess a Berlin theater — in exchange for what? Free rolls at Ratner's? For every survivor, the most important question often becomes: "Survive for what?" More than once, I wondered: for what? When I rode the subway around town to job interviews I grew frightened for Barbara who rode the East Side local subway downtown every morning to the financial district, where she had landed a job as secretary to a dealer in watch parts. I didn't like the push and crush of bodies, and worried constantly about the prospect of her being molested.

While Barbara went off to work each morning, I kept dropping by the refugee committee to see if anything had turned up. One day, I was introduced to Erich Cohn, president of the Goodman Matzoh company, and a prominent figure in Jewish philanthropy. Cohn was an avid art collector, primarily of German Expressionist works. He asked me what my line of work had been "in the old country."

"The picture business," I replied, meaning of course, the movie pic-

ture business. Being an art collector, he thought I was referring to art dealing. Picking up the phone, he called his close friend Erich Hermann, like Cohn an affluent German-Jewish New Yorker, to ask about a possible opening in his small prestigious art reproduction house. I was feeling particularly low that day. I had been pounding the pavements since early summer without even a smidgen of success. Part of the problem, of course, was that so much of New York seemed to shut down every summer. Finally in early September, I received a call from Cohn's secretary, informing me that Hermann would now like to see me, that he might have a place for me in his organization.

In a state of high excitement, I put on my good suit and tie and with anxiety made my way to Hermann's office at 383 Madison Avenue. Hermann was of Prussian-Jewish ancestry, and, although he was Jewish, he was really more Prussian than Jewish. Everything in his office was sparkling clean, maintained in the most meticulous order.

Hermann's organization was small: himself, a salesman, a stockman, a secretary, a delivery boy, and one junior partner named Dishman. I would be an apprentice and jack-of-all-trades to Hermann. I would do whatever no one else wanted to do and learn the business as part of my on-the-job training. In truth, I don't imagine that Hermann considered me a likely asset to his organization as much as he felt that I was an opportunity to assuage his conscience by helping out one of his fellow Jews, particularly a Holocaust survivor.

Hermann, like many American Jews, had learned the true dimensions of the Holocaust only after the war. The shock was unimaginable. Yes, the world had known about the "concentration camps," but not all the world had known, much less believed, that the Germans were capable of exterminating six million Jews. Being a charitable man and a Jew, Erich Hermann was in part responding to this delayed shock-reaction by extending his hand in charity to a newcomer.

Erich Hermann and Erich Cohn were not the only ones who showed an interest in my welfare. Like these other wealthy, socially prominent German Jewish-Americans, former Senator and Governor Herbert H. Lehman, the nation's leading Jewish philanthropist and statesman, also took me under his wing.

Within a few weeks of disembarking from the *Marine Flasher*, I was taken by a member of UNRRA to meet the former governor at his huge art-filled duplex apartment on Park Avenue. Having served with distinction as both governor of New York and United States senator, Lehman was then serving as president of UNRRA.

When I was ushered into his library on a hot day in mid-August,

Form W-4
(Revised June 1945)
U. S. Treasury Department
Internal Revenue Service

EMPLOYEE'S WITHHOLDING EXEMPTION CERTIFICATE
(Collection of Income Tax at Source on Wages)

Print full name ..

Print home address .. Social Security No.

FILE THIS FORM WITH YOUR EMPLOYER. Otherwise, he is required by law to withhold tax from your wages without exemption.

HOW TO CLAIM YOUR WITHHOLDING EXEMPTIONS

I. If you are SINGLE, write the figure "1"

II. If you are MARRIED, one exemption is allowed for the husband and one exemption for the wife.

 (a) If you claim *both* of these exemptions, write the figure "2" 2

 (b) If you claim *one* of these exemptions, write the figure "1"

 (c) If you claim *neither* of these exemptions, write "0"

III. If during the year you will provide more than one-half of the support of persons closely related to you, write the number of such dependents. (See Instruction 3 on other side.)

IV. Add the number of exemptions which you have claimed above and write the total 2

I CERTIFY that the number of withholding exemptions claimed on this certificate does not exceed the number to which I am entitled.

DatedOct. 10........., 194 6 .. (Signature)

A record of my first and only job at
Erich Hermann's 1946 - 1950.

he rose to greet me from behind his broad desk, shake my hand, and apologize for being in his shirt-sleeves, explaining that the air-conditioning was not working.

We spoke of the experiences of recent immigrants in general and Holocaust survivors in particular. I told the governor about our having suffered and having lost our families. But I also told him that I had no interest in becoming a charity case, or of becoming a charge or a burden on the generosity of wealthy men like himself.

For all their great wealth and position, the immediate ancestors of these powerful individuals had at one time been in my miserable shoes: fresh off the boat, as it were, filled with hopes and dreams, with only their wits and will and grit to guide them. I had come to this country, I explained, much as their own grandfathers had: to succeed in the Promised Land.

I was just thirty-three. My benefactors were all easily twenty years my senior. But I think they saw something not of me, but of their grandfathers, in my shining eyes — those earlier Lehmans and Cohns and Hermanns who did not inhabit Fifth and Park Avenue mansions but peddled dry goods in small southern towns in the troubled years before the Civil War.

Now I wanted to succeed as their forefathers had, in business and in human affairs. I hadn't their money or social connections but I had something else: my own business background, my determination and additionally my Holocaust experience. It would be a long time before I fully grasped the extent of the effects on me of those years spent in hiding, and how much these experiences would influence the man I turned out to be: incorrigible maverick, an acerbic contrarian, an obstinate S.O.B. who often bucked trends merely from instinct, who would succeed because he couldn't fail.

At my first meeting with Erich Hermann, I made it plain that I aimed to make myself not merely useful, but absolutely indispensable. In a larger sense, I wanted to prove that I could be as good an American as anyone, if only I were given a chance.

Hermann gave me that chance. For that, I am eternally grateful. In his stiff Prussian manner, he could be a very kind man. He had his pride, and didn't like having his iron will resisted, particularly by underlings. He didn't believe in fraternizing with his employees, but he believed in treating them fairly. I observed Hermann's management style intently, making mental notes along the way. I fully intended to run my own business one day, and was curious as to how such a thing could be accomplished. Rather than resent my status as a beginner, I resolved to study the boss.

A strong sense of hierarchy pervaded those modest offices, from

Hermann's own nicely furnished private office down to the stock-room, where I spent most of my time. The stockroom was lined with shelves on which reproductions of all the great art works of many centuries, from ancient Rome and Egypt to 20th century masters, were carefully arranged in alphabetical order. Other shelves contained catalogues and art books arranged by school, from the Renaissance to the Impressionists. Hermann, apparently recognizing that I was a man of intellectual curiosity, made it plain from the start that he would not only permit but encourage me to study art on the premises.

"When you have a little extra time, study and learn," he'd say, waving an expansive hand at the art-education course materials, catalogues and the like, stacked shoulderhigh against the wall of his stockroom. I took him at his word and when I wasn't filling orders or typing invoices, I read up on art.

"The sea was my Harvard and my Yale," said Herman Melville. Erich Hermann's office was my N.Y.U.'s Institute of Fine Arts. After my wartime traumas, it was soothing to pour over the books that contained the best art that civilization had ever produced. After being subjected to the brutality of Nazism, it was important to be reminded that not all of mankind were beasts, and that Western civilization was capable of producing something finer than an efficient gas chamber. Hermann was indeed a refined product of that once-great Germanic civilization that now lay in ruins along the banks of the Rhine and Elbe.

My art history lessons had a purely practical as well as psychological effect on my well-being. They taught me something about the emerging popular taste for fine art, and its development during the postwar period. There could have been no better vantage point than an art reproduction house from which to learn the finer points of the art business. Hermann's range was tremendous, covering all periods and fields, from old masters to 20th century masters.

In those days, even the best-trained interior decorators, particularly when working for corporate clients, purchased art reproductions and incorporated them into their decorative schemes. The product mix of most reproduction houses in those days tended to be about half old and modern masters, and the other half "decorative" art. The decorative pictures were simply that: pretty, innocuous pictures, not academically supportable, but well adapted for catering to an unsophisticated taste.

Art reproduction houses would buy the right to reproduce paintings from their owners, be they museums, other cultural institutions or private collectors. Over the years from the '50s to the '60s, a

sea change occurred in the industry. While a taste for "higher art," even in reproduction, had at one time been restricted to a very small, elite group of people, the more "high end" works started to increase in sales volume, and sales of unsophisticated "decorative" art declined.

I noted this trend with more than passing interest and I carefully demonstrated the changing reality with invoices and sales reports to Hermann. We were living in a fast-changing world where jets were beginning to permit middle-class people to enjoy the luxuries once limited to the very wealthy. Art, and the art business, was suddenly no longer restricted just to the society pages or the back of the book of the general interest magazines. Our product mix of fine art to "schlock" art went from fifty-fifty to seventy-five–twenty-five. We were able to become much more adventurous in the paintings we commissioned for reproduction. By the late '50s and early '60s, what would have appealed only to an avant-garde taste before the war was suddenly considered appropriate for corporate offices and middle-class living rooms.

The democratization of fine art was here to stay. While packing and shipping and examining invoices, I grasped that this was a growing field, a field that might give me an opportunity to succeed beyond the prospects of the movie-house industry. Fine art was a growth industry. An industry, furthermore, about which I was now getting the opportunity to learn from the bottom up and from the inside out.

I also learned invaluable lessons about serving customers. This could be distilled into the following principle: grasp the customer's underlying psychology, and you have a sale. For example, Hermann always told me that when showing religious art works to priests, it was simply good salesmanship to go through all the nudes first. If they weren't altogether salacious, but were of the School of Michelangelo, the priest could hardly resist taking a look. And something about the effect of gazing upon even reproductions of painted images of human flesh helped close the sale. Life, as they say, embodies many mysteries.

Hermann considered himself a German-American first and Jew second, if not third. His attitudes toward Zionism and Israel had always reflected this deeply assimilationist mindset. Even after the horrors of the Holocaust had been revealed to the world, the issue of how Jewish he wanted to be seemed remote to him and to have little direct impact on his life as an assimilated German-American, a man of property and culture and breeding.

This secular attitude was destined to be challenged in 1949, just

a year after Israeli independence, and a year before I left his employ. Hermann had to make an emergency trip to Italy to manage a crisis in what was to be the production of the first accurate full-color reproductions of Raphael's "Sistine Madonna."

Instead of following standard procedure and running off a few sample copies so that the color accuracy could be checked against the original, the Italian printer had gone brashly ahead and run off and shipped to Hermann a full print run of several thousand copies with disastrous results: the colors were muddy and blotchy.

Hermann, the proverbial Prussian perfectionist, was outraged. But the printer, rather than seeking forgiveness for his sins, chose to go on the offensive.

"You're just like all the other Jews, a real trouble-maker," he told Hermann when he arrived at the plant. Hermann clearly felt wounded, but kept his reaction to himself.

My first inkling of Hermann's changing attitude toward his own Jewishness, and the plight of world Jewry in general, came soon after his return from Italy. I noticed a subtle change of mood. This puzzled me until I was called into his office after one of our minor disputes. Closing the door, he spoke confidentially as a father might to a son:

"You know, Jacob, I've changed my mind about Israel. We do need our own country. We need to be able to defend ourselves." By way of demonstrating his conversion and newfound commitment to Zionism, he showed me a check made out in his name to a prominent Israel charity.

This final conversion signaled the conclusion of a long-running argument between Hermann and me concerning the need for an independent Jewish state. I had stated, "You don't have to be an ardent Zionist to agree, having lived through the Holocaust, that we should always have a country, a Jewish homeland, a place of refuge if such a terrible thing should ever happen again."

The New Art Center Gallery

I had been powerfully attracted to owning my own business from the first moment I walked down the gangplank of the *Marine Flasher* and stepped ashore at Pier 64. The problem had been not the will, but the means — meaning money. Senator Lehman played a significant part in providing the way, clearing my way to the money.

I'd not spoken to Lehman for several months when he dropped by unexpectedly at Erich Hermann's office one day, to see how I was doing. One can scarcely imagine the excitement that erupted in that tiny office when the message came through that Senator Lehman was waiting in the reception area and that he wanted a word with his friend, Jacob Weintraub.

I was excited, and spoke to him candidly about how much I liked working for Hermann, how much I was learning, and how well I was doing. But I also confided my real aspiration: to own my own business and, like Hermann, to be the employer of others. Senator Lehman listened to my little speech quietly, with obvious sympathy and understanding. Something about this rendition of the American Dream by a new immigrant, still dramatically underweight from years of starvation, struck him as noteworthy. He turned on his heels and gestured to me to follow, imperiously announcing that I was now on my lunch break and that I must join him.

We strode off in a thoroughly businesslike manner down Madison Avenue. He practically tugged me through the lunchtime crowds as if rushing to catch a commuter train out of Grand Central.

"Where are you taking me, Senator?"

"You'll see," he said.

He marched me straight to the nearest branch of what was then called the First National City Bank, now known as Citibank. Introducing me to the bank manager, who appeared surprised to see this greenhorn with the halting English being personally introduced to him by the former governor of New York. Lehman instructed me on opening a bank account. Up until then, I had been cashing my checks in Hermann's bank—$80 a week and needing every dollar of it.

After both savings and checking accounts had been formally opened in my name, the senator marched me over to the loan window, where he had a brief chat with the loan officer.

"Mr. Weintraub would like to borrow a thousand dollars," the senator said.

"But Senator," I protested, "I don't want any money on loan. I can't handle the interest and I have enough to get along."

"That is not the point, Weintraub," he said impatiently, dismissing my protestations with a short wave of his hand. "The point is to develop a good banking relationship. Even if you don't need the thousand, the point is to borrow it and pay it back in a timely fashion, so that you can build up a credit history. Then when you start your own business, and need to borrow money in order to be more successful, you'll be able to borrow what you need."

The faith, not to mention the interest and generosity, shown in me and my future by Senator Lehman was truly extraordinary.

Yet strange as it may sound, I owe perhaps as much of what I am today to the influence of enemies like Kurt Dishman than to the help of wonderful friends like Erich Hermann, Erich Cohn, and Herbert Lehman. Without Dishman, I might never have become an art dealer. Dishman was Hermann's junior partner, and there was, to put it mildly, no love lost between us. Dishman and I detested each other.

In over four years of working together, Hermann and I gradually developed a father-son relationship, one of whose most salient characteristics was a tendency to quarrel, to get each other's goat, but, in the end, always be reconciled.

Hermann taught me a great deal about art and the art world. I suspect he enjoyed having me under his wing. Autocratic as he could be, he nevertheless encouraged me to learn on the job.

Hermann and I also respected each other. But he was continually firing me, after which he would invariably repent by offering a silver trinket, when he was prepared to return to amicable relations.

Who knows how long we might have gone on fighting and making up, like some old married couple. But Dishman saved me from staying with Hermann, for which I will be eternally grateful.

Of course, the great irony is that Dishman never displayed the slightest interest in furthering my career. If anything, he had a petty, jealous interest in holding me back. But without him, I may never have ended up forty years later selling million-dollar Moores on Madison Avenue.

Dishman was the very model of an upright, uptight German who prided himself on conducting all of his affairs with Teutonic efficiency. Skinny, dark-haired, and full of temper, he acted toward me

in a petty bullying manner so reminiscent of the Germans during my years in the Warsaw Ghetto. I had literally no tolerance for him.

In mid-1949, halfway through my fourth year at Hermann's, Dishman departed for a job elsewhere, leaving me to fill orders and sell art work with a free hand. It appeared that my prayers had been miraculously answered. For two solid months, I felt like a free man. But then this blissful interlude was cut short when Dishman returned; the golden opportunity he had been pursuing elsewhere had failed to work out.

Now, I was faced with a new dilemma. Having enjoyed two deliciously Dishman-free months I was loath to return to my old place, under his thumb. Instead of returning a humbled man, Dishman demonstrated his usual arrogance by extracting an iron-clad assurance from Hermann that he would no longer have to answer to Hermann's brother, who kept the books and loved nothing better than bossing Dishman around.

Hermann's brother was reputed to have been a district attorney in Germany at a time when, in order to attain such a high post, he would have had to renounce his Jewish heritage. The tables were turned on him when Hitler came to power in 1933. It wasn't long before even converts were not protected from persecution and loss of government jobs. Being forced to flee for his life, and throw himself on the mercy of his younger brother in America, hardly did wonders for the man's personality, which was always disputatious. Something was bound to give in this situation. One morning I arrived at the office out of sorts, having had an argument with Barbara. By lunchtime, Dishman's petty bullying caused my already short fuse to blow. I was just about ready to wring the man's neck. Instead, I marched into Hermann's office demanding immediate relief from this abuse. "You promised me that when Dishman came back I wouldn't have to follow his orders," I challenged Hermann.

This was not the right approach. Hermann, who I later suspected might have had his own fight with his wife that morning, was not inclined to be flexible. Feeling unfairly attacked by a young employee, Hermann, in his Prussian way, chose not to back down. Instead, he flipped the situation and accused me of failing to "cooperate" with Dishman.

"What is there to cooperate about?" I asked.

"If that's how you feel," Hermann replied, drawing himself up to his full six feet, "I don't think there is anything more to discuss. I think the time has come for us to separate."

From the decisiveness of his tone and his manner I knew that this time there would be no going back.

I walked off the job, and promptly filed for New York State unemployment benefits. At one point, I received a call from the unemployment office saying that Hermann had offered to take me back. I refrained from telling Barbara what had happened, including Hermann's offer, for fear that her anxiety might be too much for both of us. Instead, I carried on a little charade, leaving our apartment at the usual time, taking my brown-bag lunch, as if I were heading off to work as usual.

"Work," in this case, consisted largely of visiting art galleries and museums, prowling the streets, making calls for interviews and scouting possible locations for setting up my own gallery. It was the one week of my entire life in America when I was neither employed nor self-employed: the year was 1950. I was in limbo and restless.

My one immediate prospect of attaining a new position was with a prominent art publisher, Raymond & Raymond, whose catalogues of reproductions were acknowledged bibles in the field. One of their employees had recently left, Leon Arkus, who later became director of the Carnegie Museum of Art in Pittsburgh. I was offered the job as his replacement at a salary of $100 a week, $20 more than I had been earning at Hermann's. The potential to climb within the company was tempting. The job offered security, opportunity for growth, and more than a bit of prestige. I turned it down.

My reasoning was becoming clearer by the day. I not only wanted but needed to be my own boss, independent of others, an entrepreneur, a marketer of my own skills and ambitions. Furthermore, I knew just what I wanted to do. I wanted to be an art dealer. I wanted to open my own gallery, to get out of the reproduction business, and start dealing in the real goods.

The state's determination on my claim for unemployment benefits arrived one morning in early November. Barbara, still ignorant of my being out of work, opened the official-looking envelope. The form letter broke the bad news:

NOTICE TO EMPLOYER OF DETERMINATION MADE—CLAIMANT DISQUALIFIED

On the reverse side, a checklist proclaimed:

"The above determination is based on the following:–in a pencil scrawled message, the manager had written–"YOUR ACTIONS WERE TANTAMOUNT TO A VOLUNTARY QUIT." [1]

My wife, whose knowledge of English was at that time even some-

1. Many years later, long after the wounds from this particular trauma had healed, my second wife, Bronka, and I had the good fortune to befriend the late great Leonard Bernstein, toward the end of the great conductor's life. He would visit the gallery to admire the art, and was sympathetic during our long conversations to my professed desire to become a true "Renaissance Man," a devotee of both music and art. After hearing this story from "the horse's mouth," so to speak, Bernstein wryly suggested this title for my autobiography: "Tantamount to a Voluntary Quit."

STATE OF NEW YORK · DEPARTMENT OF LABOR

DIVISION OF PLACEMENT AND UNEMPLOYMENT INSURANCE

CLAIMANT'S NOTICE OF DETERMINATION

LOCAL OFFICE *239 E. 42 ST*
ADDRESS *My 17 My*

Jacob D. Weintraub
606 E 83 rd
My 28 My

Date *10/9/50*

134-22-7821
S.S. No. or Ser. No.

You are hereby notified that you are
- ☐ suspended from ⎫
- ☐ ineligible for ⎬ unemployment insurance benefits/readjustment allowances
- ☑ disqualified from ⎭

for the reason checked below:

REASON

1. ☐ Unavailability for employment.
2. ☐ Incapability of employment.
3. ☐ Refusal of referral to employment without good cause for which you are reasonably fitted by training and experience.
4. ☑ Voluntarily leaving employment without good cause.
5. ☐ Misconduct in connection with employment.
6. ☐ Industrial controversy.
7. ☐ Failure to comply with reporting requirements.

PERIOD

- ☐ From *9/20/50* to *10/31/50* inclusive.
- ☐ For an indefinite period beginning
- ☐ From and until you become employed and subsequently unemployed.

The above determination is based on the following: *Your actions were tantamount to a voluntary quit*

In the event you again become employed and subsequently unemployed during the above stated period or are still unemployed at the end of such period or you believe that the reason for your suspension no longer applies you may reinstate your claim by reporting to an interviewer at the local office.

IF YOU DISAGREE WITH THIS INITIAL DETERMINATION YOU MAY FILE A REQUEST FOR A HEARING IN PERSON OR BY MAIL AT THE ABOVE STATED LOCAL OFFICE. SUCH REQUEST MUST BE FILED NOT LATER THAN TWENTY DAYS FROM THE DATE OF MAILING OR PERSONAL DELIVERY BY AN EMPLOYEE OF THIS DIVISION, OF THIS NOTICE TO YOU AS INDICATED ABOVE.

IF YOU DISAGREE WITH THIS INITIAL DETERMINATION and remain unemployed, you must continue to report to your insurance and employment office as directed for the period for which you are claiming benefits even though the assigned dates for so reporting fall within the period for which you are disqualified for benefits.

Wm E. Harris
MANAGER
FOR THE INDUSTRIAL COMMISSIONER

LO 412.1 (4-49) 2-6-50-350M (9B-1162) (OVER)

"Tantamount to a voluntary quit."

what more rudimentary than my own, had one question for me upon my return.

"Jacob dear, what does 'tantamount' mean?"

Quite frankly, I hadn't the faintest idea. I called *The New York Times,* figuring someone at "the newspaper of record" should know. After being bounced around from department to department, one charitable soul finally took pity on me, and hazarded:

"It means same as or equal to. Or amounts to the same thing."

Barbara never reproached me for hiding my dismissal from her. After all we'd been through neither of us ever had much stomach for fights or recriminations. Together, we lived and let live. While strolling down Lexington Avenue, I noticed that a small store at 1193 Lexington Avenue at 81st Street stood empty, a FOR RENT sign in the window.

It was small, humble, forbiddingly empty, and needed fixing up. But to me it looked like an opportunity. Though not an artist myself, I sometimes give myself credit for having an aesthetic eye. I could envision that little "hole-in-the-wall" fixed up, painted, outfitted with pegboard, lined from floor to ceiling with fine frames, and above all, with good works of art.

Eagerly, I wrote down the agent's number and name, Charles Greenthal & Co. I was trembling with excitement, and also from the cold in December from a great blowing storm. I made an appointment to see Mr. Greenthal. Being a young man in a hurry, never having felt like someone with much time to waste, I turned up for this appointment pünktlich, German for "punctual." Charles Greenthal kept me waiting for over half an hour. When he finally turned up, I advised him of my strong feelings about punctuality.

Somewhat taken aback at this display of pride and nerve on the part of a mere greenhorn, Greenthal solemnly promised not to be late for any future appointments. Moreover, no doubt impressed by my chutzpah, he promised to exert whatever "pull" he could muster with the landlord, Edward Kimmel, an attorney who on the side dealt successfully in real estate, to cut a deal for the store.

There was only one problem: although I could afford the rent, I needed a $5,000 loan to refurbish the place. Greenthal asked Kimmel if he might be willing to invest $5,000 in my business. Kimmel wasn't at first interested in investing in the business, but ultimately agreed to extend the $5,000 loan and, moreover, without interest. We named the store the New Art Center Gallery.

Years later, at a dinner party in Palm Beach, Eddie Kimmel toasted me with the remark, "If I had accepted Weintraub's offer, and taken a piece of his business, just think where I'd be today!" He

also confided that he never expected to get his money back because no store had ever succeeded at that location. In real estate parlance, the site was a dog.

Dog or not, I agreed to repay Kimmel $200 a month, with the payments stretched out over two years. In addition, Kimmel granted us a rent-controlled lease on a three-room apartment on the tenth floor of the same building (the entrance at 140 East 81st) an elegant pre-war building with thick walls and high ceilings. Charles Greenthal's brother, Leonard, lived down the hall with his wife, Eleanor. Our other neighbors were Frank and Peggy Kent. This "white-glove" doorman building, well maintained, with three traditional apartments to each floor — was quite a step up from our old walk-up apartment on York Avenue.

Now that I was on my own, the question became: how to succeed in business? I'd learned a great deal about art during my tenure at Hermann's but I was not yet in a financial position to acquire original art. Hermann remained my one connection to the exotic, rarified world of fine galleries and European art. Since my departure, he had repented of his treatment of me, and had gone out of his way to make amends by bringing back from his European trips some superb graphics and prints and on rare occasions, a drawing or watercolor, which he would consign to me as a way of helping me break into the art business. In Hermann I had an overseas purchasing agent with excellent taste, at a time when I could scarcely scrape together the rent.

From time to time, Hermann would call on us at the gallery, pausing to scrutinize the arrangements of prints on the wall. If he ever spotted one work hanging even slightly crooked, he would affect a stiff Prussian frown and straighten the paintings into perfectly aligned regimental rows.

Business was slow at first. But I soon became known as the framer on Lexington Avenue, with something extra. For the lack of a better term, let's call it taste. Under Hermann's wing, I had also learned something about framing, that subsidiary craft which is an art in itself. Many an excellent work has been ruined through callous imprisonment in the wrong frame, or by awkward or clumsy hanging and grouping. A delicate Degas drawing should never under any circumstances be overwhelmed by a heavy gilt frame, even if the customer should ask for it. It is part of the dealer's and the framer's job to figure out what the customer "should" want if he knew as much about art as I did, and it was the framer's responsibility to protect the art from being sacrificed on the altar of status.

My insistence upon achieving a certain level of excellence in the

otherwise routine field of framing and installation had unexpected rewards; it led me directly into the more elevated realms of fine art. From framing, I learned about how to deal with customers, which is not nearly as simple as the retailer's cliché, "The customer is always right." In the art business, whether it was framing a small Rouault reproduction or buying a million-dollar Henry Moore, placing the piece is everything. I use the word "placing" to mean fitting the work to the buyer; not every buyer is right for every work, even if he or she may be affluent. The art must fit the tastes and inclinations of the buyer. But all too often the dealer has a finer sense than the buyer as to what is "right" for the collector to own.

Paradoxically, one of the primary ways I established a reputation was by turning down work. By being a little particular, a little persnickety, displaying just the right touch of brittle artistic temperament, I established myself as a framer who was knowledgeable.

To some, my behavior was merely eccentric. Others realized that my quirkiness masked a need, if not a compulsion, to do the job right, regardless of what the buyer might at first believe. My gamble was that if I insisted upon doing the job right, without regard to cost, the customer would return and I'd make money over the long haul. If not on the framing, on the art.

I can't recall how many times a prospective customer would wander in off the street with a small, delicate etching, engraving or watercolor, and request the heaviest, thickest, costliest gold-leaf frame I had in stock, to lend the art a little "prestige." Patiently and repeatedly, I would take the time to explain to these status-conscious people that not every work of art "deserved" the costliest gold frame. One man who thought he knew better became particularly irate that I should dare to adopt such a high-handed attitude.

"Who are you to tell me what to buy?" he demanded, insulted. "You think you're so smart? You just talked yourself out of a hundred-dollar job by telling me to buy a twenty-five-dollar frame."

"Mister, the twenty-five-dollar frame suits the art," I explained. But he was not willing to listen. He thought he knew better. But for every man or woman who stomped out of my shop in disgust, ten other customers respected my judgment and my sense of pride in my work, and came back. And came back again.

To make an extra five dollars, I would often agree to install the pictures myself. "How can you put the picture in the right place without measuring?" one Park Avenue matron demanded suspiciously, as I was not using a tape measure. "Because I've got eyes in my head," I replied. I didn't need a ruler. I knew where the nail should go.

One afternoon Mrs. Eleanor Gimbel, of the department store fam-

ily, came in and said, "Mr. Weintraub, I can get the same gold frame you sell me for half the price elsewhere."

"Are you buying wholesale?" I asked, figuring you never know, since her family owned a far larger store than mine.

"No, from another framer," she said in a challenging tone.

"Then it can't be the same quality," I said confidently. Either that, or the man was framing for her at a loss.

"Are you saying that I don't know the difference?" she demanded, shocked at the suggestion.

I shrugged, and said "Yes." What was Mrs. Gimbel to me?

She didn't come back for over a year. All that time, she used another framer. But then, one day, she surprised me. "You were right," she said. I didn't gloat. It never pays to. I kept her business for years.

On another occasion, a man called the gallery and told me that his wife would shortly be stopping by with some elegant sporting and hunting prints which they wanted framed in "the best London style."

When she came in with the large sporting prints, fine old engravings on beautiful paper, I was very specific about how the job should be done: not with a conventional paper mat, but one painted directly on the glass with a thin gold-leaf border. This, I pointed out, would cost at least five times as much.

She left in a huff, announcing that she could paint the glass herself. Figuring that was her own business, I said nothing. About a week later, I got a call from her husband. "Mr. Weintraub," he said, "you are destroying my sex life."

"What?" I shouted, figuring I had misheard him.

"I can't stand this another night. I am sleeping with a woman who has to wash her hair every night with turpentine, with flakes of paint falling out of her hair all night. Please, Mr. Weintraub, do me a favor, take the prints back and tell her it will cost nothing extra. I will be glad to pay the difference just to have a little peace in this house." Of course I agreed to his plan. "And in the future, so that we don't have any more misunderstandings, when she bargains with you, always agree with what she wants and then send me a bill for the real price."

In the late '50s something occurred in the gallery which convinced me to keep my mouth shut and not talk about my clients, to keep my dealings to myself.

A gentleman, from a well-known family in communications, came into my gallery with a lovely young woman. He introduced me to his daughter, Margo, who had just graduated from college and, instead of a car, she wanted a Picasso drawing as a present. After looking for a half an hour the young lady selected a drawing by Picasso and I

sold it to the gentleman for a few thousand dollars. He told me that any time I needed something in his field not to hesitate to call. I was very pleased with this sale, and the contact into the communications world, feeling that I had a new influential client who liked me.

A few months later a woman came in and introduced herself as the wife of the gentleman. She looked around for a while and on her way out stated that she liked what she saw and would be back. As it happens she never returned after I asked her how her daughter was enjoying the Picasso drawing. She replied, "Mr. Weintraub, we do not have a daughter."

This experience taught me a lesson and I gave an order to my mouth to stay shut. I was learning every day. I was still an ignorant greenhorn in many ways, but at least I knew what I didn't know. And I made a special point of learning from my clients.

Nearly every step of the way along "Jacob's Ladder" I enjoyed the good fortune to meet, often purely by chance, people who were willing to give me the benefit of their special talent. I learned early that once discerning people had a chance to talk to me, they would sometimes look past my often halting English, my lack of fancy clothes, and the relatively humble surroundings of the gallery. Whether the person was a rich art collector or a venture capitalist, they saw something that intrigued them, something to identify with. They came in, and often stayed to chat. And after that chat, they often became friends and clients. Sometimes even partners.

At times like these, when I depended upon favors of others, I was forced to reflect that for all my distrust of the human race, certain of its members could be very generous with their time, their knowledge, and even their money. Such a man was Dr. Hans Kleinschmidt, a psychiatrist, who in the early days of his practice had an office on the ground floor of a building on Lexington Avenue directly across the street from my little "hole-in-the-wall."

Kleinschmidt was a great connoisseur of German Expressionist art, which was becoming my special field of interest. After Hermann, Kleinschmidt served as my first tutor, a service he rendered strictly out of the goodness of his heart, the warmth of his feelings for me, and for sheer love of the art itself.

At that time, a certain residue of my suffering in Poland was occasionally apparent in my face. Kleinschmidt noticed that my attitude toward the world was highly skeptical of other people's motives. He later told me that he sensed a certain integrity which made me, he said, one of a handful of New York dealers who would never foist a fake on some unsuspecting customer, simply because I was stuck with it.

Long before I knew much about the Expressionists, I responded at

some very deep, visceral level to their art. The foreshadowing of catastrophe apparent in the haunted "Scream" of Edvard Munch, and in the vivid palette and surreal quality of Paul Klee, were gut-wrenching. The drawings, etchings, paintings and dry-points of these early 20th century artists eerily corresponded to my own personal experience in Europe before and during the war.

During one of Kleinschmidt's first visits to the gallery, he was surprised to find a young secretary typing letters to various colleges, museums and galleries around the country, offering German Expressionist graphics for sale. From the beginning, I understood the value of promotion, and communicating with a wider audience. Beyond necessary expenses, every dollar I earned went immediately into some form of advertising.

One day I called Kleinschmidt with what I thought was a brilliant solution to my biggest problem: his inability to advise me on my buying art when he was seeing patients. My solution, which I thought ingenious, was to bring the art into his waiting room, wait until his session was done, and show it to him for his expert opinion.

Unfortunately, Kleinschmidt told me that some of his more troubled patients might be disturbed if they saw a man holding some large print by Emil Nolde or Munch outside his office, as if I was bringing my art with me into a session.

Once, he accompanied me when I visited a dealer reputed to have an Emil Nolde, an Ernst Ludwig Kirchner, and an Erich Heckel for sale. The dealer proudly produced each etching, placed it on a chair, and stood back to admire the effect. Dr. Kleinschmidt studied each one carefully, shaking his head and squinting, before delivering his verdict:

"This one is a fake. And that one over there is also a fake. And the third one is a fake, too." Turning to me triumphantly, he said, "Jacob, let's get out of here."

In general, I recognized a good print when I saw one. But if I ever suspected a fake, Kleinschmidt's second opinion was invaluable. In those days, the finest selection of German Expressionist graphics in New York (outside of private collections) could be found at E. Weyhe Inc. on Lexington Avenue, a combination art book and graphic arts gallery run by a starchy old German named Ernst Weyhe. I used to haunt his upstairs print gallery in search of rare items like the Schieffler Munch book including an original Munch lithograph.

When I spied one, my eyes glazed over, and I asked Weyhe if I could buy it. "For a hundred dollars," he said, eyeing me sternly.

"But it says sixty dollars right on the label," I protested. He stood firm. "It doesn't matter what is written. It matters what I say now," Weyhe said sternly, in a tone I will never forget. From Weyhe, I

learned that it never matters what is written. It matters what I say now.

The manager of the print department on the second floor told me that Mr. Weyhe had realized that I was, by his estimate, a serious dealer and therefore a serious rival. Weyhe told his print manager, "Don't sell any more prints to Weintraub. Anything he asks for or is interested in, tell him that it's on reserve, or has already been sold."

I should have been proud of being banned by New York's leading print dealer. But I couldn't afford to be cut off from this rich resource right in my own backyard. Accordingly, I asked Kleinschmidt to buy from Weyhe and what he didn't want, I would buy from him. Thus I continued to buy from Weyhe. Only he never knew it. I learned a good deal more from the crusty Weyhe. On a later occasion, when a Nolde lithograph sold at a Parke-Bernet auction for more than I had priced mine, I was in the midst of changing the label when a customer asked me to sell it.

After hearing the revised price, he protested vigorously. "Never mind what is written," I told him sternly. "It's what I say that counts."

From the beginning, I received the most value for my advertising dollar by buying space in New York's German newspaper *Aufbau* ("Building").

Aufbau was founded in 1934 as a limited-circulation news-sheet to serve a German-Jewish fraternal organization based in New York's German enclave of Yorkville, on Manhattan's Upper East Side. But as the world turned to war, and the trickle of German refugees, Jewish and non-Jewish, swelled from a stream to a flood, the proprietors of the paper made a decision to enlarge its scope, and to transform it into a first-class newspaper modeled on the large Berlin dailies.

After the war, *Aufbau* continued to serve the ever-growing German-speaking exile community, its ranks suddenly swelled by the increasing numbers of Holocaust survivors who made their way to the Promised Land. *Aufbau* was the place to advertise, or find a summer house rental in the Catskills. It was the way for a local businessman to reach cultured members of the German-speaking community.

Through advertising in the pages of *Aufbau*, I acquired my first major cache of German Expressionist art. In 1956, a call came into the gallery from a frail-voiced man who had seen my ad in *Aufbau* offering top dollar for high-quality German art. He wanted to know if I might be willing to travel to Queens to look over what he described as an extensive collection of prints which he had brought with him when emigrating from Germany before the war.

Of course I was interested. After closing the gallery, Barbara and I took the subway (this was well before the days when we routinely

traveled by taxi, let alone limousine) to Queens. An elderly and dis-
tinguished gentleman, cultured and elegantly dressed, answered
the door. Beside him stood his equally distinguished wife, who spoke
with a clipped German accent. Their apartment was furnished with
heavy dark wood furniture that they must have also brought with
them from Germany.

After accepting an invitation to join them for a cocktail, our host
explained that, in the years before the war, he had been a meat
wholesaler in Berlin. Apart from having been a member of various
"cultural clubs," through which he acquired works of graphic art by
the month, much of his collection had been traded or bartered for
meat at a time when fresh meat was in notoriously short supply in
inflation-racked Germany.

He led us into his den, a large sparsely furnished room at least 16'
by 16' piled shoulder-high with portfolios arranged in tight ranks
along all four walls. The ancient cliché rings true: my heart literally
beat faster as I began to inspect this vast treasure trove. It must
have been at least nine in the evening when I got down to business,
and it was at least one in the morning before I was done. The collec-
tion was remarkably comprehensive, ranging from Kirchner to Kol-
liwitz, Klee to Kandinsky, Nolde to Beckmann, Pechstein, Heckel,
Grosz, Schmidt-Rottluff — all the Expressionist greats.

Instinctively, I grasped that this was an opportunity not to be
missed. But at what cost? Without a doubt I was seeing one of the
finest private collections of German graphic art anywhere, outside of
a museum. Sold off print by print, I didn't doubt that it might some-
day be worth many thousands of dollars. The question was, what
was it worth today? To me?

Finally satisfied with pouring over portfolios, I told our host that I
was prepared to make a substantial offer for the cream of his collection.

"I'm sorry, Mr. Weintraub," the former meat wholesaler said, "but
if you are going to buy one, you are going to have to buy the lot. We
are in the midst of making preparations to emigrate to Israel, and
our children aren't interested in inheriting our art."

I couldn't help thinking: dumb kids.

I could see by his expression that this wasn't just a ploy. Much as
it obviously pained him to part with his superb collection, if he was
going to do so, it would have to be all in one swoop. A clean break.

His price for the lot was nice and round: ten thousand. That was
a lot of money in those days. And I was well aware that public inter-
est in German Expressionist art was still strictly limited to a small
circle of connoisseurs, mainly of German-Jewish extraction, who
appreciated its profound import. But over time, I strongly suspected

it would reach a larger market, just as the Impressionists and Post-Impressionists had done before them.

We bargained a little, but not for long. We were all tired. We wanted to settle the matter quickly, without rancor or delay. We ended up striking a fair price: eight thousand. With an anxious hand, I wrote out the check thus purchasing a few hundred German Expressionist graphics of the highest quality. I promptly turned my attention to the looming question of how best to haul this huge cache back to our gallery on Manhattan's Upper East Side.

These were the days before gypsy cabs and car services plied the streets of the outer boroughs, not to mention radio cabs. In the mid '50s, there were only yellow cabs and limousines. Another dealer might have left at that point, and arranged the next morning for pickup by a reputable art-shipping firm.

But before I could leave, I heard in my mind an urgent ghostly whisper from my old friend and fellow art dealer, Otto Gerson: "Jacob, if you buy something in the evening, for God's sake take it with you. Because if you don't, by the following morning the seller will have changed his mind, and you'll have to go through the whole deal again."

Truer words were never said. With this in mind, I asked our host if he knew of any all-night taxi or car services in Queens. The old meat dealer did not, but after a brief conversation with his wife, he courteously invited us to spend the night. That is, if we didn't mind sleeping right there in the den with all the art around, of course, on the only couch and an easy chair.

I took the chair. Barbara took the couch. We settled down to an uneasy sleep. Past three in the morning, there came a soft, but insistent knock on the door. I sat up in my chair, with the typical survivor's fear of being awakened in the middle of the night to be hauled off to God knows where by God knows who. But it was only the lady of the house, advising us that they had remembered the name of an all-night limousine service in the neighborhood which might be able to help us transport the art before morning.

Neither of us was very comfortable with the guest facilities. Figuring it was worth a try, we gave the service a call. Much to our surprise, we were rewarded with a conditional "okay" in return for the promise of a generous gratuity for hauling the precious art objects. It took four men over an hour to pack all the art into four shiny black Cadillac limousines. At four in the morning, we traveled in a glistening convoy across the Queensborough Bridge. Barbara, exhausted, went straight upstairs to bed. I, excited beyond my wildest dreams and unable to sleep, spent the rest of the morning

eyeing my new prizes, gloating and arranging them in some orderly fashion in our little gallery.

Buying German Expressionist art was my way of championing that part of German culture that had posed the greatest threat to the futile Nazi attempt to eradicate non-Aryan German culture. As a survivor of the Warsaw Ghetto I've always treasured these sublime examples of German Expressionism as the art Adolf Hitler loved to hate.

In Munich in 1937, the Nazis had organized a gigantic and typically grandiose exhibition of what they derisively termed "Degenerate Art." This negative title indicated the perverse underlying intention of the exhibition: to hold up to the ridicule of the Nazi elite and the ignorant German masses many of the foremost masterpieces of modern German culture.

The show was the culmination of a prolonged and vicious campaign waged by the Nazis shortly after Hitler came to power in Germany against "degenerate" art and the artists who created it.

Works by Edvard Munch, a Norwegian who lived for a time in Germany, and Oskar Kokoschka, Lyonel Feininger and Max Beckmann, Wassily Kandinsky, a Russian resident in Germany, and Ernst Ludwig Kirchner, who committed suicide in 1938, all fell under the rubric of "modern" or "abstract" and thus "degenerate," "immoral," "sick," or "diseased" art.

In 1934 Hitler, a failed artist whose miserable and undistinguished watercolors failed to sell at auction in late 1992 despite their presumed historical interest, had delivered a bone-chilling, hysterical diatribe against purveyors of "cultural Bolshevism," by which he meant those devotees of "abstraction" and "modernism" whose careers flourished while his own was relegated to obscurity in that period of cultural flowering and flourishing known as the Weimar Republic.

Those artists Hitler so boldly attacked represented the cream of the German artistic community, whom he darkly threatened with "jail or the insane asylum" or, it need hardly be said, the concentration camp, if they refused to bend their work to his definition of the true purpose of art: to glorify the magnificence of his totalitarian state.

That same year (1934) saw the world-renowned Bauhaus School of Art, which included graphic artists and painters like Klee, Kandinsky and Feininger, and celebrated modern architects Walter Gropius and Mies van der Rohe on its faculty, shut down by the Nazis. Hitler's threatening speech produced the desired effect, forcing a vanguard of German Expressionists, Kandinsky, Klee, Kokoschka and Beckmann to flee into exile, either to the United States or to as-yet-unoccupied Western Europe.

In 1937, the same year of the Munich exhibition, 125 pieces of

"degenerate art"—modern paintings and sculpture—were auctioned off under the auspices of Theodor Fischer at the Grand Hotel in Lucerne. The auction set off an international uproar because the art had been confiscated from Jews fleeing Germany and was therefore an auction of stolen goods.

On Thursday, November, 1956, nearly twenty years after that disgraceful auction, *The New York Times* ran a small review on its art page. The headline announced: "KITCHENER WOODCUTS ON VIEW AT CENTER," albeit containing an egregious error, spelling "Kirchner" as "Kitchener," as if promoting the little-known artistic productions of the English general, Lord Kitchener. Reading the review that followed was one of the most pleasurable experiences of my entire life up to that point.

"Ernst Ludwig Kirchner," the review began, this time getting the spelling right, "one of the great figures of the German Expressionist movement, devoted much of his creative energy to perfecting a graphic style that has considerably influenced modern painting...."

I read that first sentence with a glow in my heart. The reviewer was Dore Ashton, a delightful young art critic married to the artist Adja Yunkers, and she knew well of what she wrote. "In a very good exhibition"—I had read that phrase several times, until I concluded that it was the most beautiful phrase ever written in English—"at the New Art Center Gallery, 1193 Lexington Ave., featuring more than thirty woodcuts, etchings and drawings by Kirchner, as well as a large volume of work by his contemporaries, Kirchner's development is traced from his earliest dry points to his last woodcuts...."

Ernst Ludwig Kirchner (1880–1938), long ranked near the top of any connoisseur's list among all the great German Expressionists, was one of a group of four friends who in 1904, as young students at the Dresden Institute of Technology, founded a group devoted to artistic experimentation known as Die Brücke — in English, "The Bridge." Kirchner, Heckel, Karl Schmidt-Rottluff, and Fritz Bleyl, all painters, and all young enough to experiment, set up their fledgling artist's collective in an empty shoemaker's establishment with an eye toward shaking up a different establishment: the German Academy.

In the same years (1905–6) that the Bridge launched itself as a force in the German avant-garde, the Fauves were storming Paris. By 1911, Kirchner, Heckel and Schmidt-Rottluff had moved to Berlin and joined an experimental art association known as the New Secession, a splinter group that had formed in rebellion to an earlier "revolt of the artists" known as the "Berlin Secession," which itself signaled a determined break from the cold academic style and clinical approach of the German Academy.

by Dore Ashton

Kitchener Woodcuts on View at Center

ERNST LUDWIG KIRCH-NER, one of the great figures of the German expressionist movement, devoted much of his creative energy to perfecting a graphic style that has considerably influenced modern printmaking. In a very good exhibition at the New Art Center, 1193 Lexington Avenue, featuring more than thirty woodcuts, etchings and drawings by Kirchner, as well as a large volume of work by his contemporaries, Kirchner's development is traced from his earliest drypoints to his last woodcuts.

•

A typical early work from a period of Kirchner's adherence to "The Bridge" group is his black-and-white woodcut "The Bathers," which shows both his discovery of the Ethnic Museum with its masterpieces of Negro sculpture, and the memory of the great tradition fathered by Duerer.

Later, in such remarkable woodcuts as the portraits of Annette Kolb and of Dr. Will Grohmann, Kirchner enriched his vocabulary, developing vigorous symbols for forms (the zig-zag shadows and triangular shapes around prominent features) and slashing into the wood to bring out the most crisp lights.

In addition to the assortment of Kirchner's, there are many notable prints by contemporaries, among them some delightful landscape etchings by Lovis Corinth; a series of Berlin studies by Max Beckmann; several important Kathe Kollwitz prints, a number of Nolde, Heckel, Dix and Pechstein works as well as a few Klees and Kandinskys.

Kirchner reviews from
The New York Times,
1956 and 1957.

ART

SUNDAY, OCTOBER 6, 1957.

GERMAN MODERNS

THE NEW YORK TIMES,

By HOWARD DEVREE

Small oils, water-colors, prints and drawings by many of the artists in the museum exhibition are being shown at the New Art Center along with a great variety of their graphic work in portfolios. Nolde, Mueller, Corinth and Kirchner are well represented, and there is a large selection of the ever-moving work of Kaethe Kollwitz.

In 1913, Die Brücke collapsed. Kirchner was diagnosed with tuberculosis and in 1914, with the outbreak of World War I, he was confined to a sanitarium for tuberculosis patients in Davos, Switzerland. Kirchner survived the war, unlike a number of his artistic brethren who had been killed in action. But he did not survive the campaign of denunciation launched by the Nazis. Terrified by symptoms of his recurrent illness, and depressed about being branded officially "degenerate" by the German government, he committed suicide on June 15, 1938.

The first major exhibition from my now extensive collection of German Expressionists did not stop with Kirchner. There were notable prints also by his contemporaries, including a delightful landscape etching by Lovis Corinth, a series of Berlin studies by Beckmann, several important Käethe Kolliwitz prints, and a smattering of Nolde, Heckel, Otto Dix and Max Pechstein works as well as Klees and Kandinskys.

The Kirchner show, and the glowing review by Ashton, put the New Art Center Gallery on the map. We may still have been only a "hole-in-the-wall," but we clearly had arrived as a factor on the art scene.

As America prospered, indeed as the free world prospered, the acquisition of "fine" art mirrored that postwar prosperity. In the '50s, I first made a name for myself buying and selling German Expressionist works. At the time, these works were mainly treasured by a small circle of sophisticated collectors, mainly of German-Jewish origin. I had to wait fifty-four years for the art world to catch up.[2] I became New York's leading dealer in German Expressionist art by maintaining close links with the city's thriving European refugee community, by advertising heavily and paying top prices for works smuggled by refugees out of Germany before, during, and after the war.

In the '60s, I realized that collecting fine art was becoming a popular preoccupation in America, no longer restricted to the Vanderbilts, Rockefellers, Mellons and Astors.

I travelled frequently to Europe to buy fine modern art—Matisse, Picasso, Magritte, Cézanne—and sold it in New York to an audience yearning for sophistication, for beauty, for something authentic. We sold graphics mainly, signed prints, not mechanical reproductions like posters. Most of the graphics I sold for a few hundred dollars are worth many thousands today.

2. In 1991, the Los Angeles County Museum of Art organized a partial reconstruction of the original Entarte Kunst seen in Munich in 1937. "Degenerate Art": The Fate of the Avant Garde in Nazi Germany was seen by 750,000 people in Los Angeles, Chicago, Washington, D.C. and Berlin in 1991 and 1992.

Postwar Art Boom

A t a party recently, a total stranger came up to me and posed a simple question. It deserves a simple answer.

"How did you make it?" he asked.

I thought for a moment. "First I needed knowledge," I said. "Second, I needed money. Third, I needed luck."

Knowledge, money and luck: the first and the third I could handle myself. For the second, I needed other people. In the beginning, like any other undercapitalized merchant, I was reliant upon Other People's Money—OPM—to buy merchandise.

In my forty-plus-year career, I found that the most important contribution to my success as an art dealer was developing the confidence to buy the art my eye told me to buy. But to buy, I needed money. Coming to America with no bankroll whatever, I was forced to improvise when it came to acquiring that all-important ingredient: capital. With no capital, I started out by acquiring the art I needed for selling by the only route open to me: consignment.

Many well-known art dealers have flourished using this system, in which an owner of art, the "consignor" deposits a work with the dealer, the "consignee." The consignor determines the minimum price at which the art may be sold. This leaves the dealer, the consignee, under the control of the consignor, a relationship which always disturbed me.

What most troubled me was that under the consignment system an art dealer could not grow rich off the profit, and he remains merely a broker, an agent, a middleman. Something in me rebelled against a system in which the art dealer never builds up his own inventory. So starting out in the late '50s, I broke off with all my consignors and acquired a joint venture partner.

Joint ventures were the most common route in those days, apart from the consignment system, for undercapitalized art dealers to gain capital. No bank at that time would lend money on art. Art was regarded as too "soft" a commodity to supply sufficiently solid collateral for a secured loan. My innovation, since I had not even enough funds to plunge into a standard joint venture, was to persuade my partner to lend me my share, 25 percent, at a reasonable rate, and still split the profit with me fifty-fifty less expenses.

My first partner, a pharmaceutical magnate, after a moment's shock agreed to go along with this scheme. We profitably bought and sold art for a number of years until he decided to leave the art business. I bought him out, because my goal was to build up my own inventory. He got the money, I got the art. I ended up doing very well with that deal.

My next joint venture partner, a man who had made a fortune in radio advertising and later became a psychoanalyst, understood the nature of the financing gap in the art world. He founded the first art-based mutual fund, K-C Art Fund, which unfortunately lacked the capital base to achieve its full goals. But art-equity financing was an idea whose time had come, and in the late '60s, I acquired a more institutional backer: Rosenthal & Rosenthal, a long-established "factoring" firm. I became its first art dealer client. I had known an executive at the firm, Gideon Strauss, since the early '60s, when as an officer at the Israeli Bank Leumi, he persuaded the bank to give me a loan. It was well secured by a Picasso that still hangs in my living room. But I was forced to pay off the loan when the New York State bank examiners looked askance at an artwork serving as collateral, and forced the bank to call the loan.

Rosenthal & Rosenthal were pioneers in the art-financing business, which remains one of the most important yet little-known aspects of the international art trade. Later, following in Rosenthal's pioneer footsteps, Citibank and other major money-center banks opened art-equity financing departments.

However, before I acquired my first joint venture partner, I did some dealing on a consignment basis. One of the first collectors with whom I worked in this manner was a wealthy lady from Atlanta, Ruth Weir. Mrs. Weir was knowledgeable about art, and an enthusiastic and fervent collector of German Expressionist works. Her first consignment to me contained, as her now-yellowing invoice reads, "5 Noldes, 4 Muellers, 15 Pechsteins, 5 Kirchners, 2 Schmidt-Rottluffs and 16 Heckels." I was thrilled at the quality of the work. The prices at which she was willing to part with these treasures would bring tears to any collector's eyes today.

Kandinskys for $70 (original woodcuts), Otto Muellers for $50. Today, these works sell for tens of thousands of dollars, if not more. At the time, I had no idea what these works would bring on the open market. And I was never comfortable with the fact that it was up to Weir, as the consignor, to decide how best to price them.

In October of 1957, *The New York Times* art reviewer, Howard Devere, reviewed our exhibition of "German Modernists," "Small oils, water-colors, prints and drawings by many of the same artists

in the 'German Modernism' show at the Museum of Modern Art are being shown at the New Art Center Gallery, along with a great variety of their graphic work in portfolios. Nolde, Mueller, Corinth and Kirchner are well represented, along with a fine selection of the ever-moving work of Käethe Kolliwitz."

In November of 1958, "Signora Ruth Weir," as this Southern belle styled herself when writing from her villa in Florence, was beginning to sniff an impending run-up of prices, after attending a number of European auctions. "Dear Mr. Weintraub," she wrote. "I found the art climate in Europe very bullish and in view of the present trends, which I am sure will lead to higher prices, I feel very uneasy about the prices we set so long ago. Having had the greater part of the consignments for a full year now you will agree with me that a revision of prices is in order."

This may have been true. But at the time, I felt frustrated by her request because of the effort I had expended in trying to sell the work at the prices she set. If she kept raising her prices, I was afraid that she might raise them above what the market would bear, pricing us/me out of the market. After wavering a good deal on the issue of prices, Mrs. Weir withdrew all the works she had consigned to me, and we parted amicably.[3]

We considered buying the collection from Mrs. Weir, but lack of capital once again kept it out of reach. It would be at least a decade before the financial world truly grasped the underlying value of art as an investment and would begin to loosen credit restrictions, a welcome development in which I was destined to play a role.

In lieu of an available bank or other financial institution, I desperately needed someone to help me climb the next crucial rung on "Jacob's Ladder." I didn't need more consignments. They weren't worth it. But just as the relationship with Weir was winding down, the man I truly needed walked into the New Art Center Gallery. It was early 1957. A well-dressed man whom I took to be in his late fifties walked up to the counter, introduced himself as Marvin Small and asked if I might be interested in helping him assemble a collection of works by the Norwegian Expressionist Edvard Munch.

I knew a lot about Munch, but next to nothing about my customer, except that judging by the cut of his clothes and his self-satisfied demeanor I thought he was probably a wealthy man. Based on his freedom to stop by my gallery for a chat in the middle of a weekday, I also assumed him to be a man of leisure as well as means.

I agreed to find some Munchs for him, one of the first being the famous woodcut known around the world as "The Kiss." Edvard

3. I was distressed many years later to see Mrs. Weir's name on a list of trustees from the High Museum of Art in Atlanta who had died in a plane crash while on a group trip to Paris in 1962.

Munch (1863–1944) was a precursor to the German Expressionists, hailed by William S. Lieberman, the reigning expert in the field (now president of 20th century art at the Metropolitan Museum of Art) as "the father of German Expressionism."

Born and brought up in the Norwegian capital of Oslo, by the late 1880s Munch had become deeply immersed in presenting profound psychological themes such as love and death, which he depicted in a dark, disturbingly "expressionistic" manner.

Munch's medium of choice was the graphic: woodcuts, etchings, lithographs. From 1900 to 1909, during a period of residence in Germany, Munch came into direct contact with the leading Expressionists, and began to assume the status of guru to this emerging school. The infusion of his work with brooding introspection and desperate melancholy was the most powerful influence on the younger generation of German painters.

As I got to know Marvin Small better, I became intimately acquainted with his volatile moods. It began to explain his interest in Munch. Munch has been generally credited in our time with producing some of the first fine graphics, producing images that speak directly to the mood of existential terror pervading 20th century culture. "The Scream" is the outstanding example of the genre.

I agreed to buy Munchs for Marvin, and took a short trip to Oslo, at his expense, to acquire some rare examples available only in Norway. Small began stopping by the gallery for a chat nearly every day, at first to talk endlessly about Munch. Then he would ask me to tell him the story of my life. In fits and starts and dribs and drabs I finally did.

He, for his part, was remarkably unforthcoming about his life, which I gathered had amply provided him with the twin luxuries of the modern world: money and time. Soon Small was coming into the gallery so often, sitting and schmoozing by the hour, that I began to seriously wonder if his hidden agenda wasn't to flirt with my wife behind my back.

One day Marvin handed me, as if tendering a five-dollar bill, a check for $25,000 in return for a very rare Munch oil. Instead of taking the painting home with him he asked me to store it for him in the basement. He had done this a number of times, but since he promptly paid whatever money he owed I didn't mind holding it for a while. Still, it struck me as strange. Only later did I learn that he was in the midst of a messy divorce, and that his estranged wife, Sylvia Carewe, a self-professed painter, was attempting to gain control of his art collection.

With the $25,000 check in hand, drawn on my own bank, I marched over to my local branch to have a little chat with the man-

ager. Making sure to greet him by his first name, I showed him the check and asked him what he could tell me about Marvin Small. He knew the name right away. He didn't have to check his files.

"Mr. Weintraub," he said (you will notice he called me mister), "are you kidding? Marvin Small is on the master list."

I gazed back at him in total uncomprehending astonishment. "What's that?"

"The 'master list' means that if he needs five million, ten million, we give it to him. That he would be good for it."

Suddenly, Marvin Small's strangeness began to make sense as the eccentricity often associated with great wealth. One day, while Marvin was killing time at the gallery, the phone rang. It was a framer who had a shop downtown near Union Square.

He had heard through the grapevine that "I was the man who bought German Expressionists." I liked that identification. Yes, I responded, that was me. He wanted to know if I might be interested in a pair of good German graphics a customer had left with him in exchange for a large framing job. The framer was loath to go ahead with the job unless he could determine their value and, perhaps additionally, get some cash for them.

"Can you read the signatures?" I asked. Out of the corner of my eye, I watched Marvin Small watching my every move. Who was this guy? He acted like the FBI. I liked Small but this constant surveillance was beginning to get on my nerves.

"Kolliwitz and Kirchner," the framer replied. My favorites, and probably obtainable at less than a reasonable price from a framer. Little as I was thrilled by the prospect of taking the subway downtown in the middle of the day, leaving Barbara to mind the gallery alone—with Marvin still sitting there—to get my hands on a good Kolliwitz and a Kirchner I would have flown to the moon and back.

Arriving at the address, I was less than thrilled to discover that the frame shop was six flights up in one of those old-fashioned studio buildings with fancy but dirty moldings and cornices and wrought-iron fire escapes. My doctors had told me my heart had been weakened "irreparably" during the war and that I should avoid climbing stairs or overly exerting myself. But I wanted those works enough so that I climbed.

When I arrived, breathless, at the tiny shop which made my place look like the Ritz, the proprietor was as good as his word: he indeed had a Kolliwitz and a Kirchner. There was not a thing wrong with them. I could tell they were "good," which in art parlance means that they were not fakes. I had come a long way from the day when I would have felt uncomfortable without a second opinion. He wanted

$300 for both, but I bargained him down to $200. Even in those days, it was an incredible deal.

Feeling good about the purchase, I permitted myself the indulgence of hopping a taxi uptown. Marvin was still there, schmoozing with my wife. For such a rich man, I thought, he sure doesn't appear to have much to do but kill time. But I soon realized that having overheard that phone call, he was waiting to see what I had bought.

"Let me see what you've got there," he demanded, gesturing toward the tube I held gingerly in my hands. He was like some spoiled child anxious to open someone else's present. Reluctantly, I opened the tube and pulled out both graphics. His eyes widened with the telltale gaze of the true art aficionado.

"Very nice," he breathed out slowly, as if trying to restrain himself. "Jacob, I like these very much." His eyes lingered sensuously over every graphic detail. "Would you sell them to me?"

I had to give that some thought. After all, having just bought them, I hadn't much time to set a price. I had even idly considered putting them away and letting them appreciate.

"I haven't a price," I said, "but I can tell you they're worth at least $800.

After a few minutes of backing and forthing, he whipped out his checkbook and said, "Done." He felt as good about buying them, I thought, as I felt remorseful about selling them. For me, a $600 profit in two hours was a good day's work. For him, he had two very nice prints to round out his collection.

That, at least, was how I analyzed it at the time. But the next morning he was back, hanging around, poking around, watching me, looking at what I had. I could tell something was wrong. He was having trouble getting whatever it was off his chest.

Finally, I said, "Marvin, we Europeans don't like beating around the bush. So why don't you do us both a favor and get it out, whatever it is. I can take it."

He took a deep breath, and let rip.

"Jacob, I don't suppose you know my wife is an artist. She just happens to have a studio very close to the framer who sold you the two prints yesterday."

"So?"

He paused again. "So my wife happened to have a conversation with that framer, and he told her what you paid for those two prints I bought yesterday."

Now it was my turn to take a deep breath.

"Marvin, everything you are telling me is true. And if you would have asked me, I would have told you what I paid. But the point is

not what I paid, but what I think they are worth. And I can assure you those two prints are worth at least $800. And to prove it to you, and to assure that we remain friends, give me back the prints and I'll give you your money back."

I could tell he believed me. No, he said, he liked the prints. He was just a little bit shocked by the size of the markup between wholesale and retail.

The very next day, Marvin failed to show up, but a middle-aged man, thin, with a mustache and the distracted air of an academic, wearing a herringbone Chesterfield coat walked in off the street and began looking through my portfolios. He worked with the patient, meticulous, scholarly air of a true expert and something about the way he looked at the prints and the systematic way he selected them, made me know he was an art scholar, perhaps even a museum curator.

From time to time, he would casually take a few prints and place them on the counter, saying nothing. But I knew this meant he planned to buy them. After he was through piling up prints on the counter, he spoke, with an elegant, cultivated voice:

"Mr. Weintraub, I wonder if you might have a Kirchner, a good one, for an exhibition I am helping to organize at Harvard."

I shook my head, thinking of the marvelous Kirchner I had just sold to Marvin. "Well," I said, figuring I might as well give it a shot. "I just had 'The Prophet' but a few days ago I sold it to a collector. I may be able to buy it back from him, but I should think the price may be fairly stiff."

The man smiled and looked down at his dusty shoes, which though not shined were a fine make. The smile told me that in this case price was no object.

"I would expect the Kirchner to cost at least $1,000," I said. He didn't blink or hesitate but simply nodded and wrote out a check for that amount, trusting that if I could locate the print and buy it back, that would cover the purchase price.

Again, I knew nothing about this man except that he had some unstated connection to Harvard. He bought prints, as I understood it, for Harvard's world-famous Busch-Reisinger Museum, the greatest repository of German art outside Germany.

The next time Marvin walked in the door I said, "I'd like to buy just one of those two prints I sold you the other day for the price you paid for both: $800. Remember, I told you the two together were worth at least that? Now I'm going to prove to you what a bargain I gave you. How about it?"

He sat down. I could tell he was trying to figure out what I was up to. What crazy snow job was I pulling on him now? I could see the

mental wheels turning. He put his hand to his brow, he wiped his lip, pondered the offer and proposed a solution.

"Jacob," he said, "if you tell me what you are up to, I will consider your offer."

"Fine," I replied. "Not only will I tell you, I will show you." And with this introduction, I produced with a triumphant flourish the check from the man from Harvard.

"Now this is to buy the Kirchner I sold you. And the $1,000 represents my twenty percent markup, which is standard in such cases. You get the $800, I get the $200, and you will have gotten your money back in two days and still have a valuable print."

Now I could tell by his widening eyes that his head was still spinning. But I could also tell that as a businessman he was thinking about money and profit.

He agreed to the deal, and then added, "On one condition. Tomorrow, let me take you out to lunch so we can sit down and have a good talk."

The next day I called the Harvard buyer to make arrangements to send him the Kirchner. Barbara kept an eye on the gallery while Marvin took me out to lunch. He got straight to the point.

"Jacob, did you ever wonder why I have been coming to the gallery practically every day?"

"Yes," I said, figuring it made sense to level with him. "I figured you didn't have anything better to do. And who knows, maybe you were going to make a play for my wife."

He laughed heartily, pleased more than anything else by my directness.

"By now you know that I am a very rich man," he said.

"I know you are on the master list," I replied. He nodded distractedly, before going on to give me a brief sketch of his life and of his business background. Born in Brooklyn in 1899, he started his own advertising agency, Small & Seiffer, after graduating from New York University, then went on, in his late thirties, to found the American Dietaids Company, where he developed what he modestly described as a "wide range of commercial products" including Arrid deodorant and Rise shaving cream. Six years earlier, he retired from active business, though he maintained a majority interest in the Carter Products Company, manufacturers of the famous Carter's Little Liver Pills. He was a great gourmet and, consequently, a great dieter. He was a published author on his two favorite subjects: money and food, having written *The Special Diet Cookbook* and *How to Attain Financial Security*. Art came later. He served as chairman of the Art Committee at Brandeis University. But now, he was interested in art dealing.

"I've been watching you work, analyzing your deals, and the one

thing that stands out about you is that you are honest," Marvin began. "I want you to level with me. Do you think you can make the kind of profit you just turned on the Kirchner on a regular basis, if you had the capital to buy what you wanted to buy?"

I had to think about that. "I think so, yes," I replied, "but not every deal. Situations like the Kirchner don't happen every day. But over the long haul, given the capital, yes, I could turn a good profit."

"That's pretty much what I thought you would say," he replied. "So I have a proposition for you. What if I gave you whatever money you need to buy art, and you can sell it on consignment and we'll split the profit?"

As I explained, my recent experience with Mrs. Weir had soured me irrevocably on the consignment system.

"But what alternative is there?" he asked.

I had a counterproposition for him.

"What if we were to establish a joint venture to buy art? What if you invested seventy-five percent and I twenty-five, and we split the profit, fifty-fifty?"

He thought a little about that, and said, "Done."

"Except for one other thing," I added, knowing I was pushing my luck.

"Yes? I'm all ears."

"I haven't got the twenty-five percent to invest," I admitted. "So I want you to lend me my twenty-five percent, and I'll pay the loan back over time, at a good rate of interest."

"You drive a hard bargain," he said, laughing, but I could tell he was intrigued. Besides, I could tell he was emotionally committed to the deal.

Our 1958 catalogue was of a distinctive size, measuring 9 1/2" by 7", with a strikingly attractive black cover displaying a delicate line-drawing in beige by Paul Klee: "ZEICHNUNG ZUM WANDERCIR-CUS." I had personally selected this drawing of a traveling circus, not only for reasons of aesthetic integrity, but because, since we owned it, we didn't have to get permission from Klee's estate to reproduce it.

I had the catalogue printed in Berlin by a well-known art publisher, Max Lichtwitz, whom I could trust to handle the delicate task of reproducing the photographs.

Our purpose was to catalogue our growing collection of "Graphic Art of the 20th Century" and to establish the New Art Center Gallery as a premier institution in the field. Much but not all of the art reproduced in miniature on the catalogue's coated stock had been originally acquired from the German meat wholesaler in Queens. His

GRAPHIC ART

of the 20ᵗʰ Century

Catalogue 1958

NEW ART CENTER GALLERY

1193 Lexington Avenue · New York City

Schiele, Egon

Male Nude 60.—
Lithograph, signed and dated 1912, 17"x 14"

Lautrec, Henri de Toulouse

Poster, La Revue Blanche, bi=
mensuelle, le No. 60 Centimes,
12 francs par an, 1 Rue Laffitte
Paris, Charpentier et Fasquelle,
editeurs, 11 rue de Grenelle, Imp.
Ed. Ancourt, Paris 325.-
Colored lithograph, second state, D. 55,
50½"x 37"
see illustration

Picasso, Pablo

The Frugal Repast 800.—
Etching, 1904, 18"x 14"

*Selections from the New Art
Center Gallery catalogue with
1958 prices.*

Beckmann, Max

Self-Portrait (From Berliner Reise) 100.—
Lithograph, signed, numbered 59/100,
20"x 14", Gl. 187

Dix, Otto

Kupplerin 75.—
Colored lithograph, signed and numbered
17/65, 20"x 15"

Kandinsky, Wassily

Composition 1800.—
Watercolor, signed and dated '24, 8¾"x 7".
Best Bauhaus period. Beautiful colorings.

Matisse, Henri

Reclining Ballerina 130.—
Lithograph, signed and numbered 1/130,
8"x 17"

Kandinsky, Wassily

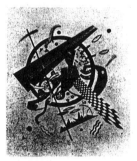

Composition 200.—
Colored lithograph, signed, from **Kleine
Welten** (IV), 12"x 10"

Magritte, René

La Clairvoyance 150.—
Gouache, signed, 12"x 14"

Gauguin, Paul

Te Faruru (ca. 1894) 1500.—
Colored woodcut, Guerin 22 ii. Proof on
Havana Japan, Roy Edition. The mat, an
exchange from the Museum of Modern Art,
was painted by Gauguin. 9½"x 16"

New Art Center Catalogue.

was such a magnificent collection that I have recently been told that if I had taken that collection, stored it in a vault for thirty years and taken a job as a street sweeper to support myself, I might be an even wealthier man today than I am now. Perhaps. Though, of course, wealth is a relative concept, not measured only in coin of the realm.

But the point was to sell art. After all, I am an art dealer, only secondarily a collector. It was critical that our catalogue showcase the art elegantly; even today, the slim paperback possesses an understated "modern" elegance suitable to the works it contained.

The selection ranged from Jussuf Abbo to Zao Wou-Ki, a Chinese artist living in Paris. It was almost entirely of graphic work by over fifty major 20th century Americans such as Milton Avery and Winslow Homer through every major Expressionist: Ernst Barlach, Willi Baumeister, Max Beckmann, Lovis Corinth, Otto Dix, Hans Erni, Lionel Feininger, Conrad Felixmüller, Johnny Friedlander, George Grosz, Chaim Gross, Hans Hartung, Erich Heckel, Käethe Kolliwitz, Max Liebermann, August Macke, Edvard Munch, Otto Mueller, Max Pechstein, Egon Schiele, Karl Schmidt-Rottluff, and my good friend from Israel, Jacob Steinhardt.

At the time, Steinhardt was considered one of the best woodcut artists; in fact the Metropolitan Museum of Art has films of him at work. In the middle of the century German artists were considered the masters in this media, and woodcuts by Kirchner and Heckel were bringing top dollar.

We had taken great pains to build up our inventory of graphics by major French moderns: Pierre Bonnard, Georges Braque, Bernard Buffet, Honoré Daumier, Raoul Dufy, Henri de Toulouse-Lautrec, Henri Matisse, Georges Rouault, François Villon, Félix Valloton, Yves Tanguy, Edouard Vuillard, Pablo Picasso, Marc Chagall. And we offered a wide selection of Wassily Kandinskys, Joan Mirós, Marino Marinis, and other international artists who had lived in different countries during the war, many of whom could be considered men without countries.

By today's standards, the prices quoted, although "subject to change without notice," were ludicrous: $60 and $70 for signed lithographs by Max Beckmann today worth several thousand, to $40 and $50 for Braque, $100 to $150 for Chagall lithographs, $200 for a Kandinsky, and so on. At the time we estimated the value of the entire collection at several hundred thousand dollars. Today, it would be worth millions.

The response of prospective clients to our distribution of the catalogue was tremendous: galleries, museums and collectors around the world received copies, and we began to enter into correspondence

with prominent dealers and collectors who used our catalogue as a bible to check prices and conduct research in the field of graphics.

As the catalogue revealed, we were heavily invested in the graphic arts and had taken a leading position in them, assuming for the first time an international stature. As for oils and sculpture, their time would come; we had not yet the financial resources to be quite so comprehensive.

In the summer of 1958, Marvin Small took a major art-buying trip to Europe, launching what was to become a customary arrangement between us. We would make trips individually, with our wives, to buy art on behalf of the partnership. We gave each other a free hand with no major caveats or provisos except for an informal agreement to buy modern recognized artists, not the avant-garde or the undiscovered. This policy kept us safely away from the cutting edge, and possessed the advantage of steering us safely clear of the poorhouse. As long as we stuck to trusted and familiar brand names, we felt safe, like stock investors buying blue chips.

Providing a window on Marvin's conservative artistic tastes, 1958 invoices from R. G. Michel on Quai Saint-Michel in Paris reveal purchases of Pablo Picasso, Edgar Degas, and André Derain. Michel was by then an elderly man, who had assembled for his own collection a superb assortment of Toulouse-Lautrec posters and watercolors. His was not a fancy place, just three stucco-walled rooms. Favored clients were permitted to browse through the whole inventory without supervision.

In addition to Toulouse-Lautrec, Michel dealt heavily in Picasso graphics, for which we knew there would be a strong demand in the United States. Marvin managed to coax a 20 percent discount out of Michel. I couldn't have done any better myself. And he bought well: dozens of fine Picasso etchings, and works by Braque, Miró, and Rouault.

Just one item on Marvin's Paris shopping list gave me pause, a copy of Chagall's limited edition portfolio of lithographs: "The Bible," commissioned in 1956 by the French publisher Tériade. This monumental project had been initiated a quarter-century before, in 1930, by the renowned Ambroise Vollard, author of the justly famed *Recollections of a Picture Dealer*. In 1956, Tériade produced an issue of the art review *Verve* (nos. 33–34) devoted exclusively to photogravure reproductions of all 105 of Chagall's marvelous etchings, along with an additional 16 full-page colored lithographs and 12 black-and-white.

Six thousand five hundred copies were printed of that issue of *Verve*. All color etchings were printed separately in an edition of 100

numbered, signed and hand-colored by the artist himself. Being a diehard skeptic, I was obsessed with confirming that these etchings were in fact hand-colored by "Le Maitre" himself.

I wrote to Chagall directly, seeking confirmation of his involvement, and after receiving no reply, wrote to Mr. Morot, the French cultural attaché in Washington, who kindly forwarded my request for confirmation to Chagall.

I received with admirable promptness a reply from Chagall dated November 15, 1958.

"Dear Mr. Weintraub:

"From Mr. Morot, the Cultural Attaché of France, I have received your letter in which you ask information regarding the copy of THE BIBLE that you purchased from Tériade, edition #37. If you purchased this BIBLE from TÉRIADE, it has been colored by me personally—I do all of this work myself. All of the proofs have been signed by me.

"With best wishes, MARC CHAGALL."

What better authentication could one want?

In May 1994 I was offered a unique set of 106 original watercolors and drawings for the "The Bible." The price was close to $10 million.

In December of 1958, Marvin's impending divorce forced us to clarify matters between us. Marvin hoped to liquidate quickly some of his holdings. I bought a substantial collection from him, including 44 Edvard Munch etchings and lithographs; one Emil Nolde watercolor (flowers); one Jules Pascin, "The Village"; one Matisse drawing, "Torso"; one Degas monotype, "Women"; 17 Erich Heckel etchings and lithographs; one Wassily Kandinsky composition, "Balance"; and an Otto Mueller pastel, "Two Nudes."

The total price? $17,500. The magnificent Munch collection I had so painstakingly assembled for Marvin I bought in a group, and regrettably, as quickly dispersed. The new year, 1959, turned out to be a banner year for my partnership with Marvin if hardly a banner year for his relations with his estranged wife. On March 9, we received a notarized letter from his attorney putting us on notice that we were not to sell any of his works because she still might want to claim ownership.

That same month, Marvin flew to Mexico, possibly to investigate obtaining a Mexican divorce, but also to buy art in Mexico City. Again, he bought well, and only the best names: Rufino Tamayo, Diego Rivera, David Alfaro Siqueiros, José Orozco. A month or so later, finding Arizona to be a more pleasant place to await divorce proceedings, Marvin consoled himself by contemplating buying a good Amedeo Modigliani, a Miró and others as well as German Expressionists that

he obtained from two California galleries — the Stendahl Art Gallery in Hollywood and Stephen Silagy in Beverly Hills. Marvin told me that many of the California galleries catered to the movie crowd and are much better than the San Francisco galleries.

A fitting termination to our ever-more prosperous '50s was my own first major European art-buying tour in the summer of 1959. For Barbara and me the trip represented a return to the "old country" from which we had fled in misery only thirteen years earlier.

We had left Europe by sea, penniless, on the first boat carrying refugees from a war-torn, devastated Europe, still reeling from the effects of the Holocaust and World War II. We returned by air, a prosperous couple to a prosperous continent, in the full swing of postwar rebuilding, helped by the Marshall Plan and by the citizens' determination to recover from the terrible traumas through which they had lived.

Marvin either telegraphed or wrote us at every stop on our itinerary, from the Bellevue Palace in Berne, Switzerland, where we received a succinct cable, "OPPOSED TO CHAGALLS. FOR PRESENT CASSATT LOOKS INTERESTING—MARVIN," to a much longer letter we received at the Hotel George V in Paris:

"I really don't know what to say to you about all the wonderful things you've done—except for God's sakes go a little slower, not only because we're going to run out of money, but also because you will run out of Weintraubs!"

He strongly advised visiting the renowned heiress and art patron Peggy Guggenheim at her famous palazzo on the Grand Canal in Venice which served as her private home and art museum, "but be very careful of her as she will try to sell you some of her new pets." (By which, of course, he meant her artistic pets, who were innumerable and constantly changing.) "She sold me a Tancredi who some day may be good but isn't yet. She was the first to introduce Jackson Pollock and has some of his early work in her place...."

Following his advice, we paid a call on Ms. Guggenheim, and had a close look at her brass bed designed by Max Ernst. She had a few rather virile gondoliers standing around, as well as a few ladies of indeterminate purpose. For all Marvin's tweaking us about the "naughty goings on at Peggy's," the place seemed sober enough to us. Peggy Guggenheim was a real lady, and I was later to know her quite well.

Venice's great glassblowing factories on the nearby island of Murano had from time immemorial been an important stop on the gondoliers' Grand Tour. The sheer entertainment value of watching the glassblowers in action had remained undiminished. Unfortu-

M A R V I N S M A L L

July 10, 1959

Dear Barbara and Jacob:

I had no trouble at all reading your twenty-one page letter of
July 2nd and also the short letter which followed.

Sorry that Barbara won't let you have a private secretary, Jacob,
particularly since you gave me the advice to travel with a private
secretary. Am I suppose to be your alter ego in this direction?

I really don't know what to say to you about all the wonderful
things you've done - except for God's sakes go a little slower,
not only because we're going to run out of money, but also because
you will run out of Weintraubs. I do think that it is necessary
to make a more formal agreement with Tamayo because she is such
an uneven person and if one is to maintain good relations with
them it would be better to have any understanding perfectly clear.

I think that one of the good things that you are doing is to find
out more places where we can export paintings and I am sure we
are going to be able to unearth a lot xxx of stuff here. For
example, our friend the Professor went to see Mr. Allen and reports
that he has two English painters who might prove to be good buys.
I am now writing from Westport and the letter from Professor Biel
is in my office. I will try to send you a copy on Monday so you
will get it before visiting London. By the way, I do not have your
address in Israel, Rome or London. I know you will be where you
will be in Venice.

I don't know what to say to you about the Jawlensky but if you want
me to talk to Mrs. Chanin without letting her know why, she may
be able to give us a better line on how Jawlensky's are selling
now. I know she and also Janis were doing fine with them but then
I heard that the prices weren't as good as at first. Nevertheless,
excellent Jawlensky's should always have a market; the waiting
period for higher prices may be longer than we want. I can also
have someone talk to Sidney Janis if you want me to; I have bothered
him a lot without ever buying anything from him but I know several
people who are his customers.

Dr. Roux-Delamel comes over here so frequently - and besides I will
be seeing him in Europe before very long - if you really think we
can sell the Monet I will be glad to try to get it at a compromise
figure. However, he is such a good friend of mine that I would not
want to give him less than it is really worth, excepting only a sales
commission. It may be as you suggest that by means of trades he can
get some picture which he or his wife want in exchange for not asking
so much for the Monet.

Have you heard anything further from Bergruen regarding our
Picasso oil? I certainly wouldn't sell it for anything less
thatn $25,000 cash. Regarding Mannessier, I think that we should
go easy on buying him unless the prices are really good because
I think I can dig some out here or in Europe thru friendships. I
have not heard recently from my friend Georges Bein but I will write
him about Mannessier. Hartung is a favorite of mine but nobody
else seems to like him enough to buy him here. This is undoubtedly
a long pull proposition. When you get to Venice don't forget to
visit the Peggy Guggenheim gallery which is open to the public on
certain days but if you call Mrs. Guggenheim and tell here you are
a dealer she may invite you over at an off time and take you around
personally. But be very, very careful of her as she will try to
sell you some of her new pets. She sold me a Tancredi who some day
may be good but isn't yet. She was the first to introduce Jackson
Pollack and has some of his early work in her place. Take a look
at her brass bed designed by Alex Calder. (Barbara doesn't have
to worry about this as Peggy will undoubtedly have some of her strong
gondoliers around and also a few of her girlfriends - although you
may both enjoy thinking about what goes on there. Whatever you
think is only part of what probably does).

Remember - the money bag is not elastic. I am sure you are going
to find something is Israel that you will simply have to have and
then what will you do in London where Leicester will also probably
have some good buys of dreck-y drawings.

Your letter was delayed in reaching me because it came to the Hotel
Adams after I had checked out there. I am living at Westport a
good part of the week now but you had better write me:

 Marvin Small
 376 Maitland Avenue
 West Engelwood, New Jersey.

Peter will call me theminute a letter from you reaches there.

 Cordially,

nately, however, much of their output had gone to market.

A dealer in glass art, Egidio Constantini, with the help of Peggy Guggenheim, enlisted such artistic names as Max Ernst, her former husband, to create sculpture in glass. Their work was to be elevated, from schlock to fine art.

Ernst's enthusiastic participation was critical to enlisting other noted artists in this effort. Jean Cocteau christened the project "La Fucinia degli Angeli" (Foundry of the Angels). What a glittering list of artists who participated: Ernst, Chagall, Clavé, Cocteau, Picasso, Arp, Kokoschka, among others.

Constantini, like other great visionaries, was a genius when it came to imagining things, but not so great when it came down to the nuts-and-bolts of execution. Even more to the point, the same massive ego that permitted him to envision and pull off this massive fifteen-year project got in the way when it came down to selling the works.

Guggenheim and Constantini, when I met them in Venice, prevailed upon me to sign on as their exclusive agent worldwide. The first signal that something was wrong came when some of the pieces, which were in an exhibition at the Museum of Modern Art, came to our gallery for sale. They displayed Constantini's signature alongside or even above the name of the artist: as if the great Egidio Constantini had been the "father" of the work in question, assisted by the likes of Picasso, Ernst, or Arp.

But the real deal-breaker was still to come. It turned out that, after promising me exclusive U.S. marketing rights to the glass sculptures, Constantini planned several tours of the glass to maximize his own exposure, while minimizing mine. Having entered into an agreement with Constantini in 1965, six months after, I reluctantly felt it necessary to terminate our relationship.

That first art-buying sojourn, however, was a most critical exploration of the European art market, basic to the development of any art dealer. I made a point of initiating relationships with every first-rate dealer selling modern art in Europe. Daniel-Henry Kahnweiler was the dean of European art dealers and one of only two direct representatives of Picasso in Paris. After checking into the Hotel George V (even when I didn't have much money, I always made a point of traveling first-class) I headed straight for Galerie Louise Leiris.

I introduced myself to Kahnweiler and showed him a copy of my 1958 catalogue to establish my bona fides. He immediately went over to one of the great bins with which his backroom office was lined and pulled out a choice Cézanne watercolor. By then an old man, Kahnweiler was until his death a man of great dignity. He made a special point of not permitting me to help him open the trea-

sure-stuffed bin. If he was going to show me a work of art, he was going to show it himself.

A German immigrant to France, he had suffered the indignity of having his stock sold off after World War I under a Draconian decree demanding the auctioning off of all "German assets" found on French territory. He had recovered from that humiliation admirably, bouncing back to take his rightful place at the head of the European art dealing community.

On the eve of the 1940 Nazi invasion of France, Kahnweiler had been obliged to flee Paris before the advancing troops. From a relatively safe haven in the French countryside, he pursued anti-Nazi activities while dealing quietly in "degenerate" art. But he had been forced to sell his stock and his gallery to Louise Leiris, to comply with the Nazi Aryanization policy.

Tall, bald, always nattily dressed, now, in 1959, he looked more like my perception of a banker than an art dealer. We spent hours talking in his elegant office. His huge desk testified to his position as the éminence grise of French modern art dealers. I bought a lovely Léger gouache and a number of Léger lithographs from him and made arrangements for the purchase of a major Picasso oil. Léger had once said of Kahnweiler, "It was he who made me Fernand Léger." Kahnweiler, indeed, was of that rare breed — a dealer who makes artists, rather than the reverse.

When dealing with Kahnweiler, at first we spoke German, but I told him after our first few exchanges that I preferred to speak in English. Nodding understandingly, he switched smoothly. He never asked why I requested the change, but I think he spotted me instantly as a survivor of the Holocaust.

Our next stop on the Parisian art circuit was Heinz Berggruen, whose gallery on rue de l'Université on the Left Bank was the place in those days to find drawings and prints by Picasso, Léger, Braque, Gris, Klee and Kandinsky. Berggruen, like Kahnweiler, was a German Jew, born Gruenberg. But he had been fortunate enough to escape Germany before the war and pass the war years in San Francisco, where he operated a successful gallery and married a wealthy American lady.

After the war, Gruenberg changed his name to Berggruen and quickly established himself as one of the leading lights on the Parisian modern art scene. He did a lively trade in fine prints. From him we bought a large selection of prints by Chagall, Miró, Matisse, and Rouault.

Our largest French purchases were from Librairie Galerie La Hune on the boulevard St. Germain, a huge book and print store

that housed one of the great collections of modern graphic art. There, we bought works by Braque, Chagall, Clavé, Giacometti, Léger, Miró, Picasso, Rouault, and Tamayo.

At the great art publishing house and gallery run by the notable Aimé Maeght and his son, Adrien, we bought more Chagalls, Mirós, Braques, and Giacomettis, all artists whom Maeght represented exclusively in Europe. We got to know the Maeght family a little bit better each year, though it would be nearly a decade more before I would be permitted to rummage through the bins and drawers alone—an honor not lightly bestowed.

At one point during that whirlwind week in Paris, we were pleased to run into Hans Kleinschmidt and his wife, Ruth. He said he knew Barbara and I were doing well, but until he ran into us in Paris visiting galleries, he had no concrete idea of how well. He could remember as if it were yesterday when Barbara and I could not afford to buy costly clothes, but now we were outfitted by the finest tailors. We discussed visiting some galleries in Paris. He was surprised when I told him that we had a chauffeured car waiting, and that it would be at their disposal at any time. Ruth was shocked by our transformation. Though she saw all the evident outward manifestations of prosperity, it was as if she was totally unbelieving.

Unbeknownst to Kleinschmidt, our car, a large Cadillac limousine, was a loan from a wealthy American friend and collector. The driver managed to get us stuck on the excruciatingly narrow rue des Beaux Arts just off the boulevard St. Germain. The medieval street simply was too narrow for the car to pass, and by the time the driver realized the problem he couldn't reverse, and traffic backed up all the way into St. Germain. The enormous American car didn't escape the notice of the chauvinistic Parisians, who jeered and shouted at us as if we were the very embodiment of ugly Americans. Upon reaching our appointment with the dealer—Mazo— we were greeted with the words, "You are now famous in Paris," referring to the traffic-halting Cadillac.

One of the high points—so it seemed at the time—of the Paris leg of that trip was a meeting with the Mexican artist, then a Paris resident, Rufino Tamayo and his wife, Olga, at a restaurant on the Left Bank. It was evident right from the beginning of the meal that his wife was the dominant one, which, I should have realized at once, spelled trouble. But we were charmed by this sophisticated artistic couple and after a few drinks, quickly reached an agreement to represent Tamayo on an exclusive basis in selling and distributing his graphic production in the United States. With a flourish suitable to the spirit of the occasion, we drew up an agreement on the back of a menu, to be finalized by our lawyers at a later date. Upon hearing

this good news, Marvin sent heartfelt congratulations, but added a few prescient words of caution: "It would be a good idea," he cabled, "to make whatever agreement you reach with Tamayo very clear and unambiguous because Mrs. Tamayo can be very uneven." A gross understatement, as it turned out.

With some trepidation we flew on to Germany — Munich, Frankfurt and Stuttgart — where we visited galleries and took care of one of our major reasons for the trip: to be officially examined by German doctors who were expected to assess the physical and/or mental damage inflicted upon us by our Holocaust experiences. We later both received German War Reparations because of the damages caused by our experiences.

The doctor who examined us couldn't have been nicer or more sympathetic, and, though not Jewish himself, he made a special point of introducing us to his Belgian-Jewish wife. Simply being in Germany, even while staying at the finest hotels, made us exceedingly uncomfortable. I didn't mind so much coming into contact with the younger Germans, who would have escaped the demon of Nazification, but with any older person only one question came to mind: Was he or wasn't he? A Nazi, of course. Where was he during the war? Though the war seemed in many ways a distant event, we could never fully escape our traumatic experiences during those troubled years.

Returning from our 1959 summer shopping spree, flush with treasures, I couldn't help suppressing the urge to pinch myself. Being adequately capitalized meant, for the first time since founding the New Art Center Gallery nine years before, that I could finally enjoy the supreme luxury of buying what I wanted, when I wanted, for the price I wanted—within reason. Marvin and I had an unusually trusting relationship with regard to purchases made on behalf of the partnership. We fully trusted each other, particularly when it came to delicate matters of taste and discernment. But, if for whatever reason, one didn't appreciate what the other bought, we kept it for our individual collections rather than have it jeopardize the partnership.

For the most part, it all worked according to plan. The only hitch was that Marvin could be a first-class pain-in-the-butt. He suffered from the stinginess of the self-made man and never let me or anyone else forget that he had pulled himself up by his bootstraps. Repeated often enough, this could be tiresome, particularly when he was cajoling me to save money by not taking taxis, or demanding that we reconsider whether it was truly "worth it" to stay at first-class hotels or dine in costly restaurants. Time and again I had to remind him that living well was more than just the best revenge. On art-buying

trips it was, in and of itself, a critical form of promotion: if an art dealer stays at Claridge's, the art world regards him as successful.

"Now remember, Jacob," Marvin was forever exhorting me, "the money bag is not elastic." Many years later, he sheepishly conceded that, all things considered, I had been right: in the long run it probably "hadn't been worth it" to deprive himself of so many of life's worldly pleasures.

So much of what made our joint enterprise not only pleasurable but profitable was that we were riding high on the crest of a wave of postwar prosperity, sailing full-speed ahead into a sustained '60s boom. In 1959, America and the dollar achieved a peak of international prestige and power unprecedented since the Roaring Twenties. Americans were flush and brash and proud, and as a newly minted American, I appreciated only too well the rare good fortune that had enabled me to make a new life in the New World, and return to the Old World not in steerage, but in first class.

Now life was sweet. As American buyers of art in Europe, we were acting according to a long-standing tradition dating back nearly a century, when Yankee robber barons and their offspring raided the art of Europe. The essential difference, of course, between Marvin and me and art-hungry American patrons of earlier generations— Isabella Stewart Gardner, William Randolph Hearst, J. Paul Getty, Cornelius Vanderbilt, "Jock" Whitney—was more a matter of scale and taste than method. Like the well-heeled Yankee Brahmins of old, we were scouring Europe for the best art on the continental market at what Americans regarded as fire-sale prices. But in our case, instead of seeking out Old Masters or Impressionists, we were on safari for Modern Art.

Just how dramatic the run-up in prices for all works of art of every conceivable school would be over the ensuing decades was beyond Marvin's and my powers to predict. But we were infected by the spirit of the confidence and optimism that would soon carry a bright new, young, president — John F. Kennedy — to power.

In art history circles, the '60s will go down as the age of Pop Art, and of the final attainment of a remarkable respectability among the most prescient contemporary dealers and collectors for its precursor, Abstract Expressionism. Never having had much interest myself in the brilliantly hyped and superbly promoted exponents of either school, I steadfastly maintained my artistic conservatism. I always felt far more comfortable, particularly when gambling with Other People's Money, investing cautiously in artistic blue-chip works: long-established modern artists, "brand names," who had shown themselves to be stylistic and cultural innovators.

Even after branching out beyond my original field of interest, the German Expressionists, into the wide world of pan-European artistic expression, I felt a certain comfort level in sticking with "certified" names, and not risking my reputation, or my partners' money, on potential rising talents. A related factor was that, as a rule, I didn't much care for dealing on a personal level with artists. I had no interest in becoming an artist's psychiatrist, or hand-holder, forever lending money and acting as some sort of pater familias to struggling, temperamental self-styled geniuses.

Soon after returning from Europe in the fall of '59, as fresh packing cases arrived daily containing our newly acquired treasures, Marvin and I set about forging a new marketing plan. The concept, in a nutshell, was to let the art world know that the New Art Center Gallery had developed a new identity as a source and repository, buyer and seller, of a wider range of art than the German Expressionists.

From that day forward, the New Art Center would be committed to carrying a large inventory representing a broad range of artists of international renown. Having invested so heavily in our new bulging inventory, we knew such a plan was more than a luxury—it was a necessity.

I would have preferred sticking with the advice of Dr. Peter Nathan, of Zurich, to not be "overeager to sell." But Marvin was first and foremost a businessman, for whom buying was simply a means to an end — selling, and selling some more. And since Marvin was by that stage putting up three-quarters of the capital, he could to some extent call the shots.

Fortunately for us, we were gambling heavily on art at just the right moment. The '60s marked the end of an era of connoisseurship, and the advent of a vast untapped mass market for "fine" art. Never in the history of the United States had art dealers done such a land-office business in "original" art. A new sophistication was in the air. Americans now hungered for more Old World refinement in their homes.

In New York, Los Angeles, Chicago and other major cities, European fashion, European food, and European art were suddenly all the rage. People gave "fondue sets" for wedding presents. Transplanted Europeans, many Jewish but by no means all, were transforming universities and other cultural institutions from hidebound Yankee bastions into more universal cultural centers.

Under Marvin's entrepreneurial influence, our new catalogue took a distinctly mass-market approach, consciously catering to the emerging breed of hard-core investment-minded consumers, who constituted a market different from the high-minded connoisseurs of

old. Our new single printed broadsheet, folded in thirds to form a neatly packaged 8 1/2" by 11" brochure, was a far cry from the dark, demure, decorous publication that preceded it. The Klee catalogue of 1958 had a tasteful layout, typeface, and pseudo-academic look and feel. This had been appropriately targeted to appeal to a limited market: the exclusive pool of academicians, museum curators, foundation executives, private collectors and dealers who might have shown a connoisseur's interest in German Expressionism.

But now that we were offering—and needed to SELL—modern art by the bushel, our new publication was more of a printed brochure, suitable for sending to tens of thousands of "customers" as opposed to a few thousand prospective "clients." The three pages were literally peppered with postage-stamp-sized reproductions of work divided into national schools: French, American, English, Mexican, German and Swiss. The captions reflected the "hard-sell" philosophy so dear to Marvin's entrepreneurial heart.

"GOOD ART BUYS FROM THE NEW ART CENTER GALLERY," proclaimed our snappy brochure, unabashedly describing a rare Renoir drawing of a nude woman, executed in brown crayon and valued at $6,000: "A Renoir of rare beauty. Besides being a gem to behold, it is an excellent investment." The "hard-sell" method was unquestionably effective in moving large amounts of art.

Still, I must confess that it made me wince then, and makes me wince now, to read a caption pushing yet another jewel in our crown, Chagall's "The Painter"—an original watercolor in gouache and ink—with the following breathless prose: "A lovely, whimsical Chagall. Should increase considerably in value." To Marvin, the "lovely, whimsical" phrase achieved an appropriate balance marrying the conflicting appeals of connoisseurship, salesmanship and art appreciation. From Rouault to Chagall, Picasso to Pechstein, we covered the waterfront, omitting practically no major artistic name. Compared to the kudos being bestowed by the press on Jackson Pollock, Mark Rothko and others, I shouldn't have felt a twinge of guilt about pushing Paul Klee like this: "In Europe, the work of Paul Klee is widely sought and the prices are rising steadily. Enjoy a Klee in your home while it increases in value." For better or worse, this was vintage Marvin.

A growing enthusiasm for the work of Paul Klee in the United States, and a corresponding desire to respond to that demand, prompted us to mount a large Klee exhibition of drawings and watercolors, in January of 1960.

Klee had once written in his diary that through "the repetition of small and original deeds" there would come one great work, upon

Congregation Emanu-El
of the City of New York
Fifth Avenue at 65th Street
New York, N.Y. 10021

Study of the Senior Rabbi
DR. RONALD B. SOBEL

April 15, 1994

The story of Jacob Weintraub is a compelling
testimony to the indomitable quality of the human
spirit. Out of the ruble of Europe's destruction
and Nazi barbarism, the author came to America with
dream and hope which he soon translated into
dazzling reality. Intertwined in these pages is
the fascinating story of a human being whose
integrity was paramount as he created for himself a
place of prominence and significance in the world
of art. The book is well worth reading,
particularly for those whose interests would take
them through the labyrinth of the art world during
the second half of the twentieth century.

Ronald B. Sobel
Senior Rabbi
Temple Emanu-El, New York City

which he could truly build a life's work. It was a sentiment close to my heart.

I obtained mailing lists from other galleries and museums, and conducted a highly successful direct marketing campaign to promote the pleasures of art ownership to a broader mass market. We were out to sell relatively low-cost but high-quality graphic art to customers who might once have been content with reproductions. Our slogan was: "Art As An Investment." No one had yet used such an approach to the extent we did. The art historian Sophie Burnham, in *The Art Crowd*, described the change that took place in the '60s in hard statistical terms: "In 1960, there were around 450 art dealers of various sorts in New York. By 1970, there were a thousand...."

Sakowitz, a Houston specialty store, went even further toward commercializing art. Responding to the sudden growth of a huge, hungry carriage-trade market for art, Sakowitz offered a "Masterpiece of the Month Club," entitling subscribers to receive an original "20th century Master" each month for a year. The artists involved were exclusively brand names: Picasso, Chagall, Matisse. The cost per annum: $83,000, plus dealer's commission. This may have been a crass way to buy and sell fine art, but those who bought those works — and held on to them — are millionaires today.

By 1970, *The Wall Street Journal* estimated the potential market for fine art at $5 billion annually, putting it in close competition with the book and movie businesses and representing a more than fivefold increase from the previous decade. Art had become the visible evidence of wealth and status. The signing and numbering of graphic art to limit distribution, thus enhancing its value, fit into this pattern by providing a new category of "original" art, touched by the artist's hand, yet reproduced by mechanical, albeit traditional means.

Before World War II even the ardent graphic art devotees among the German Expressionists, to whom the production of prints took on the aura of a messianic mission, would have regarded the deliberate limiting of editions for the sole purpose of enhancing their value as a shameful compromise of artistic principles.

However, unless the collecting community could rest assured that they were getting a strictly limited edition, graphic art could never come into its own as a medium of "high" or "fine" art. When an educated middle class achieves a certain economic level, it desires not to own posters, but original artworks. A graphic work made in limited quantities thus possesses a distinct advantage as a collectible beyond issues of artistic merit. Our deal with the prominent Mexican artist Rufino Tamayo, to be his exclusive agents for graphics worldwide, reflected our calculated effort to become "players" in this growing field.

To kick off the New Year, and the new decade, in January 1960, we led off with a one-two punch: not one but two large-scale exhibitions in the same month. The idea, of course, was to put us more prominently on the artistic map, and to celebrate our new stature as a major purveyor of not just graphic art but oils, sculpture and drawings from around the world.

Entitled "101 Paintings, Drawings and Sculpture," the show reflected our great strength, depth and range. Arranged alphabetically, the work on display ran the gamut from Milton Avery, Alexander Calder, and Marc Chagall to Egon Schiele and Jacques Villon. We also offered works by André Derain, Raoul Dufy, Sir Jacob Epstein, Lyonel Feininger, Paul Gauguin, Juan Gris, George Grosz, Marsden Hartley, Childe Hassam, Alexej von Jawlensky, Ernst Kirchner, Paul Klee, Gustav Klimt, George Kolbe, Käethe Kolliwitz, Marino Marini, Henri Matisse, Henry Moore, Otto Mueller, Emil Nolde, José Orozco, Max Pechstein, Pablo Picasso, John Singer Sargent, David Alfaro Siqueiros.

Now we had to let the in-bred art world and the public at large know that we were in business. The New Art Center Gallery was admittedly a hodgepodge of the "greatest hits" of modern art. What we had lost in specialization we made up for in variety—the difference between a selective boutique and a fine department store.

As I got to know Marvin better, his motivations for going into partnership with me gradually became clearer. Marvin was semi-retired, and his conventional business activities had begun to pale by comparison to living the good life, whatever that was. Marvin was enamored with the richness and variety of the art world, with its wealth of opportunities for travel and cultural and social advancement.

His only serious liability as an art "handicapper" was his tendency toward sudden mood swings, and his frequently unrealistic expectations of short-term profits. In a sense, of course, I had only myself to blame, considering that I had led him, albeit not deliberately, into believing that every deal would be as rich as the one on the Kirchner I sold him and resold the next day at a 100 percent markup. The profit potential was there but not necessarily realizable so quickly.

Unfortunately, when miracles failed to materialize, Marvin had a childish way of blaming me, or the artist, for not selling "properly"— which in his case, meant immediately, at an enormous markup, far greater than stocks, bonds, or real estate. One day he would be high on Munch—the next day he would want to sell every Munch he had ever bought, feeling an intense disappointment in Munch, as if the long-deceased and tortured artist had somehow let him down personally. Similarly, one day he would be high on Weintraub; the next

day, Weintraub was letting him down. These sudden mood shifts could be alarming, even after I got used to them. Who knows how much longer we might have continued, if his marital problems had not intervened?

In a 1960 letter, Marvin exhorted me to make greater efforts on his behalf: "Sales of my paintings left with you on consignment and those for investment have been very bad for the past six months. I think you will agree that I have been patient...the Picasso graphics were purchased two years ago and something needs to be done to reduce the investment...But you must not ask me to help you build yourself up the way I have been, helping to make the New Art Center Gallery an important institution, without your being more willing to 'give out' to me...."

In Paris, Marvin paid a call on Rufino Tamayo and his wife, Olga, the boss who ruled Tamayo with an iron hand. At the time, I felt that the exclusive arrangement with Tamayo conferred a degree of respectability and credibility far in excess of any purely monetary value, particularly since the market for Tamayo graphics was untested and uncertain and very much mine to build up over time.

From the Hotel Continental in Paris, Marvin wrote in a typical mood of abject self-loathing: "I doubt that I will be buying anything more as it apparently does not pay to do so. Business is not good enough to do so...." But two days later, he wrote again, now in a state of excitement. "Am buying a colored Picasso litho for $400 as I believe it is saleable stateside. But for heaven's sake don't sell Picasso lithos so cheap!...Bought a Renoir for $3,000 from Petrides...What about money? No sales? Send me all the money you can...I need to pay Tamayo...."

On May 19, 1960, writing in another fit of remorse from the Hotel Beau Rivage in Geneva: "From now on I shall buy very little. It will have to be a big bargain for me to be tempted. There is no use going crazy with inventory if Americans aren't buying and haven't bought since February, and don't pay when they buy. It's better to hold onto our money (what money?) until buying of our present stock begins...."

I didn't need a psychiatrist to tell me that Marvin was downright neurotic about money, even though he clearly had enough stashed away to carry him over any number of financial rainy days. At times, when buying art, he sounded like some sort of compulsive gambler having to perpetually fight off the "temptation" to pay good money for art which, in a few days' time, he might loathe with a passion.

Marvin's dealings with James Wise, an American dealer/collector, son of the revered Rabbi Stephen S. Wise, and an expatriate American

resident in Switzerland, were a case in point. Wise had settled in Switzerland, the land of Klee's birth, having appointed himself the spiritual disciple, if not the heir, of the late great mystical genius. He made much of his spiritual bond with Klee, holding himself out to be a great idealist and philosopher in the Klee tradition. Wise nevertheless, could be a tough bargainer when he sensed he had someone over a barrel—someone like me, or Marvin, since we clearly aimed to become "players" in the worldwide market for Klee in the United States. One couldn't become a major Klee dealer without coming to terms with James Wise, who had something of a lock on Klee's best output and knew it. This advantage drove Marvin to distraction. Thus Wise was a brilliant success at making Marvin feel small. "Don't even ask me about Wise," Small wrote from Geneva. "'Macher' (Yiddish for wheeler-dealer) is too good a word for him. He's very self-centered, a slick salesman-type individual who loves Klee, but doesn't love art."

Marvin was upset because Wise had, in Marvin's considered opinion, sought to "unload a lot of junk on us at fancy prices." Even worse, he gave Marvin a "minimum of attention." Translation: Wise didn't treat Marvin with the respect he felt due a man of his wealth and station. Wise is "nervous as a cat," Marvin wrote, and "not altogether my cup of tea."

I wrote back to Marvin, "You seem to have been influenced by some people who told you Wise was a 'macher.' We know him to be a responsible dealer, maybe a little too shrewd, but who isn't? I just had an inquiry from Mrs. de Menil of Houston, Texas, with regard to an expensive Klee that she would like to purchase. It is my personal feeling that you should postpone the deal with Wise until we can straighten everything out from this end...."

I added a postscript in an attempt to smooth Marvin's all-too-obviously ruffled feathers: "One of your last compliments was 'when you say no to Jacob, he starts to work on you.' I hope that this will become contagious in our relationship after the first few years."

To some degree, our joint venture was adversely affected by his protracted haggling over his divorce settlement; for he used it as an excuse to avoid settling with us over a sticky matter: our expenses, which were considerable and which I felt should be borne by him in equal proportion to that of his investment, as an expense incurred in acquiring the art. My accountant saw it that way as well, even if Marvin didn't.

Tension between us surfaced again in early 1961, when my attorney submitted to Marvin a modest bill for services rendered in connection with the legal proceedings commenced by Sylvia against Barbara and me. The suit was without merit and was ultimately

dismissed by the appellate court. But not without a fair degree of tsuris on our part. Marvin refused to pay the $1,000 legal fee on the grounds that his wife's suit was our problem. It was a trifling amount to be sure, but his failure to indemnify me after expressly indicating his intention to do so left a sour taste in my mouth.

I always found a certain irony in Marvin's last name — Small. In German, there is an old saying, "In Kleinighkeiten bin ich gross." In English, "In small things, I am large." Marvin Small, true to his name, could be impossibly small when it came to things small.

Looking back thirty-five years, the joint venture with Marvin had its distinct ups and downs, not due to the fluctuations of the art market but because of Marvin's roller-coaster mood swings, characterized by sudden bursts of enthusiasm, usually followed by powerful pangs of overwhelming regret. Today, he might be diagnosed as a manic-depressive. I have never seen someone suffer so much guilt over art. He wrote me long, soul-searching letters often castigating himself for making unwise, unconsidered and impulsive purchases.

"I clearly have not used the best judgment in recent weeks, and I now wish to catch my balance," he wrote on one occasion; clearly, he felt off-balance and he ascribed it to the influence of art. Often he felt wretched about buying art. At other times, he considered it the world's greatest game.

The real pity is that if he had only held on to half of what he sold during these fits of remorse, he would have made millions. In a letter written only a few days later, he referred to a Picasso "Study for the Painting of Nos de Ebro," an ink drawing signed in pencil, for which he had recently paid 5,000 German marks. At the time that was about $1,200. In another bout of remorse, he wrote: "I am willing to take an immediate loss." And then, with just a hint of a veiled threat if I didn't agree, he continued: "This is your chance to cooperate and to make something extra. Make me an offer." I did. I bought that Picasso, Zervos VI No. 1112, for about a thousand dollars. Today, that drawing is worth a hundred times that. Poor rich Marvin. He was always too much in a rush to sell.

Our last exhibition, drawing heavily on works purchased jointly by Marvin and me, was a mammoth "Homage to Chagall in Honor of His Latest Stained-Glass Achievement." His stunning series of stained-glass windows for the synagogue of the Hadassah-Hebrew University Medical Center in Jerusalem, on the subject "The Twelve Tribes of Israel," was then on exhibition at New York's Museum of Modern Art. With Chagall-mania gripping the city, if not the country and the world, we seized the opportunity to show to collectors, by appointment only, a number of rare complete sets of Chagall etch-

ings and lithographs, including "The Bible." In addition, we offered an exceedingly rare limited edition series, nine sets only, of "Les Bibliophiles de L'Union," also colored etchings; a "Vision of Paris" portfolio, one of a set of seven lithographs; and "The Fables," 100 etchings, also quite rare. We launched the Chagall show in January 1962, entitled "300 CHAGALLS" and billed it in the somewhat excessive and breathless fashion of the time: "THE MOST IMPORTANT EXHIBITION AND SALE EVER HELD IN AMERICA OF CHAGALL'S ORIGINAL GRAPHICS."

This was undoubtedly true. But the language was only fitting in that Chagall was known to be fond of circuses and traveling carnivals and was, beyond that, something of an old pro at self-promotion. Five years later, in 1967, Chagall published an entire book called *Le Cirque* with text by Chagall, illustrated with 38 original lithographs.

The "300 Chagalls" show was a tremendous success for us, certainly helped by heaps of publicity during Chagall's American tour, when he was awarded an honorary doctorate at Brandeis University and shared with the Austrian Expressionist Oskar Kokoschka the Erasmus Prize presented by the European Foundation of Culture in Copenhagen. In those years, the early '60s, Chagall was at the peak of a long and distinguished career, which carried him from a humble *shtetl* in Russia to the salons of London, Paris, and New York. As the reigning artist of Jewish extraction in the world at the time, his fondness for Judaic themes made him a great favorite of Jewish collectors and dealers who, as I have heretofore said, make up a substantial proportion of the art world.

Nevertheless, despite our success with the Chagall homage, by October of 1961, Marvin and I had agreed to separate. Marvin submitted a rough proposal calling for me to buy out his share in our joint inventory, for a total of $121,000.

"By this transaction, our separation agreement stated that both parties release each other from any claims as to their past investment venture. New Art Center Gallery, having now been reimbursed for a share of the expenses incurred, acknowledges that Small's so-called 'paper profits' for 1960 and 1961 have been wiped out." Dated October 23, 1961.

One day, not long after Marvin and I ended our joint venture, an elegantly dressed man I took to be in his early sixties strolled into the gallery.

"Mr. Weintraub, I hear that you are a go-getter," he said. "I need a book of Cézanne drawings and watercolors that was published in Berlin and I hear you have good contacts over there. Can you get it for me?"

"Of course," I said, confidently.

"Fine," he said, and handed me his card on which his name, Henry Pearlman, and an address and phone number were engraved. No business name or address. Just a personal calling card.

I made a few calls. And on some, my contacts inquired on whose behalf I was conducting my search.

"Someone named Henry Pearlman," I said to one contact, as if saying "Joe Blow."

"Did you say Henry Pearlman?" one asked, in hushed tones.

"Yes, why?"

On the other end of the line, I heard a long, low chuckle. In that chuckle, I could hear many things: "You ignorant greenhorn Weintraub," that chuckle said. "You think you're so smart and wise to the ways of the art world, but you know nothing. If you haven't heard of Henry Pearlman you are still very naive."

"Okay, give me a break," I told my friend. "Who is this Henry Pearlman?"

"The Cézanne King," he said, as if everyone in the art world knew of his reputation. "He happens to be one of the largest private collectors of Cézanne in the world. Apart from his Cézannes, he has one of the largest art collections in New York."

I later learned that Pearlman had made a fortune outfitting ships with refrigerating equipment during the war so that food could be shipped to the Allied troops overseas. He was still very big in the burgeoning field of marine refrigeration. But now, semiretired, he was devoting the majority of his time and energy to his real passion, art.

My interest piqued, I called Pearlman and told him I'd purchased the book for him. I offered to send it to him. But he preferred to come in. He also took the call himself which I found surprising, and I was pleased that such a rich man would take the time to walk into my hole-in-the-wall. He said, "How much?"

I told him: "Nothing." At this, he let out a long, low whistle that clearly said he was intrigued by my response.

"What do you mean nothing? How can you make money? How can you do business like that? What are you trying to do, bribe me?"

I said nothing. I was waiting to see what he would say next.

"What is this nothing?" He couldn't let it go. "The book must have cost you something! Why give it away? What is your game? What are you up to?" Now, he was getting excited.

After a little more pressing, I finally came clean. "The book cost me fifty dollars," I said. "And if you insist, that is what I am prepared to accept, fifty dollars."

At this he began pressing further, trying to figure out what I was

up to. "You must have made phone calls to Europe. Surely you paid postage. What is this, zero profit? You expect to get rich that way?" At this point he whipped out an elegant thin calfskin wallet and plucked out a crisp one-hundred-dollar bill and handed it to me.

"Take this," he said, "I'll take the book."

There was no use arguing with him.

The following Saturday Pearlman came back, as I knew he would. This time he arrived accompanied by a tall, dark-haired elegant man in his mid-sixties. He introduced him as Colonel Berger. Samuel Berger, I was later to learn, was also a rich man, a lawyer and president of a large insurance company. Berger and Pearlman often took art-buying trips together to Paris. They asked if they could take me out for a cup of coffee. Barbara kept an eye on the gallery while Berger and Pearlman and I went out for a Saturday stroll. As we headed south on Lexington Avenue toward 79th Street, I pointed out a coffee shop I knew and suggested that might be a good place to stop.

"Oh no," Pearlman said, glancing at Berger as if sharing some private joke. "That place charges ten cents for a cup of coffee. We know a nice place just a few blocks away that has coffee for five cents, just as good."

This was my first but by no means last introduction to the often bizarre, irrational stinginess of the very rich. When we sat down Pearlman and Berger regaled me with tales of the art world. As I listened to their stories, I finally divined what they were up to. These men considered themselves "tribal elders" of the art world. As gentlemen of a "certain age" they had seen in me a likely successor, someone worth sharing the lessons they had learned over decades of buying and selling and dealing. I was just starting out, but already I had acquired a reputation as a "go-getter." Men often don't pass on their true wisdom to their biological sons as much as to their spiritual sons. I felt honored.

On this as well as on many succeeding Saturdays, over those five-cent cups of coffee, they shared with me their secrets culled from years of experience in buying art. Pearlman described, for example, how he had bought his first major painting in 1943, a colorful Chaim Soutine, at an auction at the old Parke-Bernet Gallery. "It gave me an emotional lift," he said, "such as one might receive from listening to a much-beloved symphony." That feeling, he related, always came over him each time he came into his home and spotted the Soutine over his mantelpiece. And it was in pure pursuit of that delicious "symphonic" feeling that he had spent so much time buying art over the years.

"Never forget that it's the feeling that one has in seeing art that

matters most," Pearlman said. "It isn't simply pride of possession. It is appreciating art in a way that is hard to do if you have only a few minutes to stare at it in a gallery. Living with art gives you a different, higher, deeper feeling for art."

He told the story of buying his second Soutine at the home of a prominent female collector in Paris, and of purchasing it on the spot, at which point he was shocked to be hustled out of her home by his dealer, who had accompanied Pearlman, as if they were late catching a train. He protested strenuously, because he had wanted to observe the social niceties. But the dealer explained that sellers are very fickle, and that if one didn't leave shortly after making a purchase, it was not uncommon for the sellers to change their minds when they might think better about parting with their cherished possessions.

Pearlman admitted that he had been just a greenhorn himself when it came to the arcane ways of the art market. He was shocked again to find that as soon as they returned to the dealer's office, the woman was on the phone. She had thought better of the sale and now wanted to keep her Soutine. The dealer urged Pearlman to flee France at once, while he did his best to stall her and persuade her that she made a good deal.

In the most serious tones, Pearlman advised me to avoid any shadowy schemes that might involve me in trouble, particularly with the government or customs agents and that might irreparably damage my reputation. No painting was worth it. Once a dealer got a reputation for being open to "funny business" there was no going back: my name would always be besmirched. And at what price?

"Remember," he said, "there are always other paintings, but there is only one Jacob Weintraub."

Pearlman discussed the various sneaky and underhanded ways used by unscrupulous dealers to pawn a fake on an unsuspecting buyer. The best method was to get a prominent auction house to offer it for sale. If they did, it carried the provenance and prestige of that auction house, as was the case of a Giacometti fake I later purchased through an auction house. The same went for certain galleries and even museums—"lend" a museum one of these "big names" and the fake acquires credibility. Pearlman was aware of a Modigliani which he knew to be a fake, which time and again he saw popping up at top auction houses and "big name" galleries. The only sign of there being something "funny" was that it was always offered for sale at a suspiciously low price. This suggested that the sellers on the "daisy-chain" knew its shadowy provenance, but didn't care.

During these story-telling sessions, Colonel Berger was often quiet, and content to let Pearlman hold court. But a few months later, we

were surprised and honored to receive an invitation from Berger, to join him for drinks and dinner at his elegant duplex. It is this dinner which I recounted in my introduction, when Berger told me I would never be a rich man unless I began my own private collection.

His advice was sound. As I recounted earlier, a few months later, a prominent New York real estate developer came into the gallery. He had been forced to sell off his holdings to meet the demands of a messy divorce. Some of the only marketable assets he retained were his paintings, because all of his real estate properties were on the block. He favored Surrealists, and I bought a number of fine pictures from him including a Magritte oil "La Terre Promise." Imagine: Magritte's "The Promised Land" for $6,000!

Money

I t was my great good fortune, during forty years in the art world, to find partners who suited my changing needs at precisely the time when I was in transition and my personal evolution was demanding a quantum leap to the next stage. A case in point was that of Harold Kaye, an old friend of Marvin's from "the neighborhood" (Brooklyn) who like Marvin had made a good deal of money early in life and was now looking for some new excitement.

When I first met him, in 1963, Harold was only in his late forties. But it seemed as if he already had led several lives, first as a vendor of radio advertising, then as an art collector and connoisseur of wine, music, and all the better things of life. Harold was a "culture vulture." He taught me a great deal about how to live in this new age of prosperity without descending into the vulgarity of materialism.

Harold was also an idealist, a Renaissance man, who had set himself up for early retirement and was looking for a new interest in life. He instinctively knew that he would find it in the world of art but, until he met me, he didn't quite know how to proceed. We taught each other, Harold and I. And though at times, as with Marvin and Erich Hermann before him, we fought like cats and dogs, we remained fond of each other right up until his early death, at age sixty, in 1974.

Marvin and Harold resembled each other in that they were both self-made men, with a love of Art, but who in a pinch loved money more. Harold, however, was a more refined specimen of the genre. He was a true intellectual and bon vivant. In retrospect, I am astonished at his wide range of interests, which extended to the social implications of technological change. Back in the '60s he was talking about fax machines and wireless telecommunications, satellite surveillance and video tape. Sometimes I used to tell Harold in exasperation, after enduring one of his visionary harangues, "I think you're too smart for me." At times, though I never said it, I thought Harold was too smart for his own good.

In my years of association with him, I learned much about living the "good" life, from attending the opera in formal attire at Glyndebourne, the vast estate outside London, with what Harold called "a marvelous bandbox of an opera house," to attending first-rate theater, such as Chekhov's "Uncle Vanya" with Sir Laurence Olivier

and Michael Redgrave, making the rounds of art galleries and dining at the latest most elegant restaurants. Harold also taught me a great deal about how to relax and not worry constantly about money and getting ahead.

Though, of course, Harold worried about money too. During our period together, in the last decade of his life, already a rich man, he became a group analyst at the London-based Group Analytical Practice—an institute devoted to the concept of group therapy. He was "an American who drove to analysis in a silver-grey Bentley," his British colleague Malcolm Pines amusingly recalled after his death.

When I first met Harold through Marvin, in the early '60s, Harold was living in Great Neck, Long Island, with his first wife, Marylin, whose health was failing. One night in early 1962, Marvin and I traveled out to Harold's home to look over his extensive collection of modern art. He had a marvelous Picasso oil that he was eager to sell, along with several fine Rouaults. It was on this occasion that I was impressed by the charismatic power of this man. It was a snowy evening in midwinter, and I bought the Picasso and Rouaults on the spot.

Harold had some guests spending the weekend with him, in the true English country-house tradition, and he graciously invited us to spend the night. But we declined, preferring to see our way home and above all, get the Picasso home safe and sound. Although I trusted Harold completely, not even with him did I deviate from my cardinal principle of always taking a painting or piece of art home with me when the purchase was made.

When Marvin and I parted, Harold was there to replace him. Harold's wife had died, prompting him to move to London, accompanied by his children and Patsy, their Irish nanny. Within a relatively short time, Harold married Patsy, forming a marvelously close bond with her.

Harold, a very smart businessman, was not immune to the trends sweeping the art world, with prices rising sharply and everyone who was anyone considering themselves a collector, or even a dealer. In 1963 in partnership with a prominent Jewish writer, Arthur Cohen, Harold founded the first mutual fund intended to capitalize on the art boom. Since, as I have said, it was "traditionally difficult for dealers in works of art to secure the financial cooperation of conventional banking institutions," Harold wrote in the prospectus, K-C Art Fund had been organized "to give dealers, private museums, collectors and established artists the financial assistance which they may require from time to time...."

After establishing himself in his elegant London residence, Harold enthusiastically took up a new role as our agent in Europe. However,

our relationship got off to a rocky start when we bought an Arp sculpture together, which I quickly sold to a Montreal physician whose payment by a series of promissory notes was dishonored by his bank. If the Arp and other sculpture had not been sold to the physician for $1.5 million we might have been more inclined to treat the matter casually. But over that amount of money, particularly in those days, we got extremely excited. At one point, at the end of his rope, Harold called Montreal to sort out the problem, identifying himself as "Mr. Shapiro, from New York real estate." The physician's secretary told him that the note had been presented to his office on the Jewish holidays when the office was closed—a good excuse—but only a temporary one. A few weeks later we found out that the sculptures were coming up at auction. We ended up having to get a court order instructing Sotheby's to return the works to us as they were not owned by the consignor.

In February 1964, with Harold in London I asked him to re-establish contact with Lady Epstein, the widow of the great American-born sculptor Jacob Epstein. Just before Epstein was knighted, he had married his longtime mistress, thus transforming themselves from a Bohemian couple into a British noble couple.

I expressed cautious interest in Epstein, asking Harold to explore the possibility of my acquiring a complete set of Epstein sculpture "as reproduced in Buckle's book...." This was a well-known biography-cum-catalogue raisonné of Epstein's work. "You'll have to be terribly diplomatic about it," I advised, "because Lady Epstein is stating that she is not making any casts even though everyone knows that new casts are being made."

This was the open secret on Epstein's posthumous production, and a definite handicap in marketing Epstein's work. Harold was also interested in Hans Arp's more abstract sculpture, some of which I bought—an Arp Helmet, in marble, for $5,000—but I felt at the time that Henry Moore, who would in due course become one of my staples, was too rich for my blood.

In March 1964, Harold wrote to me in a triumphant mood: "I have reestablished contact with Lady Epstein, based on your interest in acquiring her husband's sculpture. I have spent a number of hours with Lady E and have to go back for more conversation and negotiation...."

The New York-born Epstein, an artistic child prodigy who emigrated to England as a young man, having already made quite a name for himself as a graphic illustrator, was highly regarded both here and abroad. But his strictly representational style of sculpture could often seem dated, particularly his large monuments that conveyed a somewhat sterile "Art Deco" neoclassicism.

His portraits of "great men and women," from Chaim Weitzman to Winston Churchill, amounted to a gallery of world leaders of the mid-20th century. Beautiful and versatile work, to be sure. But the question: Would they hold their value over time?

Negotiations moved quickly, as Harold advised, "I've told Lady Epstein...about your decision regarding the pieces you want to begin with. I'd recommend ordering up to ten pieces at a time, never less than five, nor more than ten...." He advised me to pick up portrait busts of Winston Churchill, Chaim Weitzman, and George Bernard Shaw without delay.

By late April snags developed. "Lady E is playing hard to get," Harold wrote despondently. "She's a very touchy dame, and I'll be wearing kid gloves...." But by May 1, they had come to terms and Harold was happily ordering dozens of sculptures. I remained cautious, writing back on May 5: "People here are still afraid of investing in Epsteins, because they are not sure of the amount of casting Lady E did or will do...."

True to form, in preparation for our upcoming visit to Europe in the summer of '64, Harold wrote: "There's an extremely interesting one-day trip to the vineyards of Alsace being conducted by the Wine & Food Society here...For the 28th, the most fascinating thing to do would be to go to Glyndebourne to hear 'La Pietra del Paragone,' but you'll need formal clothes...."

Harold had a friend named Horace Richter, a wealthy businessman with a 300-acre estate on Long Island, who was a member of the board of the Jewish Museum. In June of 1964, I suggested that the Jewish Museum mount a retrospective show of the sculpture of Sir Jacob Epstein. At a board meeting, it was decided to organize a large retrospective during the second year of the New York World's Fair. The show would run from April to November 1965.

Horace then asked me to act as his intermediary with Lady Epstein. Hans van Weeren-Crick, representative of the Museum, then wrote to Lady E: "The Board of Governors of The Jewish Museum has felt for some time that America has lagged badly in paying tribute to one of the greatest artists of our time, your late husband Sir Jacob Epstein. To our knowledge, no major retrospective exhibition has ever been held in this country, for which we would like to make amends.

"Although the American public is, of course, familiar with Sir Jacob's work, which is represented in all major museums throughout the country, it is the Board's hope to organize an exhibition showing the full range of his genius, as evidenced in his sculpture as well as his drawings...."

Just before my arrival in London, Harold cautioned me about Lady E. "She's had bigger things to deal with than The Jewish Museum Show. Epstein had a giant exhibition at the Edinburgh Festival, which was then traveling to the Tate. I feel that the best way, and perhaps the only way to impress her will be with money. Please bring a good supply...."

In fact, rather than impress her with money, when we finally met, I played the "heavy." I wanted a Churchill bust, for which I had a major client lined up—the White House. But Lady E had promised the bust to one of her favorite philanthropic causes, Oxfam—the Oxford-based food-aid-to-the-Third-World program.

She served me an extremely unimpressive glass of Chablis and played hard to get on the Churchill. I told her that without the Churchill I would cancel the whole deal. She looked me up and down for a moment and finally said: "Mr. Weintraub, I do believe you mean what you say."

I said nothing. I nodded. She nodded. I got the Churchill. Or rather the White House got it. Lady E was as good as her word. She extended every effort to help with the Jewish Museum show, which was a relatively modest affair. Lady E, however, was no pushover, and on occasion Harold gave me reason to wonder whether his increasingly close, albeit platonic, relationship with her was in the best interest of the partnership. Shortly after my return to New York, I took a hard line. I wrote to him:

"Stop being selfish about your commission and to satisfy Lady E. If she were younger, I would say 'your girlfriend.' Her reputation for overcasting is notorious and, as you know, we have already invested $45,000. Try to get more concessions in writing so that we won't have to worry about her casting more for one year...."

Billy Rose, the American theatrical impresario and philanthropic booster of Jewish causes, now got into the act, prevailing upon Lady Epstein to send a large group of her husband's original plaster molds as a charitable donation to the Israel Museum. I met Rose for the first time during these negotiations. I'll never forget one of the first things he said:

"Jacob, when you give, it has to hurt or it's worth nothing."

With his characteristic finesse—Rose could have sweet-talked a Serb activist into contributing to a Mosque—Rose smoothly arranged for the transfer of 105 out of 311 of Epstein's original plasters to the Israel Museum. Harold, meanwhile, wrote to Mr. Alfred Barr, director of the Museum of Modern Art in New York, offering some additional Epsteins as gifts from Jacob and Harold. "It would be most fitting," Harold concluded, "that some of the plasters come to rest in the city of Epstein's birth."

Desiring to further publicize Epstein's work to a larger audience in the United States, in October of 1965 I arranged to put on a large exhibition of Epstein bronzes at May's department store in St. Louis. The idea of exhibiting "fine" sculpture in a department store setting, I thought, would raise the profile of the artist to new heights by showing the work to a mass audience. Before our first meeting, I was introduced to the head buyer who was very officious about handling the arrangements. I told him, with all due respect that I would prefer to deal directly with "Buster" May. I knew Buster—whose real name was Morton — to be a great art connoisseur, particularly of German Expressionists. When the store's buyer hesitated, clearly taken aback by my shocking request, I told him sharply:

"I am not a seller of brassières. I am an art dealer, and Mr. May is a well-known collector. I will deal directly with him."

Buster May was a charming man who asked me to meet with him at his home in the late afternoon, before he was to attend a large dinner party. He allotted an hour of his time, which quickly grew to two, as we chatted on about the world of German Expressionism and his extensive collection of Beckmanns.

Our conversation became so animated that when his friends stopped by to pick him up en route to the dinner party, he said:

"You go ahead, I'll meet up with you later. I'm having too good a time talking about art with Weintraub."

Elated by the success of our Epstein exhibition, in the unconventional venue of a large department store, I wrote Harold:

"This letter may be a little chaotic as we are very tired after three hectic days in St. Louis. Our trip was very satisfactory. I met Mr. Morton May, son of the old man. He has a large collection of German Expressionists, with 50 Beckmanns, Kirchners, and others. He would have treated me like any other supplier but when he found out I knew something about German Expressionist art he gave me a few hours of his time, and we parted the best of friends....

"I suggested to Mr. May that he have an exhibition in Los Angeles...He was intrigued, but would like to know if we can assure him that we could mount as important a show as we did in St. Louis, with 50 drawings and 70 sculptures...."

I concluded this letter: "Let me know when the Sears Roebuck order is ready...." This was more than a joke. Sears Roebuck was particularly interested in selling, at Sears outlets from coast-to-coast, Epstein's "Hands," which were curiously moving portraits of personalities depicting their hands instead of their faces. Epstein's "Hands of A Child," "Hands of Pianist, Myra Hess," "Sculptor's Hand" (a self-portrait), "Hands of Risen Christ," and "Kathleen's

Hands" (a portrait of Lady E) were all huge sellers. That fine art of this kind could be sold at Sears Roebuck and May's department stores was a sure sign that, as we had long surmised, the mass market for fine art in America had arrived.

Harold Kaye was a wealthy man, but not rich enough to handle alone my growing need for capital. We did have a number of still active deals, including the major Epstein estate purchase. But financially we were on pretty much the same level: well off, but not rich.

For the Epstein estate purchase, I needed additional joint venture partners and found them in the principles of the Harlem Book Company, a small art publishing house that held the North American rights to the works of Marino Marini, among other prominent artists. Feldman and Blaustein were partners in art publishing and became partners with me in art buying. But they weren't interested in plunging headlong into financing my operation. They were limited partners in the true sense of the word. To expand my range of purchases to include major painting and sculpture by 20th century masters, I would have to look further.

The first place I looked was a bank. My own, Citibank, turned me down. At the time, the mid '60s, they did not look upon art dealers as reasonable risks. Assuming that European banks might be more flexible, I tried a Swiss bank and then an Italian bank. Again, I was turned down. They would have been more than happy to give me a personal loan, but a loan to buy art? Forget it. In due course, however, that was destined to change.

Say the word "risk," or better yet "high risk," to a financial figure. If his face lights up with a smile, instead of settling into a frown, chances are that he is a factor, or just possibly a venture capitalist, and not a commercial or investment banker.

Factors have been referred to by many names, some not so flattering, like "legal loan sharks." They are lenders and financiers of commercial inventories, most often in the retailing arena. My knowledge of factors was strictly limited. But I did know one very smart and savvy gentleman, Gideon Strauss, a former diplomat at the Israeli Consulate in New York, and an occasional buyer of prints and other artworks from my gallery. In 1960, he became a chief executive of the Israeli Bank Leumi and arranged to lend the gallery a general-purpose operating loan.

Banks at the time did not make art loans, as a rule, Gideon Strauss was to recall later. But Strauss was convinced that I was a good risk, and he was intrigued by the possibilities inherent in lending money to capitalize art dealers. Bank Leumi kept that loan on the books for a number of years, collaterized by a Picasso oil that still

hangs in my living room, the prize of my private collection. On its back it still bears the "Bank Leumi" label, notice that it had served as collateral for a bank loan.

One indication of the rarity of such collateral was that when the New York State Bank examined Bank Leumi's books, they were horrified. What was this art loan secured by a Picasso, they demanded, insisting that no work of art, no matter how valuable, could or should be considered a sound enough commodity to secure a commercial bank loan. They forced the bank to call the loan, which obliged me to sell an Arp sculpture of which I was very fond—either that, or sell the Picasso.

That art was, in fact, a superb investment can be demonstrated by the fact that the Picasso oil which in the mid '60s was used to secure a piddling $30,000 loan, is now worth two million dollars. The primary obstacle to banks lending money on art in those days was that no one on the bank staff had enough expertise in the art world to evaluate art as collateral. Banks have long retained precious-metals experts, retail experts and specialists in other fields specifically to evaluate businesses and appraise the collateral on which they base lending policies. But art, the belief went, was somehow different.

Gideon, however, had learned a great deal about art, partly by buying and selling and also reading and studying. He loved nothing more than to spend Saturday at galleries, spotting the latest emerging talent. When he took up a new post at Rosenthal & Rosenthal of New York, a half-century-old factoring firm, he finally found himself in a position to do something about art financing.

Rosenthal had been founded in 1924 by Imre—known to his friends as "Jimmy"—as a financing firm concentrating mainly in lending to retailers, with a particular expertise in garment inventories. He was, in short, in the *schmatta* business. Rosenthal, however, was interested in art, both as a potential investment and as a collector in his own right. Gideon Strauss' intuition told him that it might be a good idea to get Imre and me together. We quickly clicked.

Imre Rosenthal had a different view of art as a commodity. "It's all a question of evaluation," he told me. "The question is: Is this solid merchandise? If it is, it's okay to lend."

As the art expert at Rosenthal, Gideon's job was to help convince Imre that 1) art was solid merchandise and 2) Jacob Weintraub was a solid dealer. Imre, a small, compactly built man with a cunning insight for a good deal, stopped by the gallery several times to "case" it, and to check me out personally. Whatever it was that he saw in the gallery and me he must have liked because in early 1967 he told me in his grandest, most expansive manner:

"I have big plans for you, Jacob." He was as good as his word.

To Imre, the art business was just another form of retailing, yet possessed of a staggering upside potential—a potential which, up to that time, had not been fully exploited. Like other savvy investors, he saw a gold mine on the horizon.

"As long as you have the margin, you're okay," Imre said. This translated as: "As long as you have the collateral, and you can get out without losing your shirt, it's okay to lend."

"We accept the risk," Imre announced with a smile. "In return for accepting the risk, we reserve the right to charge rent on our capital." That meant interest, and interest rates in the factoring business tend to float at least several points above prime. "If we loan against art," he explained, "the worst thing that can happen is the dealer goes down. So we put his art up on the wall." Simple as that! In some cases, fortunately not with me, this came to pass. Witness the walls of Rosenthal & Rosenthal. Unlike those of other factors their walls are lined with multiple works by Robert Rauschenberg and Jasper Johns.

Our first collaboration was the purchase of a substantial art collection from a failed real estate investor in Coral Gables, Florida. "His business was one of those dubious affairs," Gideon recalled, with notable condescension. "The collateral wasn't there. The land deals were shaky. But the man had an extraordinary art collection. Matisse, Arp, Picasso. He had knowledge, or someone with knowledge had helped him build it. All excellent pieces."

To market the works purchased in Florida, we formed a partnership with Rosenthal called Gallery Masters. We also set up a wholly owned subsidiary, GM Graphics, to deal in graphic works—prints, etchings, lithographs and drawings.

In early 1967, Imre Rosenthal again broached the subject of his big plans for me. "Jacob, with this fancy inventory, how about thinking about moving the gallery?" I had to admit, he had a point. My gallery at 1193 Lexington Avenue had become an obstacle to further growth. It was too small, not at all elegant and, most crucially, outside the mainstream of prominent uptown galleries, which at the time were clustered up and down Madison Avenue and in prime space along the 57th Street corridor, east and west of 5th Avenue.

If I were to go with the mainstream, I undoubtedly would have settled somewhere on 57th Street. Some inner voice instinctively told me—Madison Avenue. I am not a joiner. I didn't want to be next to all the other art galleries in midtown but as a longtime resident of the Upper East Side, I knew the neighborhood well, knew its people, and above all appreciated its potential as a location from which to sell art. New York's retail Gold Coast, then as now, was Madison

Avenue. While reconnoitering the area on my daily walks, I became fixated on a particular location: that of the Ian Woodner Gallery on the northwest corner of Madison Avenue and 77th Street, site of the old Hyde Park Hotel, now known as The Mark. Woodner was himself an intriguing character. Sixty years old at the time, he had trained as an architect at the University of Minnesota in the early '20s, when he also began collecting and painting.

His first architectural assignment was at the 1939 New York World's Fair, where he designed a pavilion and where Americans were being introduced to a new global culture. The French restaurant, Le Pavillion, got its start there, in the French pavilion. Woodner was in contact with a number of international artists, including Willem de Kooning, whom he commissioned to paint a large mural for one of his buildings.

Woodner, though, never practiced much as an architect. He amassed a fortune as a real estate developer, owning lucrative properties in both New York and Washington, D.C. Unlike other art dealer-collectors, he never had any problem borrowing enough money from banks to finance his art buying sprees. "The banks have always been happy to lend me money on art," he later told London's *Financial Times*, with an air of self-congratulation. "What they look at is not the art, but whether I had other resources to pay back the loans. My real estate is my security. I spend according to my mood and opportunity."

Over the years, Woodner amassed artistic properties the way he collected real estate. In the process, he built up a substantial collection of old master drawings and paintings, in addition to works by modern artists, from Cézanne to his own personal favorite and hero, the French artist Odilon Redon.

A man of many talents, Woodner was quite a good painter in his own right, executing Impressionist-like portraits and still-lifes in the manner of Redon. My interest in his gallery was partly due to the fact that I knew something about his gallery manager: that he was a drinker.

A man's drinking problems matter little to me. But this particular fellow, although charming, was a horror-show as a gallery manager, and was rapidly driving the Ian Woodner Gallery into the ground. It was to Woodner's humanity that he didn't fire the man but kept him on hoping that the unfortunate situation might turn around.

I approached Woodner with a proposition that I thought might appeal to him: what if he let me take over the lease on his gallery, letting him out of the whole messy situation. We had established a good rapport and I could tell that Woodner was attracted to the idea of

just giving it all up. He seemed to accept my offer, but under one condition.

"I don't know if you know about me," he said, "but I happen to be something of an artist in my own right, and I am scheduled to have an exhibition of my work coming up two months from now."

I had expected something along this line, and was prepared for it. "Don't worry," I said, "why don't I prepare that exhibition on your behalf, and take the whole situation off your hands."

"But you are not known as a dealer in contemporary art," Woodner protested. I told him not to worry, that was not a problem.

On Tuesday March 12, 1967, the newly named Weintraub Gallery sent out engraved invitations requesting the pleasure of the recipient's company at a Champagne Reception from 6 to 8 p.m. for a showing of "Important Sculpture and Paintings." I had given some thought to what we should show, and I ended up offering a high-level assortment of my bulging inventory.

But what really launched me was a two-day auction of Impressionist paintings at Parke-Bernet, where buyers "led by the industrialist-collector Norton Simon bid sky high and shattered at least a dozen records in the process," as *Business Week* noted. The article carried a photo captioned, "As bidding for Renoir's 'Le Pont des Arts' stepped up, so did the pulse-rates of those in the crowd at Parke-Bernet." But instead of a picture of Norton Simon, who was bidding through a dealer, the photo clearly showed Barbara and Jacob Weintraub.

"For the rest of the auction, records fell like ten-pins," *Business Week* reported. This was the peak of the '60s art boom, an exuberant interlude soon to be broken by the stock market crash of '69, and not to be equaled again until the '80s. Sold the following evening, *Business Week* reported, were "70 paintings owned by the Paris collector, Dr. A. Roudinesco"—a Paris physician who had over the years accepted paintings, mainly of the School of Paris, in return for medical services. "Among the records set that night were Dufy's 'Les Trois Parapluies' $140,000—double the previous highest bid for a Dufy; a Utrillo, $60,000; a Pisarro, $260,000; and a Van Dongen, $80,000." A Parke-Bernet man said: "It was an incredible sweep. Everything went up across the board."

It was indeed an incredible sweep, with the broom being wielded by one Jacob Weintraub. *The New York Times* of Friday, October 11, 1968, reported, "TWO DAY SALE AT PARKE-BERNET ENDS WITH A RECORD $6,028,250."

The *Times* auction-house correspondent, Grace Glueck, led off her report:

"Bidding with his eyeglasses, Jacob Weintraub, a New York art

dealer, bought 12 School of Paris paintings at the Parke-Bernet Galleries last night for $730,000. He was by far the biggest buyer at the two-day sale....

Although the auction was officially "conducted" by Peter Wilson, chairman of Parke-Bernet, now Sotheby's, the baton-wielding conductor was its current chairman, John Marion. I've known Marion ever since he was brought into the Parke-Bernet fold by his father, Louis J. Marion. By 1951, Louis Marion was chief auctioneer, and ten years later, when he "hammered down" Rembrandt's "Aristotle Contemplating the Bust of Homer" for $2.3 million, he shattered by over 100 percent the record for a single work of art sold at auction. In 1960, Marion's son, John, started learning the ropes of the auction business. John Marion, a proverbial chip off the old block, resolved to some day beat his dad's record, a feat he accomplished eighteen years later, in 1989, when he sold Frederick Edwin Church's monumental masterpiece "Icebergs" to the Texas oil magnate Lamar Hunt, for $2.7 million.

John and I got to be friendly in the early '60s. By then he was running Parke-Bernet's print department. He always viewed me as very much of a maverick in the art world.

"For the Roudinesco auction, Jacob got his group together and began bidding to beat the band," Marion was to recall later. "All night, I kept having to say 'Weintraub Gallery' as I hit the hammer, until people who didn't already know him in the audience kept turning around and staring at him. He raised and lowered his eyeglasses, the signal he had worked out with me indicating that he was raising his bids. They stared impolitely, as if to ask 'Who is this Weintraub?' It was to the delight and great consternation of his rival dealers that Jacob carried off the entire room that night...."

Marion described me as "acerbic but lovable." A fair assessment, I think, and in its own way a sure sign that I had arrived.

M WEINTRAUB GALLERY
992 MADISON AVENUE
NEW YORK, NEW YORK

Date _____
Authorized by _____
Checked by _____
Delivered by _____

ROUDINESCO PTGS. COLLECTION

NUMBER	DESCRIPTION	AMOUNT	TOTAL
11	PAYSAGE VALMONDOIS	40000.00	
12	MOUILLAGE A LA GIUDECCA, VENICE	110000.00	
13	DANS LE PORT D'ALGER	36000.00	
24	LE PORT DES ARTS, PARIS	125000.00	
26	LE VILLAGE SOUS LA NEIGE	43000.00	
31	RIGATE A HENLEY	25000.00	
32	NOTRE-DAME DE LA GARDE, MARSEILLE (AS ANNON.)	92500.00	
42	EGLISE ET CHAMPS DE BLE	52000.00	
43	LA SALIS, ANTIBES	95000.00	
47	COCOLINA	40000.00	
55	JEUNE FILLE DANS UN FAUTEUIL	36000.00	
65	GRAND BOUQUET DE FLUERS	36000.00	
			730,500.00

New York City Sales Tax 5% New York State Tax 2% Other Sales Tax

☑ DEALER ☐ I. C. C. ☐ EXEMPT INSTITUTION
PURCHASES DELIVERED ONLY ON PRESENTATION OF RECEIPTED INVOICE

Receipt of the above property is hereby acknowledged.

Date_____ Signed_____

SIGNATURE OF BUYER OR BUYER'S AGENT

FORM 1

*My bill from Sotheby's 1968
Roudinesco sale.*

SOTHEBY'S
FOUNDED 1744

1334 York Avenue, New York, New York 10021
Telephone: (212) 606-7373

John L. Marion
Chairman

April 12, 1994

Dear Jacob,

I was very pleased to hear that you are in the process of publishing your memoirs. It will certainly be an interesting story because you have had a remarkable career.

Thinking back to your beginnings with the New Art Center on Lexington Avenue, your business has developed in a wonderful way to now house your impressive Madison Avenue Gallery. It has been my pleasure to be associated with you over those many years.

All good wishes for continued success,

Sincerely,

John

The Weintraub Gallery: Rejoining the Human Race

By the 1970s I had survived, indeed thrived, through two decades in the art world, and had been fortunate enough to attain a level of success and security that I would not have dreamed possible in 1950, when all I could do was to make ends meet. The journey in 1967 from Lexington Avenue and 81st to Madison and 77th may have been a matter of a few blocks from a professional and commercial standpoint, but that distance represented the difference between an Olympic gold medal for swimming and just treading water. Now that I felt comfortably ensconced in the new larger quarters, and more secure in operating at this more exalted level, I felt the time had come to rejoin the human race.

My misanthropic outlook on life, the deep-seated legacy of my Holocaust experiences, was gradually giving way to a tentative rapprochement between me and the cruel, unforgiving world—or so it had seemed—during the miserable and unforgettable stages of my youth. Man's insensible inhumanity to man had indeed taken its toll on my youth and my innocence, and left me with ineradicable scars. Yet I grudgingly had to concede that in my Promised Land, life had been good to me and Barbara. It was as if to show us that, in a free society, when citizens are entitled to embark on the pursuit of happiness without fear of molestation and hindrance by others, rewards do accrue to those willing to work diligently and intelligently. Now that I had material prosperity and a comfortable home, liberating us from the struggle for sheer survival that had marked our early years, I felt entitled to sit back and take stock, to take justified satisfaction at having attained a full measure of worldly success.

Now, it was time to give back. And to give in to the demands placed by society on the privileged. I was under no illusions; I had reinvented myself in my Promised Land. I had made myself what I had become. But, while also acknowledging that I had had help along the way, I began to ponder the question of whether I could now help others. This led me straight to the "Flame of Hope."

On Wednesday, December 1, 1971, the Weintraub Gallery held a

gala opening of an exhibition of artworks by mentally retarded artists, sponsored by the Exceptional Children's Foundation of Los Angeles. Thirty-four works of art, including oils, watercolors and collages by seven artists, graced our walls, offering a dramatically different bill of artistic fare from our customary Picassos, Chagalls and Moores.

These precious works had been acquired by a nonprofit organization called "Flame of Hope," a Kennedy family charity funded by the Joseph P. Kennedy Sr. Foundation, committed to providing employment for the mentally retarded through the sale of proprietary products and services.

This gibed with the principles by which I governed my own life—hard work and self-sufficiency in the face of hardships induced by the uprooting traumas of the war years. But what really swayed me was the art itself. I told the press on the eve of the opening: "I was astounded by its raw quality."

Rose Kennedy, the elegant long-suffering grand dame of the Kennedy clan, attended the opening, accompanied by her daughter Eunice Kennedy Shriver. Both graciously expressed their gratitude to me for the use of the gallery as a venue for the show. I, in turn, thanked them for giving me the opportunity to demonstrate my commitment to worthwhile causes. Though a registered Republican since my "greenhorn" days, I was vividly reminded of the Kennedys' devotion to the betterment of those less fortunate than they. Rose Kennedy demonstrated a touching graciousness by insisting that all photographs of her were to include Barbara or me.

The "Flame of Hope" show marked the beginning of a new phase of my life, during which I subtly shifted focus from a single-minded drive for material and professional success toward a larger, broader definition of self-fulfillment. No longer would the mere earning of money, the stock-piling and acquiring of valuable art, and the pursuit of prestige take precedence over a newly awakened hankering after the more important things of life.

During my partnerships with Marvin Small and Harold Kaye I had experienced a gradual restoration of a taste for Continental sophistication that had been submerged during long years of struggle for survival. After all, even after the Holocaust, during our "greenhorn" years, Barbara and I had traded the struggle for physical survival in the Old Country for a struggle for material survival in the New.

In conjunction with the opening of the "Flame of Hope" show, I agreed to donate a bust of the late president to adorn the John F. Kennedy Center for the Performing Arts in Washington. The sculp-

ture was quite valuable, which meant that it met philanthropist Billy Rose's dictum that "when you give, it's got to hurt." And it provided *New York Post* columnist Leonard Lyons an opportunity for a little squib in his famous column, "The Lyons Den": "Jacob Weintraub, the Madison Avenue art dealer, presented to the JFK Center in Washington a bust of the late president by the Italian sculptor, Salemme. The director of the center, William McCormick Blair Jr., and Jean Kennedy Smith came to the Weintraub Gallery to have a look at it first and give their approval...."

I must admit, my ego was massaged by being identified by Lyons, the arbiter of Cafe Society of that era, as "the Madison Avenue art dealer." It might be snobbish to say so, but people like Rose Kennedy and Leonard Lyons know the distance between Madison and Lexington, and that it could not be measured merely in city blocks.

Yet another sign of reconciliation with the human race was that I became, albeit a bit grudgingly, a joiner. For years, I had resisted the temptation to join with my fellow Holocaust survivors in reliving the traumas of those years. Barbara and I had made friends, but we hadn't joined clubs or societies or made formal affiliations, such as joining a temple.

But by the late '60s following my move to Madison Avenue, my visibility in the community went up. My new position dictated that I adopt a higher public persona. There I was, in a costly fish-bowl, with people peering in at the assembled art treasures. *The New York Times* art critic, Hilton Kramer, had justly termed our gallery, in a glowing review of one of our larger exhibitions, a veritable "cornucopia" of Modern Art. I was still sufficiently a greenhorn to have to ask a few native English speakers what "cornucopia" meant. The new attention awakened in me a long-dormant sense of civic pride and social responsibility, which merged with a gradual deepening of interest in other intangibles: religion, history, theater and opera.

Growing up an assimilated Jew in prewar Poland, I had not been deeply imbued with formal religion. My family's approach to the religion of our ancestors had been a typically assimilated blend of skepticism and respect, coupled with a desire to be accepted by a secular society, and to throw off the trappings of what must have at times seemed to them an anachronism: the ancient religion of Judaism. For me and my close friends and family, the medieval garb of the Orthodox Jew seemed unsuited to our status in life. If anything, such noticeable garb, setting the Jew apart from the rest of modern society, seemed as foreign and outlandish to us as we assumed it did to gentiles.

The Holocaust, of course, changed all that. After being exposed to

Polish-Catholic thugs who at any time felt free to harass a suspected Jew, we could no longer live under the illusion that we could ever be accepted by the gentiles as one of them, or even as like them. We might wear suits and ties and know something about such things as nuclear physics, but in the eyes of the non-Jew we might as well have been wearing fur-trimmed black hats, long black coats and unshorn curling side-locks.

No more could we believe that by learning the "home" language and contributing to the good of society would we be saved from the condescension, and sometimes hatred and violence, by the gentile for the Jew. The cut of our clothes, the size of our bank accounts, the lack of an accent, the extent of our education, didn't matter when they built the walls of the Warsaw Ghetto. Everyone of Jewish blood, rich or poor, Yiddish-speaking or not, was tossed into the same prisons to starve or to die, to be hunted down like animals if they escaped.

Though I knew I was a Jew, I had made no move to embrace my religion in any formal sense. During my first two decades of residence in my Promised Land, I was too busy surviving economically and getting established to give much thought to abstract matters like religion and culture. True, I had subscribed to the Philharmonic as soon as I could afford to, and the great exception had been my steadfast support of the homeland of Israel from the first tumultuous days of Independence. But that had been support for a secular Jewish state, a cultural belief rather than a religious or spiritual one. I, who had seen with my own eyes what could happen to Jews without a safe place to flee, without a homeland of their own, without a guaranteed refuge, could do more than simply hope for the survival of Israel.

When an unusually tall, handsome gentleman, wearing a derby hat and a dark Savile Row suit, walked into the gallery one day in 1964, removed his hat and introduced himself as Walter Mack, treasurer of Temple Emanu-El, I knew that my time had come. No resident of New York's Upper East Side, certainly not one of Jewish origin, could have failed to take note of Temple Emanu-El, on 65th Street and Fifth Avenue, the most prestigious temple in the United States.

Temple Emanu-El was founded in 1845 on New York's lower East Side by a small group of German Jews who yearned for a place of worship of their own. Lacking the funds to build their own temple, they transformed a deconsecrated church into a humble synagogue. By 1860, as the original group of founders flourished and as the first wave of German Jewish immigrants gradually attained stature, they constructed an impressive Moorish-style temple on Fifth

Avenue that was regarded as one of the architectural achievements of its time.

In 1929, after nearly a century of steady growth, on the eve of the Great Depression, the increasingly influential congregation of Reform Jews had outgrown the Moorish-style temple. A replacement, even more magnificent, the present edifice was built at Fifth Avenue and 65th Street. This somber granite structure was a triumph of spiritual architecture, imparting a grandeur to the experience of Jewish worship unrivaled anywhere in the world. The soaring nave, the magnificent stained-glass windows, the elegant appointments and staggering collective wealth of the congregation all reflected one marvelous fact: in America, safe from the pogroms and persecutions that had dogged Jews every step in the Old World, Jews had arrived. Not that America was entirely free of anti-Semitism—even the most starry-eyed reformer could not credibly claim that—but America was blessedly free of the sort of overt discrimination that had prevented Jews throughout so much of history from owning their own land and pursuing their own destinies.

On the eve of the Holocaust, and of the global depression, the triumphant opening of New York's great Jewish temple was a sign of hope and a shining future for Jews in America.

When Walter Mack, president of Pepsi-Cola and of Nedick's, who served as Temple treasurer for over fifty years, and on its board longer than any other, made it clear that my time had come to take my place among this privileged congregation, my first reaction was uncertainty. I wasn't sure if I was ready, spiritually and emotionally, to join. Of course, the fact that a great honor had been bestowed upon me hadn't escaped me. But like some cowering fellow in a biblical fable who has heard the call, at first I was inclined to hold back.

"I'm pleased to be invited to join Temple Emanu-El," I told Walter Mack, "but I need some time to think it over, because I have to sort out my own thoughts."

I told him, by way of explanation for my hesitancy, that I was not yet a friend of the human race. That I still nursed a deep, gnawing resentment of humankind, for it had perpetrated the death of so many of my family and friends, indeed all the six million men, women and children who had been struck down by bullets, starved into submission, suffocated by Zyklon B and slaughtered by other means for more than a decade, while the world sat back and wondered what to do, and in the end did nothing. Or practically nothing.

Speaking bluntly, I laid it all out for him: I resented the wealthy Jews of America, including the esteemed members of Temple Emanu-El, for not doing enough to stop the wholesale destruction of

European Jewry during the Holocaust. Yes, I knew some had tried and some had failed, and that efforts had been made by a few wealthy American Jews to obtain passports and save the lives of a handful of the threatened—the more prestigious, famous ones. But when push came to shove, I believed, they could have done more. They could have risked more. How could I forget cowering in the Ghetto, and hiding outside it, wondering if and when the Americans would deliver us from certain death at the hands of the Nazis?

Further, I told Walter Mack, I wasn't in the mood to hear any belated excuses. I told him that the wealthy German Jews had not always seen their Eastern European brethren as worthy of their sympathy, or their help, much less their sacrifice. Their precious Franklin D. Roosevelt, the United States president with whom so many of the Jews in America had so long been infatuated, had not done enough—if anything. The evidence was there, the aerial shots of the death camps, but still the Allied bombers had refused to bomb the rail lines which would carry millions of Jews to their deaths. The Allies favored more "strategic" targets such as factories and munition dumps.

To his credit Walter Mack silently heard me out. He simply nodded his distinguished head, discreetly pulled out a little pocket calendar, and made a mark beside my name. We agreed to allow me two years to heal my burning anger.

In two years to the day, Walter Mack was back. He had not forgotten me. Was I ready? Yes, I agreed, I was ready as I ever would be. He took me to meet Dr. Julius Mark, the Temple's Senior Rabbi from 1940 to 1977. During the course of a two-hour conversation, we spoke about life in Poland before the war, about the tragedy of the Warsaw Ghetto and about the Holocaust. He had a special interest in the Holocaust, and asked me in detail about the tragic figure of Adam Czerniakow, the head of the Judenrat in Warsaw who had committed suicide after being forced to confront the full horrors of the Final Solution. I had been among the first to discover his body, after he took a tablet of potassium cyanide rather than execute the Nazi orders to send children to their deaths.

Rabbi Mark's message to me was simple: I was in, if I wanted in. I finally joined. Becoming part of the large Emanu-El congregation was indeed a revelation. I found I enjoyed being part of the group. Upon joining the Temple on March 1, 1966, I met Dr. B. Ronald Sobel, Dr. Mark's number two, now the chief rabbi.

"Jacob's a true survivor," Rabbi Sobel told a researcher in his elegant wood-paneled office on the top floor of Temple Emanu-El's administrative wing. "I always marveled at the manner in which he

dealt with the experience of personally witnessing the destruction of European Jewry between 1933 and 1945. He never permitted that unfathomable horror to destroy the essential optimism that are part and parcel of his being. He came to America with hope in what the future could be, and he proceeded, in a classic version of the immigrant success story, to transform that dream into reality.

"He became eminently successful in the world of art, at home in America, and with a cosmopolitan confidence that allowed him to travel the world productively, yet at the same time he maintained his fundamental belief system. From the day of our first meeting, I sensed an unquenchable passion for life in Jacob that no experience, no matter how traumatic, could ever eradicate."

Something similar happened when I was approached by Victor Hammer, brother of the late industrialist, Armand Hammer, and owner of the Hammer Gallery, to join the Lotos Club. This old-line literary and cultural society was founded late in the past century as a vehicle for promoting culture in America at a time when, compared to Europe, the United States was still something of a cultural backwater. In 1870, a group of wealthy, artistically inclined New Yorkers were determined to shed the Philistine image of America in an epoch when the business of America was generally considered to be business, and cultural activities did not enjoy a high priority. It was an era of newly forming New York cultural institutions, from the Metropolitan Museum of Art, the American Museum of Natural History, and Hunter College, to list but a few. The stated aim of the club was to "promote social intercourse among journalists, literary men, artists, members of the musical and dramatic professions, and such merchants and professional gentlemen of artistic tastes and inclinations."

The name of the club, including its unusual spelling, was ironically derived form Alfred Lord Tennyson's famous poem "The Lotos Eaters"—a bold reference, no doubt, to the disparaging tones in which so many hardheaded men of business referred to the "arts" at the time. Two lines from Tennyson's poem, "In the afternoon they came unto a land / In which it seemed always afternoon," duly proclaimed the club motto. The Lotos, housed in a stately mansion at 5 East 66th Street, just off Fifth Avenue, provides a bridge between the worlds of business, politics, academia and the arts. The dinners in honor of a succession of "great men," from Mark Twain to W. S. Gilbert and Walter Sullivan to today's Walter Cronkite, are always delightful occasions.

"Join the Lotos Club," Victor Hammer urged me. "You'll meet the best people, your kind of people, our kind of people." I was sure this

was true, but once again demurred until I sorted out my thoughts. I liked the fact that the Lotos had members from every imaginable ethnic and religious persuasion, and that no one cared what color you were, as long as you were their "kind of people."

Hammer sent me a little book which included lines quoted from a Lotos State Dinner of 1906, at which St. Clair McKelway, then editor of the daily newspaper, the *Brooklyn Eagle* (and later of *The New Yorker*), attempted to capture the essence of the club: "The Lotos drew those who rated sentiment above sordidity, achievement above assumption, learning above wealth." When Victor Hammer was elected president of the club, one of his first presidential decisions, he later said, was to call me. "I'm not letting you off the hook this time," he jokingly said, though it sounded just a little like a threat. "Now it's my prestige on the line and I'm going to bring you in." He sounded like a sport fisherman preparing to reel in a major catch. Was I a major catch? Only God and Victor Hammer knew for sure, but to check up on my bona fides, the Lotos began asking members to check out the gallery and me. They asked all sorts of questions, and also checked into my bank records going all the way back to 1946, when Senator Lehman physically led me into Citibank and personally opened my first account, an account I still have.

The members didn't find any problems, and so I was admitted. Membership in this marvelous club has been a matter of pride and a never-ending pleasure. Only I wish they wouldn't serve meals in a basement grill, even art-bedecked as it is. Having been forced to live underground, it's against my aesthetics to eat meals below ground.

Tempting as it may have been to spend my days at Temple Emanu-El, reacquainting myself with the culture and religion of my ancestors, or to luxuriate at the Lotos Club, lotus-eating, I had a business to run.

Fortunately, besides Barbara, who had long been indispensable to the gallery, we now had some help. Mrs. Iwo Lowy and her husband were old customers going back to the mid '50s. They had began buying German Expressionist works at our Lexington Avenue location, when the walls of their apartment on West End Avenue were bare. The first piece they bought was a Nolde watercolor of "Sunflowers."

As our inventory expanded, and the pace of our exhibitions picked up, we realized that the two-person band we had been running for two decades was not enough. Mrs. Lowy joined us on Madison Avenue in 1968, not long after we moved into our new, spacious quarters, while Frank Kent, an elegant gentleman, a former publicity agent and one of our old neighbors, acted as the general manager on an on-call basis. Iwo Lowy managed our expanding print and graph-

ics department, on the second floor, where she had an opportunity to arrange quite a number of interesting exhibitions. We handled graphics by big-name, well-known artists as well as young, promising up-and-comers. These exhibitions gave the younger artists an opportunity to gain exposure to the sort of well-heeled collectors who often stopped by the gallery on their strolls around the neighborhood.

This was, for us, a major departure: up until then, we had not felt secure enough in our position to take the risk of sponsoring shows by young new artists. Although it took place in an unabashedly commercial context, this was all part of rejoining the human race: taking a few risks, giving a few breaks.

We had at least one major graphics exhibition every month, including a number of shows by foreign artists in which we enlisted the cooperation of their embassies and consulates. This gave the openings a truly international flavor and helped raise the profile of the artist among the European "jetset" (now called Euro-trash, by some) that might otherwise have been out wining, dining and dancing at discos.

Barbara was a very strong quiet presence, never inserting herself into the foreground. She would sit calmly in the back with her bookkeeping and paperwork. Like all good behind-the-scenes players, she was interested in keeping her influence invisible but was actively involved in every major decision. She always knew more than she was given credit for. That was just how she liked it.

Barbara's health had never been robust, a fact which I had always attributed to a combination of physical and psychological stress induced by our traumatic Holocaust years. But now there was something different; her peaceful face would at times show the strain of maintaining our full active lives. There were only a few signs at the time that we both did our best to ignore, but her strong quiet force was gradually weakening.

Barbara had been my mainstay from the beginning, and in her own quiet, cultured, unassuming way had helped me to make many major decisions. Gideon Strauss, who had many occasions to work with her and to observe her at close range, recalls: "She was always present, but she didn't often take pains to make her presence known. She preferred to remain inconspicuous and to contribute her own intuitive knowledge and wisdom when she saw fit, invariably in a low-key manner. She was a careful woman, and had a tendency to be suspicious of the new." Like me, she was a woman from "Missouri" as well as from Warsaw—you had to show her, too.

One major decision about which Barbara quietly expressed quiet

misgivings was our costly move to the new location on Madison Avenue. The risk was substantial: we would have to sell that large inventory obtained with our financial backing. And we would have to pay rent that was obscene by Lexington Avenue standards.

I must confess, my more outgoing, free-wheeling side was thrilled by the greater exposure that the new location would give us—attending art auctions alongside the likes of Norton Simon, being able to outbid the likes of Klaus Perls or Sidney Janis at auction if I saw fit. Still, the new larger premises, the new higher overhead, the risk involved, gave Barbara pause.

One major change that in my opinion justified the move was that the improved quality of passersby. Not that those who window-shop on Lexington Avenue are middle-class customers, it's just that on Lexington chances are that they are looking for new window blinds or a slice of pizza, not a million-dollar Moore.

In January 1973, Mr. and Mrs. Robert McNamara dropped into the gallery, and I spent an enjoyable hour showing them around the place, during which we struck up instant rapport. After they left, on an impulse, I sent them a book on Henry Moore. Unfortunately, not all the customers who strolled along affluent Madison Avenue were on the level of our former Defense secretary. Our new location also made us a larger target for artful art thieves. As the price of art escalated, the brazenness of the art robbers increased precipitously.

In 1970 we kicked off the new decade with a major Giacometti show, including a bust of Ciavenna, circa 1964, for which we asked $55,000 and a bust of Annette for $50,000 — works which fetch four and five times that today. One evening, on Rosh Hashanah, shortly after the show's well-received opening, Barbara and I strolled past the gallery on our return from Temple Emanu-El. We were shocked to find a valuable small Giacometti sculpture missing from its pedestal in the window. Surmising that someone must have snuck in when our backs were turned and slipped the statue out unobserved, I called the New York City police immediately. They promptly referred me to the FBI stolen art department, headed by Special Agent Donald Mason.

The next morning, during office hours, I called Mr. Mason. He politely invited me to come down to the FBI's New York office on Third Avenue and 69th to inspect my stolen property. There it was, sitting on Mr. Mason's desk. Lightly, I told Mr. Mason that art critics had long commented upon the tendency of Giacometti sculpture to "disappear," but they had meant that metaphorically, not literally. Mr. Mason flashed a standard G-man tight-lipped smile, explaining that the statue had been recovered from a "fence" who

had been cooperating with them in a sting operation to nab a particularly devious ring of art thieves. Mason asked if he could hold onto my Giacometti for a while so it could be used as evidence in court. I told him it was worth $30,000 to $40,000 at which he let out a gratifying, appreciative low whistle. In due course, the FBI returned the sculpture.

But even the best efforts of the FBI, and other law enforcement agencies, couldn't slow the traffic in fake and stolen art any more than the Drug Enforcement Agency can stop the flow of illegal narcotics. As a gallery dealer in such a prime location, I had my share of shady characters wandering into the place, lurking around until they could find me alone, at which point they typically adopted a confidential, conspiratorial tone. They always had something to sell. It was usually a work by Picasso, Matisse, Miró or some other "name-brand" artist, which had been acquired under circumstances which the seller undertook to describe in only the vaguest of terms. These works were invariably being made available to select discerning customers at low, low bargain prices. By then, I had contrived a solution to the problem of dealing with such lowlifes, which not only discouraged the particular individual involved, but exerted what I hoped would be a deterrent effect on future unwelcome solicitations.

"I'll take a look at it, but you'll have to leave the piece with me for examination," I'd say, doing my best to look them square in the eye, which, without fail, would be averted, usually downwards, though sometimes sideways, or even toward the ceiling.

"And if I find anything wrong with it whatsoever, or I even so much as suspect that something might be wrong with it," I'd say sternly, "the first thing I will do is not to call you, but call the FBI and the District Attorney for a second opinion."

That not only took care of the present solicitor but also scared off a number of his friends. I wanted to establish a reputation as hard on crooks and thieves. Once I developed this artful spiel, the word got out. These unsavory types rarely darkened my doorstep again.

In that same year, 1972, Miró-mania was in full bloom. Joan Miró, born in 1893, was a Spanish-born Surrealist who was a major participant in the great Surrealist exhibitions that swept Paris during the 1920s. Recognized as the leading Spanish Surrealist after Salvador Dali, Miró's work expressed a child-like whimsey and fantasy and reflected a rare sense of color. In May 1972, Miró was 79 and truly at the top of his form. The Guggenheim mounted a Miró show. Hilton Kramer, reviewing it in the *The New York Times*, described the Surrealist paintings from his 1920s

UNITED STATES DEPARTMENT OF JUSTICE

FEDERAL BUREAU OF INVESTIGATION

WASHINGTON, D.C. 20535

December 18, 1970

Mr. Jacob D. Weintraub
Director
Weintraub Gallery
992 Madison Avenue
New York, New York 10021

Dear Mr. Weintraub:

Thank you for your letter which I received on
December 15th. It was good of you to comment as you did about
the FBI and particularly the assistance rendered in connection
with the recovery of the bronze sculpture by Giacometti. Com-
munications such as yours are certainly encouraging to receive
and Special Agent Mason shares my appreciation for your thought-
fulness in writing.

Sincerely yours,

"Paris period" as being those of "one of the few painters who have achieved the almost impossible feat of being both extremely 'literary'—employing a full arsenal of literary puns, metaphors and poetic allusions—and profoundly pictorial."

Concurrent with the large 1972 Guggenheim show, another 58 Miró paintings were on display at the Acquavella Galleries. Not to be outdone, the Weintraub Gallery organized a major exhibition: "Two Hundred Miró Prints," including fifty prints from a 1970 retrospective at the Museum of Modern Art. Those fifty prints were part of a rush of work that took place during the three years that preceded the artist's seventy-fifth birthday in 1968.

Birds and stars were the main leitmotifs, a calligraphic form in part inspired by his visit to Japan in 1966. One outstanding characteristic of these fifty prints was a new etching technique developed by the famed engraver and lithographer Henry Gaits, utilizing carborundum and a variety of synthetic resins. On the grounds of the Maeght Foundation in St. Paul de Vence in the south of France, Miró and his printer, Dutron, prepared a series of exceptionally thin copper plates built up with layers of plastic which, when pressed into paper, imprinted crusty reliefs. Miró often expressed a desire to create prints possessing "the dignity of a handsome painting," an aim generally agreed to have been fulfilled in his prodigious "Equinox," in which he successfully attempted to capture some of the high-spirited mood of his colorful ceramic walls.

"Equinox," which we sold at that time for $10,000, now brings upwards of $150,000. Growing older myself, I was impressed with Miró's great burst of creativity as he approached his seventy-fifth birthday. It may be said that old artists never die, but if they do, they often go out with a bang, not a whimper. The same, I hope, may be said for certain old art dealers.

In 1973, we continued to mount major "mixed" exhibitions of work by artists we liked, executed in a variety of media. "Important New Acquisitions" was a typical catchall show of this variety, including "Sculpture, Paintings, Watercolors, Graphics" by Braque, Calder, Degas, Ernst, Gauguin, Manzù, Marini, Moore, Picasso, Rouault, Utrillo, ranging down the alphabet of the modern greats, leaving few contemporary stones unturned.

My campaign to rejoin the human race depended largely, of course, on a growing sense that despite all the horrors and cruelties human beings seemed capable of visiting upon one another, in the New Country right made right, not might. Yet the Holocaust horrors had not escaped my mind entirely. I remained incapable of mounting a show by the haunted (and haunting) British artist Francis Bacon,

because his work reminded me too vividly of my war experiences.

Professionally and financially, we were doing better than ever. But Barbara's health took a turn for the worse that year. Breast cancer was diagnosed and though her doctors promised some chance of remission from an intensive course of chemotherapy, the most likely prognosis was that her chances of surviving more than two years were less than fifty-fifty.

What a cruel irony. After surviving the horrors of the Holocaust, Barbara could not survive the horrors visited upon her by her own body! Barbara and I, in our lifetimes, had dodged a hailstorm of bullets, but this was not one she was destined to escape.

Much as I hate to disclose my actual age, the hateful fact is that I was to turn sixty in February of 1974. In celebration of that shocking occasion (mentally and psychologically, I have always remained somewhere between fifteen and thirty-five) we had discussed for some time taking a long trip around the world.

Barbara's and my greatest pleasure had always been foreign travel. We particularly enjoyed unabashedly reveling in the excitement of new horizons and exotic locations. Though I said nothing to Barbara about her prospects, I made arrangements to move our grand tour up by one year to ensure that she would be well enough to enjoy such an undertaking.

On Friday, May 4, 1973, we launched the first phase of what our travel agency billed with unintentional irony our "final itinerary." Flying first-class on the now-bankrupt but then-high-flying TWA to San Francisco, we spent a few days in that lovely port city before winging on to Honolulu, with a two-day stopover in Hawaii soaking up the sun and sights before continuing our Pacific Rim leg on a long-haul flight to Tokyo. There, we put up at the rebuilt famed Imperial Hotel; the original designed by Frank Lloyd Wright was demolished in 1968. Hiring a car and driver we comfortably toured up Japan's Pacific Coast past Kamakura, site of the world-famous "Daibutsu," the world's largest graven image of Buddha. From there via the famed Ten Province Pass, we soared past the commanding snowcapped visage of Mount Fuji, to the renowned hot-springs spa of Atami. From there, via "bullet train," we visited Kyoto, the old Imperial capital under the Shoguns and site of innumerable Buddhist temples and monasteries.

In Osaka, we paid a call on a Mr. Doi, a prominent collector and private museum owner who had bought a few things from us by mail over the years. Though it has always been my principle to try not to mix business with pleasure, and despite the fact that it was not my general practice to take slides with me on recreational trips, I broke

the rules on this occasion and produced a few slides of some recent works by Antoni Clavé.

This Barcelona-born Catalan sculptor and painter had launched his career as a house painter in the early years of the century. He soon graduated from painting kitchen walls to doing book illustrations. After attending the School of Fine Arts in Barcelona he took up residence in Paris, where he illustrated a number of important books and created some celebrated set designs for theater and ballet. In 1954, he had his first one-man show and won a prize for his graphics at the Venice Biennale.

We had acquired a large number of works by Clavé in preparation for an upcoming exhibition tentatively scheduled for March 1974. "Clavé's art—complex, puzzling, and on occasion even frightening— belongs to the age of nuclear fission," wrote the art critic Dr. Alfred Werner in the introduction to our lavishly illustrated catalogue.

Not surprisingly, given the Japanese people's firsthand experience of the unprecedented destructive power of nuclear fission at Hiroshima and Nagasaki, Clavé enjoyed a large, loyal, ardent following in Japan. Knowing this, I showed my slides to Mr. Doi who was clearly interested.

The Japanese have long nourished a love for "blue-chip" art. This makes them extremely conservative collectors and buyers. But when they want something badly enough, they don't mind paying handsomely for it. This was the case with Mr. Doi and Clavé. He fell in love with the work; bows were bowed and hands were shaken, papers produced and bingo! — our extravagant trip was paid for. Now, with Mr. Doi's check in my pocket, I felt a little easier about the first-class hotels and restaurants and the pampering we were receiving.

Traveling first-class had one notable exception: behind the Iron Curtain, despite the prevalence of first-class prices, first-class service was far from the norm. From Tokyo we flew to Taipei, Hong Kong, Bangkok, and from Thailand to Moscow. Our tour through Russia, including Moscow, Kiev, Odessa and Leningrad, (now again St. Petersburg), was sadly compelling; sad mainly because of the sickening contrast between the glories of pre-Revolutionary Russia (which the Soviets had done their cynical best to restore strictly for convertible-currency purposes) and the abject poverty of the population.

I have lived under two heinous, totalitarian regimes: Poland under Nazi occupation, and Poland under Soviet occupation. The Soviet presence was profoundly less threatening, but its overbearing dictatorial way was, nevertheless, tantamount to the proverbial iron fist, the inexorably tightening grip which had prompted

Barbara and me to make a desperate escape to the West before the "Iron Curtain" became impregnable.

As tourists, we were supposed to see just the best, the Potemkin Villages, so to speak, of the country. But even the best was not good enough, compared to what we take for granted in the free world. The regime remained outwardly strong, and pampered its nomenklatura in all sorts of repugnant ways that would have done justice to a print by George Grosz, parodying the worst excesses of capitalism.

Not since the postwar period in Poland (not to mention the deprivations of the actual years) had we seen such shortages. In Kiev, we had some long conversations with Soviet Jews, who after listing the depths of their deprivations—no meat, no sugar, no jobs, no hope—peppered us with questions that filled me with sorrow: "How many times a week do you eat meat?" "Do you get fresh milk when you need it?" The suffering of even these members of the intelligentsia was palpable. The stark symbol of Soviet failure became, in our eyes, the fact that nowhere in Russia, despite the presence of innumerable milk cattle, could we locate real cream. Cream has long been the essence of luxury, as in phrases like "crème de la crème." But in the Soviet Union, there was no cream.

On our Air France flight from Leningrad to Paris we celebrated our second escape from Communism. It was a far cry from the dark night when we fled from Poland's Baltic Coast, in a truck piled high with vegetables, to the smoldering ruins of post-war Berlin.

Now, some thirty years later, we sat back in our reclining seats and were offered coffee—with cream. And sweet cakes—with cream. I had a Scotch—Chivas Regal—Barbara a Bloody Mary, to join me in a toast to the good things in life, the fine things in life, to freedom and the great capitalist system! Yet in the midst of our happiness, we could not escape a certain sadness, because I knew, and she knew, that these sweet things of life, la dolce vita, this capitalist cream, would not be hers for the tasting very much longer.

After Barbara had sipped half her drink, she turned to me and said, "Jacob, taste this, I don't think it's very strong." I complied, and agreed until we burst out laughing as I held up her unopened vodka miniature. She had forgotten to pour it in. I poured it in, and she drank and I drank, and we laughed.

We had stuck together quite literally through thick and thin—through the years of feast and of famine, of cream and no cream, of hope and despair. Yet now, when there was more than enough money to go around, no amount of money could help her get well. Yes, there must be some sense of justice in life, but also a random rendezvous with destiny. As I was making my first tentative bid to rejoin the

human race, and the world of the living, I was reminded once again of the dread specter of death.

After our return to New York, under the debilitating effects of a course of chemotherapy, Barbara grew weaker and weaker each day. I found myself growing less and less interested in managing the business and increasingly inclined to attend to her needs. Frank Kent's on-call status shifted. He ran the gallery while I did what I could for Barbara.

After losing her own family to the deprivations of wartime Poland, she had dedicated the rest of her life to attending to me and our needs. Now I would tend to hers. Unfortunately, apart from giving her all the emotional support I could muster, and providing her with the best medical care New York could provide, there was little I could do. The great hardship inherent in tending to terminal cancer patients is that one feels such deep frustration at how little can be done.

I did what I could do. As major exhibitions of Rouault graphics and sculpture shows by Archipenko, Arp, Moore and Nadelman flashed by my eyes, my time spent in the gallery began to appear like a mirage, or fantasy. My time spent with Barbara, my limited time left, became real. All the rest, the money and prestige and thirst for success, began to drain away like air from a balloon.

My attitude toward worldly things, the things Barbara and I strove so hard for all our working lives, underwent a profound transformation during this trying time. I went from hunger and thirst for the "better and finer things of life" to a complete disregard for things material. What's it all for? I kept asking myself. What's the point? Though Barbara was undergoing an even more painful process of self-reevaluation, she was facing a different fate. And I knew I was facing life without her. She knew she was facing not life, but early death.

All the money and the influence in the world, the best contacts and highest connections, the wiliest or canniest survival techniques, could not buy Barbara life. Meanwhile, the powerful drugs, which the doctors maintained were extending her life, seemed to be having the opposite effect, sucking the life out of her.

In early 1974, as my sixtieth birthday approached, she was confined to her bed at the hospital. As it became increasingly clear that hospitalization would not cure her, she and I begged her doctors to let her come home. At first, they refused. "Don't you think she'd be happier back home in her own bedroom, with a Picasso on the wall?" I can recall shouting in outright frustration. Unbeknownst to me, she obtained special permission from her doctors to slip outside for

one final mission: at one of the finest jewelers on Madison Avenue she selected a gorgeous pair of gold cufflinks, in a striking modern design resembling a miniature sculpture. She presented them to me in her typical style: bravely, quietly, without fuss. I have never worn any others since.

I continued fighting the doctors, who at last permitted her to go home and die in her own bed. According to her last wishes, I mournfully placed her ashes inside the pedestals of two of her favorite works of art: an Arp sculpture that stands in my New York apartment, and a Jacob Epstein "Fist" that graces our apartment in Palm Beach.

At a time when I might have hoped that Barbara and I could have enjoyed spending our declining years together, I was forced to face life without her. To say that I was devastated, desolated, destroyed, disconsolate, would have missed the point. In fact, Barbara's death in 1975 nearly killed me.

I no longer knew what was left to live for. My ambition and drive had been for so long deeply rooted in a desire to provide a better life for both of us. When "we" no longer existed, except in memory, the purpose of it all seemed to have slipped away, like smoke and mirrors.

Now I was grateful for having joined Temple Emanu-El and the Lotos Club, because the temple meant spiritual support, while the club meant friendship and good fellowship. I needed both badly in my time of grief.

I was haunted by the little things I remembered about Barbara: how happy the art dealers were when she told them that she was finally prepared to send them a check. Barbara had always attended to the details. She had left me free to imagine and realize the big picture. Now I realized with a fresh pang how important those small things were.

One of the few real consolations of life immediately after Barbara's death was that I never knew how many close friends we had. As far as I was concerned, I was ready to retire. But it was the strength lent by those friends that helped me to pull through. They counseled me that above all I should not give up the gallery because then I truly would have nothing left to do but move to Florida and die.

I received over two hundred letters of condolence. In over three decades in the art world, we had formed bonds with many people—dealers, collectors, artists, all over the world. When these people reached out to comfort me, I knew it was not just for me, but also for Barbara. She would have been grateful for their concern and support. Surprising for me, I abided by ancient Jewish custom and didn't shave for forty days of mourning. I didn't leave home. I gave our

tickets to the opera, the ballet and the Philharmonic to friends. After two months of this extreme mourning my close friend and doctor, Stanley Glickman, called me.

"Jacob," he said sternly, "I am not only your friend but your doctor. You've got to get back to work and back to your life." I knew he was right, but my heart wasn't in it. Fortunately, due to the hard work and steadfast support of Iwo Lowy and Frank Kent, who were close friends as well as employees, the gallery ran well in my absence. It was more than just physical absence, it was also a mental one. For a time thereafter even when I was there, I wasn't there. I was often lost in memories of Barbara's and my life together, of our trips and our traumas and our good times and bad.

Having no appetite for food or life, I rapidly lost an alarming amount of weight. Now once again I looked more like an inmate than a survivor. It wasn't long before doctors detected in me the first signs of diabetes. I wasn't surprised. It all seemed of a piece.

Then the unsurprising lot of the recent widower set in! My friends, in their kindness, couldn't resist introducing me to every single woman they knew of "a certain age." I found fault with all of them. One extremely rich woman insisted on serving dinner in the kitchen. I refused. I couldn't help contrasting it with Barbara's elegant candle-lit dinners. Another "date," also wealthy, insisted on taking me to the Jockey Club in Miami, and when the waiter brought the wine list, made a big show of wanting to select the wine. Much as I could see the benefits, in some cases, of women's liberation, I told her unapologetically, "I'm sorry, but I am a European man and when it comes to picking the wine, I want to do it." I was too old a dog to learn new tricks.

I was getting sick and tired of my new single life. Why couldn't they stop picking on me? Why couldn't they just leave well enough alone? I loved my friends, but enough was enough. I went out with a woman who had a drinking problem. I went out with women with children who had problems. And also with women who had problems with their children. After years of this nonsense, I was ready to throw in the towel.

My Bronka

On the morning of May 7, 1979, I was awakened early by a call from Frank Kent, my gallery director, urging me to head straight to the gallery. The police, he said, would like to speak with me.

"It's 'Ubatuba,'" Frank said, his patrician voice breaking, almost as if referring to a person, even an old friend, instead of an inanimate object: a sculpture, a work of art. "They pulled it off its pedestal last night. It's lying in pieces on Madison Avenue." Frank's attempt to be calm barely concealed his anguish.

With that fearful feeling that only a Holocaust survivor can know when anonymous vandals strike by night, I was about to jump into my clothes when I realized, with a start, that I only had evening clothes to jump into. Furthermore, I had not spent the night in my own apartment, but in that of a female friend with whom I had fallen in love. Her name was Bronka.

The previous evening, we had attended a black-tie affair. The last thing I wanted to do was to show up at the gallery in my evening clothes. But I was too upset to take the time to stop by my apartment on the way. I ended up donning an old sport jacket and trousers of Bronka's late husband. He had been shorter than I, and the sleeves absurdly reached to just a few inches below the elbow. Figuring that no one would notice amid the chaos of a police investigation, I sped over to 77th and Madison to view the ruins of my friend "Ubatuba," by Antoine Poncet, which I had happily installed on the sidewalk outside the gallery seven months earlier.

In my distress, I felt grateful to have a companion with me. Bronka accompanied me on my brisk walk down Madison Avenue to the gallery, lending comfort, strength and a sense of hope to a scene of ruination. The next morning, *The New York Times* carried on its front page an article illustrated by a large photograph of me bending over to examine a shard of shattered granite, wearing the ill-fitting pants and sport jacket, smartly, if incongruously, accessorized by a pair of black evening pumps.

"For seven months," the report began, "a massive granite sculpture valued at $80,000 presided on the sidewalk outside an art

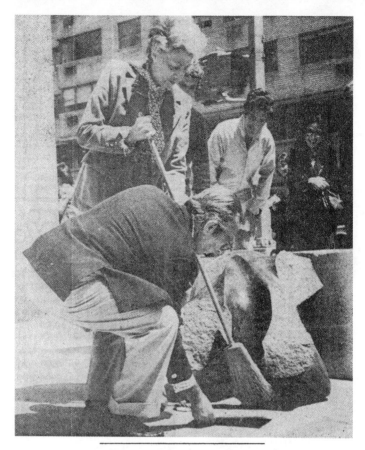

Madison Ave. Residents Mourn
A Sculpture Ruined by Vandals

For seven months a massive granite sculpture valued at $80,000 presided on the sidewalk outside an art gallery at 77th Street and Madison Avenue, where it became a favorite of many neighborhood residents. Early yesterday, unknown vandals pulled it from its pedestal and left it smashed in pieces on the sidewalk.

"It's like someone was killed," said Judah Klausner, a 27-year-old composer and neighborhood resident who led a sidewalk discussion group on the incident with passers-by. "We are in mourning now. It had made us happy that someone had enough faith in humanity to leave a very expensive piece of art outside. It made a difference to us."

The smooth, gray-green granite sculpture, by the French artist Antoine Poncet, was called "Ubatuba," according to Jacob Weintraub, the owner of the Weintraub Gallery, which had the sculpture on consignment from the artist. Mr. Weintraub could not explain the origin of the sculpture's name, but he placed its value at $80,000. He said that, with Mr. Poncet's help, he had placed the seven-foot-tall piece on the street outside the gallery "to help beautify New York." Now, he said, it had very likely been smashed beyond repair.

"What is going to happen to New York

A Sculpture Ruined by Vandals Is Mourned on Madison Avenue

Continued From Page A1

if you cannot leave a two-ton work of art outside?" he asked. "Graffiti I expected, but I could have washed it off. But this — it is heartbreaking to see such a very beautiful work of art in pieces. We try not just to make a living and employ people, but to help and beautify the city. I can't cope with this."

To Upper East Siders who had grown fond of seeing the sculpture there, the senseless vandalism also seen yesterday as a reason for despair, like the passing of a friend. And as they stopped to stare, shaking their heads at the sight of "Ubatuba" on the ground, they mourned not only the destruction of the sculpture, but also "that force of evil," as one put it, that could have prompted such a deed.

"We are all responsible," said Mr. Klausner, who happened on the scene on his return home from a morning's jog around the park.

'So Happy to Have It There'

"What can you do? There's nothing you can do," he said. "We are helpless. But we are all responsible, because we haven't found the answer to such evil that exists unchecked."

Mr. Weintraub and Iwo Lowy, the manager of the gallery, who broke into tears when she saw the sculpture on the ground, remembered yesterday how people who appreciated Ubatuba often stopped into the gallery to thank them for placing the piece outside.

"They were so happy to have it there," Mrs. Lowy said. "It had integrated into that corner. I couldn't think it away anymore."

Mr. Weintraub recalled that a judge from Montreal had dropped by the gallery especially to see the sculpture, and he said the response to the work was so positive that the gallery had been trying to find "some angel" to help them get the money to give Ubatuba to the city permanently.

Now, he said, he is not even sure whether he is insured for loss resulting from "criminal mischief" of this kind. He had to wait until today, he said, to notify Mr. Poncet and his insurance company. And he had not been able to face the task of counting up the many broken pieces left on the ground.

"You try to do something for the city, but this kills it," Mrs. Lowry said. "We lost something very, very close to our hearts. Today I am ready to give up on New York. Today I don't have hope anymore. Tomorrow may be different."

According to Mr. Weintraub, yesterday was not the first time his gallery was victimized. On New Year's Eve, he said, a bronze sculpture by the Italian sculptor Manzu, valued at $25,000, was stolen by a thief who broke the gallery's window with a cobblestone. The work was not recovered and no one was arrested. Mr. Weintraub added, expressing doubt that yesterday's vandals would be found and shock that such crimes could occur in such a "silk stocking" neighborhood.

According to Detective Samuel Draft of the 19th Precinct, Ubatuba was pulled off its pedestal about 3 A.M., shortly after four boys were spotted sitting on it by a nearby doorman. The detective said that there were "no leads" at this time, but added that the vandals had probably used a rope to yank the sculpture down.

Mr. Poncet, Ubatuba's owner and creator, was born in Paris in 1923. The sculptor has become known for his works in marble, one of which is at the Swiss Embassy in Peking. But he has also worked in bronze, clay and plaster. His work has been exhibited throughout the world, in this country at the Museum of Modern Art, the Art Institute of Chicago and the National Gallery in Washington.

gallery at 77th Street and Madison Avenue." The accompanying photo also showed the new love of my life clutching a broom to her bosom, a silk patterned scarf wrapped around her slender neck, looking like the choicest street sweeper to have hit the Upper East side in years.

"Jacob Weintraub gathered pieces of the 'Ubatuba' sculpture" the caption read, "after it was smashed outside his Manhattan gallery." The whole neighborhood had adored the sight of that calm, serene, massive stone sculpture gracing the sidewalk on Madison Avenue. When it was smashed to bits by unknown hands, they joined me in mourning its destruction.

"It's like someone was killed," the *Times* quoted Judah Klausner, a 27-year-old composer and neighborhood resident who led a sidewalk discussion group on the incident with passersby.

"We are in mourning now," Klausner sighed. "It had made us happy that someone had enough faith in humanity to leave a very expensive piece of art outside."

I told the *Times* how, with "Ubatuba"'s sculptor Poncet's help, Frank Kent and I had carefully placed the seven-foot-tall piece outside the gallery to help beautify New York. "What is going to happen to New York if you cannot leave a two-ton work of art outside?" I continued my elegy. "Graffiti I expected, but I could have washed it off. But this—it's so heartbreaking to see such a very beautiful work of art in pieces. We try not just to make a living and employ people, but to help and beautify the city. I can't cope with this."

I do love New York, though I don't display a bumper-sticker with a red heart to prove it. New York and the people in it helped rescue me and my life from the despair induced by the horrors of the Holocaust.

Faith in humanity—what a strange phrase to use about me, who had for so long taken a perverse pride in nursing my psychic and physical wounds and in despising the human race. Yet the '70s had been my decade of giving back, of rejoining the human race which had for so long deserted and betrayed me.

Now I felt differently. The psychic wounds had healed. Despite the terrible shock of Barbara's death, in the wake of her passing, I had rejoiced in the kindness of friends. Now, in the wake of the sculpture's destruction, I also rejoiced in the kindness of strangers, who wrote to me by the hundreds expressing their condolences, and their hope that somehow I would see fit to restore "Ubatuba" to the streets of New York.

Iwo Lowy, echoed my innermost thoughts when she told the *Times*: "You try to do something for the city, but this kills it. We lost something very, very close to our hearts. Today I am ready to give up

on New York. Today I don't have hope anymore. Tomorrow may be different."

Yet with Frank Kent and Iwo Lowy's help, as Bronka and I tried to sweep up the smashed pieces of smooth, gray-green granite, and inspected the jagged edges in the hope that someday this great sculpture might be restored, I couldn't help but reflect on earlier acts of vandalism in Germany and Poland, on a night that reminded me of this one, and gave me an eerie, alarming sense of déja vu. Bronka, who stood there beside me, sweeping with all her heart, had seen the same shocking sights as I growing up in prewar Warsaw. I knew, without having to ask, that her mind's eye was revisiting the same horrors.

But now, with my new love standing (indeed sweeping) beside me, my faith in humanity and in rebirth had at last been restored. I felt like a new man, armed with new hope. Despite the shock of the sculpture's destruction, I vowed to repair and restore it. My vow explicitly referred to another night of smashing that took place in 1937 in Warsaw, two years before the Nazi armies began their blitzkrieg against Poland. Then as now the vandals had smashed things for no reason except to smash. Then they had smashed Jewish things, or rather, things owned by Jews: windows of Jewish-owned stores had been particular targets.

Walking with Bronka back to her apartment with a heavy heart, it struck me that we had been strangely silent and shy with each other about our wartime lives. It was time, I resolved, to sit down and tell the whole story, however hard it would be to tell, however difficult it would be to hear.

Carrying a tiny bit of smashed granite in the pocket of her former husband's jacket as a talisman, it struck me as strangely fitting that I should be wearing the clothes of a dead man that day. During those dread years in Poland, I had seen and helped bury many a dead Jew. I was fortunate to be alive. But what happened the night before to "Ubatuba" made me fear for the future. Was "Ubatuba" destroyed because it stood outside a "Jewish" gallery? This would never be known. But I couldn't help reflecting upon philosopher George Santayana's famous adage that those who fail to understand the past are doomed to repeat it.

My own personal trauma of outliving Barbara had hung about me like an old suit for three lonely years. I had become increasingly disconsolate about ever feeling happy or lighthearted again. I had just about given up all prospects of filling the vacuum left by her death, when toward the end of 1978, an old and close friend, Zygfryd Wolloch, dangled a new "prospect" before me.

How sick I was of women whom my friends were always insisting

I meet. Bronka Rabin, Ziggy Wolloch assured me, was different, someone unique. Someone who had everything it took to please a man like me: brains, beauty, money, good family, an interesting and vivacious personality. Polish-born, a staunch supporter of Israel, a woman often favorably compared to Marlene Dietrich! She had, moreover, been widowed some months before. Having absorbed this glowing intelligence report, with the customary shaker of salt, I allowed myself for a moment to be intrigued. Sick as I was of set-ups, fix-ups, and blind dates, I gave in to Ziggy's request and promised that the next time I was in Palm Beach I would make sure to call his friend Bronka.

Having secured my assent, in principle, Wolloch called Bronka with an inspired suggestion. "There's a big show on at the Weintraub Gallery. A lot of people we know are going to be there. Why don't you go with me and you can sneak a peek at your secret admirer?"

"Who is this secret admirer, Ziggy?" Bronka practically screamed. "Darling, we haven't even been introduced!" In fact, Wolloch was in league with Bronka's cousin Danusia Swiss to arrange this "ideal blind date" destined to change our lives.

Coincidentally, the opening reception was in honor of Antoine Poncet, the sculptor of "Ubatuba," soon destined to play a catalytic role in our future relationship. Bronka reluctantly attended the opening, and was by all accounts suitably impressed with the dazzling assortment of "beautiful people" she saw. She fell into casual conversation with the industrialist Nate Cummings, who said some nice things about me. (In later years Cummings—who had an eye for the ladies—became so fond of Bronka that he offered her a thousand dollars to quit smoking—an offer she resolutely refused.)

Having agreed to attend the opening party, Bronka felt suddenly shy at the prospect of meeting "her secret admirer." "Jacob was so busy with all his glamorous clients I didn't even think to go near him," Bronka recalled later. It did strike her as an odd coincidence that in years past she and her late husband, Harry, had often gazed in the gallery window on evening strolls, admiring the art on display. Now Bronka, not by nature a shy woman, felt as if she, not Poncet's art, was on display. Everyone there was staring at her, as if they suspected that she was hiding something. Could it have been a secret interest in Weintraub?

Bronka flew down to Palm Beach over the 1978 New Year's holiday, having made tentative plans to ski in Gstaad thereafter. The wily Ziggy, I later learned, suggested that she meet me first before making any more definite plans for the New Year. I too decided to visit friends in Palm Beach over the New Year. So it came to pass

that, as promised, I called Bronka's house on Friday, December 23. The single phone call was about to change my life.

"This is Jacob Weintraub. I'm in Palm Beach and I'd love to meet you. Would you let me take you out for a drink? Or possibly dinner?" I paused. "Tonight?"

For a long second, Bronka fell silent. "No," she replied. "I'm afraid tonight would be impossible." When the moment of truth at last presented itself, Bronka balked. But then, thinking it over, she relented. "What about tomorrow night? Could you stop by at five o'clock for a drink in my lanai?"

"I'd love to," I replied.

All the next day, Bronka felt oddly excited, she told me later, as she bustled about preparing her lanai full of flowers, waiting for five o'clock to strike, awaiting the arrival of a gentleman caller. She has never forgotten that feeling, or the clothes, down to the last detail. "Jacob was wearing a beautiful brown sports jacket with a beige shirt and beige trousers."

On this grown-up blind date, I felt like a teenager. I rang the bell. She opened the door. I feel obliged to report that I was, as the modern saying goes, "blown away." Here was a woman, my head and heart told me, that I could love: good-looking, charming, sexy. Isn't it remarkable how much information two eyes can take in, at a glance? My internal chemistry began to churn, sending waves of blood to my head, my heart to pounding. Collecting my senses, I recovered sufficiently to kiss Bronka's hand in greeting, a touch of Continental gallantry that made her heart, European born and bred, leap in ecstasy.

Thank God, some things never change. As she ushered me into her sweet bower of flowers, and we sat down to make customary small talk, we both felt strangely at ease and comfortable with each other, as if we had known each other for years, not minutes. As we sat, speaking freely of our pasts in Europe and in America, of the many people we knew in common, of the connected worlds we had inhabited for so many years without ever chancing to meet, we began to feel like old friends. Later that evening, we enjoyed a lovely, traditional, romantic candle-lit dinner followed by dancing at the Colony, at the time one of Palm Beach's most popular hotels and night spots. At two in the morning, we said goodbye: goodbye to our old life, hello to the new.

The following morning, I sent my Bronka forty red roses. I knew I was hooked. A few days later, Ziggy called Bronka.

"So how was your blind date?"

"Not blind date, darling. I am going to marry this man."

Even Ziggy was taken aback at her certitude.

I felt certain myself. Returning to New York a few days later, I

said to my housekeeper of many years, "Anna, I think we're going to have a new Mrs. Weintraub." Six months later, we were married.

During our whirlwind courtship, Bronka and I helped each other get through the tragic tunnel of widowhood. Neither of us had any children, which made being widowed particularly hard. So often we mourn the departed, rarely pausing to think of the pain suffered by those left behind. But Bronka, I realized, having undergone this suffering before, after the death of her first husband, had discovered the secret to moving on: killing death with life. And energy, optimism, courage, and grace.

Before meeting Bronka, I had felt ready to retire. This is another way of saying that I thought that my life was over. Without being Weintraub the art dealer, what would I be? But Bronka's boundless energy revived me, like breath given to a drowning man. Only after I recovered from my unhappiness did I fully recognize how truly down in the dumps I had been. "Ubatuba" became the symbol of our relationship, because having vowed to rebuild the sculpture, we indeed restored it. The whole neighborhood turned out to witness its renewal when we mounted it back on its pedestal and when the vandals tore "Ubatuba" down a second time, we didn't lose faith, but simply restored it again.

The act of dedication and commitment to restoring "Ubatuba" felt like the courtship between Bronka and me. The shattering of old life, the putting together of a new. Before I was able to entirely make up my mind about marrying again, I felt in urgent need of a second opinion. And so I took Bronka to meet my old friends Melba and Moise Steeg Jr. who live in New Orleans and enjoy life in that beautiful city to the hilt. Moise, a prominent attorney, moves in the highest cultural circles of the city, having served as the president of the New Orleans Museum of Art and on the board of Tulane University. I felt proud to introduce Bronka to my old friends, proud of her cultured style, of her fluency in speaking half a dozen languages, of her natural warmth, grace and beauty. In fact, I hardly needed a second opinion. But I valued the Steegs' opinion as a way of confirming my own high regard of my future wife.

Sure enough, all went well on the visit. The Steegs' fell in love with Bronka, and she with them. I felt ready to take the plunge. We stayed in a beautiful penthouse suite in the New Orleans Hilton, with a splendid panoramic view of the city. When Bronka awoke to see a thick layer of fog surrounding the city, the way she exclaimed at this sight was rather humorous. For more details, write to me at the gallery—988 Madison Ave., New York, 10021—because the whole story, I am afraid, is scarcely suitable for a family memoir.

The natural and inevitable culmination of courtship, our wedding, took place on June 10, 1979—the day I was scheduled to take off on my annual art-buying European tour. I had, of course, invited Bronka to accompany me to Europe, but she sensibly and rightly refused to travel as my consort, indeed in any capacity other than as my wife. I immediately proposed, and was thrilled to find my proposal accepted. The prospect of signing in at hotels as "Mr. and Mrs. Jacob Weintraub" began to appeal to me strongly.

So, six months after our date, we were married in a simple ceremony on the Air France Concorde at Kennedy Airport. Rabbi David Seligson of Central Synagogue in New York conducted the service, with our good friends the Wollochs, our marriage brokers, serving as witnesses. The pilot took the place of honor beside the rabbi, in the tradition of a sea captain officiating at a floating wedding. The wedding took place in an unorthodox setting, but was a traditional Jewish ceremony, complete with the marriage contract (ketuba) read aloud by the rabbi in Hebrew, the ritual smashing of a glass by the groom, and all the accoutrements save a chuppa, which would not have been easy to construct inside the plane.

After the ceremony, we were joined by forty or so close friends in the Concorde lounge at a reception skillfully catered by Air France. A slight snafu transferring our guests by bus from our house on Fifth Avenue to JFK airport (the coach supplied by Air France briefly broke down) had been overcome, and this flying wedding aptly symbolized a marriage not set as a trap, but as a soaring metaphor for freedom, liberty, and movement. At the appointed hour, Bronka kicked up a shapely leg to display the traditional bridal garter, and we flew off to Paris.

After we broke the sound barrier, the pilot announced over the P.A. system that we were carrying some special passengers: a pair of newlyweds who had just been married aboard the plane! All the passengers gaily toasted us with excellent French champagne, and presented us with a copy of the in-flight menu signed by all. During that supersonic flight, Bronka and I had time to reflect on some of the more marvelous aspects of the occasion. There we were, jetting from the New World of New York to the Old World of Paris, bridging the gap between past and present, between the land of our youth and the continent of our maturity. In our childhood to have even dared to imagine that I and my bride would fly the Atlantic in under three hours, would have consigned me to the local nuthouse. But now, after the sadness, desperation, and degradations of war and Holocaust, of the deaths of loved ones, of triumph and tragedy, we were soaring swiftly at unheard-of speed from one place we loved to

another we loved. It felt like an ending and a beginning. As T.S. Eliot wrote, "The end is where we start from."

I had a chance to reflect on our three-hour flight, Bronka and I had so much in common: we were both born into affluent, assimilated Jewish families within the thin upper crust of the now-scattered Polish Jewish gentry. Her upbringing had been even more assimilated than mine: Catholic schools, field hockey, sheltered from the harsh reality of poverty and squalor of the poorer Jewish sections of the city, soon to be squeezed with an iron vice into the notorious Ghetto.

Bronka's awakening to her own inescapable Jewishness took place during Warsaw's Kristallnacht, when Polish thugs rampaged through the streets smashing the windows of Jewish businesses, shouting "Jew! Jew!" Some of the windows smashed belonged to pharmacies owned by Bronka's parents, and that smashing shattered the hopes and dreams of assimilated Jewish families like Bronka's, like Barbara's, like mine, to ever enjoy a peaceful and prosperous future in increasingly anti-Semitic Poland. Even before the Nazis invaded, Poland had made it plain that Jews, despite our contributions to society, were no longer welcome.

And so, her father, like my father, began to undergo his own metamorphosis, evolving from a worldly, secularized Jewish man into a passionate devotee of Zionist causes. Amid that fearful, ominous atmosphere of prewar Poland, as laws began to be passed restricting the freedom of Jews to own businesses and to participate in Polish life (laws passed not by the puppet regime of Nazi-occupied Poland, but by the Poles themselves) Bronka's father increasingly placed his faith, hope and trust in the precepts and teachings of a new leader, the Revisionist Vladimir Jabotinsky. In 1923, Jabotinsky founded a Zionist youth movement he called Betar, which he described as "a blend of school and army camp." Its young members called Jabotinsky "Rosh Betar" (Leader) and scrupulously followed his precepts, which were more militaristic and antagonistic than those of Chaim Weizmann and David Ben-Gurion, his rivals in the Zionist movement. Menachem Begin, the future prime minister of Israel, commanded the Betar in prewar Poland.

On a visit to Warsaw in early 1939, the year of the Nazi invasion, Jabotinsky addressed a large gathering of Jews, at which he rendered a terrible prophecy: "If the Jews do not leave Germany, Poland, and Eastern Europe, they will be exterminated by the Germans in the worst massacre in history!"

After the speech, Jabotinsky was greeted by a large number of supporters and well-wishers, among them 17-year-old Bronka, and

her father, who had become one of Jabotinsky's ardent Polish supporters. With Jabotinsky was a towering figure, Abraham Stavsky. In his mid-thirties, intensely charismatic, imbued with a passionate vision of the future of Jews in a liberated Israel, Stavsky laid eyes on the beautiful young girl and fell urgently, passionately in love. "I thought they had hanged you," Bronka challenged Stavsky, flirtatiously, in brazen reference to his conviction by a British court of inquiry into the murder of a promising young Zionist politician, Chaim Arlosoroff, on a Tel Aviv beach in 1933. Stavsky's conviction was later reversed on appeal, but he remained on the British blacklist of Zionist troublemakers.

"No, they didn't hang me," Stavsky replied, with a smile. "I came back to Poland so I could meet and marry a girl like you."

They were married almost immediately, with the blessing of her father, and with Menachem Begin, Shmuel Merlin, Yosef Klarman, and the great Jabotinsky in attendance. After a truly whirlwind courtship and marriage, Stavsky with Bronka at his side plunged back into the work which had made him a living legend: smuggling Jews out of Europe to safety in Palestine, in defiance of the British blockade.

The Jews called Stavsky simply the Rescuer. He opened a new door to Bronka: a door to Israel. An Israel that only existed at that time as a dream in the minds of visionaries like Begin and Jabotinsky, Ben-Gurion and Weizmann. Their methods might have differed, and frequently they clashed over strategy, but their ideals were the same: to create a state of Israel, a refuge and haven for the Jews of the world, in British Mandate Palestine.

Again and again, as we told each other our stories of the war years, we saw how our paths diverged and converged, intertwined and unraveled as the Jews of Poland, and all Europe, faced the impending Holocaust. On September 1, 1939, as I was making my way out of Warsaw toward the Russian front, Bronka and Stavsky were in Romania, readying one of Abrasha's (as he was known) boats slated to ferry Jews to Palestine. From Paris, Jabotinsky ordered Stavsky back to Palestine, at considerable risk to Stavsky, who remained on the British watchlist.

Armed with fake passports, Stavsky and Bronka sailed on separate boats for Palestine (Stavsky in disguise, Bronka bearing the passport of a South African diplomat's wife). But Bronka was betrayed by agents working for the British, unmasked as Mrs. Stavsky, and confined to Jaffa prison.

The British treated Bronka well in prison. "Only I was given a bed—noblesse oblige!" she later recalled, with evident relish. She

was forced into confronting the thinly disguised Stavsky on his boat, and rushing into his arms, helped to ensure that Stavsky's mission to Palestine would be aborted. Their sentence: immediate deportation back to Romania.

From Bucharest, as the Nazi war machine rolled across Europe, the couple made their way across embattled France and after wrangling a pair of exit visas (and exemption from French military service for Stavsky) they traveled via a circuitous route (Tangier, Cuba) to New York. Abrasha and Bronka changed their name from Stavsky to Palest (short for Palestine) and moved into a large apartment on Central Park West, where they entertained a never-ending stream of Jewish patriots.

"To say that Bronka made an impact in those days is like saying Scarlett O'Hara lived in Atlanta," Frank Rohr wrote in 1985 in a glowing profile of Bronka for the magazine *Lifestyles.* "Bronka's battlefield was the salon, her weaponry a high-energy whirl of teas, receptions, and night-long planning sessions that involved everyone from Abrasha's own team to Billy Rose, Bernard Baruch, New York Governor Tom Dewey, Kurt Weill, and always the passionately committed author/propagandist playwright-in-arms Ben Hecht." Rohr, Bronka tells me, scarcely exaggerates.

Just three years after the war in Europe ended, in 1946, the year that I sailed to America on the *Marine Flasher,* the Jews of Palestine took the fateful course of declaring their independence, and proclaiming the creation of the new state of Israel. In aid of his comrades in Palestine, Abrasha and a committee of like-minded activists purchased a decommissioned U.S. Navy transport and filled it with Jews who wanted to migrate to Palestine.

The *Altalena* was sailing off the coast of Tel Aviv on June 27, 1948 when David Ben-Gurion, whose provisional government had declared itself the de facto rulers of Israel, became concerned that the weapons and armed men aboard the *Altalena* were not arriving to fight the Arabs, but to mount a possible coup against their Haganah rivals. Although Menachem Begin brokered a brief truce, a misunderstanding caused ships of the fledgling Israeli navy to open fire on the *Altalena.* Among the wounded, standing in the bow shouting "shalom" was Abraham Stavsky. Hospitalized, he developed gangrene in his shattered leg, and within days, Stavsky was dead.

Bronka just happened to be walking in Times Square that day when she glanced up at the electronic headline atop the old Times Tower: "Altalena aflame!" Her heart, it seemed, burst into flames. She flew straight to Paris and then to the Israeli hospital where they

gave her Abrasha's wedding band. He was buried, with considerable ceremony at Israel's sacred burial ground of heroes: Nahalat Yitzhak. But in her heart, the flames that engulfed the shattered *Altalena* set fire to her entire world.

She threw herself into the cause for a long time until she was emotionally prepared to begin a new life. On a flight to Montreal, to attend a memorial service for Stavsky, she met the second great love of her life. Harry Rabin was a Canadian industrialist whose 51-year-old bachelor heart was weaned from the joys of solitude by the lovely young widow. She too was swept away, by Rabin's heart more than his height. "He was shorter than me," she later recalled, with a twinkle in her eye, "but he had such bright, adorable blue eyes." As well as, by her account, a passionate devotion to life at least as intense as her own.

Before they were married, Bronka heard that a great Talmudic scholar had dreamed of Stavsky's distress at the prospect of her impending marriage without performing the ancient ritual ceremony of halitza. To set Stavsky's soul at rest, and permit Bronka to marry Harry Rabin in good conscience, Bronka flew with him to Israel. In keeping with the Jewish custom as ancient as the Bible itself the halitza ritual was performed with the deceased's brother, which is done when there are no children from the first marriage. Bronka and Harry were married for twenty-seven happy years, during which she and Rabin passionately embraced a wide variety of Jewish causes, from Israel Bonds to a number of prominent artistic and scientific institutions in Israel. Every year, on the anniversary of Stavsky's yahrzeit, they made a pilgrimage to his grave at Nahalat Yitzak.

When Harry died peacefully at their home in Palm Beach in early 1978, Bronka was devastated. Like me, she felt herself comforted and surrounded by supportive friends, among them the Wollochs and her cousin Danusia, who when the time felt "right," urged her to consent to meet me.

And now, a year after Rabin's death, Bronka and I were flying to our beloved Paris, to be met by her brother, Michel Swiss. I had been acquainted with Michel, a prominent member of the French perfume industry, to whom I often sent friends eager to bring back the most elegant perfume as presents. Michel met us at the airport that evening, and drove us back to his house, insisting that we get a good night's sleep because of the round of parties that was soon to begin. Parties, as I was quick to learn, that seemed expressly thrown so that a suitable assortment of Bronka's and Michel's Parisian friends could check me out, size me up, and get a good close look at whom Bronka had married.

Much as I enjoyed meeting Bronka's and Michel's French friends,

and being inspected from every possible angle, and despite the satisfaction of apparently making the grade, I was so worn out by the never-ending social swirl that on Friday night I grabbed Bronka and set out for Charles DeGaulle Airport, relieved that at last the social ordeal was over.

We sailed by customs and an assortment of ticket counters and ticket takers, boarded the flight, and disembarked in Zurich. At that point, I felt ready to take a long breath. The attendant sense of relief unfortunately didn't last long. In fact, within minutes relief turned into anger, and humiliation, because after my several decades of staying at Zurich's grand hotel, the Dolder Grand, this was the first time that the management had failed to send a car to pick me up. And on my honeymoon, no less!

By the time I packed Bronka and all our bags into a taxi, I was steamed. Marching into the hotel lobby, I demanded to see the manager, whom I had known for years. "Mr. ——," here he shall remain nameless, in part because he was blameless. I upbraided him roundly.

"How could you possibly have forgotten to send a car, on this of all days?" I demanded, getting a little sharp in tone.

With characteristic Swiss discretion, my old friend's impassive face betrayed not a hint of alarm or resentment at this dressing down. When I was done, he quietly asked for a private conference with me, which I reluctantly granted.

"Mr. Weintraub," he began gently, "I really am terribly sorry about the misunderstanding. But I'm afraid that we couldn't very well have sent a car for you today, because you're scheduled to arrive on tommorrow's flight from Paris."

I was stunned. Smiling ever so mischievously, he asked to see my plane ticket. Sure enough, he was right! I had been so eager to flee Paris that I had yanked Bronka out of the social swirl a day early. As profusely as circumstances permitted, I apologized to my friend for the misunderstanding.

"Apology accepted, of course," he smiled briskly. And then just as efficiently ushered us up to the honeymoon suite, which was magnificent beyond even my high expectations.

From Zurich, we flew to London, to attend the annual auctions of Christie's and Sotheby's. Bronka, I was pleased to learn, soon felt comfortable in the world of fine art, which has its share of social festivity and panache, two of life's great worldly pleasures which Bronka holds in high regard. In fact, Bronka was so charming that I began to see her as a tangible asset to the business. Instead of the customary 5 percent dealer's discount, Bronka's charisma raised it, at my own estimation, to 10 percent.

In London, we stayed at Claridge's. The kind people at Christie's and Sotheby's, knowing that this was our honeymoon, went out of their way to show us a good time, even going so far as to obtain tickets for us to a number of exclusive clubs and hard-to-attend plays and performances, in the way that my old friend Harold Kaye would have done, if he had been alive.

Before leaving Great Britain, we paid a visit to Much Hadham, the estate of Henry Moore, where we enjoyed an excellent pub lunch with Moore and his wife, Irina. Moore gave us, in honor of our marriage, a number of fine photographs. He was so taken with Bronka that in addition to my usual allotment of sculptures, he sold directly to Bronka a very fine "Mother and Child," which Bronka cherishes, and is one of the prizes of our private collection.

From London, we flew to Israel, where Bronka is the true V.I.P. Used as I had been to being treated with deference in the art world and in European hotels, I learned something about the prestige of politics from the way we were treated in Israel. After checking into the seventeenth floor of the Tel Aviv Hilton, generally considered the V.I.P. floor, I found that my category of V.I.P. was not necessarily the highest. My level of tipping, I assumed, was not quite passing muster with the troops. Only when the paging system began blaring the message "Prime Minister Menachem Begin calling for Mrs. Bronka Weintraub" did the expressions on the hotel staff dissolve into smiles. The ensuing largesse, of larger suites, complimentary cocktails, fruit baskets and other amenities was extremely satisfying.

The high point of our visit to Israel was being invited to an elaborate luncheon at the Knesset in honor of the hero of the French Resistance, Simone Weil. Prime Minister Begin greeted Bronka effusively, treating her as a sister. I regained the feeling I'd had in Paris, as the old revolutionary sized me up, no doubt thinking to himself, "This is the man who married Bronka," and no doubt thinking of his departed colleague Stavsky.

After a casual conversation peppered with anecdotes about mutual friends and old times, Menachem said that he still had some work to do at the Knesset but that his wife, Aliza, had asked us to head straight for their house, the White House, so she could spend some time with us before Menachem got home. We were driven to their modest, simple apartment, tastefully decorated with modern Israeli art. Aliza greeted Bronka like a sister, embracing her warmly, before turning her gaze on me, looking me over, once again wondering about this man Bronka had married.

We enjoyed a long discussion before dinner, during which Aliza chain-smoked cigarette after cigarette. She mentioned her passion-

ate fondness for clocks, which she collected avidly, and I promised to send her from New York any art book on clocks I could find. The four of us had a simple dinner, lightly cooked, at their simple table. Aliza at one point turned to me and said, "Bronka tells me that you can sometimes be a little blasé about Israel. But did you know that we are the only country in the world that has installed moving platforms on dance floors so that deaf children can dance by feeling the music, as opposed to hearing it?"

No, I hadn't known. And after absorbing that comment, I realized in time what she had meant: that Israel was not only about security and protection for Jews, but also about a special sort of compassion, a sweetness and largeness of heart that I had seen in Bronka, and that I also saw in Aliza Begin. Her husband, Menachem, was a hard man, and a tough politician, but Aliza showed the softer, sweeter side of the soul of the country. And though I had visited Israel many times before, mainly in search of the art of the country, with Bronka I felt in search of its heart, and its soul. In Aliza's company, I felt we had found it.

Bronka's large heart has taken, I admit, some getting used to. Many an evening over the past fifteen years I have had to leave a nightclub or a performance early so that Bronka could bring a hot bowl of "Jewish penicillin" — chicken soup — to a stricken friend in the hospital. And though I have taken pride in my time, a bit like Menachem Begin, in being a hard man, the older I get the more I've learned to value the strength of heart, and the charity, to which Bronka has devoted her life.

One of our most gratifying philanthropic relationships has been with the Albert Einstein College of Medicine. On October 5, 1988, we received the Albert Einstein College of Medicine Humanitarian Award, sponsored by Einstein's Art Associates Council. Co-chairing the dinner dance was my old friend John Marion, chairman and chief auctioneer of Sotheby's North America. The gala's honorary chairmen were the Hon. Benjamin Netanyahu, former Israeli ambassador to the United Nations, and the Hon. Frank R. Lautenberg, U.S. senator from New Jersey.

The dinner was held at Sotheby's New York, and was attended by close to three hundred guests, drawn from the worlds of science, art, and social service, with a smattering of Hollywood for additional glamor. "Mr. and Mrs. Weintraub are extraordinary individuals who have a deep and abiding commitment to the College of Medicine and their community," said our old friend and favorite matchmaker Ziggy Wolloch, who co-chaired the affair. An Einstein Overseer, Mr. Wolloch, when not serving his community as a philanthropic force, is a

partner in the Woodhole Management Company, a Manhattan-based realty firm.

"They are most deserving of the honor Einstein and the art world bestow upon them," Ziggy continued. The stated purpose of our benefaction will be "to enhance the quality of life, to advance medical research, to alleviate human suffering, and to support with ongoing grants dedicated young scientists who wish to carry on their research at Einstein."

At this elegant dinner, I was asked for my reasons for underwriting research at Einstein. I replied by telling a story about Dr. Harold Rifkin, my physician of many years and a professor of medicine at Einstein. For over thirty years, I replied, I badgered Rifkin about not spending enough time with me. In reply, he promised that when I became a senior citizen, he would give me a half-hour examination and talk. Shortly thereafter, I became a senior citizen and he made good on his promise. After a complete examination, we discussed diabetes, and moved on to a question and answer session. He asked me how I slept, what I ate for breakfast (he changed it), what I ate for lunch (he changed it), and what I ate for dinner (he changed it).

The next question was about sex. Afraid that he would demand changes in that area too, before I answered I asked:

"Harold, if I listen to you, will I live longer?"

Turning to me, he said, "Jacob, I don't know, but it will seem longer."

Unhappy with this answer, I decided to support research at Einstein in the area of prolonging life and reducing human suffering. In response to my joke, a number of our guests pledged donations in the name of Dr. Rifkin to help this effort.

When we became Benefactors, the College of Medicine graciously asked me if there was anything they could do for Bronka and me in return. Quite honestly I explained that the war and the Holocaust had intervened before I had the opportunity to attend my own commencement from college in Poland. I asked that we be invited to their commencements each year, which we attend with great joy and pleasure. Now, every year, when the new doctors receive their diplomas, we are invited to bestow sashes on the graduates. I am not often a liberal, but one of the greatest gratifications I know is to watch diplomas be awarded to new doctors of different races, sexes, ages, national backgrounds, single and married, married with children, and watching the proud, happy faces of their families of every color and age at this great moment. As a witness to these ceremonies, I permit myself to believe that one day (though not in my lifetime) the different races and nations may be able to live together in peace.

TRAVELING WITH THE STARS

THE RIGHT ONE: Nella Yaacobi, wife of
Israel's UN ambassador, has to get her
priorities straight. She spoke at an Israel
Bonds luncheon at the Regency Hotel
honoring Bronka Weintraub. Bronka and
Jacob own the Weintraub Gallery on
Madison Ave.

Praising Bronka's lifetime involvement
with Israel, Yaacobi said, "You go to sleep
with Israel and you wake up in the morn-
ing with Israel."

"Jacob!" Bronka corrected her.

The truth about life with Bronka.

STATE OF ISRAEL BONDS
DEVELOPMENT CORPORATION FOR ISRAEL
730 BROADWAY, NEW YORK, N.Y. 10003 · 212-677-9650
FAX 212-529-4769

AMBASSADOR MEIR ROSENNE
President &
Chief Executive Officer

May 24, 1990

VIA FAX

Mr. Jacob Weintraub
Weintraub Gallery
988 Madison Avenue
New York, NY 10021

Dear Jacob,

As I was boarding the plane in London on May 22nd, I saw the ad you sponsored in the International Herald Tribune. It is outstanding and I wish to congratulate you for this excellent idea. It helps alot in encouraging the Jewish Communities all over the world to fight anti-semitism.

When the history of this era is written, I am sure the historian will record your love and devotion to the Jewish people.

Love to you and Broncha.

Cordially,

Meir Rosenne

MR/td

"During the coming year, the whole Israel Bond money
will be devoted to the absorption of immigrants."—Shimon Peres—March 2, 1990

In 1989, the College of Medicine received a Richard Erdman sculpture as a donation, with no strings attached. They asked me to sell it for them so that they could realize its monetary value as a means of underwriting additional research. As a specialist and dealer in Erdman, I was able to sell it for the college at an attractive price. In return, I received a letter which I cherish:

"Dear Jacob,

"Thank you so very much for your help and assistance in selling the Erdman. What makes this so very gracious on your part is that you handled the situation without charging a commission, as a gesture of goodwill to your friends at the College of Medicine. You must know that you have added another dimension to this relationship. We are deeply appreciative."

Bronka's world of charity has formed the last chapter in my gradual, often tentative, movement toward rejoining the human race. In the spirit of joining, and giving back, and in the memory of Aliza Begin, Bronka and I have endowed a sculpture garden at the Assaf Harofeh Medical Center in Tel Aviv. We are donating sculptures from our collection, in keeping with the growing trend toward sculpture gardens, which in the '80s became the fashionable way to display sculpture in the setting in which it was meant to be seen: out of doors.

On Thursday, July 29, 1993, an advertisement appeared in the *Jerusalem Post*, wishing "a very happy birthday to Mrs. Bronka Weintraub" on the occasion of the official opening of the Bronka and Jacob Weintraub Sculpture Garden as part of the Aliza Begin Commemorative Project. The opening was held that day, at noon. The ad tastefully noted that "the sculptures, part of the private collection of the Weintraub Family, will be a source of pleasure to the patients, their families, and all who wish to visit."

Speaking of prime ministers, Bronka has fittingly been named a Prime Minister of Israel Bonds, which puts me in mind of the question asked of Mr. "Margaret" Thatcher, "What's it like to sleep with the prime minister?" That is for me to know and for you not to find out, thank you. And I thank Bronka for opening a new door in my life, and what is more, high-stepping on my arm through it with the grace of a ballet dancer and the bravery of a fighter.

"In reviewing the events that took place during Bronka Weintraub's tenure," the committee for State of Israel Bonds wrote in dedication to her, "one must marvel at the elegance, showmanship and creativity that were her hallmarks. From intimate lunches and teas in her home to gala black-tie ballgown dinners at Maxim's, these functions were noted for their exciting mix of Jewish dignity, Israeli panache and stylish presentation. But most important, they

were always successful in mobilizing investment in State of Israel Bonds. Always the welfare of the Jewish homeland, and adding to the economic strength of the State of Israel, were uppermost on Bronka's agenda."

I couldn't have said it better myself. But Bronka did.

"I believe in parties," she told Frank Rohr, in her interview for her 1988 profile in *Lifestyles*. "Nowhere is too far for me to fly for a good party, and a good cause. And at my parties, darling, bright people are brighter, dull people are bearable, and rich people give more."

With Bronka, I have learned another side to Billy Rose's adage of giving till it hurts, I've learned that giving can also be fun. And Bronka, of course, is also right. Bronka, in fact, is always right. Which is why I was right to marry her.

Part Two:
The War in Europe

Looking Back: The Holocaust

A s Bronka had told me of her past, so I too, felt compelled to share with her my secrets. To tell her of my experiences in those dark days. I returned to 1939:

Barbara and I were married in Warsaw, in mid-1939, and took possession of our new dream home, a handsome, sprawling apartment high up in an exclusive new building, constructed in the latest streamlined Art Deco style by the Pluton coffee merchants on Grzybowska Street in downtown Warsaw. Like all newlyweds, we were thrilled to have a home of our own. But by September 1, 1939 the Nazis had invaded Poland, suddenly shattering our romantic dreams of domestic bliss.

The dreaded blitzkrieg commenced at 6 a.m. with an intensive aerial bombardment of Warsaw. The object of that first air raid was the airport, which the Germans quickly reduced to rubble. As the bombardment continued, the Luftwaffe next targeted the city's Jewish quarter, wreaking havoc and panic. Stuka dive bombers flew low over Jewish neighborhoods, destroying hundreds of buildings and killing thousands of inhabitants trapped inside the exploding hulks. The first warning of the invasion came with an announcement on the radio, followed by a barrage of posters frantically put up by the traumatized Polish government in an effort to keep the frightened population at least somewhat informed. After five days of constant bombardment, the embattled Polish government in its desperation called upon all able-bodied men of military age, from fifteen to fifty, to evacuate the city at once. We were ordered eastward toward the border with Russia to avoid being taken prisoner by the advancing German forces.

In compliance with these orders, on September 6 a human wave of male refugees surged out of Warsaw, leaving their wives and children behind, filling streets and sidewalks with crushing bodies, moving in tandem ever eastward, across the bridge to Praga, away from the path of the approaching Germans. As a flotilla of dive-bombers went about their deadly work, we felt a sense of purpose in fleeing the city, consoling ourselves that this was no cowardly flight, but an orderly retreat, freeing us to fight the Nazi menace. The last-minute mobi-

lization at least preserved some shred of hope that at some later date remnants of resistance to the Nazi aggression might be organized.

Sadly for us, such a day was not soon to come. As flights of Stukas split off from their tight formations to strafe our long stag line of civilian refugees, we did all we could to dive for cover. My first corpse of the war, but by no means my last, lay outstretched along that shell-pocked road leading eastward from Warsaw. While bullets sprayed around our shoulders and legs, we dived for ditches, waiting until the threat of attack seemed momentarily to subside. Traveling alone in the midst of the crush of bodies, I fell in with a tall, stoop-shouldered, middle-aged merchant from Warsaw, Isaac Zuckerman. He wore a stylish fur-collared overcoat despite the warm early fall weather. Sizing me up, he offered to merge his money with my youth in the hope that two heads might be better than one. Contrary to instructions, he had his beautiful young wife in tow. Obediently, I had left Barbara behind. Zuckerman's money, I reasoned, might buy us out of a few scrapes and his young wife's angelic face might soften some Soviet's war-hardened heart.

At a small country inn, Zuckerman tracked down a peasant and persuaded him to sell his cart and horse for a stiff price. With wheels and horsepower we set off in newly heightened spirits for the Soviet border, only to be stopped outside a small village by a detachment of Polish infantry, who insisted that they had orders barring civilians from passing any further on the road to Russia.

My assumption had been that the evacuation would be strictly temporary, until the political situation was "sorted out." Instead we were all taken by surprise by the sudden collapse of the Polish government under the pressure of the overwhelming Nazi forces. Unbeknownst to us, Stalin's Molotov and Hitler's Ribbentrop were fast closing negotiations slated to slice Poland in half. The Germans took Warsaw and most of western Poland, while the Soviets took the eastern half. Before 1918, the provinces of Poznan, Pomorze, and Upper Silesia had belonged to Germany. Now Germany regained control of the strategically critical coal mining region of Zaglebie, along with the provinces of Warsaw, Bialystock, and Lodz—the largest industrialized zone in the country. As the Red Army moved into position in the east, and the Wehrmacht seized the west, we were trapped in the middle.

Rumors swirled through the crowds of refugees to the effect that the stretch of Poland in which we were trapped was to be ceded to Russia. Soviet troops soon marched into town and began shooting on sight all fighting-age men not in uniform, taking them to be partisans. Ultimately, the town in which we were trapped was turned over to Germany, and the Nazi troops, who promptly took up posi-

tions within the town's perimeter, began shooting more suspected "partisans." Within two weeks of fleeing Warsaw, I saw no alternative but to turn back, despite the fact that as Jews we had every reason to be apprehensive about the fate that lay in store for us in the occupied capital. But at least Barbara and I would be able to share it together in the company of our families, who needed us.

Back in occupied Warsaw, Nazi food trucks were driving through rubble-strewn streets, distributing slim rations to the starving population. All but the Jewish inhabitants received just enough food to live. Jews were thrown out of food lines. If by chance a hungry Jew managed to smuggle in unnoticed by the Nazi guards, he was promptly denounced by the Poles. This was all part of the Nazi's grand strategy of isolating Jews from their fellow Poles, to make them a race apart, hated even by their co-sufferers under the shackles of alien occupation.

Poland now was officially partitioned into German and Soviet territories. The German-occupied provinces were divided into "incorporated territories," under a German governor general, Hans Frank. General Frank ruled his occupied territory, composed of four districts—Krakow, Lublin, Radom, and Warsaw—with all the plenary power of a Teutonic prince. Within these borders, 1.5 million Jews found themselves at the mercy of their Nazi captors. The Warsaw district contained an estimated 600,000 Jews, of whom about 350,000 resided within Warsaw proper. That number swiftly swelled to over 400,000 as some 50,000 additional Jewish refugees fled to the relative safety of the city. In the outlying areas, in small villages, marauding bandits and German troops were harassing Jews.

I had grown up in Warsaw in a middle-class neighborhood, on a broad boulevard of handsome townhouses looking down toward Marszalkowska Street, often referred to as Warsaw's "Fifth Avenue." As the eldest of five children, with two younger brothers and two younger sisters, I had early on adopted my father's relatively assimilationist stance. But, with the abrupt upsurge of anti-Semitism, he quickly abandoned this no-win position and he prevailed upon me to take a more active role in Jewish affairs.

A singular manifestation of my father's newly awakened interest in Judaism was his insistence that I attend a Misrachi grade school, which had a strongly Zionist orientation. I continued my education at a Tachkemoni school, a secondary school with an emphasis on religious studies.

Thereafter completing law studies, I had been astonished to find my application to diplomatic school summarily rejected without explanation. The reason given, unofficially of course, was the Polish

diplomatic corps' deep distrust of my Jewish heritage. The Polish hierarchy wanted no potential Alfred Dreyfuses in their midst. A further problem was that as I attended law school classes at the University of Vilna, one prominent professor of Roman Law, a notorious anti-Semite, refused to give his Jewish pupils high marks, in disregard of their intellectual capacity or achievement. Even before the Nazi invasion, Polish Jews' lives had become circumscribed by a welter of anti-Jewish laws and ordinances.

On October 1, 1939, Einsatzgruppen IV entered Warsaw, installing itself in a commandeered headquarters at 25 Szucha Avenue. Before the war, I had served briefly at the Jewish Community Council, the Gemeinde, at 26 Grzybowska Street, near our new apartment. My father, publisher of textbooks, whose family originally hailed from Austria, had many friends among the Jewish elite.

On October 4, a month after the invasion and a week before my return to Warsaw, a detachment of Einsatzgruppen raided the Jewish Community Council. They emptied the safe at gunpoint and demanded to be told who was in charge. A janitor said that the man they were looking for was Adam Czerniakow. A native of Warsaw, this mild-mannered, studious 59-year-old civil engineer and former vocational school teacher had authored some technical publications and a few reams of unpublished verse before embarking upon a brief, relatively undistinguished career as a middle-level Jewish politician. As a member of the Jewish Community Council, Czerniakow had devoted himself to championing the cause of Jewish artisans when the rights of Jews to pursue a trade inside Poland were coming under attack because of anti-Semitic legislation.

After the occupation, as most men fled the city, a handful of able-bodied Jewish males, who remained, formed a citizen's committee to cope with the problems presented by the state of emergency. They were quickly recognized by the Polish mayor of Warsaw, Colonel Stefan Starzynski, and when the previous chairman of the Community Council, Maurycy Mayzel, failed to return to Warsaw after the evacuation, Czerniakow assumed his post.

The Security Police issued Czerniakow his first orders: quickly assemble with all possible haste a new council, which would henceforth be known as the Judenrat, no longer the Gemeinde. It would be comprised of twenty-four "elders" of the community, supported by a body of twenty-four additional "delegates." Once the council was formally constituted, its first order of business would be to conduct a census of Warsaw's Jewish population. The ominous tone of this directive so shook the confidence of the council members that Czerniakow felt constrained to point out that in his desk drawer he had

placed a brown glass bottle containing tablets of potassium cyanide. Those poison pills would provide, if needed, a means of escape if they felt they could no longer in good conscience carry out the orders issued by the Nazis. As one council member later recalled, with macabre calm, "Czerniakow showed us where to find the key to the drawer, should the need ever arise."

The new council, the Judenrat, contained a number of representatives from the old: engineer Marek Lichtenbaum, attorney Benjamin Zabludowski, commercial court judge Kobryner, rabbi Sztokhammer, doctor Milejkowski, and two bankers, Hayim Szoszkes of the Cooperative Bank and Sztolcman of the Bank of Jewish Merchants. Councilman Josef Jaszunski, a lawyer and former director of the Jewish social service agency ORT (Organization for Rehabilitation through Training), was assigned to take charge of the census. Along with a few other mid-level functionaries, I was assigned to assist him.

On my first day at work, I entered Jaszunski's office to find him peering over a map of Warsaw, dividing the city into census districts with the aid of a red wax pencil. He assigned me the task of taking charge of the Ochota section, and we set off to work. Barbara, meanwhile, was at work helping her mother run the family movie theaters.

One lone voice, that of an elderly lawyer, was raised against our passive posture with regard to the conduct of the census. "Why not resist?" he cried out in bewilderment, his mind no doubt obsessed by any number of unsavory purposes to which the Nazis might put our census results. When I asked Jaszunski if the council had established any "policy" concerning the need to follow Nazi mandates without question, Jaszunski responded in an uncertain, quavering tone: "We have no policy."

This admission set off a brief, impassioned discussion of the possible benefit to be gained by distorting or falsifying the census results. The problem, of course, was that if we deliberately lowered our estimates with an eye toward saving Jewish lives, the Nazis might well use the artificially deflated figures as an excuse to supply us with less food and fewer supplies. The only recourse open to us seemed to be to conduct the census as faithfully as possible. Refugees were pouring into the city, sleeping ten to a room.

After a hellish few whirlwind days spent knocking on Jewish doors and filling out Nazi census forms, on November 1, 1940 we officially estimated that 410,000 Jews of all ages were residing in Warsaw proper, Not before long, that number was revised upwards to 430,000 as all the Jews from the various counties of the Warsaw district situated to the west of the Vistula and some in the Minsk district were transferred to Warsaw to live as refugees.

One night, returning home exhausted after an eleven-hour day standing in the lobby of the Judenrat building trying to cope with the hundreds, sometimes thousands, of frightened, semi-hysterical Jews justifiably anxious about their future, I found Barbara lying in bed in our bedroom with the lights out and the blinds drawn. I sat down on the edge of the bed and asked as gently as I could if anything in particular was the matter.

"They sealed off our theaters and gave them away," Barbara wailed, before bursting into a torrent of tears. The only child of a prosperous Jewish movie-house owner, like many assimilated upper-class Polish-Jewish girls of that era, Barbara had been sent to Catholic schools and had led a sheltered early life. In the early '30s, concerned about the possible adverse effects of the new anti-Jewish laws, intrigued by the hopes of Zionism, and alarmed by the prospect of a Nazi invasion of Poland, Barbara's father had embarked on an exploratory trip to British Palestine, now Israel, to evaluate it as a possible safe haven. He ate some bad fish in a seafood restaurant in Haifa. The doctors correctly diagnosed ptomaine poisoning but in those days could do little but wait for a stricken patient to recover. Barbara's father did not recover.

Her father's death came as a devastating blow to Barbara. But that was just the first calamity in a long line of losses to strike that once-proud family. Barbara had a good head for figures, as would later be proven by her success in running the bookkeeping and management of our art gallery business. Like any number of young women of her generation, interested in learning something more "practical" than dressmaking or home economics, Barbara had briefly studied accounting and business. After our marriage, she continued to help her mother manage the family movie theaters, until disaster struck them as well.

One of the first steps taken by the newly constituted German authorities was to establish an economic pogrom to weaken the Jewish population by encouraging the looting and smashing of Jewish businesses and establishments by bands of Polish thugs. The strategy was a straightforward one: outright pauperization. While the Polish and German Security Police looked on with glee, gangs of young hoodlums conducted their own Warsaw Kristallnacht, smashing windows, looting stores and seizing property at will from Jewish homes and commercial institutions.

At the same time, the Germans moved with true Teutonic efficiency to commandeer the best Jewish apartments and property. All Jewish real estate was carefully sequestered under Aryan control. German troops moved systematically through Jewish homes, seizing

money and valuables, paintings and furniture, indeed any salable objects they could lay their hands on. The libraries of prominent physicians were not spared, nor the pianos and other musical instruments of accomplished musicians. Jews were not permitted to keep more than 2,000 zlotys in cash. Irrationally high fines were levied against Jewish enterprises. Access to Jewish bank deposits was blocked. The ensuing decline in Jewish business was precipitous: out of 193 Jewish-owned industrial and commercial concerns operating in Poland before the war, by April 1940, only 38 remained. Not surprisingly, these were reduced to mere skeleton enterprises. In their place, German firms moved into Warsaw to capitalize on a potential raw material resource: cheap Jewish labor.

When the Nazis seized Barbara's family's property, the business was arbitrarily "assigned" to a number of "reliable" Aryan former competitors. The Gestapo ordered Barbara and her mother to turn up at their headquarters with the keys to their theaters. A majority of the theater owners in Warsaw were Jewish, and their movie houses similarly were ordered closed by order of the German Ministry of Propaganda—Herr Goebbels, proprietor—without recourse or delay, ostensibly for the crime of spreading "anti-German lies and propaganda." The handful of theaters operated by pro-German Poles were permitted to remain open. Their owners were actively encouraged by the new confiscatory policies to apply for permission to operate theaters seized from their Jewish owners.

At Gestapo headquarters, one of Barbara's family's former Polish employees, Kowalski, a Volksdeutsche, while professing pity for Barbara, immediately applied for permission to "open" their theaters. Permission was granted.

Such humiliations, relatively minor in themselves, were all part of the Nazi's grand scheme. As a direct result of this economic squeeze, unemployment among Jewish artisans and laborers soared. The relatively high number of Jewish professionals, doctors and lawyers, teachers and professors, were forbidden to practice—except among "their own kind." It was left up to the new Judenrat to squeeze whatever help it could from shrinking resources.

The scene I faced every morning at the Judenrat building was devastating as my colleagues and I desperately tried to sort through the chaos and take down details of complaints concerning offenses both major and minor, real and imagined. Much of our work consisted of hand-holding and concerned listening because, like all bureaucrats, our primary function was to process paper and forward it to higher authorities. Our authority, though significant in certain circumscribed areas such as food distribution, religious and secular

education, cultural activities, hospital and mortuary services, was of course strictly proscribed by the German agencies then vying with each other for jurisdiction over "Jewish affairs."

At its inception in the late fall of 1939, the Judenrat consisted of a hundred employees in support of twenty-four delegates and an equal number of alternate members. Within two years, before its eventual dissolution as the Holocaust unfolded, it swelled preposterously to nearly 3,000 members. Apart from the legal department, in which I had worked before the war, its various agencies administered a shrinking pool of health care and other social services, including, in due course, the highly controversial "Jewish Police." Of course, the German policy of pauperization of our community in time made a mockery of many of our efforts to organize and stabilize. Warsaw's Jewish community under Nazi occupation, even prior to the formation of the sealed-off Ghetto, was inherently powerless since its members lived in constant fear of being hauled off and shot without provocation, of having their livelihoods threatened or entirely cut off, and of, at the very least, losing any semblance of control over their own lives, present and future.

Living under the constant threat of dislocation, disruption, and economic catastrophe, what had at one time been a prosperous, flourishing ethnic community was systematically reduced to a seething mass of chaos, turmoil, infighting and misery. The main thrust of the Nazi's conduct of so-called "Jewish affairs" was to set Jew against Jew and Pole against Jew in an endless strategy of dividing and conquering, of setting the weak against the strong, before weakening the strong, in order to advance a process of gradual dehumanization of the Jews.

This sweeping diabolical strategy had its failures, thank God. The real triumph of the story is that the Nazis never fully succeeded in attaining their evil ambition of rendering the whole world Judenrein (Jew-free). Neither did they succeed in entirely degrading, dehumanizing or destroying the pride and the honor and sense of community of the Jews of Poland. And they did not succeed in killing us all. Their Final Solution, despite the deaths of six million, was not final for all.

Much to the chagrin of the Germans, the tragic tale of the Jews of Warsaw during the Holocaust contains countless small sagas of unparalleled bravery and sacrifice, courage and altruism, generosity and even nobility in the face of death. The Holocaust created many heroes, and one such, although not entirely unsung, was the mild-mannered Adam Czerniakow, the ill-fated Judenrat chairman.

After the war, in her ground-breaking study of Nazi brutality, *The Banality of Evil*, Hannah Arendt sharply criticized the Jewish lead-

ership for in effect being Nazi collaborators. But I, who was there and was an eye-witness to these events, could not disagree more. The Judenrat leaders and functionaries were caught in a terrible bind: our job, as we saw it, was to "organize" the Jewish community with a view toward saving the maximum number of lives.

The only alternative to the various forms of passive resistance ultimately adopted on a broad scale, such as hindering the implementation of anti-Jewish laws, procrastinating in the imposition of new sanctions and fines, attempting to exempt as many Jews as possible from work detail, or for that matter being shipped off to "labor camps" (as the concentration camps were then euphemistically referred to) would have been one of active, open, and of necessity, suicidally violent resistance. Even as that option was passionately debated among the various underground as well as open organizations and factions within the Ghetto, the overriding problem was that it would have necessitated the loss of countless innocent lives, sacrificed in the fighting itself, not to mention the incalculably larger numbers who would surely have been lost in the inevitable Nazi reprisals.

The Judenrat leadership, most of whom died in the death camps, included the strong and the servile, the active and the passive. As time went on, the Judenrat found that it had been infiltrated by a number of Nazi collaborators, as well as double agents, informers and spies.

An incident typifying the dangers we faced in our exposed position took place three weeks after the Germans created the Judenrat, the members of the new council were summoned to an urgent conference by the Gestapo, on a Friday evening, the Jewish Sabbath. Demanding a session of the full Judenrat Presidium at four on a Friday afternoon, of course, was an obvious show of contempt for our religious beliefs. A gang of eight Gestapo agents armed with rifles and revolvers stormed into the council chamber and surrounded the frightened delegates. The Gestapo commander addressed the council members in alarmingly stern terms: the Jews of Warsaw would be confined to a "ghetto" as shown on the map—an aide-de-camp unrolled and pinned a map to a nearby wall. With a pointer he scrupulously distinguished between Jewish and non-Jewish streets and then with a final and brutal flourish, drew a circle around the proposed ghetto area with a blunt red pencil.

Once the Gestapo detail departed, our workers' representative, Shmuel Zygelboim, passionately urged a policy of active resistance to this dreaded "ghettoization" plan. Czerniakow and his deputy, Dr. Szoszkes, departed at once to implore the German commandant of the city, General Neurath, to cancel the order.

In the absence of hard information, the ever-present rumor mills spun faster. By early evening, while we at the council were still awaiting word of whether the "ghettoization" order would be implemented, thousands of frightened Jews assembled in a state of panic outside Judenrat headquarters.

Before violence erupted, the workers' representative, Zygelboim, took the courageous step of addressing the crowd, asking them to return to their homes and remain there until driven out by force, advising them to by no means retreat behind the walls of any future ghetto voluntarily. The panic subsided for the moment but we knew that eventually, if not at any moment, the dreaded policy of "ghettoization" would be activated. When Czerniakow and Szoszkes spoke to the German military authorities about the Gestapo order, they professed ignorance of the matter, insisting that civil orders regarding the conduct of "Jewish affairs" were strictly under Gestapo control.

That evening, the Gestapo rounded up twenty-four Jewish hostages from the ranks of the Judenrat bureaucracy as a means of insuring that their orders would be carried out. I had returned fairly late that evening after conducting some follow-up interviews on the census report when Czerniakow asked everyone still present inside the building to volunteer as "substitute delegates" to become hostages so as to replace those delegates who had gone home and could not be reached at that late hour.

I was included by Czerniakow and shoved with my twenty-three fellow hostages into windowless Gestapo vans that pulled up, with tires squealing, outside Judenrat headquarters. We were driven to the jail on Danilowiczewska Street where we were turned over to a Polish warden. He was under strict instructions to separate us so that we could not communicate with each other. The guards frisked us, took our valuables, as well as our belts and suspenders, and forced us to fill out endless forms and submitted us to hours of interrogation.

I was marched up six flights of stone stairs to a tiny cell, outfitted with neatly made bunks. A small, barred window was set deep in the stone wall. My cellmate was Ferdinand Jarosy, a well-known Hungarian stage actor who had been arrested during a performance of "The Naughty Maidens" on charges of having "spied for Western powers." Apparently, the fact that his work required him to travel a good deal to Vienna, Prague, and his home in Budapest had raised the hackles of the Gestapo, who had somehow heard of his Marxist leanings. He was, in short, a political prisoner and a thoroughly charming one.

Holed up in my cell, I couldn't help worrying about the fate of my fellow hostages—all ordinary Polish citizens whose only crime was

that they were Jews. This hostage-taking was designed to impress upon us the bizarre Nazi legal concept of "collective guilt," under which the innocent members of an ethnic community could be held collectively responsible for the "subversive" acts of its members.

Meanwhile, a frightened Barbara had made a beeline to Judenrat headquarters as soon as she heard the news. She approached an obviously distraught Dr. Szoszkes to find out if he knew anything. He didn't. But, after at first sending her away in exasperation, he relented. Gently he told her that he and Czerniakow were doing everything in their power to free the twenty-four of us.

In prison, I was having my own troubles persuading my cellmates that I was what I claimed to be: a hostage taken by the Gestapo to humiliate and subjugate Judenrat members, as insurance that the "ghettoization" order would be implemented without hesitation by the intimidated Judenrat.

"I am a hostage," I told Jarosy, the actor, and Professor Rakowski, a philosopher, also imprisoned for his free-thinking. Rakowski, for some reason, shunned me. "There are twenty-four of us," I told them over and over again, until it did sound a bit as if I was reciting some coached line. "They are going to make a ghetto for the Jews, and we are insurance that the leadership will comply."

At one point, Rakowski clearly had enough of my story. "Cut the crap," he said coldly, staring meaningfully at my soft, unblemished hands. "You are no freedom fighter. Are you really a hostage?" he taunted. Only after he had held a private conference, conducted in subdued whispers with the warden, who made no secret of his anti-Nazi sympathies, did Rakowski trust me. Until then, he had for some reason been convinced that this toehead was a Gestapo plant.

After a week of being cooped up in that tiny cell, I was led to a large holding pen, where I was heartened by the sight of my fellow hostages. One of them, David Pizic, embraced me, his spectacles wobbling emotionally on the bridge of his nose. Other hostages fell to their knees praying the Viduy, the Hebrew prayer asking for forgiveness for one's sins on one's deathbed. Pizic, one of the most respected men of the community, stood up and addressed us in strong tones:

"Friends! This is a time for courage! We have to be brave! We must show the Germans that a Jew is not afraid to die for his cause!"

Was I afraid to die for my cause? I wasn't so sure. As Pizic began singing, softly, the Hatikvah, the Jewish anthem, the warden stood sympathetically by the wall, before announcing, "You can go."

Immediately, pandemonium broke out in that airless room. Unfortunately, this was not tantamount to being saved. In fact, we were

being dumped from prison, into the larger prison of the Ghetto.

Upon my return from prison, I learned that my father had spent much of the past week praying for me at his synagogue. At his request, I accompanied him there after a brief celebratory meal in honor of my deliverance, to chant the Hagomel—a Hebrew prayer giving thanks for deliverance. For good measure, I also prayed for the safety of my family facing an ordeal which clearly loomed. Tragically, all the prayers in the world were mere whispers in an ill wind.

A few days after our release, a Jewish criminal, Jankel Zylberberg, who had been released from prison after the invasion, had holed up in a building in the Jewish quarter, No. 9 Nalewki Street, after a bungled robbery attempt. Cornered in the courtyard, and before being captured by the Polish police, he fatally shot a Polish policeman. Reprisal by the German authorities was swift, sweeping and cruel: the Gestapo promptly imposed a fine of three million zlotys on the Jewish community, payable by all of us under that odious tenet of Nazi dogma, collective guilt.

The day after the shooting, Polish police vans pulled up outside No. 9 Nalewki Street and rounded up all male residents of the complex, men and boys as young as thirteen, fifty-three people in all, and hauled them off to prison without explanation. Czerniakow's mission to determine the fate of these hostages turned into a harrowing, multi-hour interrogation by the Gestapo. While taking turns humiliating and abusing him verbally and at times physically, the Gestapo agents gave the impression that if the fine levied on the Jews was paid in full and on time, the hostages would be released.

In remarkably short order, with strong pressure applied by Czerniakow on some of the wealthier members of the Jewish community, the full sum was raised and paid. But no word was forthcoming about the fate of the fifty-three hostages. Every day, the wives and mothers and sisters of the missing would appear before the community council to await word of their men. For a terrible week we were forced to tell them that we had no news of their whereabouts. The Gestapo insisted that they knew nothing—that it was entirely in the hands of the Polish police. The Polish police denied this. They steadfastly maintained that the whole thing had been cooked up by the Gestapo, and that they, the Warsaw Police, were holding no hostages.

Finally, on the tenth day, the Gestapo summoned Czerniakow to headquarters to receive the news that all the Jewish hostages had been shot. For what crime, Czerniakow demanded. For their "arrogant behavior during the investigation," he was told.

When he returned, ashen and trembling, to Judenrat headquarters, a painful conference was held among the council members

whose sad task it was to inform the women that their men were all dead. Czerniakow asked five women waiting outside to come in. He permitted those council members who couldn't bear to witness the ensuing scene to leave the premises. All departed but one, who stood by in horrified silence as Czerniakow addressed the assembled women in mournful tones.

"Be courageous, my sisters, and be prepared for the worst," Czerniakow said, at which point, all the women in the room began to weep uncontrollably. One of the women asked hoarsely, "You mean all of them?"

"Yes," replied Czerniakow, about to burst into tears himself.

"Can you warrant that they are all dead, are you sure of it?"

Czerniakow simply nodded, and said nothing more.

"Then I know what I have to do," one woman, tall and pale, said as she stood up and silently left the room. I knew this woman. Her name was Lydia and she had come to Warsaw from Krakow the year before, accompanied by her husband, Eugene, who had intended to conduct biochemical research at the University of Warsaw. Unable to restrain myself, I followed her. I was able to locate her apartment, and after hearing no answer at the door, I managed to shove in the flimsy wooden barrier. I nearly fainted as I found Lydia hanging from a pipe by what appeared to be her husband's belt. All I could do at that point, other than weep, was arrange for a decent burial. That much I was able to do for her. I didn't know in what mass grave her husband's body lay buried. I was crushed.

This incident simply confirmed for the Jewish intelligentsia that the Nazis were bandits and thugs and thieves, and lying betrayers to boot. These great supermen of the Aryan race were, in fact, no better than well-organized extortionists and murderers. The Jewish intelligentsia had a hard time believing that the German people were such barbarians because Eastern European Jewry had long looked to Germany as a bastion of high culture, as exemplified by the symphonic achievements of the "Three B's"—Beethoven, Bach and Brahms—and the poetry of Goethe.

In December of 1939, after two months of occupation, a series of anti-Jewish "extermination" decrees was imposed upon occupied Poland. These decrees established "educational" camps in the countryside, places to which vast numbers of now unemployed, able-bodied Jews could be transported to perform "useful" work. Hence, the ironic German motto at the gates to the death camps: "Work will make you free." That many of these work camps were actually death camps was a closely held secret in those early days, well kept by the upper echelons of the S.S.

A panoply of prohibitive ordinances was imposed upon Jews. These included the decree requiring Jews over twelve to wear on their right arm a white armband with a blue Star of David printed on it. Jews were forbidden to work in "Aryan" industries, to bake bread, to earn more than 5,000 zlotys per month, (bread cost over 40 zlotys a pound), to trade with Aryans, to ride trains or trams, and to possess gold or jewelry. We were also forbidden from being treated by Aryan doctors; Jewish doctors were forbidden to treat Aryan patients. This welter of laws had the effect of strangling the Jewish population by "legal" means, of criminalizing all Jews in a maze of collective guilt from which few would ever escape.

These laws, with their legal sounding tone, lent an official air of legitimacy to the killing of as many Jews by "legal" means as possible before the mass extermination started without bothering about subterfuge. This was a Partial Solution. It provided a means of softening up the population prior to the implementation of the far better-known Final Solution. This Partial Solution—my own term—was in its perverse way nearly as cruel if not as violent and brutal as the more absolute Final Solution. It was a technique of torturing an entire population, and of punishing them for their "collective guilt."

The utter barbarity of the German people under Nazi domination was unambiguously demonstrated by the next but by no means final indignity to be visited upon the Jews of Warsaw. The Passover Pogrom of April 1940 was conducted by groups of hooligans bused in from outlying industrial suburbs of the city by the Gestapo. Paid two zlotys each a day for the privilege, they rampaged at will through the Jewish sections of Warsaw, breaking into homes and stores, destroying windows and furniture, stealing valuables, smashing to bits what they didn't or couldn't steal. Clearly, a once civilized people had in the space of a few short years descended into utter barbarity.

Instead of intervening to protect private property, German cameramen moved into position to film these scenes of violence. These were later to be used in Nazi propaganda films depicting scenes of Catholic Poles "liberating themselves from the scourge of Jewish domination." We at the Judenrat did intervene, by working hand-in-hand with representatives of the Jewish Workers' Guild, to fashion some form of resistance to this communal assault. We distributed what we could gather by way of "cold weapons"—iron pipes and brass knuckles—to beat off the thugs. Three groups of transport workers, slaughterhouse workers and other strong types were deployed at strategic sites around the Jewish quarter. When the thugs showed up in the morning fresh off the bus to wreak havoc, our neighborhood defense squads were in place to greet them. The ensu-

ing battle was more than the thugs had bargained for, and they quickly dispersed.

Such a small victory in such a minor skirmish could not prevent what was yet to come. On October 16, 1940, the decree declaring the establishment of the Warsaw Ghetto finally went into effect. Placards went up overnight in German and Polish across the city declaring a cramped, congested slum area of Warsaw, populated mainly by Jews but also by some eighty thousand gentiles, to be henceforth the "Jewish Living Section."

In the space of two short weeks some one hundred and fifty thousand Jews were forced to abandon their homes and take up residence in the quarters evacuated by the eighty thousand gentiles. Jews were told to enter the Ghetto stripped of all possessions. To enforce this edict, no horses or other nonmanual conveyances were permitted, just pushcarts. These were frequently turned over in the street by Polish thugs who made off with the scattered goods with total impunity. Jewish Ghetto-dwellers were quickly reduced to a medieval life-style. Pushcarts, special ones with double handles fore and back, were soon developed to haul bodies — the dead from starvation — through the congested streets to the overfilled cemetery.

Warsaw was officially divided, like Gaul, into three parts: a German quarter, including the center of the city and an affluent suburb; a Polish quarter; and a "Jewish Living Section." To make matters worse, the Gestapo continuously rearranged the borders so that some Jewish citizens were forced to change apartments four, five and six times. The pain and suffering were staggering.

Once the Ghetto boundaries were finally drawn the Ghetto was surrounded by a 10-foot-high wall 11 miles long and two bricks deep, covered with plaster and topped with jagged shards of glass. The wall had to be erected with Jewish funds. The Judenrat thus was forced to impose yet another levy to underwrite the cost of their own inprisonment, while a German firm was awarded the concession of erecting the wall, at a handsome profit.

Within a few weeks of the wall's erection, Jews were no longer permitted to exit the Ghetto, upon penalty of death. In an article in the *Frankfurter Zeitung* newspaper it was reported that the Nazi General Government of Warsaw, under General Dr. Hans Frank, had announced to the world with great pride that "in order to restrain the Jewish population from hampering the process of economic and administrative reconstruction through their anti-social attitude, and in order to check the spreading of epidemics, since the Jew has long been recognized as the carrier of all kinds of dangerous diseases, it was resolved to establish special Jewish living quarters.

This would, at the same time, make it possible to utilize the Jews for productive work...."

From the middle of March to the middle of May, 1940, Czerniakow did what he could to stave off this calamity. Time and again he trooped over to Gestapo headquarters where he was ordered to remove his hat before he even entered the courtyard. He was armed with charts and graphs, presenting arguments against the implementation of the Ghetto. Naturally his arguments were to no avail. As Czerniakow later told me, his reward for such pleading and downright begging was to be addressed by his Gestapo masters as "Jew dog!"

Czerniakow's special pleading, however, at least had the effect of delaying "ghettoization" for a few months. But in the end, the wall went up, and a bridge connecting the Ghetto's southern and northern sections, separated by an "Aryan" street—Chlodna—was built by Jewish labor. In the first few months, some fifty thousand residents were granted "crossing permits" authorizing them to utilize twenty-two exit and entrance checkpoints. But Dr. Lambrecht, the German chief of the occupation government's health services, objected to the number of such permits, as it defeated the whole purpose of the Ghetto: to erect a "quarantine wall" around the Ghetto to prevent the supposed threat of infectious diseases.

By some quirk of good fortune, a strange term under the circumstances, the large building in which Barbara and I lived straddled the Ghetto border and we were not forced to move. The building simply divided in half, with Jews using the entrance leading into the Ghetto, while Aryans used the entrance leading into their half. A force of eighty-seven German police, augmented by detachments of Polish as well as the recently formed and highly controversial "Jewish police"—formerly called "The Jewish Order Service"—patrolled the borders to detain attempted escapees. The typhus-protection argument was of course not only scientifically specious but odious in the extreme, offensive not simply because it was an egregious medical falsehood calculated to spread fear and hatred of Jews, but because the cramped, congested conditions in the Ghetto were contrived to create a typhus epidemic, not to prevent one. By first deriding Jews as typhoid carriers, then herding us into a typhoid breeding Ghetto, the Nazis were condemning us to fulfill their hateful lie.

Of course, there was little we could do in the face of implacable Nazi brutality. Even small concessions were hard to come by. In a December 1940 conversation with the German Kommissar, Czerniakow amazingly argued that the Jews should not be made to pay for the wall when by rights it should be the liability of those being "protected" from the threat of epidemic. Kommissar Auerswald flew into

a rage, complaining that not enough "strong, healthy Jews" were being sent to the forced labor camps to work on behalf of the Reich. Of course, the Nazi desire to recruit "healthy" Jews for labor battalions directly conflicted with their interest in starving the Jewish population into cowed submission. By May 1941, Czerniakow had sadly reported to the Gestapo that in the first half of that month, some seventeen hundred people under his charge had died of starvation. In response to this, S.S. troopers stormed into the offices of the Jewish council, arrested Czerniakow and carted him off to prison. The charge leveled against him during several hours of brutal interrogation by the head of the Security Police included not only "speaking ill of the S.S.," but of offending the Reichskommissar by including in his report on Ghetto conditions pictures of children starving in communal shelters. By deliberately creating vast pools of unemployment and misery, the Nazis calculatedly created the conditions under which the unemployed could be enlisted in labor battalions.

When I took up my post with the Judenrat, the Jewish quarter of Warsaw was experiencing a vast influx of refugees from the countryside. The congested living conditions directly contributed to deprivation within the Ghetto. By early 1941, one of Czerniakow's tasks was to organize a Department of Jewish Labor, in the hope that the Germans might be persuaded to trade work for food. All Jewish males between fourteen and sixty were to be registered for work detail, their identity cards were to be stamped to state their status: able-bodied or not, in addition to pertinent professional exemptions.

I was exempt from the labor detail because my new job at the Judenrat consisted of serving as paymaster in the accounting department, handling payments to Judenrat employees, as the bureaucracy swelled to absurd proportions. The labor battalions, offensive as they were, were the only course open to us. We were even given reason to believe that since the workers would be paid a small subsistence wage their funds would end up flowing into the Ghetto to purchase increasingly scarce food and supplies.

The sole income allowed the soaring number of Jewish unemployed came from that pittance earned on work detail. Every morning, large crowds of sickly looking, starving stick figures would gather in the courtyard of the Judenrat building to be picked up by German army trucks and be hauled off to work. Some better-off, able-bodied men would lend their registration cards to these impoverished refugees who could at least obtain a few zlotys in return for their backbreaking labors.

Astoundingly, given the conditions under which they were forced to operate, a network of semi-illicit factories maintained operations

within the Ghetto. Jewish manufacturers and artisans managed to find enough raw materials inside the Ghetto and to smuggle more in from outside. Smugglers maintained links to the world beyond at great personal risk to themselves and their associates. They were systematically derided by their outraged customers as profiteers, sharks, and thieves. This was for the most part true. Yet even the most outraged had to admit that the deprivations imposed made smuggling a vital necessity. Smuggling also was the main distribution mechanism for an active black-market import-export trade that for a time sustained many lives within the Ghetto. Brushes, metalware, textiles, and haberdashery, all manufactured by Jewish artisans, were sold to pay the bills of Ghetto families.

The monthly income of private carpentry shops operating within the Ghetto amounted in the first half of 1941 to five million zlotys; during the same year, some two thousand Ghetto families supported themselves in the brush-manufacturing industry, which at its peak produced some twenty-five thousand brushes a day.

While "legal" exports from the Ghetto during 1941 totaled a relatively modest two million zlotys, "illicit" exports were unofficially estimated at eighty million, or forty times official levels. In canny ways, we Jews sought to thwart the Nazi policy of depriving us of our traditional livelihoods and starving us into submission. Nevertheless, even this volume of exports could not ensure long-term survival for a half-million people. Within the Ghetto, the average occupancy came to seven people per room. Living under such crowded conditions, with below-subsistence levels of food and medicine, the inevitable result was not only starvation but rampant disease.

The major fear, indeed the unavoidable prospect, in the Ghetto was an epidemic of typhus. Within the Ghetto, conditions were ideal for sustaining certain organisms. Lice and rats, both well-known disease carriers, became commonplace. By the spring of 1941, typhoid fever within the Ghetto had indeed reached epidemic proportions. The only means of combating it was to quarantine affected households, and enforce frequent bathing. Unfortunately, the only solution to the problem of lice was to change clothing frequently, something the victims were too weak to do for themselves, even if they had had the extra clothes. Moreover, soap and clean water were both in severely short supply, and sanitary conditions rapidly deteriorated.

From January 1, 1941 to June 30, 1942, the Judenrat recorded 69,355 deaths, or one-seventh of its total population. Ghetto Jews were dying off at an average rate of five thousand per month. As the death rate shot skyward, Czerniakow petitioned the German government to buy land from a Polish sports club. Its soccer field was

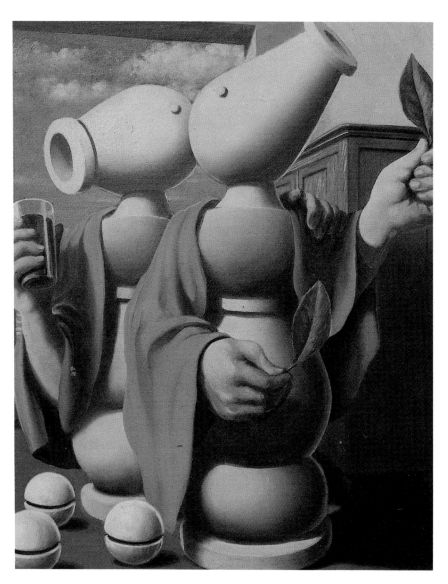

René Magritte,
La Terre Promise, 1947.
Held hostage in Poland
en route to Verona, Italy.

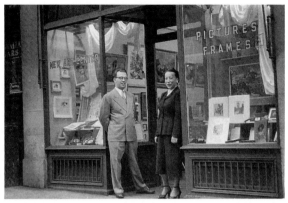

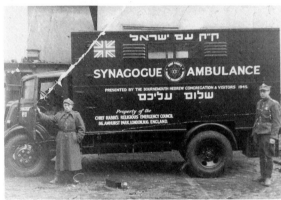

Top left:
Jacob Weintraub, Berlin 1945,
weight: 90 pounds.

Top right:
Jacob and Barbara Weintraub
in front of the New Art Center
Gallery, 1950s.

Center:
The ambulance brought by
Captain Baker for the Jewish
population of Gdynia,
October 26, 1945.

Bottom:
Dedication on the back of
the ambulance photograph.
Captain Baker used my real
name — Weintraub.

Top left:
New Art Center Gallery Manager
Frank Kent and his wife Peggy.

Top right:
Mrs. Rose Kennedy, Mrs. Eunice
Shriver with Jacob Weintraub at
the "Flame of Hope" exhibition,
Weintraub Gallery.

Center:
Iwo Lowy, Graphics Manager,
with her husband Dr. Gerhard
Lowy.

Bottom:
At the 1968 Sotheby's Roudinesco
Sale: Barbara Weintraub, Mr. &
Mrs. Imre Rosenthal, Jacob
Weintraub and Gideon Strauss.
Signaling my bids by raising and
lowering my eyeglasses over my
thick eyebrows, I purchased over
$700,000 in art.

Top:
Bronka and Jacob Weintraub greeting Klaus Perls of Perls Gallery when the Weintraub Gallery opened in its second location on Madison Avenue, 1987.

Above:
Entertaining Henry and Irina Moore and family at La Pace in Montecatini, Italy.

Left:
Jacob Weintraub with Harry Brooks, President of Wildenstein and Co.

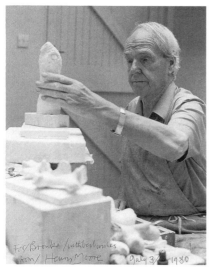

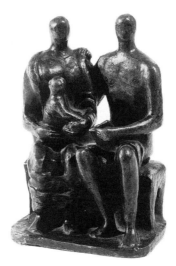

Top left:
Bronka Weintraub's autographed
photo of Henry Moore.

Top right:
Henry Moore, Family Group, 1944.
Maquette, bronze, 6 inches high.

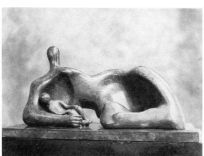

Left:
Henry Moore, Draped Reclining Mother
and Baby , 1983.
104 inches in length. The mother and child theme
was one of the most popular; we sold works in all
three sizes: maquette, working model and
monumental.

Bottom:
Henry Moore, Mother and Child Arms, 1980.
Bronze, 26 inches high.

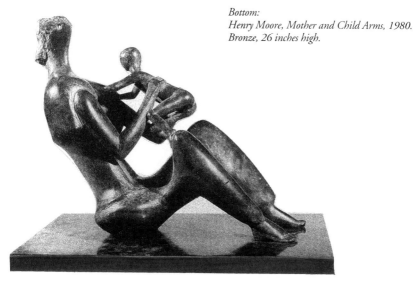

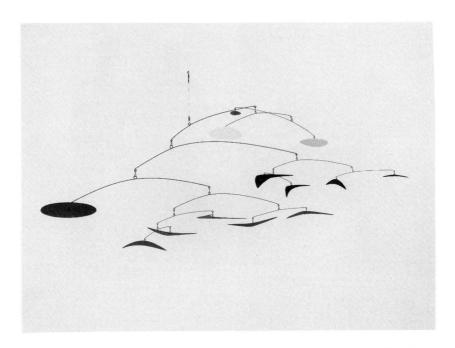

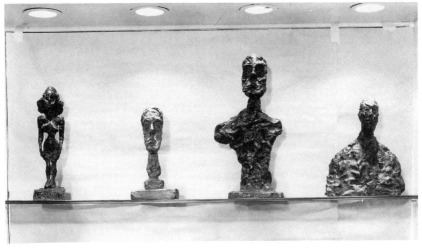

Top:
Alexander Calder,
Boomerangs, 1950. Purchased
at the Chess Club Auction at
Parke-Bernet, 1961,
for our private collection .

Above:
Four Giacometti sculptures
in our 1970s exhibition in our
first gallery on Madison Avenue.

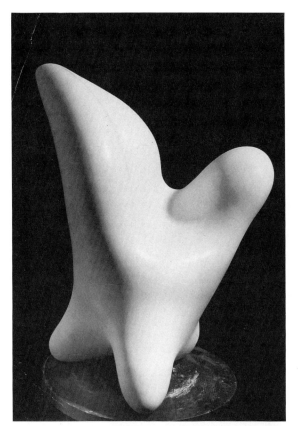

Top left:
Jean Arp, "Flower Muzzle," 1960,
marble, 20 ¼ x 16 ½ x 13 ⅜ ins.

Top right:
Jean Arp, "Io," 1964,
marble, 33 ½ ins. high.

Left:
Portrait of Jacob Weintraub
by Marc Klionsky.

Pablo Picasso,
"Femme Reposant," 1940.
In our private collection.

Left:
Jean Arp, "Demeter," 1960,
marble.

Right:
Alexander Calder, "Mask," 1950,
painted wall mobile in honor of
New Orleans' "Red Light
District" in my private collection.

Above:
Portrait of Alexander Calder,
dedicated to Barbara.

Top:
Paul Klee, "Guillotine," 1914.
Ink drawing, in our private collection.

Center:
Paul Klee, "Zu Beginn eines Festes," 1940,
gouache, in our private collection.

Bottom:
Paul Klee, "Die Knospe des Lachelns," 1921, pencil
on paper, in our private collection.

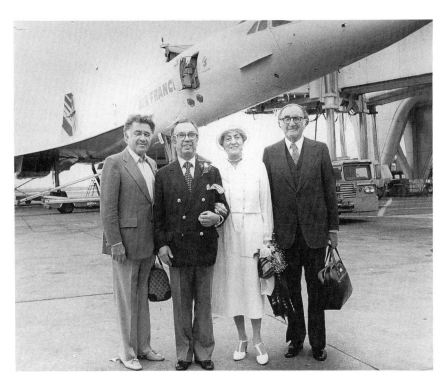

Top:
Zygfryd Wolloch, the Weintraubs and Rabbi
Seligson in front of the Concorde.

Right:
Bronka and Jacob tie the knot on the Concorde,
Rabbi David Seligson officiating.

Left:
Bronka and Jacob Weintraub at the dedication in
1993 of their sculpture garden created in memory
of Aliza Begin, for the Assaf Harofeh Medical
Center, Tel Aviv.

Top left:
Dr. Lamm, President of Yeshiva University,
presenting the Albert Einstein College of Medicine
Humanitarian Award to Bronka and Jacob
Weintraub at Sotheby's New York, in 1988.

Top right:
Burt Resnick, Dean Purpura, Bronka and Jacob
Weintraub, Dr. Lamm and Zygfryd Wolloch
after the Yeshiva University ceremony.

Right:
John Marion, President of Sotheby's, Dr. and
Mrs. Lamm, Bronka and Jacob Weintraub at the
Sotheby reception given in the Weintraubs' honor.

Bronka and Jacob Weintraub at the 1989
commencement of Einstein College of Medicine,
Yeshiva University.

Top left:
Bronka and Jacob Weintraub
with Hatia Begin, the Prime
Minister's daughter, and
Dr. M. Waron, director of the
Assaf Harofeh Medical Center.

Top right:
Bronka and Jacob Weintraub
with Mrs. Meir Rosenne, wife of
Ambassador Rosenne, former head
of Israel Bonds.

Center:
Bronka and Jacob Weintraub
with Prime Minister Shamir of
Israel.

Bottom:
Bronka Weintraub receiving the
1980 Jabotinsky Centennial
Citation from the Prime Minister
Menachem Begin of Israel.

Top:
Bronka Weintraub meeting
author Jerzy Kosinski.

Right:
Bronka and Jacob Weintraub
with composer Leonard Bernstein.

Dedication reads:
"My thanks to the beautiful
Bronka and Generous Jake,"
Leonard Bernstein.

Bottom left:
Bronka and Jacob Weintraub
with Senator Howard Metzenbaum
and Mrs. Nathan Goldman.

Left:
Bronka and Jacob Weintraub
with the newly elected
President of Brandeis University,
Jehuda Reinharz.

Bottom right:
Jacob Weintraub, Liza Minelli,
Chaim Gross and Bronka
Weintraub at Yeshiva University.

A Sculpture Plaza for relaxing.

ABOVE: Monumental Sculpture by Stella Shawzin at Robert Moses Plaza, Fordham University credit: Chris Maynard

STELLA SHAWZIN
recent sculpture

Eighteen pieces of monumental sculpture in bronze and marble
by Stella Shawzin are currently on exhibit at the
Robert Moses Plaza, Fordham University. The entrance to
the Plaza in on 62nd Street, near Columbus Avenue.

Stella Shawzin is represented by the *Weintraub Gallery*
where smaller size works are being shown.

Catalogue available

 WEINTRAUB GALLERY

988 Madison Ave. at 77th St. NYC • (212) 879-1195 • FAX: (212) 570-4192

THE NEW INTERNATIONAL TREND	The trend to create public and private sculpture gardens is becoming increasingly popular.

*The first color advertisement
placed by an art dealer in
The New York Times.*

adjacent to the Jewish cemetery. Our own cemetery was by then overflowing and the extra land was sorely needed to bury our shoulder-high mounds of dead.

In my capacity as Judenrat paymaster, I always insisted upon first paying the rabbis who conducted funerals, so that dead bodies lying about in the streets, an increasingly common sight, wouldn't breed disease as well as despair. The rabbis enjoyed certain privileges in war-torn Warsaw. They were considered "Kidusz-Hashem," which in Hebrew, loosely translated, means "sanctified to God." Unfortunately, these privileges also included being special targets for Polish thugs and abusive Germans who felt free to pull their beards and knock off their fur-trimmed hats, for their own perverse amusement.

I vividly recall one distinguished elderly rabbi storming into the Judenrat building with tears streaming down his face, crying in fury and humiliation that he had been caught by a group of German soldiers who had literally pulled huge hunks of his beard out by the roots, causing him not merely enormous physical but also psychological pain and anguish. Rabbis and Orthodox Jews, were, of course, special targets, but they were by no means our only co-religionists routinely and casually abused. Jews on work detail outside the "Jewish Living Section" were vulnerable to being set upon by roving gangs of Polish thugs and beaten. They were identified by the mandated white armbands with the blue Star of David. Jews were forced to carry heavy loads of stones or bricks up and down stairs without dropping any. My father was forced to submit to this form of harassment, and nearly died of a minor heart attack in the process.

As a Judenrat manager, I wore a special armband known as a "leiter" which entitled me to intervene, to the extent possible, in these hazings when I saw them. As the Ghetto ordinances took effect, and as their effects became clearer, our time was spent trying to figure out ways to intervene to stop harassment and molestation, which frequently included kidnapping, rape, and even casual murder.

We knew, for example, of an unidentified German soldier we called "The Killer" who, when the spirit moved him, would drive down the street to certain favored corners and shoot passing Jews at random. No amount of complaining on our part could persuade the German administrative authorities that it was worth expending any effort to catch this man. What were a few more dead Jews?

No indignity was too cruel to be visited upon innocent Jews by the sadistic Germans. One sordid proposal that the council rejected out of hand, risking death for defiance in the process, was one in which the Nazis promised to prevent cases of harassment of Jews,

and in particular the kidnapping and molestation of Jewish women in the street, if the Judenrat would organize brothels staffed with Jewish women for the pleasure of their German masters. Our instantaneous reaction was one of abject horror, that preventing no amount of harassment or molestation was worth paying such a horrendous price. In fact, the proposal caused such an uproar that the Ghetto nearly came to a complete halt. The Nazis miraculously ended up tabling that proposal, but they stiffened their insistence that no able-bodied men be exempted from work detail, except Judenrat staff.

In April of 1941, the Nazis demanded fifteen hundred Jews to work in "forced labor camps." Only fifty reported, and when the Polish and the Jewish police searched for the rest of them, they could not be found anywhere. Wealthy individuals paid ransoms to keep themselves and their families out of the camps. Of course, that was merely a means of extracting funds from wealthier Jews.

The much-despised "Jewish Police Force" was technically a Judenrat ancillary body, although Czerniakow exerted no control over its day-to-day operations. By mid-1942, this small army numbered some two thousand five hundred men, all outfitted in a uniform with wide caps with a blue band around them. The Jewish Police Force included men drawn from all levels of society, from members of the academic professions with college degrees to the lowest dregs of society. After its first chief, a Jewish convert to Catholicism named Szerynski, was arrested in connection with a fur-smuggling scandal, he was replaced by his assistant, a lawyer named Jacob Leikin. The Germans called him "Little Napoleon."

This hated little man became a much-feared sight inside the Ghetto as he paraded down garbage-strewn streets interminably walking his ever-present little dog. He held a leather rod in his hand which he used to hit innocent people without provocation. Later, in October 1942, he was singled out as a traitor and collaborator by the underground Jewish Fighting Organization. The death sentence was exacted by an assassin named Elihu Rozhanski who shot Leiken outside the police station on Gésia Street. Leikin's German paymasters, in return for his years of loyal service, responded by shooting his wife and his newborn child after his death. Such were the rewards of collaboration.

Even more despised and feared than the Jewish Polish Force was a sinister, shadowy organization known as the "Control Office for Combating the Black Market and Profiteering in the Jewish District." More popularly, it went by the dreaded name "Thirteen," after its headquarters at No. 13 Leszno Street. This murky bureaucracy

came into being in late 1940, soon after the erection of the Ghetto. At its head sat a former Zionist intellectual, Abraham Gancwajch, a journalist by profession who had been active in anti-Fascist circles before the war. After the Nazis came to power, they found in him the perfect tool to watch over his compatriots in the anti-Nazi movement. As early as 1933, Gancwajch was acting as an agent of the Gestapo, as an informant on "Jewish affairs." In his capacity as head of "Thirteen," he deployed an army of secret agents and informers throughout the Ghetto. A number of these collaborators were eventually liquidated by the Jewish Fighting Organization. Czerniakow feared and despised the "Thirteen" and Gancwajch, and by August 1941 was successful in having the group dissolved.

By that time the Ghetto had been provided with a new German administration, under a new Reichskommissar, Heinz Auerswald. Auerswald claimed total authority over the Judenrat, and its police organ, the Jewish Order Service (Jewish Police). Czerniakow found Auerswald cold and calculating and predictably Germanic in his compulsive determination to control the Jewish population like so many herd animals. He enjoyed trying to terrify Czerniakow with specific threats, such as that he would surround the Ghetto with captured Russian barbed wire until the entire population died of starvation.

Even more fearful than starvation was the continuing threat of typhus. The fever struck my father in early 1941. My mother was afraid to even summon a doctor, because she didn't want him confined to a hospital where conditions were downright murderous. Through a friend, Dr. Max Fliederbaum, I contacted the Judenrat's Health Department, which arranged to have medicine sent to him at home. The Jewish Police, we heard, were searching apartments to track down typhoid patients and forcefully confine them in the hospital. Sure enough, they came to search my parents' apartment and my mother had to bribe them to leave. To avoid a recurrence of that trauma, we had to find my parents a second apartment, no simple task under the chronically crowded conditions.

Not long after that incident, just as my father's condition began gradually to improve, we received the depressing news that my brother-in-law, my sister's husband, had disappeared. He had been arrested, we later learned, in the company of some of his fellow young lawyers, with whom he had been operating a clandestine radio station. We kept the news from my father, but after my brother-in-law didn't show up for a week, my father didn't have to be told what had happened. We never did learn what fate befell him.

Our lot was alleviated to some small degree by the arrival in our apartment house of a representative of the American Joint Distrib-

ution Committee, David Guzik. We became friendly, and his access to money and other scarce supplies was a godsend.

I was struggling to support an extended family of some twenty people. All food was distributed through a strict ration system, and as a Judenrat employee I was permitted to request an additional bread allotment. Since I knew every manager of every department, I was helpful to Guzik in discretely distributing his largesse through "channels." Though Guzik's official job was confined to providing food and supplies to Poland's starving Jewry, he quietly set aside a portion of funds with which to purchase arms, in preparation for a possible Ghetto uprising.

As 1941 turned into 1942, my job at the Judenrat became increasingly depressing. The conditions in the Ghetto, both materially and psychologically, further deteriorated. One unedifying sign of the times was that the council's Cemetery Brigade, under the ultra-orthodox Meshulam Kaminer, had become the Judenrat's chief source of funds, as the few remaining wealthy souls paid top dollar to bury their dead so that their death taxes "might go to keeping the living alive," as Kaminer put it. With the suicide rate soaring to unprecedented levels, traditional Jewish law complicated the burial task, requiring that suicides be buried beside the cemetery gate rather than in the cemetery proper. Now, there were so many suicides that it became physically impossible to accommodate all the bodies near the gate.

"Eat, drink and be merry, for tomorrow you'll die," became the prevailing philosophy within the shrinking, withering Ghetto. Many a formerly sober Jew fell prey to the vices of drinking, gambling, and lewdness out of sheer despair and lost hope for the future. Though I was no prude, the advent of semi-pornographic cabarets shocked my sensibilities. It was all part of the Nazi desire to reduce us to moral subhumans according to their twisted ideology.

Fewer and fewer Jews were willing to sign up for labor detail: the wages were too low, and the supervision too brutal. Now, details of Jewish police were forced to hunt for shirkers hiding in apartments, many of whom simply collapsed and begged to be shot in the street, rather than have to submit to another day of brutal slavery.

Soon, under the virulent combination of typhus and hunger, the dead began to collect in the streets like paving blocks. The poor could not afford even the cost of a modest burial, so they simply abandoned their dead in the streets. Like everyone else in the Ghetto, my strained sensibilities gradually grew numb at the sight of dead bodies clogging the gutters, sometimes covered with newspaper, other times lying exposed to the elements and to all of us. An over-

whelmed sanitary force stacked them like cord-wood in the freezing gutters, until the burial detail could cart them away. Sewage treatment and hygiene became nonexistent. As plumbing broke down, sanitary conditions deteriorated to a level unbelievable in a supposedly civilized Europe.

Finally, poor people sold their food ration cards to buy liquor, and went without food, preferring to numb their suffering and starve to death in drunken stupors than to go on living under such conditions. Morality unraveled; prostitution and bribery became the norm. The Nazis had deliberately created a new Sodom and Gomorrah on the Praga (the Warsaw suburb across the Vistula River).

Who could blame the weaker-willed victims among us? Who could condemn the women who fell into prostitution to save themselves and their families from starvation? Who, for that matter, could even entirely condemn the traitors, whose fear was so great that they would do anything, even betray their fellow Jews, for the slim chance of saving themselves? Elie Weisel has written movingly about these collaborators and traitors and smugglers and profiteers who deserve our pity, he maintains, because they were simply the weakest link in the moral chain.

Life in the Ghetto even for the relatively privileged Judenrat staffers became a constant, nagging struggle for sheer survival. I used what power I had to help friends and family get whatever provisions I could lay hands on, but as the noose tightened, the solidarity engendered by shared misery gradually dissolved, until even the most soft-hearted had to become practical and desperately realize that it was not possible to save everyone. At that point most people tried to help only their own immediate families. Unfortunately, as time went on, even those with access to small privileges began finding their links to supplies dwindling and, finally, cut off.

As a Judenrat staffer with a moral conscience, I began to define my job as a never-ending struggle to alleviate the misery of some— not all—no one could help all. The Warsaw Ghetto was a place where the quality of mercy was strained, and deliberately so. Bribery and corruption became commonplace, as daily life for all of us degenerated into a battle for diminishing resources. In the Nazis' eyes, we were rats trapped in a cage, fighting with each other like rats scrambling for any possible scrap of food.

A cataclysmic turning point in the destruction of Eastern European Jewry came in June of 1941, following the surprise Nazi attack on its former ally, the Soviet Union. Code-named Operation Barbarossa, this blitzkrieg swiftly brought an additional 1.7 million Jews under Nazi control. Inside the Ghetto, we heard only vague

rumors of the invasion, which ran counter to the Molotov-Ribbentrop pact and took Joseph Stalin completely by surprise. Stalin's purges of the military during the '30s had virtually wiped out the trained military cadres of the Soviet Union. As the Nazi blitzkrieg overwhelmed the unprepared Soviet forces, it was a miracle that what happened to Poland—total conquest—didn't strike down the Russian Bear as well.

As the Germans diverted more scarce food and supplies to their bogged-down troops in Russia, the Jews of the Ghetto received less and less of their castoffs. In theory, Jewish rations were roughly half that provided per capita to the Poles. In practice, we received little more than stale cereal. We reacted by growing as many vegetables as possible on the tiny bits of arable land inside the Ghetto, including the cemetery, as well as in flower pots on window sills, but this could not feed a hungry half-million, and only served to keep the starving barely alive, in a state of extreme malnutrition.

We reacted by obtaining what we could on the black market, and through "unofficial" channels, namely smuggled goods. In a situation in which the mere importation of enough food to keep people alive was branded a crime punishable by death, it became hard to condemn the smuggler who took his life into his own hands to meet the demand. As in all shortages, the Warsaw Ghetto had no shortage of profiteers and shysters and opportunists, not to mention outright thieves and scam-artists. Anybody who had any "pull" whatsoever with the authorities, even if it was the Jewish authorities, faced a dilemma: in theory, it was unfair that any one of us should get better treatment than anyone else. But in practice, the Nazis instituted an administrative hierarchy which those of us in it defied at our peril. And anybody who had "pull" and the will to exercise it risked being branded a traitor and collaborator merely by virtue of being co-opted by the highest authority: the German agencies in charge of "Jewish affairs."

In December 1941, just days after the Japanese attacked Pearl Harbor, another day that "will live in infamy" struck my immediate family. My brother and his wife were shot dead in cold blood in front of their own home upon returning from our parents' apartment, supposedly after the eight o'clock curfew. I was informed the following morning when a package of my brother's clothes and his personal effects was delivered to me at the council, with the terse explanation that they had been shot by a unit of Polish police for defying curfew regulations. Bernard was my younger brother, and of all my siblings had been the most optimistic about our chances of surviving as a family through this devastating ordeal. Now, this spirited, cheer-

ful voice had been silenced, as if at random, along with that of his charming young wife.

At that time, the thoughts of nearly every Jew in Poland were turning to desperate hopes of escape, and desperate courses of action. Of course, there was not a chance that our entire family could make it out together, even with the best-laid escape plan. The only chance was for individuals, possibly couples, to make their own plans and keep them well hidden even from family. My personal situation took a sharp turn for the worse as I waited on line to see a doctor near a large group of thin, diseased refugees, waiting for meal tickets.

At the request of a friend, an artist named Turkow whose child was suffering from tuberculosis, I had paid a call on the head of the Welfare Department, Mieczislaw Lustberg, a tall, handsome fellow with pronounced Aryan "good" looks who, rumor had it, enjoyed the favors of the Nazi bigwigs because he was homosexual. Homosexuality was rampant, we knew only too well, among the Nazi upper ranks, despite their martial bearing and military regalia. They loved dressing up in costumes, and engaging in all forms of perversity. On my way back from visiting Lustberg, carrying a tiny packet of virtually unobtainable medicine, I felt a biting itch in my neck. At home, I located a louse in my shirt. A louse found on one's person in most cases meant only one thing: typhoid fever.

In two weeks, I was running a fever of 103 degrees. Under the conditions then prevailing, despite my privileged access to rudimentary medical care, this was likely to be a death sentence. While Czerniakow's office kindly provided the services of a nurse and enough soap and milk in which to bathe my burning body, I consciously prepared for death while doing my best to revive my often-faltering belief in a benevolent God.

Czerniakow, despite all the pressures under which he was operating, noticed my absence and took care to induce the head resident of the overwhelmed Jewish Hospital to pay me a house call. But the doctor lacked medicine to treat my condition. All he could offer was a small piece of white cheese. This I devoured gratefully, to keep up my strength. Amazingly I recovered.

During my grueling convalescence, we received word that a group of resistors who had been meeting at the apartment of a friend of ours, the ardent Socialist Popower (my colleague at the Judenrat and head of the whole accounting department), had been arrested on suspicion of operating a clandestine printing press churning out anti-Nazi literature. Their worst crime, of course, was simply spreading the truth. The grainy broadsheet contained a smattering of "hard news" on the progress of the war gleaned from the dwindling

number of concealed radios. Not all of this was good news for the Nazis, and might encourage the Jews to resist by sowing the faint seeds of hope.

By that time, still hallucinating from the high fever, I knew that I had been close to death. I half expected the Germans to come and take me away at any moment. My crime? Simply knowing these doomed people, of course. Barbara sat at my bedside constantly, nursing me back to health. Gradually, as I continued to recuperate, although still suffering extreme weakness and after having lost close to 40 pounds, I attempted to report back to work. Assisted by Popower, who had miraculously escaped the hangman's noose during the roundup of his associates, I stumbled into Czerniakow's office. Taking one look at me, he forced a grim smile before ordering me out of the building and straight home to bed. I did win one bet though. I'd told the doctor that I was well enough to go to the toilet on my own. He insisted that if I dared to I would fall flat on my face. I bet him a bottle of wine, not easy to obtain in those days, that I could make it. He took the bet, and I won. Unfortunately, I was too sick to drink the wine.

Although disgusted by myself, my anxiety forced me to set up an appointment with the "King of the Smugglers," Yosele Fuhrman. I had heard through the grapevine that he might be interested in acquiring a few small pieces of art that had years before fallen into my possession from an acquaintance of ours, a former film director who had the wisdom to flee the country before the invasion. Few people in the Ghetto had much cash to spare, other than the Gestapo informants and the smugglers. These miserable creatures often possessed unimaginable wealth, by our standards at the time.

At a Dionysian bacchanal given by Fuhrman, which would have done justice to a banquet thrown by Petronius' Roman freeman Trimalchio, I watched with an odd taste in my mouth, a strange mixture of sickness and envy, as our gluttonous host devoured one hard-boiled egg after another, chased down by endless swigs of costly Russian vodka, obtained on the flourishing black market. Even to be able to digest a hard-boiled egg, let alone obtain one, was something of a status symbol. The deteriorated digestive tracts of many Ghetto Jews, so long deprived of sustenance, could never have dealt with such a massive assault.

After the hors d'oeuvres and before the first course, Fuhrman became too drunk to stand up. I seized my opportunity to show my paintings to this wine-sodden smuggler king. Fuhrman was, not surprisingly, something of a philistine—in Polish, we called his kind a "Baleguleh," which means "horse-and-cart man"—in short, a peas-

ant. Like so many newly rich entrepreneurs I would meet in later years, he had developed, or at least professed, a growing interest in art. Fuhrman seemed to like something about the way I approached this first of what would become a long line of art deals. As we sat down to the main course, he suggested in a half-serious, half-facetious vein that it might be interesting to acquire a young, smart ambitious junior partner close to the Judenrat bureaucracy.

He asked if acquiring the beginnings of an "art collection" would improve his social standing after the war. When I said yes, he shouted out in a half-drunken stupor to his young wife, whose cheap good looks were those of a courtesan, "Rochele, did you hear? We might become high-class citizens after the war!"

Now, drunk and out of control, Fuhrman openly propositioned me: he would make sure to provide my extended family with as much food as they could eat, if I would only consent to become his partner. Slurring his words, he confided that he had been selected by his "house committee"—informal organizations had arisen to provide a "populist" counterweight to the increasingly corrupt life—to supply a bunker suitable for twenty families, to await the end of the war.

All this, so far as I knew, was merely the stuff of pipe dreams and smuggler's fantasies. The real stuff of dreams lay before me on the table, waiting to be devoured at will. As I slurped vodka and attempted to swallow one hard-boiled egg, I was sorely tempted, I must confess, by Fuhrman's offer. I wasn't convinced that Fuhrman was evil so much as a clever opportunist. But some inner governor prevented me from giving in, despite his enticements. To get out of a potentially awkward situation and not offend this powerful underworld figure, I shook his hand with a firm grip and said warmly, "Yosele, don't worry, we'll be partners after the war."

That response seemed to please Fuhrman, and considerably relaxed the gathering tension among the other guests, who had grown concerned lest this young stranger offend their generous host. As the fish course was followed by a strange-looking, odd-smelling dumpling soup, which I was assured was pork not horse, he made the usual apology for serving "khazer," or non-kosher food. In return for the pork, which had become increasingly hard for even him to come by, he had been forced to give the recalcitrant farmer a beautiful set of fine English china.

The noose tightened further throughout 1942. The pace of "illegal" anti-German activity stepped up. The ever-divided Jewish leadership began to realize that it would be only a matter of time before the Ghetto faced extermination. Illegal newspapers, produced by underground organizations like the Jewish Bund, as well as the var-

ious Zionist factions, including the Revisionists who worshiped their absent leader Jabotinsky, did their best to keep up morale and advocate policies of passive resistance. Every Zionist faction had its own newspaper, distributed in editions of only a few hundred copies, but with an estimated fifty readers per copy. The left-wing Poale Zion faction, the Socialist Labor faction of the Zionist movement, published its own newspaper, *Proletarisher Gedank* ("Proletarian Thought"), while the Communist weekly, *Morgan Freiheit* ("Morning Freedom") was also widely distributed, in addition to an irregularly issued Proletarisher Radio-Bulletin, a compendium of precious news reports gleaned from foreign radio broadcasts.

Still, all the news and discussion in the world could not disguise or belie the fact that the Jews of the Warsaw Ghetto, whatever their political persuasion, remained essentially powerless in the face of overwhelming Nazi force. We were untrained civilians, lacking arms and training to fight back. The Germans, for their part, were experts in killing, in subduing captive populations, and in the most advanced methods of counterinsurgency. While the left remained convinced that fascism was doomed and advocated a policy of "sitting tight" until Hitler's inevitable defeat, the Zionists waited in vain for some show of support from world Jewry, particularly the wealthy Jews in America.

The onset of Operation Barbarossa, Hitler's invasion of Russia, provoked the Zionist Hechalutz organization to organize units of active resistance in preparation for a possible uprising. But the vast majority of the Jews of the Ghetto, weakened and frightened and literally starved into submission, preferred to passively wait for the Red Army to liberate Poland. The more hopeful among us were in for a shock when the tragic news came of the brutal extermination of the Jews of Vilna, the Lithuanian capital. Before the war, Vilna had been the most intellectually vibrant Jewish community in all of Europe, if not the world. I had attended law school in Vilna and had gotten to know a number of the more prominent Lithuanian Jews. In their passionate devotion to high culture and the life of the mind, I had found no equal to them, certainly not in relatively unsophisticated Warsaw. Now, they were all dying, or dead. I could do nothing but hang my head in sadness, recalling all my elegant hostesses with their fine food and finer conversation, exterminated in the death camps. Hope began to fade. The Germans might well be defeated, but when? Probably not soon enough to save us.

The harsh, brutal reality of our increasingly desperate situation prompted the advocates of active resistance to become more passionate in extolling the virtues of violent reaction. Adopting such a course on a broad scale, however, meant the immediate deaths of

hundreds and thousands of passive Jews. We felt like gladiators in the Roman coliseum, raising our right hands to the Emperor, crying out "Hail, Caesar, we who are about to die salute you." We were about to die, we all felt—the only question was when, and how. We had long since stopped asking why.

In early 1942, a rumor spread in the Ghetto that a Soviet parachutist had landed within our sealed borders with the express purpose of organizing active resistance inside our walled prison. The rumor turned out to be true, though the so-called "parachutist" had actually joined us by the less glamorous means of bribing a wall-guard to let him in. Pinya Kartin, better known by his Party name Andrzej Schmidt, was indeed a Soviet agent, a chemist by profession, and an ex-officer of the International Brigade in Spain. He came as an official representative of the Polish Communist Party (P.P.R.) and his mission was to help organize the various left-wing Jewish factions into a so-called united front. All sorts of splinter groups, from the top-secret Spartacus to Communists to Social Democrats were busy recruiting young, angry men for special combat training, particularly in urban guerrilla tactics. The Bund and the Zionists were active too, while the Revisionists under their leader Dr. David Wdowinski attempted to organize a group called the Jewish Self Defense. The Bund, a more conservative group, was opposed to the concept of a united front, for fear that the various cells might expose each other to infiltration by Gestapo agents.

The Judenrat leadership, for better or for worse, remained against violence right up until the very end. Passive resistance was sanctioned, condoned, even encouraged, but active resistance? It was plainly suicide. Nevertheless, whether to resist or not, and with whatever means was available, was obviously a matter of personal choice. Among those dedicated to pursuing the active resistance option, the great challenge was to organize "fighting units" of up to five men, trained without the benefit of arms in theories and techniques of firearms usage, in addition to the use of dynamite and the fabrication of homemade land-mines and Molotov cocktails.

The Germans had their spies out in force, and were waiting for the opportunity to strike. Early in the morning of April 18, 1942 they seized 52 "subversives" in their beds and shot them in the street outside of their homes for the capital crime of "resistance to German authority."

The cadres were further weakened when a significant number managed to slip out en masse and decamp for the Polish countryside, with the stated intention of linking up with Polish partisans said to be in hiding behind every tree in the hinterland. The leaders of the

P.P.R. were captured and shot while attempting to smuggle a hand-press into the Ghetto. The so-called anti-Fascist bloc was severely weakened by these raids, but not entirely eliminated.

Passive resistance, in effect sabotage, became the course of action adopted by many of the less bold who nevertheless found the opportunity to deface and virtually destroy the fur coats that were supposed to be collected and turned over to the authorities to keep the German troops warm while shelling Stalingrad. Some makers of uniforms sent out entire shipments of military tunics with the sleeves missing, or the pants legs sewn together. One morning in May, a number of smugglers were captured and executed by the Germans, among them the "King of the Smugglers," Yosele Fuhrman.

As rumors circulated that the Ghetto itself was shortly to be liquidated, and all its inhabitants exterminated like the Jews of Vilna, my parents began to pressure Barbara and me to use my connections to see about obtaining some Aryan papers. These could be kept hidden should an opportunity arise to slip out of the Ghetto to hide on "the other side." Danger also awaited Jews on the "other side," of course, the major one being that Jews would be denounced to the Gestapo by their Polish landlords or neighbors, or set upon by blackmailers and thugs, known as "catchers" who, upon the slightest suspicion of finding a Jew in hiding, would force men to "show their religion" by dropping their pants, often at knife-point, or require women of "dubious origin" to recite the Catholic Catechism and give the name of their Saint's Day.

At a substantial cost in both psychic and financial terms, Jewish men did have the option, if they wished to and could afford it, of having their circumcised penises surgically "corrected" by adding a foreskin constructed from skin grafts. This procedure was painful and risky. Infections could hardly be stopped due to lack of disinfectants, let alone antibiotics. Yet many had the operation, which often led to chronic impotence.

My "connections" among Aryans consisted of a few friends who worked in one of the workers' eye clinics, the so-called "Kasa Chorych." They set up an appointment for me to meet with some members of the Polish underground who had ways of acquiring Aryan papers. After taking off my armband and obtaining a special pass from Czerniakow, I paid a visit to the eye clinic. After waiting several hours in the waiting room, I was brought into an "examination room" where two underground agents posing as eye doctors gave me identity cards taken from a Polish couple named Winiawski who had recently passed away without leaving relatives. We were given a code to contact when the time rose for us to "cross over." But they

stressed that it was becoming increasingly difficult to obtain "safe houses" for Jewish families. The Germans were doing a too thorough job of discouraging the practice of hiding Jews, by shooting entire families caught so engaged, without trial.

I was given the papers free of charge. Despite the widespread anti-Semitism of the Polish people, clearly there were exceptions. Many Jews, like me, would never have survived the war without the intercession of Poles like these brave resistance fighters. My Aryan papers were obtained just in the nick of time because, on July 21, 1942, the mass liquidation of the Jews of the Warsaw Ghetto began.

The Germans announced that 60,000 Ghetto Jews were to be deported for "resettlement in the East." The reason given was that Warsaw would remain a center of Jewish war production for the German military and that those Jews deemed "unproductive" or "nonessential" to the German war effort would be deported. They would simply be "resettled" in some strictly segregated enclave in the conquered Soviet territories, another ghetto, but this one in verdant rural surroundings. To pacify the Judenrat, Czerniakow was told that the Jews who went willingly to be resettled, would be permitted to "start new lives" in this new enclave, free of German law. Of course we didn't know that it was all a diabolical charade. Even the sometimes overly gullible Czerniakow knew that the Germans were not to be trusted. Still, one questions whether the Judenrat should have cooperated so willingly in organizing these first, not to mention the later, mass deportations. Czerniakow, had no choice but to follow German orders. If he didn't, the orders would have been enforced without him. The penalty for not obeying was execution. He was told that the unskilled Jews of the city would be forced to perform farm labor. But he actively wondered, as evidenced in his moving diary which survived the war, if such a fate was worse than that suffered by the starving Jews inside the Ghetto.

The Gestapo went to great lengths to deceive the Jews into believing in this "new life in the East." Postcards came from the fabled country "in the East" where hardworking, morally superior, full-bellied Jewish farm laborers claimed to have found happiness in a life of stark, harsh rural labor. The Gestapo sent agents into the Ghetto factories to conduct extensive, detailed inventories of machines and equipment, with the explanation given that this was the first step in the process of "shipping" entire factories to the East. Not all the work would be lowly or menial "farm work." There would also be ample room for artisans, skilled industrial workers, even artists and scholars.

Nobody knew, save the Germans of course, that at the now-notorious Wansee conference held at an elegant villa in a Berlin suburb,

GENERALGOUVERNEMENT
GENERALNE GUBERNATORSTWO
KENNKARTE
KARTA ROZPOZNAWCZA

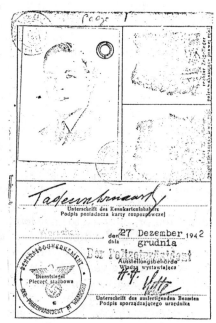

Kennort / Miejsce wystawienia

Kreis / Starostwo powiat. — Distrikt / Okręg

Kennummer / Numer rozpoznawczy — 665839

Gültig bis / Ważne do — 27 Dezember 1948 grudnia

Name / Nazwisko — ~~Winiawski~~ Wajntrob

Geburtsname (b. Ehefrau) / Nazwisko panieńskie (u mężatek)

Vorname / Imię — ~~Tadeusz~~ Jakub-Dawid

Geboren am / Urodzony (a) w dn. — ~~21.8.1915~~ 21.8.1905 r.

Geburtsort / Miejsce urodzenia — Litzmannstadt

Kreis / Starostwo pow. — Litzmannstadt — Distrikt / Okręg — Warthegau

Land / Kraj — Deutsches Reich

Beruf / Zawód — erlernter / wyuczony — kein – żaden
— ausgeübter / wykonywany — Büroangestellter urzędnik

Religion / Wyznanie — röm.-kath. – rzym.-kat.

Besondere Kennzeichen / Szczególne znaki rozpoznawcze — keine – nie ma

Unterschrift des Kennkarteninhabers / Podpis posiadacza karty rozpoznawczej

den / dnia — 27 Dezember 1942 grudnia

Ausstellungsbehörde / Władza wystawiająca

Dienstsiegel / Pieczęć służbowa

Unterschrift des ausfertigenden Beamten / Podpis sporządzającego urzędnika

*Tadeusz Winiawski's Kennkarte
—Jacob Weintraub's Aryan
passport.*

the Final Solution had been devised, and was now in the process of implementation. Despite the example of the Jews of Vilna, and the exterminations of other Jews in similar provincial cities, the Jews of Warsaw desperately wanted to believe in this fabled "resettlement."

Not everyone, however, bought the German deception. Some political parties increased their pressure and preparations to embark on a course of active resistance. Other people, less brave perhaps but also possibly a little less gullible, laid plans to escape like me.

The political parties called a meeting of their leaders to plan some sort of reaction to the deportation order. Among the sixteen who met in secret were David Guzik and his associate, Isaac Giterman, from the Joint Distribution Committee, in addition to representatives from the left-wing Poale Zion, Hechalutz, and a member from the Agudah, an Orthodox group, as well as a sympathetic member of the Judenrat, Rabbi Zishe Friedman.

In response to the obvious question, "What is to be done?" only the left-wing Zionists, the Hechalutz, and a handful of others backed a program of active resistance. Rabbi Friedman proclaimed his faith in God and his hope for a miracle. "Dear friends, endure a while longer and freedom will come!" the rabbi exhorted them, but few among his listeners were moved.

On July 28, a week after the announcement of the intended deportations, a general staff of the grandly named Jewish Fighting Organization (Zhydowska Organizacja Bojowa, hence the acronym "ZHOB") was mobilized. The total arsenal of fighting weapons consisted of a single revolver in questionable working order. A delegation of would-be resistors with good "Aryan visages" were deputized to cross over the wall and obtain weapons on the black market.

By the end of July, the Bund received word through underground channels confirming what many of us had for so long suspected: the Germans were lying. The transports being shipped ostensibly to "the East" were heading not for the former Soviet territories but to Treblinka, the top-secret "death camp" near the Bug River in Poland. After obtaining this news from a railway worker who had seen evidence of mass exterminations and gas chambers with his own eyes, the Bund issued a special edition of its underground paper *Der Storm*, in which explicit details of the mass exterminations at Treblinka were revealed.

The Bund raised the outcry, "Do not go voluntarily." But the Judenrat officials chose to denounce the Treblinka story as a fabrication. Meanwhile, the Polish underground debated the issue: whether it was nobler to help the Jews mount a mass uprising or let them go like sheep to their deaths.

One of the great unexplained tragedies of this period was that word was sent to the Polish government-in-exile imploring them to appeal to the British High Command to threaten reprisals against German nationals held under Allied control unless the deportations were canceled at once. London ignored the appeal—if the Polish exile government had in fact even bothered to transmit the request. The sad fact was that this supposed bastion of Polish anti-fascism contained large numbers of professed anti-Semites not in any great disagreement with the German desire to once and for all provide a solution to Poland's "Jewish problem." General Sikorsky, commander-in-chief of the Polish military forces under the direction of the government-in-exile, was one noble exception. He deserves high praise for doing what he could to counter this overt anti-Semitism by pointing out what should have been obvious: that the Allies were fighting for democracy, and that doing whatever could be done for the Jews in Poland would further the cause of democracy.

It says much about the depths of anti-Semitism in the Polish upper classes, who were well represented in the government-in-exile in London, that Sikorsky's passionate appeals fell on deaf ears. Meanwhile, the Polish Communists who were following their own agenda—the pacification of Poland after the war, following a probable Nazi defeat—arranged for a few arms to be smuggled into the Ghetto. Other would-be Jewish partisans managed to escape over the wall and into the woods, but quickly came under attack from anti-Semitic bands within the Polish resistance. A large number of the unarmed Jewish partisans were killed. Only a remnant returned, profoundly disillusioned, to the elusive safety of the Ghetto. Other partisans, by contrast, did what they could to help the Jews and traded weapons for smuggled German military uniforms manufactured in ghetto factories.

But no amount of hand-weaponry could stop the German killing machine. A deportation center was set up at the Umschlagplatz, the square leading to the loading platform in the freight yards from which Jews were sent to their deaths at Treblinka. The "center" was to carry out the "selection," ostensibly separating the "productive" from the "nonproductive." In July there had been an estimated 350,000 Jewish inhabitants of the Warsaw Ghetto. In September, just 50,000 remained. Close to 300,000 Jews had been shipped from the Warsaw Ghetto to their deaths. The survivors were herded into four separate districts set up within the confines of the Ghetto.

At that point, I devoted myself to obtaining working papers (Ausweis) for as many friends and family members as I could by trying to get them declared "productive" by some official in charge.

Judenrat staff were, for the time being, considered nominally "productive," although that exemption was not to last for long. While it did, I felt I could justify my continued existence by using my remaining connections to save more lives. Unfortunately, I had very few means at my disposal.

Czerniakow, for his part, tried to do much the same thing, right up to the last minute. When instructions for deportations were announced, with provisions for granting exemptions to certain categories, he invariably pulled as many strings as possible to widen the exemptions. He repeatedly requested, though never received concrete assurances, that orphans, for example, would be saved. Of course, Czerniakow had heard the "rumors" but he firmly believed right up to the last day that the "camps" to which the deportees were being sent were in truth "labor camps." While two death camps, Belzen and Sobibor, were by then operating at full capacity on Polish territory, their true function was kept well concealed. Treblinka, the most notorious of the camps, had been rushed to completion in the spring of 1942 at the edge of the Warsaw district, near the Bug River. But up until the very end, Czerniakow was convinced that the "rumors" about gas chambers were just that, unfounded rumors.

On the evening of July 23, Czerniakow went home to supper. Around seven, he was summoned by the S.S. to council headquarters. There, he was provided with a set of new directives. That afternoon, I had gone with Hornstein, a Judenrat secretary, to visit Hillel Zeitlin, a friend whom I was hoping to exempt from deportation. As we made our way back toward the council building, we were stopped by a Jewish policeman, short of breath. "Chairman Czerniakow has committed suicide," he gasped. We ran headlong to the council building. Just a few minutes before Czerniakow's body had been found by a clerk who wondered why the phone in the chairman's office had kept ringing, ten or twenty times, without anyone answering. On Czerniakow's desk there was a half-full glass of water, and beside it two letters: one to his wife, asking her to forgive him for abandoning her, another addressed to "the world." In that second letter he wrote: "10,000 are demanded tomorrow, 7,000 after that...." He closed the letter by saying that the S.S. wanted him to "kill children, with (his) own hands...."

No longer gullible, no longer a wishful thinker, Czerniakow had faced the truth on July 23, 1942, the ninth day of the Jewish month of Av, the day on which 1,872 years earlier, Roman legions had set fire to the Temple in Jerusalem.

The deportations continued as Czerniakow wrote — one day 10,000, the next 7,000, as Jews by the thousands were marched to

the Umschlagplatz, the square from which the trains left for "the East." The "Jewish Order Service" conducted this "action," lulled by a false sense of security that they would be protected from being next. Many of these men, who had begun their service with college degrees from prestigious universities, had by the end sunk to a level approaching the barbarian. These weren't born killers; but their recent experiences had efficiently dehumanized them.

By early autumn, the Warsaw Ghetto had become a virtual ghost town, with four distinct neighborhoods which contained the fateful Umschlagplatz, the offices of the Judenrat, and the houses assigned as living quarters for Judenrat personnel. It also contained the Wertergassung, the S.S. department responsible for the reception and "disposition" of Jewish goods seized from deportees en route to the death camps. The "Productive Ghetto" contained the factories and warehouses of certain large German firms which continued to operate using Jewish "slave labor." The "Brushmaker's Ghetto," smallest of all, contained a single complex in which Jewish workers turned out brushes ranging in size from toothbrushes to heavy floor brushes for use by the German army. In a "Neutral Zone" that had been cleared of its former inhabitants a number of so-called "wild Jews" lived; these were Jews without identity cards.

Even harsher new rules now went into effect. No one was permitted to be on the street without special permission. Movement from one factory to another was not allowed. Workers were marched in groups, like the prisoners they were, from their homes to the factory. Even sick workers were escorted by police to the hospital. Violation of these orders was punished by immediate execution on the spot or by transportation to Treblinka.

"Selections" continued, and the only way to avoid being picked up by the cruising selectors and shipped to Treblinka was to try not to be around when they raided a certain section. Generally, up until the very last days of the deportations, the Jewish Police would advise the Judenrat members as to the next section to be targeted. But as time went on, and the Jewish Police themselves came under threat, such warnings were no longer reliable, even when they were forthcoming.

During one such selection, I narrowly escaped when I spotted the Gestapo units accompanied by their sadistic Ukrainian guards stomping right down the street in my direction, just a few yards away from the street corner where I was standing. I made a mad dash for cover, to a bakery off Gésia Street, where I hid in a cold oven until the Gestapo contingent had moved on. Remarkably enough under these conditions, the Jewish resistance actually gathered strength, as it became increasingly clear that the choices open to

most of us, such as they were, were to find some means to escape from this hell-hole, stand and fight or at the end, be led like the proverbial lamb to slaughter. Of course, still another option was the one taken by Czerniakow, a means of escape which Barbara and I actively considered.

Fortunately, we had our "Aryan" papers, which we'd kept well hidden. The papers alone, of course, would not save us unless we accomplished the nearly impossible escape from the Ghetto. The most accessible escape route, the sewer system, was a high-risk option since the Germans routinely sent poison gas though the sewers, while Polish hoodlums lurked in their watery shadows, lying in wait for Jews from whom they stole whatever money they carried.

And even the dangers of being caught and found out as a Jew on the "other side" were very real. One precaution that any would-be "Aryan" had to take was to learn the Catholic Catechism from some sympathetic priest, along with whatever Catholic lore one was able to pick up, including such details as the name of one's "Saint's Day."

A small group of us hatched a secret plan to escape from the Ghetto and take up residence in an apartment on Ciepla Street, on the Aryan side, just over the border. The apartment was rented by some friends from the movie-theater business named Jan and Irene Goldfarb, who had papers identifying them as an Aryan Polish couple named Wozniak. They had obtained the apartment through a prewar friend, Dr. Karl Kosowski, who had managed to flee the country. One day in October 1942, the Wozniaks managed to leave the Ghetto as part of a labor battalion and slip away unnoticed. They went straight to the apartment on Ciepla Street.

Unfortunately, my parents did not agree to participate in this plan to go to Ciepla Street, and chose to await whatever fate lay in store for them in the Ghetto. As Barbara and I made our plans, my parents were living in a small apartment on Nalewki Street outfitted with a small bunker in which they hoped to survive the ensuing months. The Russian planes were by then regularly bombing Warsaw, and the optimists among us hoped that the Red Army might cross the Vistula and liberate Warsaw before the Germans managed to kill us all.

As Barbara and I were finalizing the details of our escape plan, I was at my office in the now-empty, much smaller Judenrat building on Muranowska Street when a Jewish policeman came running in and screamed that the Germans had "picked up" Barbara and that she was even now being hauled off to the Umschlagplatz. I nearly collapsed at this word. But I calmed myself to think clearly that my wife's life was in danger. I managed to wangle a car and driver from

the few remaining available to Judenrat staffers. We quickly nego-
tiated the shell-pocked streets to the great square where the railroad
tracks met: the dreaded Umschlagplatz. The first person I saw was
my friend Nahum Remba, a Judenrat staffer who had set up a
"clinic" at the Umschlagplatz staffed with men and women in white
coats whom he claimed were doctors but who by sheer bluff had
gained permission to haul deportees out of the "selection" line for
"medical emergencies."

I told Remba what I'd heard, and together we scouted and scoured
the long lines of grim figures for Barbara. Finally we found her, shuf-
fling purposefully and dutifully along like a lamb being led to slaugh-
ter. She later told me that she simply felt she was done for and that
there was no point in trying to resist. Remba and I cried out her
name, she turned, and Remba dispatched one of his "doctors" to
retrieve her from the death line. Barbara and I returned to our
apartment, and when she finally recovered from the trauma, she
said with large tears coursing down her face, "I don't think I'll leave
home again."

It was clearly only a matter of time before we both would be
"deported." We couldn't wait a day longer. One particularly cold day
in November, I dressed in worker's clothes and joined a labor bat-
talion on work detail just outside the Ghetto walls. During a break,
I bribed the Ukrainian guard and slipped away, intending to make a
break for Ciepla Street. We had laid plans for Barbara to follow pre-
cisely the same plan, joining a woman's work detail and follow me a
day later. As I strolled down the street toward an alley where I had
hoped to change into less-conspicuous "civilian" clothes, I sensed
somebody following me. Soon the shadow behind me became real,
and touched me lightly on the collar. He was a tall man in army-
issue woolen great coat, buttoned tightly to the neck. He shook a
bony, tobacco-stained finger at me.

"Jew!" he cried out, after examining my face.

"Get your hands off me," I tried to bluff him. "Let me go!"

"You'd better give me all you have," he replied, thrusting his filthy
face, with beer-laden breath, into mine.

"I am a Polish citizen," I replied, "and if you don't let go of me, I'll
take you to the Germans."

"Let's duck into that alley and you can prove you're a Pole," the
man sneered. "Go on Jew, prove it! Show it!"

This man, I knew, was what in Polish we called a "fat skimmer,"
meaning someone who lives "off the fat" of others—in this case Jews
hiding under secret identities. The man wore glasses and without
thinking, small and weak as I was, I raised a fist and punched him

square in the face. The glasses broke and I heard the cartilage of his nose snap. I ran as fast as I could.

Returning to the safety of the labor battalion, I asked the Ukrainian guard for a swig of his vodka with which to disinfect a small cut on my right hand from the man's shattered glasses. With that particular escape now foiled, Barbara and I nervously awaited another opportunity.

By January of 1943, Judenrat staffers were losing their exemptions from deportation. Clearly, every Jew in Warsaw was going to be killed, if the Germans could manage it. During that month, the Gestapo requested from the Judenrat a complete list of single employees, the clear and ominous implication being that those unmarried Judenrat officials would be deported immediately. A number of us hatched a plan to have our single employees marry each other, which would require the help of Professor Meyer Balaban, a prominent rabbi and head of the Jewish Archives. Approached with what we assumed would be a straightforward request to conduct a number of marriages and sign the necessary certificates, backdating them if required for plausibility, Professor Balaban insisted that this went against his religious principles, and that it would mean taking the solemn ceremony of Jewish marriage in vain.

This decision would have meant the death of a number of close friends, so I led a delegation to Balaban's home, to convince him that he should sign the necessary documents, strictly as a formality, only for the sake of saving lives. I was tough with him. I said, "Professor, I was your student at rabbinical school and you taught me that in time of an emergency a rabbi is empowered to do certain things that are not, shall we say, strictly kosher."

Balaban was astonished. He clearly had not expected to find a former student willing to argue with him a point of Talmudic law. "If you are not well on Yom Kippur," I pointed out, "you don't have to fast, on the principle that to do so might endanger a human life. Is that not true?"

"Yes," Balaban admitted that the point was well taken.

"Well, Professor, I think the same principle could be extended to this situation." That was all we needed. Balaban signed the marriage certificates.

Little did I know that I would have a problem with a few female staffers, one of whom said to me, "Thanks, but no, thanks. I don't want it, I don't want him," by which, of course I knew that she did not want or intend to sleep with her new "husband." I explained that she didn't have to. That was not the point. This was about saving lives, her life, the man's life, not making love.

When the S.S. finally came for us, in our apartment building, they posted a Ukrainian guard at our door. They waited while Barbara and I gathered a few precious belongings before being marched down to the Umschlagplatz, from where we were scheduled to be herded onto waiting cattle cars.

We were packed into the old hospital building. Several thousand of us soon filled it beyond capacity. I saw a man take out a brown glass vial, sip it and slump toward the floor. Our bodies were packed too tightly for him to even hit the floor. It was six or seven hours before the loading of the trains began. This at least provided us a bit more room to maneuver.

Stepping into an adjoining room with the hope of relieving myself, I was struck by the thick stench of human feces, many of these people having voided themselves strictly out of terror and anxiety. After relieving myself in a corner, I was shocked to hear a woman's voice call my name. Turning, I saw my old secretary, Irene Kesselman, for whom a few months earlier I had succeeded in obtaining an exemption from deportation. It must have been near midnight when Irene came and sat beside me and an exhausted Barbara on the filthy floor. She confided to me that she had arranged to make a break for the "Aryan" side the very next day. Now, she said, that prospect seemed remote. Something in her eyes signaled stark resignation.

"Jacob," she said quietly, with tears in her eyes, "I have something for you."

Lifting her dress, with all possible modesty, she began to yank at something sewn into the lining of her corset. Irene, I knew, was from a well-to-do family. Within a few seconds she produced a worn, bulging leather purse. Inside, she whispered, she had managed to secure one hundred gold dollars.

"Look, you and Barbara are young and energetic. Take it."

She pressed the purse into my hand; I tried to return it.

"No," she said repeatedly, "I've made up my mind."

A Jewish policeman stood in the shadows. I called to him in a hoarse whisper, asking him to step with me into a corner. Explaining that I had a certain amount of money, I asked him to ask one of the German S.S. officers if a bribe might be possible to let us out of the building.

He hesitated, possibly sensing a trap, but then agreed to do what he could. He was gone for half an hour. When he returned, he whispered that between three and four in the morning — it was now midnight — the officers on duty changed shifts. I gave him fifty dollars, half of all Irene had given me, and promised to give him the other half on our way out of the Umschlagplatz. Wondering if I'd

ever see him again, my heart soared when about four in the morning, the policeman reappeared. I gave him the rest of the money and he led us out a side door into the bitter-cold Polish night.

In the end, I don't know what happened to my parents; Barbara found out that her mother had been taken to the Umschlagplatz, and had never been seen or heard from again. I heard rumors that my brother Nathaniel had escaped to Russia, but I have never been able to locate him. My sister Esther, married to a doctor, was killed when her bunker was bombed and my other sister, Gucia, did not survive either. I have never found out how Gucia's life ended. Barbara and I had done all we could to help them, but for all of us to try to escape together would have meant suicide.

Slipping through the infamous square, the policeman pointed us to a hole in the wall, which he assured us would not be a trap. We had no choice but to trust his word. Carefully we made our way out into the deserted street, finding ourselves in the unoccupied no-man's land surrounding the Ghetto walls. Irene had a place to hide with a friend in a bunker. We arrived at the apartment on Ciepla Street, where we knocked on the door the agreed-upon Morse code. The door was slowly opened by a sleepy-eyed Irene Goldfarb, aka Wosniak.

Fair-haired Irene Goldfarb, nearly six feet tall, was the handsome daughter of a successful architect. Raised by nurses and educated by private tutors, Irene had grown up as the pawn of her dictatorial father who scrupulously controlled her choice of companions and activities.

In obvious rebellion against her authoritarian parent Irene fell in love with Jan Goldfarb, a penniless, dreamy inventor with a head full of ideas for kitchen appliances—mechanical potato peelers, electric knives—that he had convinced himself would some day revolutionize the modern kitchen.

For all his interest in domestic gadgets, Jan was not the most cooperative of husbands, and the underlying unhappiness in the relationship only deepened when the marriage produced a beautiful boy named Michael. Michael was captured by a German patrol, apparently bent on rounding up all the good-looking Jewish boys in Warsaw. Irene, against her better judgment, had given Michael permission to visit a friend just a few blocks away and never saw him again. After Michael's disappearance, Irene attempted suicide by downing a whole bottle of sleeping pills. With the help of a friendly Catholic priest and a doctor with a stomach-pump, Irene survived. Thereafter, under the pressures induced by the war, their marriage miraculously improved.

Jan then responded well to the pressures on him to provide for his family under the occupation. While to his credit he disdainfully turned down a job with the Jewish Police, he did join a labor battalion as a foreman. This brought in enough money to survive. Irene and Jan managed to rent this large apartment on the "Aryan side" of Warsaw through the mediation of some sympathetic Poles whom she for justifiable reasons would not name. Much as Barbara and I had done, they had slipped across while Jan was on labor detail by bribing a guard, and managed to take up residence on the Aryan side with the help of their doctored papers.

The dangers of detection, though, were enormous. These were compounded by Irene and Jan's willingness to share their humble abode with other couples, all refugees from the Ghetto: Jan's brother, Stefan, and his wife, Maria, and a couple named Altman, Benjamin and Dvora, and now, Barbara and me. Irene, who had the most "Aryan" appearance and the least suspicious papers, had placed herself in charge of obtaining provisions for the entire extended household. Each woman was responsible for cooking for her own family, but everyone shared in other domestic tasks, such as cleaning, which could not of course be entrusted to a Polish maid because of the danger that she would expose us.

To conserve our funds, we ate the plainest meals—even for the Poles on the Aryan side. The basic staples had become hard to come by, and horrendously expensive. But at least they were meals, and the illusion of prosperity and safety could be maintained during our happy, intellectually stimulating conversations around the table. It was dangerous even to chance a glance out the sitting room and kitchen windows, for suspicious neighbors might catch a glimpse of this "overcrowded" apartment. Such a density, even in war-ravaged Warsaw, meant only one thing: this was a residence of Jews-in-hiding.

Jews-in-hiding could be denounced and turned in to the Gestapo at any time. Armies of Gestapo agents, along with Polish ancillaries, were on the constant lookout for just such "deviant" living situations. To keep a low profile, anyone wishing to go into the sitting room while other residents were in the kitchen had to pass through the bedroom. As if we were living in the dormitory of an exceedingly strict water-short boarding school, in the morning each of us rose at a designated time, performed our morning ablutions, while only the sixth person to use the toilet flushed it, so as to minimize a potentially suspicious frequency of flushings. Irene's tutelage under her rigid, strict father had given her the training in domestic precision to run this household like a tight ship. It was a form of survival train-

ing, living this way, as critical as any we had learned while negotiating the horrors of the Ghetto.

A great hardship, hard as any after a while, was cabin fever: claustrophobia, boredom, restlessness, lethargy, irritation, depression, these too were enemies to reckon with. All these states of mind, in a bewildering variety of semi-lethal combinations, struck each of us at various times and it fell to their housemates to try to lift the most afflicted out of their despair.

Jan's brother Stefan, highly cultured, proud, and a fervent Socialist, had found many faiths in Western culture and socialism. Badly shaken by the anomalies of wartime, from the massive betrayal of the Molotov-Ribbentrop pact, which made a mockery of Communist espousals of strident "anti-fascism," to the inescapable fact that the most culturally advanced country in Europe had within the space of a few years mutated into a sadistic nationalist monster, Stefan had not had an easy adjustment to the realities of the Ghetto. Particularly after his mother was shot by a Ukrainian guard impatient with her slowness while being taken to the Umschlagplatz.

Still, despite a smothering pall of bitterness and misery, Stefan was bright and articulate. At times I felt grateful for his companionship, whiling away the endless hours analyzing the progress of the war from a Marxist-historical perspective. Stefan planned our discussion groups so that the idleness and confinement wouldn't atrophy our minds: on Monday, discussions of religion and the role of God in the modern world, particularly in contemporary Warsaw, where the intercession of a benevolent deity had been sorely missed; Tuesday, financial concerns and solutions; Wednesday, literature and philosophy; Thursday, in fond memory of Stefan's Thursday night subscription to the Warsaw Philharmonic, music and art. Friday we chose to settle the problems of the world, with particular attention to settling the future of the world after the Nazi's increasingly inevitable defeat. On Saturday the Altmans taught us to play bridge. On Sunday, we kept the Sabbath! For to our Polish neighbors, any deviation from the conventional routine, no matter how subtle, might have aroused undue suspicion.

Benjamin Altman, only in his mid-forties, looked much older, with his stark white hair and marked tendency toward mystical, Cabalistic prediction. He maintained Jewish ritual with a fervency admirable under the circumstances, and every morning on our way to the bathroom we could see him, old before his years, standing before the window, with his silk tales (fringed prayer shawl) draped across his massive shoulders, deep circles under his eyes, and his lips moving in silent prayer. In civilian life, for all his mystical qualities,

Benjamin had displayed a positive talent for making money. Now, living under the dark shadow of the Holocaust, Benjamin prayed steadfastly for guidance in a world where money had helped, but only marginally, to solve life's problems. His wife, Dvora, for obvious reasons, profoundly resented her husband's shortsightedness in having ignored her constant entreaties to visit America, ostensibly to pay a visit to the 1939 New York World's Fair. Now, racked with guilt, Benjamin played bridge and prayed, still mentally immersed in the arcane complexities of long-forgotten business ventures in prewar Warsaw, while his bitter wife, unable to forgive him for the sin of historical myopia, sat by the hour plucking the gray hairs from her dark mane, or silently mending nearly invisible flaws and rents in her voluminous clothes.

In the month that we took up residence in hiding on Ciepla Street, Hitler's sadistic S.S. chieftain, Himmler, took umbrage at finding even the miserably shrunken Warsaw Ghetto still in existence. In a secret letter dated October 10, 1942, addressed to Obergruppenfuhrer Frederic-Wilhelm Krueger, chief of staff in charge of S.S. police operations, Himmler ordered that out of the 40,000 Jews still estimated to be living in the four small ghettos of Warsaw, only 16,000 should remain. All the rest were to be liquidated at once.

On January 18, 1943, the carefully conducted selections commenced at the Umschlagplatz, with the commander of the Treblinka death camp, S.S. Hauptsturmfuhrer Theodor von Eupen-Malady, a celebrated guest at the spectacle. The Jewish Fighting Force (ZHOB) was taken by surprise by the rapid onset of this "action," but rapidly responded: a German detail was attacked with a barrage of Molotov cocktails, iron bars, stones, and a few precious hand grenades as it escorted a throng of weeping Jews to the dreaded selection center. The attack surprised the German forces, which had never encountered any organized resistance to its Jewish roundup and deportation operations. But the attackers were quickly killed by an overwhelming German response as their battalion was quickly reinforced. But not before the many Jews, now free of armed escort, escaped by melting into the Central Ghetto.

Fighting broke out all across the "Productive" and "Central" ghettos. At the Umschlagplatz, fighters who infiltrated a group of workers in the process of deportation threw hand grenades at the guards, disarmed the Germans and their Ukrainian back-ups, and urged the workers to flee to safety. Scenes like these were played out across the Ghetto, in response to this final order for deportation. The now-famous Warsaw Ghetto uprising, one of the bravest and most isolated instances of active resistance to German genocide, had at last begun.

The remaining Jews were united in this course of action. If they were to die, they planned to die fighting, while killing as many Germans and Ukrainians as they could before being wiped out themselves. All over the Ghetto, bunkers were built, with the active involvement of professional architects and engineers recruited from the labor battalions. Under the noses of the Nazis, the Warsaw Ghetto was tunneled and transformed into a virtual underground labyrinth, with sub-cellars dug under cellars, leading down to huge caverns under hidden false floors, with entrances artfully and carefully concealed.

Multiple exits were dug for massive and rapid evacuation of these communal shelters. ZHOB had its own reinforced underground bunker, outfitted with short- and long-wave radio transmitters and receivers, providing the rudiments of a communications system. The sporadic and largely spontaneous uprisings of January had impressed the Polish resistance, who now began to adopt the position that to help the Jewish resistance was to help themselves. The Jews were supplied with weapons in ever-increasing strength. All over the Ghetto, primitive workshops were constructed specifically for the purpose of manufacturing homemade explosive devices and grenades. Still, the Jewish Fighting Forces remained poorly armed, in comparison with the enemy. The entire Jewish force still had, for example, just one machine gun.

Assassinations of the most-hated collaborators were carried out by the Jewish Force. The Gestapo agent Dr. Alfred Nossig, Furstenberg, a Judenrat director of the Umschlagplatz area, and other criminal types such as the infamous Ele Malpe (Ele the Monkey), a notorious Gestapo informer, were among the enemy marked for death.

The inevitable response to this brazen resistance was not long in coming. On February 16, 1943, Himmler wrote to his commanding S.S. officers: "For security reasons, I have ordered the destruction of the Warsaw Ghetto...to put an end to the criminality which will continue as long as the Ghetto exists." By April, the "detailed plan" requested by Heinrich Himmler was ready: "Concentrate armed forces on Zamenhofa Street, then spread out in all directions, and clear the Ghetto by force." The force assigned to carry out this "final action" was overwhelming: an additional 7,000 S.S. troops were assigned to Warsaw. The "ethnic cleansing" operation was expected to be completed in three days, or less.

The Nazis predictably selected Monday, April 19, the eve of Passover, to commence the operation. At 6 a.m., detachments of German troops entered the Ghetto via the Nalewki Street gate and proceeded to conduct cleaning-up operations. ZHOB ambushed the vanguard and killed twelve Germans immediately, while from the windows and balconies shots rang out and Molotov cocktails filled

the air. The overwhelmed German commander placed an urgent call to General Stroop, the nominal commander of the operation: "All lost in the Ghetto. We can't get in. We have dead and wounded."

Stroop left his hotel, and rushed to the Ghetto, and took over the operation. In revenge for the attack against his "innocent troops" Stroop took immediate reprisal: he killed all the doctors and hospital workers at the Jewish hospital, then executed all the patients, including small children, on the spot.

While the Jews rose up at last to fight off the shackles of Nazi domination, the world at large remained strangely unmoved. The Polish government-in-exile did not even bother to respond to the urgent appeal for arms sent by a secret emissary from ZHOB. The Polish resistance turned down a meeting with a top Ghetto commander. But as the uprising proceeded, the Polish resistance did lead a number of attacks on the Germans attacking the Ghetto, thereby helping their Jewish on-again-off-again allies.

The Nazis set out with relish the task of destroying the Ghetto, block by block, building by building, setting fire to structures in which holdouts were believed to be hiding, smoking out pockets of resistance in house-to-house, hand-to-hand combat. Polish groups on the Aryan side aided and abetted the Jewish uprising, committing acts of sabotage as diversions and distractions, blowing up a railway station here, an arms depot there, doing what they could to capitalize on the ensuing confusion. Himmler, annoyed and surprised at what he considered the slow pace of the liquidation, ordered Stroop to burn down the entire Ghetto at once, taking no prisoners.

Now that the Judenrat had no further function, the Nazis simply shot the remaining members of the Judenrat presidium, all of whom were being held as hostages: the engineers Marek Lichtenbaum, Alfred Stolzman, Stanislaw Szeroszewski, Dr. Gustav Wielikowski. Their bodies were thrown into sewers already filled with the corpses of dead Jewish fighters. The last remaining members of the Jewish Polish Force, who had always hoped that their own necks would be saved by helping to kill others, received their reward for years of loyal service: summary execution at Gestapo headquarters at 103 Zelazna Street.

As the Germans continued their methodical extermination of an estimated 35,000 Jews remaining inside the Ghetto, Jews kept fighting, Germans kept destroying. From the rear windows of our apartment on Ciepla Street, we could see the pillars of smoke rising from the Ghetto, amid screaming sirens and the rat-tat-tat of artillery fire.

Much as we hoped and prayed that the uprising might succeed, we knew as well as the brave resistors that the point was to resist to the

last man, not to win but to die fighting. As the uprising persisted through May Day, 1943, much to the consternation of the Germans bent on the liquidation of every remaining Jew in Warsaw, two szmalcowniki (blackmailers) jumped Jan on the street. He had taken over Irene's shopping duties for the day. Forcing him to lead them straight to our apartment, they announced their presence by hurling Jan bodily through our doorway like a small package. Hiding two by two on our fragile raft in this sea of misery, we felt as if the flood had finally overwhelmed Noah's Ark.

There were just two of them, both nearly six feet tall, one dark, the other albino, with eyebrows that met above his nose, imparting to his narrow face the vulture like beak of a bird of prey. "You Jews have no right to live!" the albino cried out while the two of them embarked on a frenzied search of our apartment for hidden valuables. Ripping open drawers and spilling clothes on the floor, they soon became outraged that our only belongings appeared to be clothes.

As they conducted their search, Benjamin and I had a quiet little talk. We approached the dark one and made him an offer that we hoped he wouldn't refuse: for a monthly wage of 5,000 zlotys, paid promptly on the first of every month in perpetuity, which meant of course until the end of the war, would he and his friend agree to "protect" us from other hoodlums? After a brief whispered discussion with his comrade-in-thuggery, the two agreed.

All we could hope for was that the hoods would prefer to be patient and take our money than to derive whatever immediate monetary benefit they could get from the Germans for turning us in. We knew well that the typical method adopted by these blackmailers was to bleed their victims dry, then turn them in. But we had no other choice. Warsaw was exploding all around us, and our only real hope was a quick end to the war.

I managed at last to send word to our old friend, David Guzik, director of the Joint Distribution Committee, who was holed up at the Hotel Polski in downtown Warsaw where, rumor had it, it was possible to obtain foreign passports that the Germans respected because their own people were being held in Allied countries. The whole operation turned out to be a Gestapo-run sting operation designed to flush out as many Jews as possible while separating them from their money. But in light of recent developments, the Altmans made a decision to try this dangerous way out. We learned, after the war, that, though Guzik's role in this debacle was entirely honorable if, perhaps, a trifle naive, out of the estimated 3,000 Jews who were able to obtain these shady "passports," only a handful escaped the death camps.

Barbara and I actively pondered this option, but chose instead to hope that our blackmailers might be greedy enough to be honest, even in crime. Our savior was, once again, David Guzik, who upon hearing of our travail from Benjamin Altman, dispatched two friendly people to our doorstep to offer us an alternative route to escape. One day, we heard the code of three short knocks on our door, followed by one short one, and we carefully opened the door, expecting to see one of the Altmans on their return from the Hotel Polski. Instead there was a diminutive Pole in his forties, slightly gray at the temples, with a younger, taller good-looking woman at his side. They introduced themselves as Karol and Lalka.

Taking out an expensive-looking cigar, after routine introductions, Karol struck a match and in an expansive tone, ventured, "Since Friday is the day your 'friends' are expected to return, perhaps we should move in the day before." Grinning at his female sidekick as if the idea were some enormous joke, he winked and announced his intention to return on Thursday, to "take care" of our problem for us.

When the thugs returned, they were astonished to find us sharing our apartment with these two Polish friends, who seemed remarkably unaffected by their arrival, and perfectly willing to "show their religion" by any means. Karol and Lalka's supreme confidence confused them. From the unintimidated way that they acted, the blackmailers clearly assumed that they might possess some hidden source of power: firearms, perhaps, or even resistance and/or Gestapo connections. When Karol casually laid a hand on one of the blackmailers and told him as gently as possible to take his and his friend's business elsewhere, they astonishingly turned on their heels and fled.

After they were gone, the veneer of courage vanished as easily as it had appeared. With an adoring Lalka kissing him lovingly on the hand, little Karol shrugged and winked, "You're all lucky I am such a good actor," he said.

Karol, as it turned out, was in truth an actor, a member of the old prewar Polish elite, a bohemian, a Socialist and an ardent anti-Fascist. Through Karol and Lalka's connections, now that the blackmailers had been driven away, we located a "safe" apartment in a house.

In 1944 we were in our last hiding place in Grochow, a Warsaw suburb in an apartment owned by a couple who were proprietors of a small grocery store. Pani was the woman of the house. Her husband, whom we never saw, was "Volksdeutsche," a Pole of Germanic origin. We assumed that he might be serving with the German army, or for that matter, with the resistance.

Grateful for the opportunity to hide out at this safe house, we

waited with increasing impatience as the Germans were finally defeated at Stalingrad and the invasion of the Soviet Union was finally repulsed. The rapidly advancing Red Army did not reach the outskirts of Warsaw until the fall of 1944 and, with a display of utmost cynicism worthy of that old tyrant Stalin, sat cooling their heels on the banks of the Vistula River as the Germans dug in around Warsaw and did what they could to finish off the non-Communist Polish resistance.

As the situation deteriorated around us, and the Germans seemed ready and willing to destroy every last building in Warsaw before handing the city over to the Russians, we built a primitive bunker under the kitchen floor of our modest hiding place. It was a makeshift affair, made entirely of scavenged two-by-fours and clumsily patched linoleum for a roof.

Even as the Red Army's ultimate victory began to seem more likely, the Germans stepped up the pace of their searches in Polish apartments for suspected Jewish refugees and escapees from the now-demolished Ghetto. A German contingent searched the apartment while we hid in terror in our tiny bunker, listening to the barked German commands, the sound of smashed china and an interrogation of Pani.

After the Germans left, we began to breathe easier, particularly when Pani came rushing in to greet us in a state of intense excitement. She had just heard that the Russians had been ordered by Stalin to advance past the Vistula and make a dash to liberate Warsaw—or what little was left of that once-proud, once-magnificent city.

The Russian bombardment and the Nazi response leveled significant stretches of whatever neighborhoods had not yet been destroyed. A shell struck the roof of our house, setting the flimsy wooden structure on fire. Coughing our lungs out from smoke inhalation as we made our way through the corridor to the grocery store and thence to the debris-littered street, all we could make out was columns of thick black smoke occasionally illuminated by short bursts of flame.

At the end of the block, one house out of a long row of blackened hulks loomed miraculously intact. We found Pani wandering around this surreal moonlit landscape in a state of shock as she returned to find her house burned to the ground. More explosions rocked the city with earthquake like tremors. We followed Pani's urgent gestures into a bunker just down the block, a primitive bomb shelter in which we found more than a hundred fugitive citizens, some shell-shocked, others just mildly dazed.

Huddled in one corner, in a state of obvious embarrassment, was

a small group of German deserters, disarmed and obviously demoralized. We could have empathized with them, but we couldn't help feel a thrill of triumph that we had lived to see some of them cowering in defeat while we looked forward hopefully to ultimate victory.

The fortunes of war have a way of turning eventually, I reflected with a sudden burst of intense feeling as the stark terror and tragedy of the deaths of so many thousands, nay millions, of our innocent Jewish compatriots hit me. For so long I had done everything to suppress my sadness at the intensity of our suffering. Now, suddenly, the sadness was overwhelming.

We were still sufficiently traumatized by over a year of hiding, terrified lest our true identities be found out, that we felt intimidated by asking our Polish shelter-mates for food. But shortly after our arrival, a kindly faced elderly gentleman shyly approached us, possibly suspecting that we were Jewish, and offered us a small plate of boiled potatoes, the only food then available.

After some forty-eight hours of intensive bombardment, with Germans and Soviets exchanging salvo after salvo, finally there was a brief lull. Around noon the following day, as all Poland turned to illegal radios to hear the Angel of Krakow's long-silenced bugle ring out from high atop the Church of St. Mary in Warsaw, we too heard the sound of bugles. But our bugle calls were the far-off sound of a military band, playing songs of liberation.

An hour later, the door of our shelter was flung open. The sweet smell of air, heavily laced with cordite, wafted into the stale unventilated shelter. A little blond boy of no more than fifteen, his bare knees thin as sticks in his torn shorts, gladdened our hearts as he turned a shining face in our direction, and cried out like a boy herald in some medieval Polish pageant, "The Russians are here, the Russians are here!"

Citizen Winiawski

After Warsaw was liberated by the Russian advance brigades in the late summer of 1944, the real reason that the Soviet army had procrastinated for so long on the banks of the Vistula became clear: they had cynically waited for the Germans to wipe out the valiant Polish resistance to ensure that no organized parties would survive the war to counter a Soviet takeover.

In the chaotic days following the liberation of Warsaw, Barbara and I (the Winiawskis actually) made our way overland to Lublin to make contact with friends and acquaintances being called upon to serve in the new government. That this was ultimately going to be a Communist government was not entirely clear at first. Upon our arrival in Lublin I met with former Polish Senator Emil Sommerstein, a founder of the World Jewish Congress, who was working closely with the Polish Committee for National Liberation, a Communist-sponsored body established in Chelm in July 1944 that assumed administrative functions under Soviet military occupation.

Sommerstein, a distinguished-looking gentleman with a full head of gray hair and a captivating manner, had spent a fair part of the war in Soviet prison camps, being transferred from prison to prison before being liberated in early 1944 as part of a general amnesty. I had known him from the prewar days in Warsaw and knew him to be a valiant supporter of Jewish rights. He had been instrumental in drafting the so-called "Lublin Manifesto" of July 1944, which proclaimed to the world the intention of Poland's new Soviet-sponsored government to protect the rights of Jews both as individual citizens and as members of a national minority.

That minority, tragically, had been reduced to the merest vestige of its former self. In 1945, Poland's 3.5 million Jews, which had once been the largest Jewish population of any European country (or roughly 10 percent of Poland's population of 35 million), had been reduced to under 50,000 — a few thousand survivors of the death camps and a larger group who, like us, had managed to survive the war under false Aryan identities. When I met Senator Sommerstein he was deeply immersed in negotiations with the Russians to repatriate some 250,000 Polish-Jewish refugees who had survived the war

inside the Soviet Union. He recalled how in the spring of 1944, soon after his release from the Soviet gulag, he had been invited by Stalin's regime to take part in a conference being held at the Kremlin, gathering together the Soviet-sponsored Association of Polish Patriots.

In a tone richly tinged with irony, he told me of having been personally received by Stalin at an elegant dinner, which he had been obliged to attend on crutches after having contracted a miserable case of rheumatism from his days of confinement and abuse in Stalin's concentration camps. Stalin had embraced Sommerstein warmly, as if utterly oblivious of the absurdity of his position, and even went so far as to heartily agree with Sommerstein that "the world Jewish problem" should, after the war, be solved on "an international level."

"I agree that the problem should be solved in a definite manner," Stalin replied.

"May I make your statement public, Marshall?" Sommerstein asked.

"Yes, of course," came Stalin's crafty reply.

Despite his own adverse experiences under the Soviet system, Senator Sommerstein harbored an overly optimistic, even naive, view of the opportunities open to Jewish survivors under the new regime. A good and a tough-minded man, he shared with the majority of the surviving Polish Jews high hopes for the new left-wing government. He seemed utterly unfazed by the prospect of rebuilding the country under the stern eyes of Uncle Joe and his henchman. "In general, Jewish survivors of the Holocaust in Poland regarded both the Soviet army and the new Polish regime with favor, if not outright enthusiasm," wrote Michael Checkinski in a groundbreaking study of Poland after the war. "The anti-Semitism of Stalinist rule in Russia was either unknown or conveniently forgotten."

For myself, I could not sweep Stalin's anti-Semitism under the rug, not after all I'd been through during the war. This was one reason I steered clear of becoming involved with Sommerstein's new Kehillah, the Central Committee for Polish Jewry, of which he was president. My term of service at the Judenrat before I became "Aryanized" had given me more than enough experience, in the complex conduct of "Jewish affairs" under dictators, to last a few lifetimes.

I yearned to be involved in something more concrete. Quite frankly, I also felt simply too weak and tired to be able to fully immerse myself in such a physically demanding field as politics. Besides, what would politics be under the new regime? The so-called "free-elections" to which the government paid lip-service struck me under the circumstances as an unlikely eventuality. True to my gut

feeling the government never did hold "free" elections until the late 1980s, following the collapse of the Soviet empire.

My only other previous experience, for what it was worth, had been gained working with Barbara and her mother running their family's movie theaters. Since so many of the old theater owners were dead, mostly murdered in the death camps or starved in the ghettos, there was little organized or active opposition to the prompt nationalization of the cinema industry. Poland's whole population, the few remaining Jews and Gentiles alike, were still so shell-shocked by the events of World War II that the Soviets were able to embrace us in a warm Russian bear hug with little more than token resistance.

To me this "fascism with a friendly face" was profoundly disturbing. But after surviving the appalling cruelty of the German occupation, fascism with a friendly face at least seemed friendly, no small distinction after the "Final Solution." But I wasn't so traumatized as to welcome the Russians with open arms. If anything, my Holocaust experiences had left me profoundly paranoid, suspicious of everyone and everything. I remained virtually incapable of trusting most individuals, let alone institutions or political parties. Still under thirty, I had become cynical and world-weary beyond my years. Barbara and I had both stared death in the face and lived to tell of it. Or not to tell for a long time.

Even a paranoid has his real enemies—and ours were all around. The vast majority of Poles, newly liberated, remained violently anti-Semitic. Poland's overwhelming Catholic majority accepted astonishingly little guilt and displayed even less sympathy for the Polish Jews who had been slaughtered. Yes, it had been the Germans who committed the Holocaust, but many a Pole had a hand in the genocide. Incorporating large sections of Germanic Poland into the new nation was the price Germany had to pay for their aggression. But these so-called "Volksdeutsche" were even more virulently anti-Semitic than the mass of ordinary Poles. Barbara and I knew we had to be wary with no opportunity to luxuriate in our survival or to let down our guard.

While all Eastern Europe was being rapidly dismembered by the Soviets, one of the most important weapons in the arsenal of political power, from a Socialist standpoint, became the power of the mass media: newspapers, radio and cinema. Ever since Eisenstein revolutionized Soviet cinema, the Communists had developed an uncanny sense of the power of cinema to lull, to exhort, and to control the proletarian masses. Cinema provided entertainment, but also a subtle form of brainwashing. Movie theaters were places where the masses could be cynically moved to fear and pity, all in one

place. This made the film production and distribution industries crucial in the process of postwar Socialist rebuilding.

In Lublin, Barbara and I made contact with a Minister Ford, whom we had known from prewar days in Warsaw. He was quickly emerging as an up-and-comer in the now-nationalized Kinofikacja: Cinematic Distribution Division of the Culture Ministry. As Warsaw was still at war, Barbara and I had dinner with Ford at his home in Lublin, where he — knowing of our cinema experience — graciously offered us a chance to open the first movie house in the Warsaw suburb of Praga.

Although Barbara was the one with the greater experience in theater management, I was offered the higher position. Women in Eastern Europe at the time were expected to be subservient and like it or not they mainly were. At the time, such discrimination, and women's acceptance of it, seemed only natural.

Being permitted to run a movie house, however, was far from our fondest dream, which would have been to have had Barbara's extensive family theatrical holdings, illegally confiscated by the Nazis, returned to us, or at least to be given their financial equivalent in compensation. In American-occupied West Germany a capitalist solution to the problem of reparations was still under discussion, and would in due time be implemented. But in Soviet-dominated Eastern Europe, the Socialist solution prevailed: prompt nationalization of private property, rendering our claim moot. Nevertheless, whether living under a Communist, Fascist or capitalist regime, I have always relished hard work. To be given an "important" job, a responsible managerial position running a movie theater, to be given a certain degree of autonomy, and the chance to support Barbara and me in dignity, struck us at that point as approaching a miracle. The emerging political reality that Poland was being turned Communist without consultation with her people seemed secondary. Whether working for the Judenrat, or for the newly formed Polish Ministry of Culture, my primary aim was to succeed. I was by nature a go-getter, determined to do well and make good. Determined to earn the respect of my superiors, I was more than just a good manager, since at heart I was an entrepreneur. Still, I had not yet been given an opportunity to exercise my skills. As time went on, I became more and more horrified by communism and the ways in which it subtly and insidiously undermined freedom. Capitalists might want to steal your money, a wise man once said, but a Communist wants to steal your soul.

We looked on in horror as the Soviets irreparably transformed the country of my youth and earliest dreams. I didn't have to be told

that I was going against the grain of the emerging dictatorship of the proletariat. Communism maintained that its ultimate goal was to breed a "new man" who would not exploit others, who would gladly commit the ultimate self-sacrifice in exchange for the opportunity to work collectively for the common good. That was not my idea or objective. I wanted the opportunity to run a private venture with its attendant private rewards.

The Socialist ideal may have been fine in theory. In practice, the results were less noble. In the real world, communism made people even more conniving and craven, emotionally, intellectually, and commercially dishonest.

Some forty years later, on a visit to Poland in the mid '80s, I was to see the devastating effects of decades of Socialist breeding: a generation of Polish do-nothings, lazy, unimaginative, cowed. Praga, across the Vistula river from Warsaw proper, was once an affluent suburb of gracious tree-lined streets and handsome houses. In the spring of 1945 its bombed-out hulks were just marginally more habitable than downtown Warsaw, which had been leveled by the Nazis in retaliation for the uprising and had become a virtual ghost town. The Syrena cinema, which Culture Minister Ford had turned over to us, was centrally located on the main thoroughfare of Praga, in battered but not irredeemable shape. By driving my staff to a frenzy of productivity, we managed to become the first operational movie theater in postwar Poland.

Our opening night was a tremendous event, as glamorous as we could make it given the continual, ongoing postwar shortages. Soviet and Polish soldiers and their girlfriends lined up around the block to gain entrance while ordinary citizens tried to jostle their way into line to see "Swiniarka and Pastuch." With music by Tchaikovsky, this feature—its title loosely translated into English means "The Swineherd and the Shepherd"—was a smash hit in Praga. Audiences could not get enough of it. We showed the film over and over until the projectors nearly burned out.

Such roaring success in opening the Praga cinema on time did not go unnoticed in Lublin. Only a few days after our gala event, I received a congratulatory phone call on my special line, the first civilian connection in that area, from Culture Minister Ford. In exultant tones he cried out that "Citizen Winiawski" had become the toast of Lublin. At the very least, having cinemas open and operating took people's minds off their continuing impoverishment—an impoverishment which was due to last forty-five years.

In referring to me as "Citizen Winiawski" we were sharing a deadly serious private joke. Ford was one of the few if not the only

eminent personage in the Polish power elite who was in on our secret: our Jewish heritage. Ford, and the few other friends from prewar Warsaw who had also survived, knew we were Barbara and Jacob Weintraub. But to the hierarchy, and to everyone else, we were Tadeusz Winiawski and his quiet wife, Mentlak.

The reasons for maintaining this fiction were several. Our Aryan identity papers were the only official documents we possessed testifying to our existence as Polish citizens. Without documents, we were virtual nonpersons. Even more to the point, we had legitimate reason to fear the Poles, and the Volksdeustche in particular. Since I had every intention of becoming successful in my appointed work, and I had already been selected as a cinema director, I had reason not to rock the boat. To have revealed ourselves as Jewish at the time might have proved suicidal. In fact to be Jewish in postwar Poland was scarcely better than in prewar and wartime Poland. Rather than being showered with affection as victims, and in many cases heroes of the struggle against fascism, Jews who survived were generally looked upon as anachronisms, unfortunate reminders of the regrettable fact that the Germans had not, to the Poles' endless chagrin, solved Poland's vexing "Jewish Question" once and for all.

Poland's tiny surviving Jewish community was also, rightly or wrongly, looked upon by both friend and foe alike as one of the mainstays of the new regime. In addition to Sommerstein, a prominent Jewish politician, Dr. Boleslaw Drobner, a left-wing Socialist, had taken a high-profile post as the minister for Health, Social Welfare, and Labor in the new government. In the meantime, the great Christian majority of Poles were more overtly hostile to communism and viewed the Soviet occupation not as a "liberation" from totalitarianism, but as simply the switching from one oppressive regime to another. In this, of course, they were right, while many of my more left-leaning Jewish compatriots turned out to have been overly optimistic about their prospects under the new regime.

My position was strangely ambiguous because while I was not an enthusiast for socialism, I desperately needed a job and a place to live. Under the circumstances, we had no choice. The right-wing slogan at the time decried "Judeo-communism" (Zydukomuna). To make matters worse, these lunatics were indiscriminately murdering innocent Jews—those few remaining—along with their more usual targets: Soviet and Polish soldiers.

Why did we remain in such a hostile environment? Why didn't we flee at the first possible opportunity? The answer is simple: we did eventually. To make our escape precipitously would have been self-

destructive. And to decide to escape was such a momentous decision that we had to arrive at it judiciously, gradually, and securely.

Revealing Barbara's and my Jewishness did not seem wise at that time. Particularly, after Minister Ford informed us, with what I took to be a sly chuckle, that our next assignment would be to open the central cinema in Gdynia, the former German Baltic port that the Germans called Gottenhaven (during the war also known as Gdingen). This once-vibrant, affluent seaport lay a hundred miles from the recently redrawn Polish-Soviet border, and an even shorter distance from Gdansk (formerly Danzig)—the birthplace of solidarity. This was the heart of Volksdeutschland—the most anti-Semitic area of anti-Semitic Poland.

In keeping with our newly elevated status as important cogs in the new regime, we were flown in two separate open-cockpit small planes, one for us, a second for our luggage, to Gdansk. The airport runways there were still pocked with bomb craters. Only small propeller planes could land. The second plane was inexplicably detained en route, but Barbara and I were whisked with brisk military efficiency into a Soviet-made Volga limousine that sped down the pine-lined Baltic Coast to Gdynia, having been repeatedly assured that our luggage would follow.

Poland's Baltic coastline remained under direct Soviet military control as an official combat zone since in those early months of 1945 small contingents of German troops were still holding out, suicidally, on the former resort island of Hel in Gdynia's vast, well-sheltered harbor. We were driven straight to our scheduled appointment with the Volksdeutsche local culture administrator, Mr. Switka, whom I detested on sight. He casually alluded to the fact that the large apartment he had requisitioned for us within the sprawling cinema complex had formerly been occupied by a "Jewess," whose husband and children had been killed by the Germans before she herself had been hauled off to a camp. He intimated, with scarcely a trace of regret, that she was not expected to return. His calm tone in relating this tragedy sent chills down my spine. He recited the details in a businesslike monotone, as if to suggest that "these things happen," as if the Holocaust had been nothing more than an unfortunate event, now best swept under the rug and forgotten.

I could no more forgive than forget, but I had a job to do. There was nothing I could do to save that woman or her family. What guilt I might have felt at occupying that vacant apartment rapidly dissipated upon seeing Barbara's pleasure at inspecting our new home, our first really private residence since the Warsaw Ghetto. As she fixed us a cup of tea, and we began to relax after our long and tedious

journey, Barbara expressed for the first time her regret at the need I felt to bide our time and remain in hiding, under a false identity. She hated living a lie.

I stood firm. Whether out of excessive paranoia or justified caution, it's hard to say even now. "It's just not time," I said sharply, cutting off all discussion. "It's too early. We're not sure of anything or anyone here. Let's wait and see what happens." As subsequent events proved, I was right.

The Soviets were not Nazis but they weren't exactly angels either. To be Jewish was to be suspect. As we fell into a deep but uneasy sleep on the bed of the absent "Jewess," we both felt her presence, as though looking down on us. The Holocaust we survived would never leave our minds.

The next morning we were given a tour of the Cinema Baltic, an imposing Art Deco structure on the city's once-gracious main street, constructed in the '30s to resemble New York's Radio City Music Hall. I was shocked on this preliminary inspection to find the huge auditorium stocked to the rafters with stockpiled German munitions and other military hardware. After the tour we met with the Russian military commander of the Gdynia sector. I noted with appreciation the Battle of Stalingrad Medal among his decorations. From behind his vast polished desk, which reflected the magnificent array of medals on his chest, Colonel Ryabov confided to us that he was a great movie fan, verging on the fanatical. As I was soon to find out, this was no exaggeration. He announced with a thunderous pounding on his desk top, "People need to be entertained and amused, now! Without delay!" As he went on waxing eloquent in vintage Socialist style, about "moments of contemplation of truth and nature, escape and ecstasy," I couldn't help but contemplate, with something less than ecstasy, the enormous portrait of Stalin looming ominously on the wall behind him.

Within three days, he bellowed, it was necessary that the Cinema Baltic reopen, to entertain the rivers of Soviet soldiers now streaming eastward, some to fight the few German holdouts, others on their way home to Russia. "Ungrateful locals," he bitterly complained, had "procrastinated" in the face of this challenge. The way he said that word, I knew he intended subversive implications. He hinted darkly that my predecessor in the same job had been an obstructionist, coyly refusing to disclose what fate had befallen him. Privately, I had heard that my predecessor had been fearful of being stigmatized for collaborating with our Soviet occupiers. Not everyone was thrilled about the Soviet occupation, particularly the Volksdeutsche who had vastly preferred the German presence.

Assuring the anxious Colonel that I was, if nothing else, a can-do-man, I promised to schedule the gala opening in time to celebrate the upcoming "Festival of the Sea," a Baltic seaport tradition that had been suspended during the war. This celebration possessed enormous propaganda implications as a symbol of a "return to normalcy" under Russian rule.

Noticeably relaxing under my assiduous stroking, the colonel coolly looked Barbara and me over from head to toe, then muttered softly, almost inaudibly, "You two are awfully thin, aren't you? You're not too healthy-looking, even for Poles."

He gazed upon us quizzically yet not unsympathetically. Nervously I mumbled something about wartime shortages.

"You were in prison?" he inquired, with surprising gentleness. With a shudder, I tried to guess what he might be driving at. I hesitated. He could tell I was holding back.

"Were you in hiding?" he asked cautiously.

To admit this was tantamount to admitting that we were Jewish. I thought about taking a chance, but something told me not to. The time was not right. I didn't know the colonel. I felt unsure and frightened at the possibly ominous implication of his questioning.

"No, sir," I said softly. "Just hungry, that's all."

For the moment, he seemed to accept that explanation. Our interview over, we were about to be chauffeured back to the theater where potential disaster awaited. The 1,000-plus-seat theater had plush seats that were threadbare and covered with years of dust and grime, fallen plaster and leaky plumbing, all readily reparable if reachable through all that rubble and armaments. But what a timetable! Thinking fast, I decided to take a wild stab and request something from our apparently benign colonel.

"Sir," I said, after he'd already turned his attention from us and was focusing on some apparently long-neglected paperwork. "I'd like to ask you a favor."

He glanced up, clearly astonished at my audacity.

"If I'm going to open that theater in three days, I'm going to need a large military crew to clean all that weaponry out."

Now he appeared even more astonished. "Military hardware? Inside the theater?"

I nodded smartly, at which point he gestured firmly to an aide hovering nearby eagerly awaiting the first opportunity to whisk us out of his master's august presence. His gesture, universal body language, made it clear that this would be done, that it was already done, as far as he was concerned.

Pressing my luck, I went for broke. "And we need electricity,

immediately. If you want a theater up and running, we can't do it by candlelight."

His adjutant fell silent, clearly expecting the colonel to explode, perhaps even to whisk me off to prison on a charge of treason. But appreciating my chutzpah, he waved smartly again. With satisfaction, I saw his aide make a note. "Anything else?" he asked, wryly challenging me to push my luck. Figuring that he needed me to get the job done, I blurted out, "We also need electricity in our apartment, if you want us to work around the clock. It's just above the theater, so your men should be able to string a line at the same time."

At this point, the colonel burst out laughing, as if this was the best joke he had heard all week.

"Here we are, still fighting the Germans, and you need electricity. All right, you've got it," he said, almost choking with amusement. "You are now the first civilians in Gdynia to be supplied with electricity. I do hope you are satisfied!"

I nodded sharply, restraining myself from saluting as we withdrew. Communism might not be so bad, I reflected, as long as you had clout with the right people, and the chutzpah to use it. On the other hand, on a deeper level, I had always loathed communism, and was liking it less and less the more I saw of it.

A decade later, when I was in New York, the Soviets astonished the world by launching the first space satellite. During the furor over Sputnik, and the surprise Americans felt at Soviet technical capacity, I felt a wry twinge of satisfaction, recalling the stunning efficiency with which the Soviet military cleaned out that theater, installed electricity, and restored order to that chaos. If only the Soviets had been able to turn their military efficiency to civilian needs, to turn swords into ploughshares, they might have won the Cold War.

Back in Gdynia things were shaping up. I felt increasingly confident about meeting our three-day deadline. The Kinofikacja, courtesy of Minister Ford, had sent us an accountant named Timoczko, who casually confided that he had just received word that his girlfriend, Wanda, would be joining him shortly at his new post. Something about the way he said it, some degree of anxiety in his tone, made me wonder what he was driving at. Finally I asked him point blank. He reluctantly admitted that she had survived a concentration camp. From the way he said that, I inferred that he, too, might be Jewish, living with a Polish name. Even as he assured me that he would accept her no matter "what might have happened," from which I supposed a wide range of possibilities, from rape to disfiguration to psychological trauma, I blessed our lucky stars that we had escaped the camps.

Barbara busily mended the faded plush curtain, her nimble fingers whisking through the thick material with simple pleasure. Timoczko and I eagerly broke open the recently delivered canister containing our first feature film. Gazing at the label, I smiled: "Swiniarka and Pastuch," it read, with score by Tchaikovsky.

"Sounds great," Timoczko said. "Do you know it?"

"I know it well," I said. "They'll love it." They did. Between Praga and Gdynia I must have watched that film sixty times. The film itself is eminently forgettable, but I will never forget that haunting score.

Our opening night was a smashing success. It made our opening in Praga look like a dud. The street in front of the huge theater was bumper-to-bumper with military vehicles, from Jeep-like combat transports to elegant officers' convertible town cars. The lobby was brilliantly illuminated by thousands of bulbs, their glitter made all the brighter because they faced no competition from a city utterly devoid of electricity. As I stood in an ill-fitting, strange-feeling suit greeting the Communist bigwigs, I spotted Switka, sternly inspecting the facility like the Teutonic dictator he aspired to be. He must have been pleased, because after performing every sort of inspection, short of examining the well-oiled projectors under a magnifying glass or running a white-gloved finger along the highly polished wooden armrests he congratulated me on my "efficiency." Such praise, coming from Switka, sent a chill down my spine.

Colonel Ryabov was also pleased, in fact elated, at the prospect of garnering credit with his superiors for having adopted such a "nonobstructionist" protegé. He could no doubt look forward to having the newly issued Recreational Cinema in Combat Zones Medal, Order of Merit Number Eleven, pinned on his tunic.

"Winiawski," he shouted, bussing me on both cheeks like an old comrade-in-arms, "I never thought you could do it!"

"Thanks to you and your men, Colonel," I replied, trying not to snap my heels together in a military salute.

He accepted this tribute in silence, as the minimum due.

After the opening, which went off without a hitch, keeping the audience on the edge of their seats as in Praga, we repaired to the Gdynia Yacht Club for a post-show reception. The colonel offered us a ride in his limousine but I declined, preferring not to get too close to the country's emerging Communist elite. Much as I yearned to be a success, an important person, to prove myself as capable and efficient as the next man, I had deep misgivings about being so cynically co-opted. The Soviets talked a good game but behind their professed goal was old-fashioned conquest.

At the yacht club this disturbing fact came more into focus, as we gazed upon a vision of prewar Poland in all its elaborate elegance: candles flickering in silver wall-sconces and great heaps of precious food spread high on elegant tables. The richness of the repast reminded me of the Faust-like banquet of Yosele Fuhrman's, the black marketeer in Warsaw. He too, had traded his soul for the price of a few hard-boiled eggs and a little gefilte fish, and perished in the process. I was not collaborating with evil, but I was cooperating with communism, something that deep in my heart I could never believe in. It was discomfiting.

At that bounteous banquet, as we danced amid those surreal surroundings, I made up my mind that we had to start planning our escape from Europe. The whole scene, in all its nouveau opulence and superficial glamour, took on a faintly sinister aura. After a few glasses of champagne the lights from a hundred costly wax candles shed a fluid glow on the walls, throwing fantastic shadows of cavorting figures. In the shadows of my mind's eye I could discern the contorted shapes of the dead, of my family, of millions of other families.

With a pang of pain, the first real pain I had permitted myself since the true horrors of war had receded, I realized that I could never be truly happy in Poland again. Poland might be reborn, but it was no home for Jewish survivors. Here I was, a roaring success, and yet I felt like a fraud. I was no longer even myself, this figment, this fiction called Tadeusz Winiawski. In Poland, whatever I accomplished, I would never rebound to the glory of the real me.

Suppressing my nausea, so as not to spoil the moment for Barbara, who, after all those horrifying years of hardship looked beautiful in her formal gown. I whisked her into a gay waltz.

As we moved into the throng of dancers, I tried to repress my dark thoughts. In a rare moment of elation, Barbara whispered, nuzzling her nose into my neck, "I'm so happy. I can't remember the last time I was so happy."

Not wanting to spoil her momentary if misplaced pleasure and thinking grimly of our prospect of a high-powered life as members of the newly emerging Socialist elite, I instinctively knew that this scene was not for us.

"Are you really happy here?" I asked, daring to darken the moment for the sake of real if brutal honesty. "Do you think we could ever be really happy here?"

She didn't utter a word. But in that half-light from the sputtering candles, I thought I could see a hint of tears running down her face. I knew she was feeling as I did. The evening ended on an ambiguous note as we were introduced to a tall, very Aryan-looking aristocratic

gentleman, Lieutenant Count Wojcheh, and his beautiful blond wife, Yuka.

A short time before, Timoczko, who had never admitted to me his racial heritage, pointed her out to me as being "Jewish, and a bit of a whore." I wasn't sure what he meant, but I thought I might have an idea. A "whore" in those days was a woman who had slept with Germans for favors or just to stay alive. Those who might have briefly descended into prostitution by keeping company with fellow Jews as a means of survival, were not so roundly castigated as "whores." We had all had to do regrettable things to survive. Sleeping with Germans was another matter: a very unforgivable form of collaboration with the enemy.

The following morning I awoke to a pleasant surprise in the form of a front-page article in the local tabloid *Dziennik Baltycki*, appropriately titled "A Pleasant Surprise."

Translated it read:

"A pleasant surprise was given to the inhabitants of Gdingen on the day of the 'Festival of the Sea' by the Management of the Cinema 'Baltyk.'

"The Hall of the Cinema was decorated very effectfully and with great artistic taste, under the lively participation of the Department for Propaganda and Advertisement of the District Committee for Film Production.

"The Entrance to the Cinema, and the passages were adorned with coloured paper plastics representing motives of the sea. Portraits of the high Officials of the State, white-red colours, placards and verdure gave a festive appearance to the interior.

"The Hall of the Cinema itself was decorated in a particularly artistic manner. On both sides of the screen were two magnificently executed transparencies, symbolic representations of the reconstruction of the harbour, and the taking into operation of the same.

"Mottoes of the Sea and Navigation were everywhere to be seen.

"The Department for Propaganda and Advertisement of the District Committee for Film Production designed the placards, paper-plastics and transparencies, the construction was placed in the hands of the Studio for painting Just and Pawlowski. The Management of the Cinema, with Citizen Winiawski at the head, took the greatest pains in decorating the Hall, and special appreciation is due to the same for placing the Hall, free of charge, at the disposal of the public for yesterday's Festival.

"We must state that the Management of the Cinema 'Baltyk' was always prepared to lend assistance in the arrangement of artistic-cultural performances.

" A Pleasant Surprise!".

A pleasant surprise was given to the inhabitants of Gdingen on the day of the "Festival of the Sea" by the Management of the Cinema "Bałtyk".

The Hall of the Cinema was decorated very effectfully and with great artistic taste, under the lively participation of the Department for Propaganda and Advertisement of the District Committee for Filmproduction.

The Entrance to the Cinema, and the passages were adorned with coloured papers plastics representing motives of the sea. Portraits of the high Officials of the State, white-red colours, placards and verdure gave a festive appearance th the interior.

The Hall of the Cinema itself was decorated in a particularly artistic manner. On both sides of the screen were two magnificently executed transparencies, symbolic representations of the reconstruction of the harbour, and the taking into operation of the same.

Mottoes about the Sea and Navigation were everywhere to be seen.

The Department for Propaganda and Advertisement of the District Committee for Filmproduction designed the placards, paper-plastics and transparencies, the construction was placed in the hands of the Studio for painting Just and Pawłowski. The Management of the Cinema, with Citizen Winiawski-atvthe head, took the greatest pains i n decorating the Hall, and special appreciation is due to the same for placing the Hall free of charge, at the disposal of the public for yesterday's Festival.

We must state that the Management of the Cinema "Bałtyk" was always prepared to lend assistance in the arrangement of artistic-cultural performances.

Our sincere thanks are due, as well to the creators of the idea as also to those who carried out the latest Surprise.

t.

The translation warranted

Congratulations on my artistic
eye in decorating the Baltic
moviehouse for the Holiday of
the Sea, March 1945, Gdynia,
Poland.

Dear Bronka & Jacob —
Thank you for your
note & good feelings —
I'm finally back to
normal. I too was so
pleased with the evening
& with Spielbergs rewards
So happy to hear your
book is "on the road " — we
look forward to it. I love
the title !!
We did have a good
Passover. Gwennie
cooked up a storm & I

My connection with the "picture" business
continues today.

cooked up a short
service!
We'll be passing through
New York on the way
back from London — but
only for a day & a
half. If we can we'll
stick our heads in.
All the best to you
both.

Arthur

"Our sincere thanks are due, as well to the creators of the idea as also to those who carried out the latest Surprise."

Bit by bit, I was becoming a great favorite of our Russian colonel, whose not subtle hand I easily detected in the effusive praise bestowed by the Baltic newspaper. Nothing under a totalitarian regime is ever quite accidental because nothing is ever really left to chance.

What puzzled me, though, was why did the Soviet colonel like me so much? What was his game? What was his secret agenda? He couldn't just be a nice Russian. My curiosity about his "hidden agenda" grew daily.

The colonel had taken to arranging private screenings for him and his friends, all higher-ups in the Soviet military. The custom of private screenings was dear to Soviet military brass. I recalled Stalin's habit of holding private screenings for his inner circle inside the Kremlin. This was well known and now deliberately emulated by the colonel.

After each such exclusive screening, he remained behind for a heart-to-heart chat. "You've put on some weight," he muttered gruffly but approvingly. "I do hope we're treating you well here."

"No complaints, Colonel." I summoned my sincerest tone.

All of a sudden, after a protracted and awkward silence, Ryabov barked, "Winiawski, is there anything I can do for you?"

Frankly, I couldn't understand what he was driving at.

"No," I replied, unable to think of anything at the moment.

"How do you get around," he asked suddenly, as if suspicious that in one of my more audacious moments, I might have succeeded in requisitioning a private car, perhaps even a driver.

"By foot," I answered. This was the simple truth.

"I think you're getting a little out of shape," he said. I made a point of ignoring his own considerable bulk filling out his smooth tunic. "And I think I have just the solution."

I was confused, a touch frightened. What was he trying to do here, recruit me for the NKVD? Was I to be an informer for the secret police? My suspicious mind, conditioned by years of oppression, concealment and duplicity searched madly for answers. Finally, before rejoining his friends, he invited Barbara and me to join him for lunch at his headquarters the following day. Over a fine meal of fresh sturgeon and salmon, caviar and pirogies, all liberally washed down with the best chilled Russian vodka, Ryabov confided:

"Winiawski, did I tell you already how much I appreciate, in fact how much we"—he paused to let the significance of that "we" sink in—"appreciate all you have done for us?"

Now I braced myself for a revelation, such as: "And now, your mis-

sion, should you care to accept it, will be as follows."

"Yes, Colonel," I responded, wearily, yet warily, half-wondering when he might tire of this interminable game of cat-and-mouse, and come clean. I nearly blurted "out with it."

"I've been thinking about the inequality of transportation," he went on expansively, as if contemplating a broad social sea change. It was as cryptic a message as I'd heard. Patiently, I waited for the other shoe to drop.

"We couldn't justify requisitioning a vehicle for you," he said frankly with a charming wink. "So we've come up with the next best thing. A mere token of our appreciation at a hard job well done."

He snapped his fingers like the grandee he was. His ever-present yet discrete aide came bounding in, nodded smartly and returned a few minutes later waving in a pair of flunkies carrying two desk-sized cardboard boxes.

"Voila!" he exulted, as my confusion grew. I hadn't the faintest idea what Barbara might be thinking. The flunkies unwrapped our presents, revealing two shining new Swiss-made bicycles. Just after the war this was the approved mode of private transport even for the middle class. I said nothing, but emitted a sigh of gratitude and relief.

"You understand, don't you, Winiawski?" He asked apologetically. I had no idea what that related to.

Suddenly, as if against his better judgment, he blurted, "Where I grew up in Minsk," he said slowly, as if retreating in a trance, reverting back to a long-ago childhood, "it was once called the Pale of the Settlement. Only the rich could buy their way out. The only other way out was the army...."

Now I got it. At some subconscious level, I must have suspected the explanation for his kindness. Now I knew that he knew. The colonel was Jewish, and like us, living a lie. I felt my Aryan mask slowly slip away, like a snake skin. Only someone harboring his own secret identity could see through our charade. Suddenly, instead of feeling safer, I felt more insecure. Who else knew? What did it mean? Were we in danger?

As a final fillip Colonel Ryabov confided that it was partly because of his Jewish heritage that he inwardly despised communism. He loved the Russian people and the Russian soul, but considered Stalinism an abomination. He was particularly perturbed by the anti-Semitism of the Soviet hierarchy.

This chilling confession, confirming as it did my worst fears about communism, solidified my determination to escape. The only questions remaining were practical and logistical: how, when, and where, no longer why. Our situation was becoming ever more precarious, if

for no other reason than that the demobilized soldiers flooding the town, having nothing to do, were growing increasingly troublesome.

Upon our return to the cinema, we found Funke, our Volksdeutsche usher, with a swollen mouth and a black eye, gained while stoutly defending Elsa, our cashier, from being molested by a rowdy gang of discharged soldiers from Tashkent, the capital of Uzbekistan, a Moslem region.

Yet in other ways, normalcy was returning. The harbor had reopened and the Island of Hel had at last been subdued. Shops were reopening with supplies coming in from Scandinavia and other ports on the Baltic Sea. There was little to be frightened of here, few demons of the past left to threaten us. Yet somehow, I remained anxious, on guard, still traumatized.

One day, a small plump little lady in her mid-thirties came unannounced to the door of the cinema, asking to see me. I had no idea how she had gotten my name, or what she wanted. Coming right to the point, she explained that she needed a job and that she hoped I might need a cashier.

"We have a cashier," I explained. Though Elsa had, in fact, left our employ after the incident of the Uzbek soldiers, Barbara had taken her place. At this news, the woman, who introduced herself as Bela Spund, nearly burst into tears. Explaining that her husband had been "killed in the war," and that she had been forcibly recruited to head up a German general's household staff, now that the war had ended the German general and his staff had vanished. She was left stranded in Gdynia.

"Why didn't you go back to your home in Poland?"

Gesturing with outstretched hands, she said that there was nothing and no one there for her. She was all alone, stranded and frightened. My heart went out to her. I said I thought we could find something for her to do and I invited her to join Barbara and me for lunch. Instinctively, I felt that Barbara's recovery would be helped by having a female friend. The woman seemed honest, modest and kind. Grasping my hand, she said fervently, "I don't know how to thank you, Mr. Winiawski, even if that's not your real name."

That did it.

"What makes you say that?" I inquired.

"Didn't you know?" she said quietly. "I'm Jewish."

"Don't say that," I whispered, hoping that no one could hear. "It isn't safe." She just shrugged in resignation, as if to admit her Jewishness after all she had been through was at least some solace in her dismal condition. Or perhaps, in resignation, what more could happen to her?

To Barbara, later, I said, "I've just met my first Jew. I think you'll like her. Her name is Bela."

"But what about Timoczko and Ryabov?" she replied.

"I mean my first Jew who's brave enough to admit she is a Jew," I corrected myself, suddenly wondering about my own courage. My rationale for perpetuating this charade was beginning to crumble, even as my insecurity increased.

As a purely practical matter, the vast majority of Poles, particularly the Volksdeutsche so omnipresent in Gdynia, feared Jews, hated Jews, despised Jews, and resented Jews. To work for a Jew, to obey the orders of a Jew, would have been nearly impossible for some, and would have made my job virtually impossible.

Strange as it may seem today, at that time it was possible to maintain these secret identities partly because protocol and customs had adapted to the confusing circumstances of the period. "What did you do during the war?" was a question that was never asked. To volunteer information was fine, among friends, but to request it was the height of rudeness. It wasn't simply an unspoken assumption that everyone had been a collaborator or was a Jew in hiding. It was just that most people's experiences were painful, whatever they were, and it was widely assumed that whatever had happened was probably best left unsaid.

Barbara liked Bela immediately. She moved in with us and became the third member of our tiny family. I opened a kiosk in the lobby from which Bela sold cigarettes and candies which she bought wholesale from a local trade union. Outwardly, we were flourishing. Beneath the surface, there remained over the three of us a lingering, uneradicable pall.

"The wake of a modern war may be in many ways more depressing than the war itself," wrote John Lukacs, expressing a sentiment that corresponded acutely to my fragile feelings during this period. A typical example of what made living this lie depressing happened to Timoczko shortly after Bela's arrival. His prewar girlfriend, Wanda, arrived.

One night after supper, Barbara and I were cleaning up when there was an unexpected knock at our door. Bela opened the door to find Timoczko standing beside a tiny woman, wearing what appeared at first to be a child's red overcoat.

Wanda strode in, practically stepping over Timoczko as she entered the apartment. Pulling out a suspiciously expensive-looking cigarette box, and lighting up, she glared at us as if it were we who were forcing ourselves on her, rather than the reverse.

Something about her manner irritated me sufficiently to cause

me to break protocol, simply to increase her unease.

"You're one of the lucky ones, aren't you?" I asked bluntly.

She returned my gaze with a stare blunter than my own, terrifying in its curiously blank, almost bland intensity.

"I suppose you could say that," she exhaled arrogantly.

"You were in a camp?" I inquired.

"Auschwitz," she said. Then, after a pause, she added: "I was a kapo." A kapo was an inmate who acted as a foreman in a concentration camp. Without batting an eye, she spoke as if reciting a monologue from a Greek tragedy, arousing in us both fear and pity.

"I stood every day in a special place in front of the crematorium," she said in dull, almost dazed tones. "Standing by piles of white ashes, picking them up with my bare hands and putting them into little bags. Those little bags, by the way, were carefully mailed to relatives along with a bill, an invoice submitted to the receiver to pay for the enclosed 'remains.' It was all very official, with the receipt signed by the S.S. Obersturmbannführer, the crematorium director...."

She spoke calmly and coolly, as if reading a newspaper article about some atrocity taking place elsewhere, halfway around the world. What could we say? Who could condemn her? Who could defend her? She was what she was: a damaged person. After that night, Timoczko, who had sworn in my presence that it "didn't matter" what they had done to his "girl," never spoke of her again. How had he survived? God only knew. I certainly didn't. I didn't ask.

Another damaged person was the beautiful Yuka Wojcheh, the one whom Timoczko had so casually called a "whore." Bela had also heard through the Jewish grapevine—the same Jewish grapevine that whispered that Winiawski, director of the Cinema Baltic, was Jewish—that Yuka had been a "collaborator" of a sort not uncommon in those Volksdeutschland parts: a mistress of a high German officer. Her husband had been at the front when the Germans overran their region, and one thing had led to another. Who could condemn her? Who could defend her?

It was after a visit to Yuka's flat, where she made a clumsy attempt to seduce me, that I returned to my office to find two men in sleazy trench coats flanking the doorway.

"Citizen Winiawski?" they asked.

"Yes," I said, though I was sorely tempted to say, "No, I'm Jacob Weintraub, former Judenrat paymaster, at your service."

"Please come with us," one said softly.

They didn't have to identify themselves. I knew who they were. Their uniforms gave them away: Polish Secret Police. The Informacja had been formed by the Soviet secret service "Smersh," a Russian

acronym for "Death to Spies," as a center for Polish military coun-terintelligence. After the war, the secret police's primary job was to neutralize or eliminate Polish intellectuals who might pose a threat to the newly established order.

According to time-honored protocol, I sat between them in the back seat as their driver skillfully negotiated the bumpy, war-wrecked coastal road to Gdansk, which had at one time been not unjustifiably compared to the Corniche near Nice.

I knew there was no point in asking these stooges questions, even simple ones, such as "Why have I been arrested?" They no doubt knew nothing anyway, and even if they did, their orders would never have permitted them to reveal such a state secret. At the local Infor-macja headquarters, located in an appropriately featureless building on the outskirts of that sprawling industrial city (later home to the vast shipyards that bred the uprising known as Solidarity) a secret police officer straight out of central casting, led me into a standard-issue interrogation chamber, complete with the requisite sparse fur-nishings: a table, two chairs, and the classic goose-necked lamp.

He bombarded me with inane questions, regarding my political beliefs, membership in various organizations, and the like. Finally, knowing the value of bluffing, I interrupted.

"I refuse to answer any more questions unless you take me to your leader." It might have sounded like an alien just landed in a space ship, but astonishingly it produced results.

After cooling my heels for close to an hour, no doubt in reward for my audacity, I was at last ushered into the office of a certain "Major Pope" who, when he turned to face me, cried "Jacob!"

I nearly fainted with fear and surprise. I had been found out! Who had told? Ryabov? Adrenaline coursed through my body until I got a closer look at a familiar, though now aged, face.

"Israel!" I cried out, as much in exultation as in confusion.

It was Israel Popower, my old colleague from the Judenrat. He explained that he was little more than a high-level clerk. He had been given the job because his son-in-law who had survived the war in the Soviet Union, having been evacuated with the rest of us, made it over the border and was now chief of the Fourth Investigation Department.

Instead of an interrogation, I was now treated to a troubling soul-searching discussion of our prospects as Jews in the "new Poland" under Soviet-style socialism. Despite having been co-opted by the new regime and having been a lifelong committed theoretical Social-ist, Popower was no more optimistic than I about our future under this system.

"There's no future here for people like us," I said, to which he replied soberly, "only in Palestine," then just three years away from becoming the State of Israel.

I left Popower's shabby little office fervently focused on the prospect of escape as soon as possible. Popower had lost his daughter in the camps and had become a haggard-faced, though recognizable, shadow of his former self, a figure to be pitied even as he hid his true identity. In a more subtle way, I felt, communism was not literally killing us, but was figuratively stealing our souls. Popower, in some undeniable sense, was a dead man. I could see the death look in his eyes. There was no light left. Like me, he was only biding his time; unlike me, he had no hope of escape.

After being driven back to the theater I was in a considerably better mood. I found Switka running around like a chicken with its head cut off, wringing his hands in a sickening combination of abject servility and despair. Spying me, he grabbed my arm like a long-lost friend.

"Where have you been?" he demanded. "Look at this!"

He showed me the offending message, written on the side of the building:

DOWN WITH COMMUNIST BOSSES! DEATH TO COLLABORATORS!

"What does it mean?" Switka cried out in terror. "Who do you think committed this atrocity? Could it have been any of your employees?"

I shook my head impatiently.

Now his eyes narrowed, "Could it have been you?"

I laughed outright. "Don't worry, Switka, it's all been taken care of." I patted him condescendingly on the shoulder, as if I were his superior rather than the other way around. This profoundly confused him, because subtle gradations in hierarchy meant everything to this worm of a man.

"What do you mean taken care of?" His eyes had by now narrowed to slits.

"One of my close friends is a high NKVD official in Gdansk," I said airily. "He's looking into it, and is going to get back to me as soon as he has a suspect. In the meantime, let's get on with the show, shall we?"

Switka beat a hasty retreat, no doubt wondering about my "high connections." Now at least I knew why I'd been arrested. In a case of true Stalinist thinking, they'd been hoping to catch a scapegoat for the "subversion" of writing this graffiti in a public place. Could they have been on the lookout for a convenient Jewish scapegoat—perhaps a scapegoat they could reveal and unmask as a hidden Jew?

If I'd wanted to stay in Poland I might have made it up the Socialist ladder. All it took was brains, drive, cunning, and brashness. But what was the point? Where did it get you? I wanted to be gone from this place.

My situation was becoming even more dangerous, at least to my suspicious mind, as more and more whispers on the Jewish grapevine began to suggest that I too was Jewish. Also that I might be in a position to help those in need.

Later that day, a beautifully polished brand-new ambulance bearing the letters in English "SYNAGOGUE AMBULANCE—Presented by the Bournemouth Hebrew Congregation, Property of the Chief Rabbi's Religious Emergency Council, 86 Amherst Park, London England" pulled up outside the theater. A uniformed gentleman asked to be shown to my office.

He introduced himself as "Captain Baker," and explained that he had come as a representative of the British Red Cross, on a mercy mission to deliver an ambulance for the purpose of helping the surviving Jews of Poland.

"And why did you come to me?" I asked, "Because I need help," he said, smiling enigmatically. "They tell me that you're an important man in this town," he went on. I took this to mean: "Important Jew in this town."

Perhaps the jig truly was up. Later, in the privacy of my own office, I told Captain Baker my real name. "I don't think there are enough Jews left in Gdynia to form a 'minyan,' and if there are, they're all in hiding, like me."

Captain Baker nodded slowly, and made a note in a tiny, scuffed leather notebook. "Perhaps you came to the wrong place?" I volunteered.

"I think I came to the right place," he said, with a definite twinkle in his eye.

Not long after that, another unannounced visitor turned up at the theater, demanding to speak to me, except in this case, he kept asking Funke and Timoczko to let him speak to the "owner, Mr. Weintraub." To which they repeatedly replied, "There is no owner. There is no Weintraub. This theater belongs to Poland." This fellow simply refused to take "no" for an answer. He refused to budge until he conferred with the director in person. They showed him up to my office. Something about his appearance made me take the precaution of excusing my staff, before asking him what was on his mind, and whether I could help him.

"Yes, I am looking for Jacob Weintraub, and I was told he is the owner of this theater," he insisted stubbornly.

"I am the director," I said.

"Oh, very well," he sighed. "I suppose there must be some mistake. But in Warsaw I was told by David Guzik of the Joint Distribution Committee, that I could find Jacob Weintraub here, and that he was the owner of this movie theater."

I trembled before saying: "I know David Guzik and yes, my name is Weintraub." How long had it been since I'd said that? It seemed like a very long time.

The man introduced himself as Mr. Pokorny, a representative of the Joint Distribution Committee. He went on to explain that he had been sent to await the arrival in Gdynia harbor of the first boat carrying food for the Jews of Poland. He had come to see me, only with great reluctance, having been unable to find a hotel room in town, or for that matter, anywhere decent to stay.

"I think I can help you with that," I said. On rare occasions, I would call the colonel for favors, but I never permitted any of my staff to make these calls, or to be privy to the substance of our conversations. Picking up the phone with trembling fingers I dialed the number of the colonel's office, and I asked to be put through to Ryabov.

I knew with that call I was letting the cat out of the bag. Ryabov knew about me. My openly lending aid to the "Joint" would help erase any lingering doubts in curious minds. By coming "out of the closet" as a Jew I knew I was signing a virtual death sentence for Citizen Winiawski—but possibly a reprieve, and a new lease on life, for the missing Jacob Weintraub. Regardless, I succeeded in getting a suite of rooms in the hotel for Pokorny.

This one charitable act opened the floodgates of my uncomfortable altruism: before long, petitioners were showing up at my door from Lodz, Lwow, Lublin, Krakow, from all over Poland, even Ukraine. Alumni of Auschwitz, Treblinka, Maidenek and Chelmo would turn up asking for advice, a handout, or contacts. A man named Blum asked for my help in obtaining travel documents for Jews moving West, fleeing the Iron Curtain, en route to Munich and the American sector of Berlin. I told him I would do what I could, which wasn't much. But even as I said it I knew that if I could possibly manage it, I would be joining the flood soon myself.

In strictest confidence, Barbara and I let Bela into our escape plans. We wanted her to come with us, if she felt up to it. With some misgivings, I also confided in Timoczko, who without hesitation recommended that we travel first to the town of Stettin, on the German border, and from there make a break for Western-occupied Berlin.

It was possible to purchase railway tickets to Stettin, although one needed a travel pass. My decision to escape was firmly reinforced by Yuka Wojcheh, who unexpectedly showed up, bearing a

recently published list of various known suspected "Communist collaborators" put out by some shadowy Polish right-wing underground organization. On the list of collaborators she showed me Switka's name, and, though my name wasn't on it, they had also published a list of suspected "Jews in high places." These ultra-nationalist organizations—this one called itself "Niepodleglosc"—were anti-Semitic beyond belief. They would have preferred to blame communism on the Jews, because Marx was Jewish. They conveniently overlooked the fact that Stalin himself, and the whole Soviet hierarchy, including their Polish imitators, were for the most part violently anti-Semitic gentiles.

Further down on the hit-list, carefully arranged in alphabetical order, Yuka pointed with a trembling finger to the name, "Manfred Wojcheh."

"He's marked for death because he went to Russia to fight for the motherland," she said sadly. Whether she was sleeping with the enemy or not, I forgave her at that moment. I'd heard that her husband knew, and that he'd forgiven her. We were all weak to some degree.

"We're taking the train to Stettin tonight," she whispered, glancing around out of fear that someone might hear. I admitted that we were also planning to make a break for the West but that our plans were still somewhat unformed, and that we hadn't yet purchased tickets.

"With us you'll be safe," lowering her voice even more to near inaudibility. "Manfred has a gun."

"All right, tonight is the night," I said grimly, sounding a little like a character in a crime movie.

The train was poised to pull out of the station, smoke bellowing from its red-glowing stack, when Bela, Barbara and I at last caught sight of Manfred, pushing madly through the crowd, with Yuka in tow. They jumped into the carriage behind us, and joined the crowd packing the cars to the low ceilings, spreading out on bedrolls and sprawled on the once-red plush seats, now dusty and faded to almost pink. This was a recently converted troop train, halting and slow, but at least we were leaving behind what had come to feel like the snake-pit of Gdynia.

Manfred was gloomy and uncommunicative, possibly scared out of his wits at what might happen if we were caught trying to cross the border. Through the open window we inhaled the dense smell of diesel fumes, which seemed to dance in the dark air to the rhythmic cadence of the clacking iron wheels. As we rode westward across Pomerania, the landscape gradually changed to a battered, bleak forested plain of blasted trees, splintered by shells. With some 350

kilometers to go before the border with Germany, we were crossing a great battlefield. It was only fitting that at a silent whistle-stop, in the middle of the night, the train ground to a halt to take on a contingent of Soviet soldiers. For some reason, the mere fact of their presence aroused visible fear among the passengers. Sure enough, as soon as they boarded, they started harassing women, fighting with men, generally kicking up a terrible, potentially lethal, ruckus. A number of soldiers simply stole or ransacked valises using frequent occasions when the train slowed to a near-stop to jump off the train and escape into the dark Pomeranian night.

I felt grateful for Manfred's company, silent as it was, but more for his concealed weapon. The rickety train rumbled slowly across Poland, taking another tension-filled nine hours before reaching Stettin, the wild, wild West of Eastern Europe. I had spent a weekend in Stettin just a few months before, scouting out the possibilities of opening the local cinema on behalf of the Ministry. At Stettin, Bela, Barbara and I bid Manfred and Yuka goodbye and wished them well. We never saw or heard from them again. I contacted a Jewish couple I knew who I thought might be able to locate an empty apartment for us, in which we could rest and await the finalization of whatever arrangements we might need to make our actual break for the West.

We discovered that finding an empty apartment posed no great problem. Half the apartments in town had been abandoned by their former residents. We were able to squat in one, once we rounded up furniture and food. The town was crawling with recently demobilized Soviet and Polish troops, who did a roaring trade in contraband articles. One Soviet soldier turned up at our place selling a grand piano, God knows where he got it. We bought it on the spot, for approximately the price of a pack of cigarettes. Unfortunately, this trophy was not ours for long, as another soldier, presumably his friend, turned up demanding the return of "his" piano. Possessing a piano was not our highest priority, so we released the piano, under protest nonetheless. We planned to remain in Stettin only long enough to arrange for transport across the border from Poland to Germany.

Through our local contacts, I was able to obtain the name of a man who drove truckloads of vegetables across the border, usually in the middle of the night. For a fairly hefty sum of money, he was persuaded to take the three of us with our valises, concealed beneath a truckload of vegetables.

It was in this extravagant style, with our valises secreted beneath the farm-fresh produce, that we were smuggled by night to the West. "That was a trip I'll never forget," recalled Bela recently from her

Florida home. "We arrived in West Berlin in the middle of the night. It was terrible—the place was nothing more than a smoking ruin. Charred buildings everywhere you looked, and no transport working except for military vehicles. It was a bombed-out shell of a city.

"We arrived with only fifty marks to our name and no contacts. Still, we were free to roam as we pleased, without having to worry about being picked up by the police on the street and being whisked off to some dingy police station for interrogation. We felt we were in a Boschian fantasy."

We were fortunate to locate a few pushcarts and some strong men to push. In return for the equivalent of three marks they were willing to transport our belongings, while we trudged beside them, to the nearest DP (Displaced Persons) camp. The camps weren't Utopia but they offered food and a tent for shelter. After filling out forms, then answering a few perfunctory questions, I was told by an American sergeant to seek out the office set up by the American occupational forces to help so-called "victims of fascism." That certainly included us.

When our small supply of marks ran out, I acquired more by selling one of my prized possessions—a beautiful sheepskin coat which I had bought very cheaply from a drunken Russian marine back in Stettin. It was so luxurious that it fetched a substantial sum even in this depressed city.

In retrospect, it was most amazing that anything functioned at all in Berlin. Still a smoking ruin of a city, in those bombed-out blocks of streets, here and there a building remained standing, and even habitable. The transient refugee camps were fine for a few days, but I needed to find a room, or perhaps even a few rooms to rent. The next morning, still elated by our escape and ready to face anything, I found a temporary room through a waiter at one of the few open sidewalk cafes, miraculously operating amid the rubble.

At the few shops that remained open, there was no meat to be had, and few fresh vegetables. At the local office of the Joint Distribution Committee I cited my service with Pokorny and my long-standing friendship with David Guzik. I needed some help, some free advice, and a little money to tide us over until we could find work.

They told me to make contact with Herr Heinz Galinski, who was head of the Jewish Gemeinde in the gradually forming German democratic government. As president of the local Gemeinde, or Kehillah, Galinski located an apartment for us in a very fine West Berlin neighborhood, on Schadestrasse, a prestigious address. The owner of the building, which turned out to be a handsome mansion, was Mr. Lux, owner of a large chocolate company. At first, he refused

to rent any rooms to Jews. But then his arm was twisted by a local magistrate, after the office for "Victims of Fascism" ("Opfer Das Fascismus") forcibly intervened. They had threatened dire consequences, including forfeiture of his property, if he didn't back down.

One symbol of the "new Germany" was that, after an initial coldness, Lux eventually repented and warmed to us.

Maybe it was a new day dawning; "victims of fascism" did receive some special privileges — such as special cinema and opera tickets, not having to wait in line at cultural performances and additional coal for heating.

Such compensation, however, was inconsequential compared to what the German government was prepared to offer, if we could somehow prove or persuade the occupation authorities that our losses had been significant. Through the office of the "victims of fascism" I began immediately to discuss with the cultural authorities the possibility of receiving a movie theater, in compensation for just one of the chain seized from Barbara. The one we had our eyes on was a movie theater in a great location, on Alexanderplatz, in the Soviet sector. After answering another barrage of searching questions, all designed to establish whether we were telling the truth, I was informed that if the Soviets didn't object, Barbara and I would receive the theater as just compensation for our losses. I received papers saying "next month you will be the owner of the movie house on Alexanderplatz."

This sounded promising, and might even have happened, if I hadn't had a chance run-in with an old student friend from Warsaw, Meyer Klein, in uniform. He had fled Poland before the war, made it to America, and enlisted in the United States army. Recognizing his insignia as that of a mere sergeant and not officer, I wondered why a brilliant chemical engineer like Klein had not attained a higher rank.

He confided that his major interest in being in Germany was in locating leads to search for surviving members of his large family in Poland. Klein came from an Orthodox Jewish family, many of whom were brilliant scholars. His brother-in-law, named Warhaftig, came from a famous family of lawyers, and would just a few years later play a key role in the drafting of the first Israeli constitution.

Klein said: "Jacob, I know that you aren't religious, but after all you've been through how would you like to come to Friday Sabbath services?" They were conducted by a wonderful rabbi named Joseph Shubow, who since 1943 had served Eisenhower as one of his chaplains.

Thinking not much of it one way or another, I went to synagogue, alone. There, after the services, I spoke to the rabbi who said that he

had been born in Lithuania at the turn of the century, and emigrated to the United States as a child.

I learned later that he had received his A.B., M.A., and Ph.D. from Harvard in the late '20s, and his rabbinical ordination from the Jewish Institute of Religion, a Reform institution, in the early '30s. Since 1933, he had served as a rabbi for a number of American Reform congregations. He was an ardent Zionist, ever since his student days at Harvard where he had founded the Harvard Zionist Society, and had co-founded, in 1925, Avukah, the American Student Zionist Organization.

After a brief conversation, during which he was obviously sizing me up, he asked me if my wife and I would like to go to America.

"Of course," I replied, "but I have no way to go." I mentioned that the office for the victims of fascism was actively negotiating on my behalf to obtain a large movie house in a good location as war reparations.

That sounded like a worthwhile pursuit, he admitted, but he said it remained an open question whether Germany could ever become a country friendly to Jews.

I too expressed my misgivings. After a pause, he said, "Jacob, I've been personally given a certain document known as a corporate affidavit by the Truman White House, which permits me to invite two hundred Jewish 'victims of fascism' to America, bypassing ordinary immigration quotas and procedures."

Surprised, I told him that I couldn't say anything final without consulting my wife, but that the prospect certainly sounded more than appealing. It didn't take long for us to decide. The very next day we returned to the American consulate to discuss the affidavit. Our applications, with Rabbi Shubow's blessing, were promptly approved, along with that of Bela Bund (now White).

In late April of 1946, a gigantic U.S. military truck, an 18-wheeler, turned up at our apartment on Schadestrasse to transport us, and what little luggage we had, to Bremerhaven. There, we were put up for a few days at a local DP camp to await the arrival of the *Marine Flasher*, a converted troop ship requisitioned for the sole purpose of transporting the first Jews from postwar Europe to America. While staying at the DP camp, waiting for the ship to take on its cargo of passengers, Barbara and I wandered down to the black market to buy provisions for what we understood might be a long journey. We had no idea what sort of accommodations might be awaiting us on board, and after living through the privations of war, we had long since learned to be prepared always for any circumstances. While we were busy haggling with a black marketer for a carton of cigarettes, a sweet-faced young American soldier in uniform politely

approached and asked us if he could be of any assistance. We explained that we were simply stocking up for the long trip aboard the *Marine Flasher*. Laughing he pulled an MP (Military Police) armband from his pocket and sympathetically explained that we shouldn't worry, that we were now in the capable hands of the United States military and that everything we needed would be provided for us. "Don't pay exorbitant black market prices," he said, "it isn't necessary."

That nice young soldier was my first introduction to America, my promised land. In early May of 1946, two large buses pulled up to the gates of the UNRRA camp to take us down to the docks, which were still being rebuilt after the saturation bombing of the port area. We were instructed to each bring no more than 25 pounds of luggage and to embark in alphabetical order, as our names appeared on the passenger list. We had only a few precious bits of property, like the fur coat I had acquired for Barbara in Berlin in exchange for an old typewriter. In those days, most purchases were by barter. Still, Barbara and I were a bit overweight in the luggage department, and were concerned about having to jettison some belongings. Just then a charming young man, without valises, offered to take one of ours, and count it against his weight allotment. He explained that he had cousins in America who had written telling him to bring nothing, that everything would be provided. I can recall thinking that America must surely be the Bible's Promised Land of milk and honey.

The young man introduced himself as William Ungar. He had been with us at the DP camp in Bremerhaven, and shared our former German military barracks with us, along with the other *Marine Flasher* passengers.

The American ambassador to Germany, Mr. Murphy, came to the dock to see us off and to wish us a safe journey. His speech was followed by a few rousing songs played by a Marine band. And so we departed for an unknown future which we considered the Promised Land.

Part Three:
At the Top

Sculpture

More than forty years later the June 1987 issue of *Financial World* featured a photograph of me with a Henry Moore sculpture. In large type across the top of the page, the magazine quoted me that "sculpture is generally undervalued."

The reasons for this undeniable trend of the '80s are many and mysterious. But I think it could be largely attributed to a lack of knowledge on the part of collectors and dealers as to the value and virtue of sculpture as an artistic medium. The British art critic Peter Watson, author of the 1992 book *From Manet to Manhattan*, which claims to be a comprehensive account of the rise and fall of the international art market in this century, ignores the sculpture market altogether. If one were to read his book as a guide to the contemporary art world, one might well conclude that sculpture does not exist as a legitimate art form.

"I have considered painting the senior branch of the fine arts," Watson writes in his preface. "This is not so simply because van Goghs and Picassos have recently changed hands for sums that make even bankers dizzy, but because painting still evokes a greater popular response than do other art objects. People do not travel by the hundreds of thousands to see silver exhibitions or furniture displays, the way they travelled to the van Gogh centenary exhibition in Holland in 1992."

I could not disagree with Watson more strongly. Sculpture by great masters, whether Picasso or Michelangelo, Henry Moore or Rodin, is as great an art as painting, not at all in the same class as mere "furniture displays" or "silver exhibitions." True, no sculpture has yet commanded the eighty-million-dollar-plus price tags commanded by van Gogh's finest works. These skyrocketing values in the '80s were almost entirely due to the influx of cash-heavy Japanese buyers. But as one of the world's most successful dealers in 20th century master sculpture, I believe sculpture to be at least as representative of changing tastes in the art world as painting.

The '80s financial boom was in large part fueled by massive investment in real estate, particularly large office buildings, built along highways in Houston or avenues in New York or Tokyo. Nearly

every one of these new massive buildings are graced with plazas on which some monumental sculpture has been placed, whether a purchased or a commissioned work, to dignify the setting, and to elevate a strictly commercial building into an appropriate environment for art. The '80s and '90s have seen the rise of sculpture gardens all over the country, from country estates to suburban shopping centers to downtown malls and arcades. In short, the global sculpture market came of age in the '80s. And I was there to participate.

Even as art critics like Peter Watson don't refer to sculpture, as a lifelong contrarian I have always believed that in any undervalued product lies a wealth of opportunity, or an opportunity for wealth. In the '80s , I found my golden opportunity in large modern sculpture by 20th century masters, like Henry Moore, Alexander Calder, Marino Marini, Giacomo Manzù, and Fernando Botero, among others. During that high-flying decade, I became the largest private dealer in sculpture in the world. Sculpture became my stock in trade—what the Weintraub Gallery became noted for worldwide.

I had been buying and selling large works of sculpture by major modern masters in a small way since the early '60s. With Marvin Small I had featured a variety of small sculptural works by Max Ernst, Henry Moore, Alberto Giacometti, Joan Miró, Pablo Picasso, and Henri Matisse. In the late '60s, I had gotten my "feet wet" in the sculpture market by buying nearly the entire Jacob Epstein estate from Lady Epstein. We sold his magnificent bronzes all over the world, from the United States to Europe and the Orient.

In the '80s, my interests turned to monumental sculpture. Even as prices soared along with painting to levels far beyond our wildest dreams, I bought and bought. Sculpture struck me—no pun intended—as a solid investment for the coming decade. The '60s had seen another boom in the art world, and I remembered the mood of the time: expansionistic, grandiose, at times manic.

A large part of art dealing is, of course, gambling to make a major return in the market. It's an exquisite form of futures trading though; like poker as opposed to dice, it takes more skill and imagination than just a straightforward roll of the cubes. Some inner voice of experience and intuition told me that monumental sculpture, the larger, more ambitious and costlier the better, would fit the grandiose mood of an expansive decade.

In the early '80s I invested several million dollars in modern sculpture. A short review of sales in that period tells part of the story. In 1980, I made my first several hundred-thousand dollar sale of sculpture to Pepsico, under the aegis of its art-patron chairman, Donald Kendall, for a large work by Marino Marini (Horse and Rider):

$275,000. In 1986, a Moore (Draped Reclining Mother and Child) to Johnson & Johnson for $1 million. This was my first million-dollar sale of a single sculpture. In 1988, I sold a different cast of that same Moore for $2 million to a gallery of modern sculpture in Tokyo, through a California dealer. In 1989, with a joint venturer, I sold a large Giacometti for $7 million. By the end of the decade, we were growing accustomed to multimillion-dollar sales of sculpture, often, but not exclusively by Henry Moore. In my career, I have sold some 200 works by Moore. In the 1980s alone, I sold 97.

If in the '50s I became known as "the dealer with the German Expressionists," now I had gained global recognition as "the dealer with the big sculptures in the window." Speaking of windows, my huge plate-glass ones overlooking Madison Avenue were, I realized, one of my greatest assets. Conferring visibility in a high-profile location, these were my windows on the world, and the world's windows on my wares. Nothing, I learned in my days on Madison Avenue, quite caught the wandering eye of the casual passerby like monumental sculpture, properly placed so as to fill that huge space with mass and volume.

Putting "Ubatuba" on the street corner was a ten-strike from a public relations perspective. Because of its now-celebrated capacity to survive and endure, that big hulking, arcing hunk of green-gray granite had become a symbol of survival under adversity, an icon for embattled and besieged New York. Since its destruction, and Phoenix-like resurrection from its own shards, the two-ton art object had taken on new weight and importance as a survival symbol for an uncertain age. But on a less existential, more commercial level, "Ubatuba" also served as my logo, my shingle, just as the spiral-striped barber's pole once marked the place where the barber/surgeon conducted his trade, or an oversized set of dentures outside a dentist's window once advertised the office of a tooth-healer, "Ubatuba" shined like a beacon on Madison Avenue in mute proclamation that Weintraub Gallery was the place to see and buy great sculpture in the city.

Great sculpture—polished, crafted, elegant, immortal. Something hard and enduring about this solid medium has always appealed to me. Its virtual indestructibility seems its cardinal virtue. Bronze, granite, marble, wood—all can be shattered, burned, fragmented, melted down to make cannon balls. But of all media, sculpture is the hardiest, the most durable, the most enduring. The Elgin Marbles may have been torn off the Parthenon, but there they are, good as new, in London's British Museum. When I visit the world's greatest museums, I always rush to the sculpture galleries first, where massive works from all ages, whether Mayan or Byzantine, Greco-Roman

or Egyptian, Chinese or Japanese or ancient Indian, may be seen, and touched (when the museum guard is not looking). Sculpture is the medium of survival—was it a wonder that I had come increasingly to admire survival, tenacity, and endurance—all qualities of sculpture?

In April and May of 1980, we mounted a major exhibition, in association with the Dominion Gallery of Montreal, of a number of large sculptures by what I dubbed the "Three M's": Manzù, Marini and Moore. The following year we put together yet another major show of large sculpture by Moore, Marini, Maillol, Calder and Arp. We also included a group of maquettes (small three-dimensional studies for monumental works, usually in bronze) by all of these artists.

We started to get fine notices in newspapers around the country for our sculpture exhibitions, like the one from the Sunday, November 10, 1985, New Orleans *Times-Picayune*: "Works by Henry Moore fill the Weintraub Gallery at 77th Street and Madison Avenue. Dominating the entrance to the gallery is a gigantic bronze sculpture by Moore, 'Mother and Child: Block Seat,' while rising against the rear wall is a glass case containing 50 bronze maquettes by the artist, dating from the 1930s to the present. Also on view are large and smaller sculptures by Jean Arp, Alexander Calder, Jacques Lipchitz, Marino Marini, and Joan Miró.

"The gallery seems to be a small, somewhat cluttered museum of modern art," wrote Roger Green, the *Times-Picayune* critic, "causing the visitor to wonder by what extraordinary means so many examples of blue-chip sculpture ever were assembled in a two-story commercial space. Yet according to its owner, Jacob Weintraub, the crowded gallery is becoming an anomaly on Madison Avenue." I was referring to an untenable situation, that as rents escalated throughout the decade, prestigious art galleries were being squeezed out by pricey foreign-owned clothing boutiques.

In early 1982, I sent an engraved invitation to my entire mailing list — several thousand interested parties — printed on the back of a silver-toned postcard on which a glittering photo of one of Moore's most recent, most magnificent monumental works was carefully reproduced. "Mother and Child: Arms" had recently been completed at Moore's Much Hadham Studio. It provided a fitting and powerful centerpiece to our newest exhibition of sculpture. "Watercolors, Drawings and Graphics by Moore" opened on Wednesday, April 28, 1982, and proved a great success.

That year, Henry Moore, son of a Yorkshire coal miner, had turned 84. Accompanied by Queen Elizabeth, he opened a magnificent new wing of the Leeds City Art Gallery, funded by the Henry Moore Foundation. Moore had been born in 1898 in Castleford, about 12

miles from Leeds, and had attended the Leeds College of Art, cramming a three-year course into two, before commencing a course of instruction at the Royal College of Art in 1921. By 1982, Moore had become the world's foremost living sculptor. His work was shown around the world in thirty-five major exhibitions in a single year, of which ours in our small space was one of the largest.

Although by then Moore was getting frail, having suffered a fall at his home in Much Hadham a few months before, he was still able to execute brilliantly his monumental bronzes, with the help of well-trained assistants. Bronka and I dropped in on Moore and his wife, Irina, for an elegant luncheon at Much Hadham in late summer of 1982. During a philosophical moment, he gestured grandly toward his beautiful garden, surrounded by open fields, and remarked, "I look out there and I've only got to move a few inches in my chair, and every piece of sculpture looks different."

"Nature is never symmetrical," he told a reporter a few months later, in reference to his obsession with the appropriate positioning of his monumental sculptures, which were carved and sculpted to live and breathe outdoors, preferably in large gardens. When he carved and cast his sculptures, Moore said, he liked to visualize them sitting in open fields and pastures, or by a stand of trees in the woods, perhaps even with a brook roaring by. "The sky changes all the time—it's one of the best backgrounds." Moore was a hardy man living in the rugged English countryside, and his rough-edged "primitive" sculptures, so close to nature, seemed to breathe and come alive outdoors.

Moore told me how important context and positioning were to his vision and intention for a work of art. In keeping with this artistic desire, on which he had to count upon his faithful collectors and dealers to comply voluntarily, I always tried to place his works in suitable settings, a gesture he always appreciated.

In conjunction with our 1982 exhibition, I coordinated the installation of a monumental Moore which had been donated to the United Nations, with a simple ceremony to mark its careful placement on the elegant greensward fronting the Secretariat Building. I had a photographer take pictures of the work from a variety of angles, and I sent them to Moore's home at that marvelously lyrical address: "Dane Tree House, Perry Green, Much Hadham, Hertfordshire."

On November 10, 1982, I was elated to receive a warm personal note from the artist:

"Dear Mr. Weintraub,

"Thank you for your kind letter written to Mrs. Tinsley and for the photographs of the ceremony at the United Nations. I am very

pleased to have them for my records. As you know, I always like to see my sculptures placed properly!"

Between the lines, obviously typed by his valued secretary and longtime aide, the redoubtable Betty Tinsley, Moore had written in pen, in a slightly crabbed, elderly hand: "Of course!" A personal touch I particularly enjoyed. Of all the artists I ever worked with, I felt the closest personal affinity to Moore, a rapport I feel was returned in kind. In 1983, we mounted yet another major Moore exhibition, "Homage To Moore," designed to run concurrently with a vast Henry Moore retrospective, "Henry Moore: 60 Years of his Art," at the Metropolitan Museum of Art. These were the declining years of his long, remarkably productive artistic career and the art world was eager to repay the great man for all the pleasure his work had given. Our exhibition was held also in conjunction with a major promotional effort by the British in America, culminating in a large festival "Britain Salutes New York." Our "Homage to Moore" consisted of "major pieces of sculpture, watercolors, drawings and prints, reflecting Sir Henry's extraordinary achievement and distinguished career." During a luncheon held in Moore's honor at the Metropolitan Museum for the opening, Moore's close friend, fellow sculptor Bernard Meadows, gave a glowing address. Sadly, too weak to travel, Moore was unable to attend. As I listened to Meadows discourse fondly and familiarly about his old friend, I detected a minor commotion behind me. This turned out to be my then-assistant, David March, pushing his way through the crowd, anxious to give me an urgent message.

Whispering as quietly as he could into my ear, yet trying to restrain his excitement, March murmured, "A major Moore collector is waiting for you in the gallery, and he wants you to come back immediately. He wants to buy every Moore in the collection." I had him repeat this wild message, unsure that my ears were not deceiving me. Every Moore I had? By then, you see, I had amassed the largest private collection of Henry Moores. I told March: "If he wants to buy just one Moore, I'll leave the luncheon. But if he wants to buy all the Moores, he'll have to wait for me to return."

Figuring that would put a stop to this nonsense, I sent my assistant back to the gallery, only a few blocks from the Met. I contentedly listened to the conclusion of Meadows' address, and returned to the gallery at my leisure. The man impatiently cooling his heels in the gallery turned out to be George Ablah. This colorful, eccentric Kansas-based oil and real estate investor was fast becoming one of the major Moore collectors in the world. By then, he had collected over thirty large Moores, and was reputed to be on the lookout for more.

The 54-year-old Ablah, who made a point of never wearing a jacket and tie, did indeed intend to buy every Moore I had. It therefore behooved me to invite him across the street to the Carlyle Bar to discuss his special needs. "They'll never let me into the Carlyle dressed like this," he laughed, gesturing down at his rumpled polo shirt, polyester slacks and cowboy boots.

"I don't know about that," I said, winking. "They've known me a long time."

"They've known me a long time too," he laughed. "But they still don't like the way I dress."

I didn't either, but I didn't say anything. The number of wealthy celebrities whom I've asked to leave my gallery because I thought they were bums has become legendary on Madison Avenue. "We're only open by appointment," I'll tell them, only to find that often as not it's some underdressed movie star, like a Bruce Willis or Demi Moore. Ablah told me with irrepressible excitement about his latest pet project: lending, or as he preferred to put it "sharing," twenty-five monumental Moore sculptures to the City of New York, to be installed in the parks of the five boroughs, according to the sculptor's desire for his sculptures to "breathe." Moore had told Ablah's representative, David Finn, of his earnest desire to have as many of his major works exhibited out of doors, particularly in "woods and pastures." Ablah felt so desirous of pleasing the master that he had a marvelous idea: to buy more Moores, and share them with the public. He promptly plunged into a major Moore buying-spree, which inevitably had brought him to me, the largest purveyor of Moores in the country. We quickly struck a deal on seven Moores. Much as I hated to see them leave, business is business.

"More Moores!" became George Ablah's rallying cry, along with his slogan, "In everything you do, always try to hit a home run," a sentiment with which I most heartily agree. I liked Ablah.

After all, as a sculpture dealer, how couldn't I love a man who outfitted his $10 million Gulfstream private jet with sculptures by Rodin, Arp, Brancusi, two Henry Moores and, as the final pièce de résistance, a Giacometti in the head! Perhaps having every button, every light fixture and all the hardware down to the seatbelt buckles and even the overhead air nozzles gold plated, was not entirely my taste, but I couldn't see Giacometti being anything but amused by the placement of his work.

As the press got wind of Ablah's plan to lend twenty-five large Moores to New York City for a year, "Ubatuba" was frequently invoked as a negative precedent. *The New York Times* of Monday, March 26, 1984, put the point succinctly: "Of course, the prospect of

exposing such great works to the potential ministrations" (I liked that, "ministrations") "of vandals and graffiti artists is enough to keep their donor and a whole array of bureaucrats awake at night. All are aware of such unfortunate precedents as the destruction— twice in ten months—of a granite sculpture displayed in front of an art gallery on Madison Avenue four years ago."

The all-important question of placement for Moore sculptures served as the inspiration for the Henry Moore Sculpture Preserve. This was created, again in an attempt to fulfill Moore's fondest dreams, in a lovely garden setting near Arden House on the old Harriman Estate in upstate New York. A portion of the sprawling property in the Hudson Valley, not far from Bear Mountain, had been left by Harriman to Columbia University. In 1978 Henry Moore visited the property and was astonished to find it resembled a "piece of Scotland only an hour from New York." As the invitation to a luncheon I received in August 1986 put it, "with its promontories and rugged contours and beautiful vistas of fields, forests and sky, the Preserve is without question one of the world's most ideal places for Henry Moore's sculptures."

Early that spring, the increasingly frail Moore had traveled to the United States to install personally three monumental works, all gifts presented by his Henry Moore Foundation, in the new Preserve. Moore was too ill to attend the luncheon, but it was a touching event, in that it truly represented a permanent attempt to realize the sculptor's highest artistic ambition. "Sculpture gains by finding a setting that suits its mood," Moore had once said, "and when that happens, there is a gain for both sculpture and setting." At Arden House, sculpture and setting suited each other exquisitely.

Within a few months, the great Moore was no more. He died peacefully at his home in Much Hadham at age 88. Bronka and I felt privileged to attend his moving memorial service, in London's Westminster Abbey on November 18, 1886. Present were most of the British royal family, including the Queen and Prince Philip, Prince Charles and Princess Diana, and an astounding and impressive representation of lesser royals and notables who attended to pay tribute to Moore's genius.

Now his great raw, rough, "primitive" sculptures would live on in perpetuity, to thrill generations to come. During the service, Bronka and I were both in tears as we recalled our last extended visit with Moore, a few years before, on one of our annual summer art-buying excursions through the Continent. We called on Henry and Irina, at their home at Forte dei Marmi, in Tuscany. Fernando Botero, Marino Marini and Giacomo Manzù, along with a number of the other noted

sculptors also maintain homes in the area, due to the proximity not only of the marble quarry in Carrara, but also of two of the world's finest foundries, Tomasi and Mariani.

Moore and his wife couldn't have been more charming, though one had the sense that certain personal matters had begun to weigh heavily on his mind: he missed his daughter, Mary, and his grandchildren. I had heard through the Henry Moore grapevine that would-be buyers of sculptures (Moore, like Picasso, could be terribly selective about whom he sold to) would sometimes bring little children with them, knowing his love of children would soften his occasionally crusty demeanor.

Bronka and I, unfortunately lacking children, brought only ourselves, but we were made warmly welcome all the same. We were staying at the Montecatini spa not far from Forte dei Marmi.

We invited Henry and Irina to dine with us at restaurant Hotel LaPace that evening. Though we tried to keep the identity of our guests a secret, one of the restaurant staff took a phone call from Moore's secretary and blabbed to her boss, who immediately, in true Italian fashion, alerted the press. Moore and his wife had expressed the desire to attend incognito, but once his cover was blown and the paparazzi flashbulbs popped, Moore, ever the English gentleman, was a good sport.

As the funerary trumpets sounded a sad dirge for the departed Moore at Westminster Abbey, I reflected on the hard fact that while the human body may perish, great works of art endure.

I hope it doesn't sound crass, but after Moore's death I decided to buy each and every Moore I could get my hands on. My assumption was that the prices for Moore would escalate dramatically now that the number would be finite. I had been buying as many large Moores as I could during the last few years of his life. Now, with a kind of calculated impulsiveness, I flung all caution to the winds, and imitated my good friend George Ablah in going on a virtual Moore-buying spree. Contrary to my usual practice, I made a point of not trying to drive hard bargains. This was a deliberate course of action, all part of an overall scheme: I wanted word to get out that Jacob Weintraub was willing to pay top dollar for Moore, and beat out all other buyers. Unlike Lady Epstein, there was never a whiff of over-casting of Moores, the market for which was tightly controlled by the Henry Moore Foundation. There would be no more castings. There would, in short, be no more Moores.

But what Moores there were, as I expected, swiftly increased in value. In July of 1986, just a month before Moore's death, a corporate curator for Johnson & Johnson, the pharmaceutical company, walked into the gallery and gave a cool appraising look over one of

our 8-foot Moores—a "Draped Reclining Mother and Child," widely considered by Moore authorities to be one of his finest works in the genre. The curator, Michael Bzdak, liked the Moore very much, and seemed pleased to find that its previous owner was the Henry Moore Foundation (I had bought it directly from Moore). He explained that he was interested in acquiring it for Johnson & Johnson's corporate art collection, to adorn a grassy rise outside the firm's campuslike headquarters in New Brunswick, New Jersey.

My asking price was an even $1 million. After the CEO and his wife dropped by to take a look, the question was raised about a discount. I regretfully explained that that would be impossible, because Henry Moore was very ill and that after his death prices were expected to escalate, possibly sharply. That was it. There was no more talk of discount. My price was met. This was my first one-million-dollar sale for a single piece, and in a way it had been as easy as selling a one-hundred-dollar graphic was in the old days. The difference was that now I was in a position to have a million-dollar-Moore in my gallery, and I didn't feel compelled to come down in price.

Shortly after Moore's death, the deal with Johnson & Johnson closed. The company had already increased the value of their investment by no negligible amount. I arranged for our art shipper, Auer's, a family-owned firm founded in 1926, to handle the task of transporting this valuable work to its final location. True, a bronze sculpture is extremely durable, but it can also be damaged in transport if improperly handled. Bob Degan of Auer's arrived with his crew of six strong men to inspect the work, for which they would construct a special shipping skid out of plywood.

A sculpture like that will not, of course, simply sail out the door. Auer's arranged for a glazier to arrive at the appointed hour to remove our 25-foot-long plate-glass window. A big moving day always creates an event on our street, as gawkers gather to oversee the move, often offering unhelpful advice as they see fit. Degan needed a rig fitted out with block and tackle to lift the work off its base in our gallery. They wrapped the sculpture and laid it gently on the skid, forklifted it into the van and trucked the two-ton work to their warehouse, where the crew constructed a huge crate out of cribbing wood, for protection while in transit.

At Johnson & Johnson, the crew erected a gantry over the pedestal, which had been prepared on site to accept the sculpture. It was then lifted and rolled out across a steel I-beam and very carefully lowered onto the pedestal base, where "Draped Reclining Mother and Child" was to rest in the future.

Another example of the increase in value enjoyed by Moores after

his death can be illustrated with three separate castings of another sculpture, "Mother and Child: Block Seat." I bought my first on September 1, 1985 from Moore himself, just a year before his death. In 1986, just after his death, I sold it to Donald Rechler, a real estate dealer, with the understanding that it would remain in my possession until an office building he was constructing in suburban Long Island was completed.

Before the year was out, we had a visitor from California, a major collector, who saw the work in the gallery and fell madly in love with it. I explained that I couldn't sell it because it was already spoken for, even though 1) the original buyer had not yet paid for it in full, and 2) the new buyer was offering more for it. Sometimes, in order to maintain one's integrity, one must forgo an opportunity for more profit. I told the collector that I couldn't sell that one, but that I might be able to find another cast of the same work for him.

He implored me to do so, urging me to act as quickly as possible because he was leaving for California at noon the following day. I spent all day on the phone with every Moore contact I could think of, even calling Korea, until finally, just as my time was about up, I struck pay dirt in—where else? California.

My good friend José Tasende, a Basque and a noted Moore dealer, had another cast of "Mother and Child: Block Seat" in his La Jolla gallery. He was willing to sell it (we would split the profit) but now the question arose: should I ship it directly from La Jolla to San Francisco, or should I pay to have it shipped to New York, and from there back to California? The only reason, of course, for shipping it back to New York was that the collector might find it a trifle absurd to have flown all the way to New York to buy a Moore that he might just as well have found closer to home. In the end, figuring that there was no point in subterfuge, I ended up shipping it directly from Tasende to the collector's home. If he noticed or cared, he never mentioned it to me.

In May 1987, a man came into the gallery and asked me if I wanted to buy a cast of "Mother and Child: Block Seat." Having done so well by the first two, I expressed interest. But now he wanted a million dollars, roughly twice what the same sculpture had commanded a year ago when Moore was still alive.

That was too steep for me, but after he lowered the price to $800,000, he offered to go in on the sculpture with me. It turned out that he was acting as a middle-man for a dealer, not an uncommon occurrence in the art world, in which many sellers and buyers prefer to operate through middlemen, so as to preserve their anonymity. We agreed to split the price of the sculpture, each investing $400,000,

and in August of that year, I sold it through an American dealer in California to a corporate collector in Japan for $2 million: more than doubling my money in one year.

Japan was, of course, the key. The rise of cash-heavy Japanese dealers did wonders for the market for Moores and other blue-chip Western artists, particularly the Impressionists. I had a sense, or let us say a premonition, after visiting Japan once during those fabulous bubble years, that the party would not last indefinitely. This would be more like a game of musical chairs: when the music stopped, not everyone would be a winner.

The Japanese often bought through middlemen, often because the purchasers weren't individuals but a variety of consortia and trading companies. We typically dealt with representatives and often didn't know the name of the client until after the transaction was completed. There were, however, a few exceptions. One night as I was closing the gallery I saw an extremely well-turnedout elderly Japanese gentleman peering in the window. Something about his expression struck me as imploring, yet in a dignified way. I was also struck by the hat he was wearing, a battered fedora that was probably as old as he was: over eighty.

I opened the door, and he gratefully entered. I said, "I can tell that I am dealing with a very rich man."

"And how do you know that?" he asked, astonished.

"Because only a very rich man could afford to wear a hat like that," I replied.

"Well, you are right," he said, as he shook my hand, bowed deeply, and presented me with his calling card, in the formal Japanese manner. I was glad I had opened the door for him, because after the most cursory of inspections he bought the large Henry Moore he saw in the window for well in excess of a million.

Million-dollar sales were by then becoming, if not precisely commonplace, no longer the stuff of art-world legend. When I asked this client about having the statue shipped to Japan, his expediter told me, "Don't worry, we have our own containers." Indeed, this gentleman had his own ships. It must have been that the hat did it: a mark of great honor in that stratified society.

My great love affair with Henry Moore did not cause me to neglect the other great sculptors of the 20th century. My particular favorites were the other great "M's": Manzù and Marini. In 1987, when we moved across the street to our present location in the old Parke-Bernet building across from the Carlyle Hotel, we celebrated with the publication of a new catalogue entitled "MASTER SCULPTORS OF THE XX CENTURY" photographed by my friend David Finn.

I wrote the introduction, in which I attempted to sum up my fondest feelings about the deeply gratifying world of modern sculpture. "The publication of this catalogue, dedicated to my wife, Bronka, marks the thirty-sixth anniversary of our gallery as well as our move to a new location at 988 Madison Avenue. It culminates a lifelong dedication to the work of the leading sculptors of the 20th century in the revered tradition of dealers Curt Valentin and Otto Gerson. Each sculptor's vision reveals a special quality in our lives. Moore's organic works, often enriched with patination that seems to contain the residue of ages, create unforgettable forms in his smallest maquettes as well as in his most monumental sculptures. Arp's creations, whether in polished bronze, white marble or abstract cut-outs, rival nature's remarkable inventions. Calder's colorful mobiles are miraculously balanced and his floating forms a marvel to behold. Marini's sculptures combine strength and sensuality in their noble conceptions. Manzù shows in his work a sense of grandeur which endows a quality of religiosity to everyday life. Giacometti magically depicts the spirit that lies behind or within all physical beings. Picasso demonstrates his fantastic genius and unparalleled imagination in sculpture that matches his achievements in painting. Lipchitz, Botero, Greco, Archipenko, Miró, Meadows—have their own unique creative contribution to make to the history of our time. It has been an extraordinary opportunity to present the works of master sculptors over the years, and to introduce exciting young talent such as Kodama, Dolfi and Shawzin. We are proud to include in this catalogue outstanding sculptures by these and other major artists."

Proud indeed. As the decade wore on, we expanded aggressively into the global marketplace, bringing the Japanese buyers into the sculpture market in a major way. As the power of the auction houses increased and prices climbed steadily, multimillion-dollar sculpture deals became increasingly common. David Norman, of the sculpture department at Sotheby's, had this general comment on the sculpture market in the '80s: "The sculpture market generally paralleled that for painting, enjoying a rapid increase in prices from 1980 through 1985, with a real take-off point in 1986 running through 1989. If a piece first sold in 1983 came up for auction again in 1987, chances are it would have easily quadrupled in price. The remarkable thing is that from 1987 to 1989, if that same piece came up again, it could be expected to double again."

A boom on that scale tends to come only once or twice in a lifetime, and can never be sustained for more than a few years. As the Japanese buyers fell out of the market in 1989 when their bubble burst, the Germans, the Italians, the English and our own still-thriving domes-

tic market sustained us. With the '90s, the drop-off was rapid. Now, things have quieted down considerably, giving the market time and room to regroup. Though I had enjoyed dealing with Japanese buyers, I had long suspected their addiction to buying on credit, as their banks lent money hand over fist simply to put out the loan. I decided to ship large pieces, particularly on multimillion-dollar sales, only after receiving the check marked payment in full.

My relationship with the great Italian sculptor Marino Marini was as important in some ways to my growth as a dealer as was that with Henry Moore. Marino Marini was born in Pistoia, Italy in 1901, and was educated in painting and sculpture at the Academy of Fine Arts in Florence. In the tradition of the great Renaissance masters, for many years Marini devoted himself to mastering the arts of painting and engraving. He was a frequent visitor to Paris in the early '30s. There he fell in with such artists as Kandinsky and Maillol. During this period, he also associated with Picasso, Braque, and Laurens. He was an avid traveler, intrigued by the artistic potential inherent in deeply penetrating other cultures and other worlds. The war caused him to emigrate to neutral Switzerland, along with innumerable other artists of international renown who would otherwise have remained trapped in the war-isolated Fascist countries.

His true artistic flowering took place after World War II, when a famed art dealer, Curt Valentin of the Buchholz Gallery, agreed to mount a large Marini exhibition in New York. While in America, the artist had become acquainted with Lipchitz, Calder, Beckmann, Tanguy and Feininger, among others whom Valentin represented. I have long considered Curt Valentin to be my role model as an émigré art dealer, and an arbiter of taste. Valentin also revered the great German Expressionists, and I consciously followed in his footsteps in my own modest way as I amassed my own considerable German Expressionist collection.

On his way back to Europe after his 1948 New York exhibition, Marini stopped off in London (where the Hanover Gallery gave him a large exhibition) to meet Henry Moore. Six years later, Valentin passed away on a visit to Marini's home in Forte dei Marmi.

The horse and rider is far and away the dominant theme in Marini's work, verging on a personal obsession in much the same way that the mother and child dominated the work of Henry Moore. To Marini, the horse represented the height of vitality, speed and controlled strength, while the rider represented the human race's often futile yet poignant attempt to control nature. In the flexing of the magnificent muscles of the horse, one sees grace in motion, while the action of the rider in controlling the horse symbolizes man's

aggressive urge to channel and control energy. Horse and rider are twin images joining man and beast in a strange symbiosis. Since the dawn of man, the domesticated horse has been mankind's primary vehicle for hunting and fighting, chasing and being chased, in an eternal cycle of life and death.

In Marini's first horse and rider, his 1936 "Cavaliere," completed at age 35, the horse was a relatively sedate creature, subdued and submissive, controlled by its human master. Eleven years later, in his "Cavaliere" of 1947, the rider sits rigidly, conferring a phallic significance: upright and violent. I began dealing in Marino Marini's work when his New York publisher, Tudor, a subsidiary of the Harlem Book Company, approached me in the late '60s with a massive Marini portfolio entitled "Color and Form," at a time when I was working closely with Harlem on my Epstein purchases. The portfolio, a collection of twelve lithographs, was an impressive achievement. I bought a dozen, with the proviso to which Tudor agreed that I was to get the artist's proofs gratis, as a bonus. I was so pleased with this virtuoso performance by Marini that the following year on my annual European summer sojourn I called on Marini at his Italian home. We had luncheon in his sunswept garden with him and his wife, Marina, and a third guest—Marini's Parisian publisher. Over a magnificent banquet, I shared with Marini my own personal feelings about his theme of horse and rider. To me, it eloquently symbolized modern man's ambivalent attitude toward the rampant violence of the 20th century. The horse and rider motif was deliberately archaic, conjuring up images of warfare of an earlier age. By the 20th century, the gas mask would have been a more appropriate image, or the submachine gun. But the horse and rider spoke to more eternal verities. I mentioned that the late polychrome work in which the horse and rider appeared, to me at least, to be riding at full gallop away from some catastrophe spoke to me of the modern Holocaust and an earlier one—that of Mount Vesuvius, which looms above the volcanic alluvial plain as a reminder that man can never control nature.

My little speech must have had some effect, because after our visit, Marini would stop by the gallery whenever he visited New York. His great friend and promoter, Valentin, had passed away by then, and though he had moved to Pierre Matisse's New York Gallery for representation, he never felt, I divined, quite at home there. Marini's pre-1954 work was most highly valued by collectors, who generally felt that he had flourished artistically under Valentin's close influence. After Valentin's death, the emotional intensity of his work never quite recovered. On a later visit to Forte dei Marmi, Marini kindly signed my collection of his artist's proofs of

"Color and Form" in my name. In 1970, I acquired an unusual poly-chrome 84-inch-high horse and rider "L'Idea del Cavaliere" later reproduced on the cover of the catalogue and book published by Palazzo Venezia, a prominent Roman art publishing house. We later sold it to Alexander Kasser, a New Jersey collector, for $80,000. It would be worth in excess of a million today.

In 1980, for a large Marini exhibition that I was planning, I wanted to borrow a magnificent "Horse and Rider" on permanent display at a Manufacturer's Hanover branch on 57th Street and 5th Avenue. I called the branch manager. He promised to see what he could do for me, but advised that he would have to seek the approval of the board of directors to approve the loan. He wasn't optimistic.

A few days later, he called back with a note of surprise in his voice: "Mr. Weintraub, you must have a darned good reputation in this field, because the board has agreed to lend you the work for a speci-fied period of time." Still, before lending it, they would need an inde-pendent appraisal of its worth, primarily for insurance purposes. Its assessed value: $400,000.

When I went to speak to the branch manager, to work out the pro-visions of the loan with the bank manager, I prepared a proposition. "In one pocket I have the independent appraisal for $400,000," I said, trying not to appear too cute. "In my other pocket, I have a check made out to you for $500,000. Take your pick."

Unfortunately, the ploy did not work, because as the branch man-ager regretfully explained, "Banks are being closely watched by the regulators and their stockholders more than ever. If we approved this sale, it might look suspicious, as if someone around here might be on the take."

Sympathetic as I was to the banker's need to maintain a pristine image, I must say that I didn't see any problem. How could anyone in an oversight position look askance at the bank's turning a quick, effortless 20 percent profit? Then again, neither did I understand the S&L crisis. We installed the huge Marini as the centerpiece of the exhibition. It succeeded in attracting such luminaries of the art world as Pepsico chairman Donald Kendall, who fell so madly in love with the Marini that he asked me to get him a similar one, as I had explained the situation involving Manufacturer's Hanover.

I later did acquire a similar "Cavaliere" from the collection of the film producer Billy Wilder, for $600,000. It's now worth close to $2 million. When I returned the loaned Marini to "Manny Hanny," as the bank was called, I was shocked to receive an irate phone call from the new art curator at the bank. He complained that the Marini had been scratched while on loan. The curator was an idiot; these so-

called "scratches" were simply artist's marks, the primary sign of its value! To settle the matter, I agreed to show the Marini to Pierre Matisse, who readily confirmed that these were indeed sculptor's marks, not the result of mishandling.

This incident only confirmed what I had long suspected: corporate curators do not know much. I longed to get my hands on that Marini, I loved it so much. In 1989, as the crisis in commercial banking was beginning, threatening the very existence of Manufacturer's Hanover (three years later, it would merge with Chemical Bank and pass out of existence), I picked up the paper and read in the business section that the bank was spinning off several unprofitable subsidiaries and departments at fire-sale prices in a desperate bid to raise needed liquidity.

Now I saw my opportunity to get that Marini. I called my old friend the bank manager and asked simply, "What's going on?"

"What do you mean what's going on?" the manager replied coldly. Butter wouldn't have melted in his mouth.

"I see in the paper that you are trying to raise cash," I said, "and if you might be willing to part with that Marini, I'd pay a million tomorrow." In the decade, it had doubled in value.

He took a deep breath, and said, "Now I know why you're successful in business, because you are right—the Marini is for sale." My blood rushed to my head, until he gently broke the bad news that the matter was out of his hands: the Marini had been turned over to an auction house for sale to the highest bidder. They couldn't sell to a dealer, for propriety's sake.

Still frustrated at the big fish that got away (the Marini would be at the Sotheby's auction) I rounded up a joint venturer with whom I agreed to pay up to $2 million, if it were necessary. After a long, protracted, heavy bidding contest we got what we wanted: a giant Marini "Cavaliere" for $1.76 million, one of the highest prices I ever paid for a single piece of sculpture.

I was in Israel when I got word that he had died. I considered him a close friend, along with Moore.

Another artist who was to inhabit a major place in my stable of sculptors was the Colombian-born painter and sculptor, Fernando Botero. Born in 1932 in Medellín, Colombia, an elegant provincial capital settled mainly by Basques from Spain in the early 1600s (and best known more recently as a haven for one of the world's most powerful cocaine cartels), Botero attended Jesuit schools before being expelled from one Medellín academy for writing an article praising that modern "subversive," Picasso.

In the '50s, Botero visited Europe, mainly Spain, where he steeped

himself in the Spanish heritage, the Baroque colonial version of which he had been exposed to as a child in Latin America. At the Prado, in Madrid, and later at the Louvre, in Paris, and the Uffizi in Florence, Italy, Botero found himself more attracted to the Old Masters, whose visual richness he sought to emulate in his own work.

Botero's first New York exhibitions, in the mid '60s, were reviled by the critics. One critic, upon visiting his studio, stood with his back to it, he was so disturbed by its emotional content. One of the earliest and ardent Botero collectors was J. Jean Aberbach, who with his brother Julian made a fortune in the music business before becoming art dealers. Coincidentally, it was the Aberbach Gallery that I moved into across 77th Street in 1987, from the northwest corner to the southwest. Botero's paintings increasingly took on a hallucinatory quality, of obese, often unshaven, coarse people engaged in all sorts of "reprehensible" activities: sex, drinking and brawling.

Even his paintings contain a sculptural quality, but it was Botero's sculpture with which I was most madly infatuated. My first significant exposure to Botero was in 1981, when a close friend of mine, a Paris-based art dealer, bought a large Botero gouache in Basel, and exhibited it in his gallery on the Left Bank.

I loved this painting, "Lady In Red," which depicts a characteristically obese Botero lady with round cheeks and face, fat arms folded neatly across her substantial waist, adorned with ruby-red lips, crimson earrings, and even pincushion red eyes. I offered to pay $10,000 above what my friend had paid for it and consummated an amicable deal: $40,000.

I was generally familiar with Botero because not only Aberbach, but also my old friend Ian Woodner, the real estate magnate whose gallery I had taken over in the mid '60s, would occasionally show Botero's work. I exhibited my new "Lady In Red" for about a year before selling it to the Acquavella Gallery in Caracas, Venezuela, operated by the uncle of my old friend Bill Acquavella of the gallery in New York. A year later, Peppino Acquavella, of the Caracas Acquavella Gallery, dropped into my place and remarked casually, "You know, I still have that Botero. I haven't been able to sell it."

Botero was becoming increasingly popular in the United States, particularly among the Hollywood crowd, so I felt no discomfort at offering to buy it back. I'd sold it to him for $50,000 but now he wanted $70,000.

"Peppino," I said, "I made $10,000 profit off you, so you should make $10,000 profit off me." This sounded reasonable to him, so we settled at $60,000.

I placed it prominently in the gallery with a price tag of $80,000.

A young lawyer collector, very successful at advising stock-market whiz-kids, offered to buy it for $70,000, I refused. While we were still negotiating, neither of us willing to budge mainly as a matter of principle, I was invited to a large Botero exhibition in Paris, part of the annual fall art festival known as FIAC.

As a major Botero dealer, I was also invited to be a guest of the artist at the vernissage, a gala celebration the day before FIAC opened to the public. Marlborough Gallery was still Botero's official dealer in New York, so all the Boteros I showed were bought at auction or from friends of the artist abroad. While attending the opening, we received word that Bronka's sister was seriously ill in Paris. We had to attend to her at the hospital rather than attend the dinner in Botero's honor at a renowned four-star French restaurant overlooking the Seine.

I always visit art exhibitions at the earliest possible hour, so as to have time to study the work without the distraction of crowds. I ran into my old friend, the art dealer Mauricio Quintana, who immediately asked, "Where were you and Bronka last night?"

I explained that Bronka's sister was sick, and that we had had to visit her in the hospital. "Why do you ask?"

"Because Fernando gave to each of the guests a specially inscribed book called 'Botero,' published by Editions de la Difference in Paris."

"So?"

"So guess what's on the cover?"

I hadn't the faintest idea.

"Your 'Lady In Red'!"

I was by turns aghast and thrilled. On the one hand, technically speaking, since I owned the painting, I presumably retained all reproduction rights to the work and no permission had been requested from me. On the other hand, while this is a gray area of copyright law, to have my painting reproduced on the cover of this handsome work substantially increased its value.

When I later saw the book in a Paris bookstore, with text by Peruvian novelist Mario Vargas Llosa, a Nobel Laureate, I bought a dozen copies of the limited edition, containing two original signed graphics of Botero's best work. That afternoon, I chanced upon the young lawyer and ardent Botero collector who had been so adamant about not going above $70,000 for "The Lady In Red."

Once again, he asked me to sell him the painting for $70,000. Again I refused.

"Okay," he said, "I made a mistake, I'll give you the $80,000."

Now that the painting had been reproduced on the cover of the book, I considered its value to have increased considerably.

"No sale," I said. "You didn't meet my original price. And now I'm going to take it home to add it to my personal collection."

I enjoyed watching his face fall as I whipped out a copy of the new book and triumphantly showed him the painting on the cover. I've never enjoyed losing $80,000 more. The painting happily still graces my library wall and the walls of the room and its two leather sofas are lipstick red to match my lady in red.

In my early years of dealing in Botero's, work, the artist maintained his distance out of respect for the Marlborough Gallery, which had an exclusive lock on his work in the United States Botero had consigned all of his work to the gallery and shared in the profits from all sales.

The consignment system thereby creates an opportunity for a nonexclusive dealer such as myself. If a Botero painting or sculpture comes up at auction, or is resold by a collector, I am free to bid on it. Marlborough is free to bid on it also, of course. But a gallery with an exclusive relationship with an artist is rarely willing to part with hard-earned cash to acquire work by an artist whose production they are used to gaining on consignment.

As I sold more and more Boteros around the world, becoming second only to Marlborough in volume of sales worldwide, Botero became increasingly friendlier. In 1987, a good year for Botero, I bought a number of his sculptures, including "Man With a Cane," which depicted a roly-poly bowler-hatted boulevardier standing on top of a voluptuous naked woman. The symbolism was fairly obvious, and having just recently obtained the work, I advertised it in *The New York Times* without the benefit of the necessary documentation. I didn't even know the proper title. Taking a calculated risk, I made one up: "Get Off My Back!" At the time, Marlborough was having a large Botero show, and frankly I wanted my Botero to ride home on the cresting wave of Marlborough's publicity.

I soon received word that Fernando was not amused. It was "Man With a Cane," and that was that. I sold my "Man With a Cane" within days of placing the ad, and received orders for two more. Out of a casting of six, I obtained three through various dealers and sold them in a matter of weeks. Fernando, I heard, was rather impressed with my performance. I was happy that he was happy, because I had a little trick in store for him, a joke that I hoped he would appreciate. I had a thousand posters made up of "My Lady In Red," to be distributed to major donors to the Albert Einstein Medical School, of which I am a benefactor. I sent one to Botero, pulling his leg for reproducing my painting without telling me.

Shortly thereafter, Botero stopped by the gallery accompanied by

his companion, the sculptor Sophia Vari. After a little idle chitchat, they readily agreed to stop by our apartment on Fifth Avenue for a cocktail, particularly after I told them that Bronka and I had had our den redecorated in red, to go with its centerpiece: "The Lady In Red."

After we settled them comfortably on the red leather sofa and mixed their drinks, Botero slyly glanced at the copy of Mario Vargas Llosa's limited edition *Botero* lying on the glass coffee table.

Picking it up and leafing casually through its glossy pages, on the spur of the moment he signed it.

"Fernando," I said smiling, "that increases its value." After a few more drinks, his eye happened to catch my Calder "Mask," a face with the tongue hanging out, above the bar, and he gave a closer look. He fell in love with it.

"There's a story behind that mask," I remarked, going on to relate how an architect had commissioned the unique work from Calder to decorate a converted warehouse in New Orleans' former red-light district. The deliberately salacious mask, with the tongue hanging lasciviously out, had been intended to capture the bygone flavor of New Orleans French Quarter.

Unfortunately, the client wasn't sufficiently caught up in the spirit of the piece and refused to pay for it. The architect sold it to me and when I wrote to Calder to ask about it, he wrote back, "For you Jacob I will authenticate it, even if that bum screwed me out of the money he owed me." The mask is now in all the Calder books, and is considered one of his most whimsical works.

I went on to relate how the mask hang in my gallery, unsold, until a beautiful young woman came running in, sometime in the '70s, clutching a copy of *Penthouse* magazine.

"Look!" she cried out triumphantly. "It's just like your mask." Opening the skin magazine, she produced a lavish illustration depicting an act of oral sex.

Now to put it bluntly, I viewed the work with new and different appreciation. I grasped, so to speak, what Calder was getting at. I resolved to take the mask home.

Botero loved this story so much that he took up the book again and quickly dashed off a portrait of Bronka.

"How much do you think it's worth now?" he laughed.

"$10,000," I said, always the bargainer.

"$12,000," he said seriously. "Maybe more."

That is one other Botero I'll never sell, so the value is strictly academic. Botero and I are now friends, and we see each other socially. I live surrounded by his work, along with that of my other close friends, Sandy Calder and Henry Moore. Their sculpture endures

Fakes, Frauds, and Other Problems

On Thursday, December 9, 1965, the *New York World-Telegram* carried a large illustrated feature written by a staffer, Michael Stern, entitled "Shadow Over Art: Traffic in Fakes."

"The woman walked into the gallery and cocked a peremptory forefinger at the owner, summoning him to the big, waist-high table where he displays his graphic art," ran the lead paragraph.

"With a triumphant flourish she unrolled a Käethe Kolliwitz lithograph and said: 'Look. I got it for only $90. And you'—that 'you' carried a weighty charge of duplicity—'you wanted $300 for the same thing.'

"The owner held his temper and replied: 'Congratulations on your bargain. Where did you get it?'

"The woman was hardly able to rein in her galloping exultation as she told how she had outsmarted a Greenwich Village bookseller, a man who handles art as a sideline in a basement room below his shop.

"'He's a book man,' the woman said. 'He doesn't know art. He didn't know what he was selling. But I spotted it right away.'

"The gallery owner examined the woman's lithograph more carefully, then told her the truth. 'That man knew very well what he was selling. This is a restrike, worth $12, maybe $15. It is not an original.'

"Jacob Weintraub—the incident occurred at his gallery at 1193 Lexington Ave.—smiled sadly as he finished his story. 'This was an intelligent woman,' he said. 'She got cheated because she was greedy for a bargain.'"

The writer went on to relate that this cautionary tale was particularly appropriate at a time when "the critics and culture-mongers tell us interest in the visual arts is epidemic. The sociologists of modern mores tell us art confers unquestioned status on its owners. And your own eyes will tell you there is hardly a middle-class living room in New York whose walls are naked of at least one original painting, lithograph, woodcut or etching...."

No question about it: America had come a long way. The public—that part of the public disposed to spend its disposable income—

Shadow Over Art: Traffic in Fakes

THE WOMAN WALKED into the gallery and cocked a peremptory forefinger at the owner, summoning him to the big, waist-high table where he displays his graphic art.

With a triumphant flourish she unrolled a Kathe Kollwitz lithograph and said: "Look. I got it for only $90. And you"—the "you" carried a weighty charge of duplicity—"you wanted $300 for the same thing."

The owner held his temper and replied: "Congratulations on your bargain. Where did you get it?"

The woman was hardly able to rein in her galloping exultation as she told how she had outsmarted a Greenwich Village bookseller, a man who handles art as a sideline in a basement room below his shop.

"He's a book man," the woman said. "He doesn't know art. He didn't know what he was selling. But I spotted it right away."

The gallery owner examined the woman's lithograph more carefully, then told her the truth. "That man knew very well what he was selling. This is a restrike, worth $12, maybe $15. It is not an original."

'She Was Greedy'

Jacob Weintraub—the incident occurred in his gallery at 1193 Lexington Ave.—smiled sadly as he finished his story. "This was an intelligent woman," he said. "She got cheated because she was greedy for a bargain."

Weintraub and other art dealers say it is the bargain hunter, the buyer seeking some way around today's admittedly high prices, who is both cause and victim of most of the art frauds perpetrated in the city.

We are living in affluent times, the economists never tire of telling us. The critics and culturemongers tell us interest in the visual arts is epidemic. The sociologists of modern mores tell us art confers unquestioned status on its owners. And your own eyes will tell you there is hardly a middle-class living room in New York whose walls are naked of at least one original painting, lithograph, etching or woodcut.

But it is an open secret that many of those living-room art

JACOB WEINTRAUB: This gallery owner warns the bargain hunters.

Fakes and Frauds.

works are cooked up fakes with forged signatures. The only thing real about them is their price tags. They are frighteningly real and often represent every surplus status dollar the proud owners were able to scrape up.

With ready customers ready to pay these prices—"five and six figure money for the works of living artists," according to Attorney General Louis Lefkowitz—there is ample temptation for the middleman (the dealer) to cut out the manufacturer (the artist) and grab all the profits for himself.

"Since the end of World War II," Lefkowitz said, "the increase in traffic of works of art and the prices fetched for them has been staggering. Art as an investment today even appeals to persons in the middle income bracket. All this simply means that the temptation to climb aboard this 'gravy train' is greater than ever before."

The frauds occur on every level. Faked etchings for $200 for the young collector. Faked Jackson Pollocks and Franz Klines for the more affluent (one Pollock—a real one—sold recently for $100,000).

Even the museums get caught. In 1961, the Metropolitan Museum of Art had to announce that three Etruscan sculptures it had been showing for 40 years were fakes.

New Laws Needed

Lefkowitz now is calling in art experts—museum curators, dealers, collectors, scholars—to help him draft new laws to protect art buyers. He will meet with the experts again tomorrow and hopes to submit his bills to the Legislature next month.

At a recent hearing held in the Attorney General's office in Centre St. a number of proposals to frustrate the art fakers were proposed.

Lloyd Goodrich, director of the Whitney Museum, asked that immunity from law suits be granted to museum experts who give opinions on the authenticity of art works. He said the Whitney insists on a signed waiver from any buyer who asks the museum to authenticate his purchase, but the waiver form never has been tested in court.

Other museums are even more careful. The representative of the Metropolitan Museum said it gives only oral opinions and very few of them. The Guggenheim Museum representative said it gives no opinions at all. Thus, private collectors are cut off from the disinterested experts who could protect them.

Alvin S. Lane, a collector and for three years head of the Committee on Art of the Assn. of the

LLOYD GOODRICH: He wants immunity from law suits for museum experts.

Bar of the City of New York, proposed that all art dealers be licensed and that a strict code of ethics be enforced.

At present, Lane said, anyone can set up a gallery and sell what he pleases. He need show no proof of expert knowledge of art and no proof of financial responsibility.

Signatures on File

Lane also proposed that buyers insist on certificates of authenticity from dealers and, in purchases of works by a living artist, from the artist, too. He said no reputable dealer and no artist ever has refused such a request.

As a further safeguard, Lane suggested the establishment of a central depository where copies of such certificates could be filed as a permanent record.

Joseph Chapman, a former FBI agent who investigated many art frauds, cited the benefits of the Napoleonic Code in France, which protects the rights of artists in their work. He said an artist or his heirs may demand that a forged work be destroyed.

The problem of what to do with a fake is particularly hard to solve because no one wants to get stuck. A man who has invested $20,000 in a painting and then finds it is a forgery will not willingly take the loss.

Often, he just keeps quiet and sells the fake to someone else. Sometimes the victim passes the fake on to a museum for a tax write-off and then the museum gets stuck.

Goodrich of the Whitney said the same fake Winslow Homer had been brought to him for authentication by five different owners, and each time he was powerless to confiscate it.

Useful Fakes

But Ralph Colin, counsel and administrative vice president of the Art Dealers Assn. of America, said it would be wrong to destroy all fakes. He said forged works have their uses as teaching tools in universities and museums. The Fogg Museum at Harvard University has a notable collection of fakes and is willing to buy more.

Colin also pointed out that even forged works sometimes have real artistic value. Frequently a second-rank painter works in the style of a master like Picasso. An unscrupulous dealer may put Picasso's name on the second-ranker's painting and sell it as a Picasso. This is a fraud, but the painting still has whatever merits it possessed when the second-ranker painted it.

The dealers association believes new laws and regulations can be helpful, Colin said, but even after the new laws are on the books, the buyer's best protection will be to deal with a reputable gallery. Even the dealers sometimes make mistakes, Colin said, but the responsible ones will make them good.

Rarely Fooled

Jacob Weintraub made the same point in his warning to bargain hunters. He conceded that in the market most young people enter — original lithographs and other graphics—fakery is quite easy. But, he said, gallery owners rarely are fooled because they insist on knowing the source of everything they buy.

When Miro does a new lithograph—say a series of 50, each example signed and numbered by the artist in the order it is taken from the stone—it is offered to all dealers at the same price. And since all dealers have roughly the same operating costs, they all sell at roughly the same price.

Thus, a $300 Miro may cost $280 at one gallery, perhaps $310 at another. This is not an unreasonable spread, Weintraub said. But when someone offers you that Miro for $100 or $175, beware. It could be a bargain, he said, but it is much more likely to be a fake.

wanted nothing more to do with reproductions. Reproductions might have satisfied their parents, but this was a new generation, determined to have "the real thing." John Canaday's writings in *The New York Times* were a force in this.

The great hitch was that when demand threatens to outstrip supply, all the schlock dealers and con artists come out of the woodwork. Many of those living room artworks gracing middle-class walls were cooked-up fakes with forged signatures. The only thing real about them was their price tags, which often represented every surplus dollar the proud owners were able to scrape up.

By the mid '60s, with prices for "original" graphic art soaring, I was seeing more and more fakes coming into the gallery. Fraud, forgery and fakery have enjoyed a long, deeply undistinguished history on the darker side of the history of art. When something becomes highly valued, there are always people who figure they can take advantage of the gullible public.

With buyers prepared to pay "five and six figure money for the works of living artists," to quote the New York State Attorney General Louis Lefkowitz, "there is ample temptation for the middleman (the dealer) to cut out the manufacturer (the artist) and grab all the profits for himself...."

A fair assessment, although it might have been fairer if he'd said "unscrupulous dealer," because to a scrupulous dealer the idea of risking one's reputation by deliberately pawning off a fake on an unsuspecting customer would be out of the question. I stress that word "deliberately" because even the best of us can be fooled.

"Since the end of World War II," Lefkowitz went on, "the increase in traffic in works of art and the prices fetched for them has been staggering." Staggering, of course, in comparison to past prices. Looked at from a more contemporary vantage point, those '60s prices look more like small change.

"Art as an investment today even appeals to persons in the middle income bracket," Lefkowitz commented. "All this simply means that the temptation to climb aboard this 'gravy train' is greater than ever before."

One of the great problems facing art buyers was that the only appraisers who had no real special interest in authenticating or deauthenticating any work were academicians and museum staffers.

Lloyd Goodrich, then director of New York's Whitney Museum of American Art had, in fact, explicitly called upon the Attorney General to include as part of his proposed "art buyer protection plan" a grant of immunity from liability on the part of museums willing to give opinions and make judgments on questions of authenticity.

The Metropolitan Museum of Art had limited its possible liability

to the rendering of oral opinions and even that only on rare occasions. The museum had itself been embarrassed a few years earlier when, in 1961, it was forced to announce that three supposedly "Etruscan" sculptures that it had been displaying for forty years had been identified as forgeries.

The Solomon R. Guggenheim Museum gave no opinions at all, the problem being, of course, that only "disinterested experts" took their reputations into their hands when rendering opinions on art. One fake miscalled could ruin an expert's hard-won reputation. The only players left in the game were the auction houses.

One proposal floated by the New York Bar Association's Art Committee to license art dealers never worked its way through the legislature. A rival proposal, to set up a central repository for certificates of authenticity along the lines of a data bank, drew a certain degree of interest but simply was not practical to execute before computerization. In France, where the Napoleonic Code protects the rights of artists to not have their names sullied by fraudulent knock-offs, artists and their heirs have a right to demand that an unmasked fake be destroyed. But not in America, where all too commonly, as Henry Pearlman had warned me years before, most fakes never go away. They are just recycled to either more gullible collectors or dealers, or possibly unscrupulous ones, often at suspiciously low prices.

"Let the buyer beware" (caveat emptor) was the acknowledged slogan of the art world. But I would amend that to say: Let the buyer beware of unscrupulous, not-well-established dealers. And in particular, let the buyer beware of bargains.

■ ■ ■

When the *World-Telegram* mentioned the increasingly common method of pawning off a fake to unsuspecting philanthropic institutions, usually to gain a tax write-off, I had to smile, thinking of an incident in 1964 when I received a call from a board member of the United Jewish Appeal requesting an appraisal of a Kirchner recently donated for a charity auction. Shortly a lady drove up to our gallery in a chauffeured limousine, swept in all swathed in furs, carrying the Kirchner under her arm. With the flamboyant flourish that some usually inexperienced people employ when unveiling a work of art, no matter how modest, the lady produced the Kirchner and set it out on the same "waist-high table" that the lady with the fake Kollwitz had used.

One look at the Kirchner, for one experienced with the artist's work, revealed it to be a fake and a clumsy one at that. But to make perfectly sure, I asked the lady to take a walk around the block.

When she returned, I had made up my mind to level with her on all fronts.

"Mrs. ———," I said gently. "I haven't a doubt in the world that this Kirchner is a fake."

She turned a few shades of red and other intriguing colors before asking whether I was utterly sure.

"Absolutely. I know the painting," I said grimly.

"So why did you need a few minutes to render that opinion?"

"Because I know the donor," I said, without hesitation.

■ ■ ■

But perhaps my strangest tale of a fake concerns Tamayo. Rufino Tamayo, born in 1899 in the central Mexican city of Oaxaca, studied at the Academy of San Carlos in Mexico City as a contemporary of the so-called Muralists: José Clemente Orozco (1883–1949), popularly known as "the El Greco of Mexico"; Diego Rivera (1886–1957); David Alfaro Siqueiros (1896–1974). During the tempest-torn '20s and '30s in Mexico, with currents of social revolution sweeping the country, the Muralists adhered to a staunchly Socialist political position, in which they subjugated their artistic output to propaganda purposes in the tradition of "Socialist Realism" but with a typically Mexican twist.

Tamayo went a different route, preferring to engage with Mexico's historical past rather than with socialistic utopian promotion. After meeting a fellow Oaxacan in Mexico City who gave him a job at an archaeological museum, Tamayo discovered the wonders of pre-Columbian art. Immediately and intuitively, Tamayo knew that this ancient "popular art of my country," would be his main source of inspiration: "From that moment on, it became the basis of my art," he wrote.

While the so-called "Big Three" continued painting their great Socialist-inspired murals, Tamayo took up easel-based painting. By 1926, at age 27, he had become increasingly disgusted with the art being produced in his country. Even those painters who turned against the Muralists were just turning out bad imitations of French art, he later remarked.

After taking a short side trip to New York, Tamayo set out for Paris, the center of the global art scene in the '20s. His first New York show was held in September of 1926 under the auspices of my old rival, Weyhe. During the '30s and '40s, Tamayo settled in New York, taught at the Dalton School and the Brooklyn Museum Art School, and married Olga Flores Rivas, a young pianist he had met in Mexico City. The couple shuttled back and forth between New York and Mexico City, maintaining links with the home country.

In 1948, his position in Mexico was permanently secured by a gigantic retrospective at the Palace of Fine Arts in Mexico City. In the '50s and '60s, the Tamayos settled in Paris, where he continued to paint and exhibit and assemble an impressive collection of modern art, including Picassos, Mirós, Chagalls, and Klees, as well as works by Abstract Expressionist and Pop and Op artists.

One of the great frustrations of his life was the resistance he encountered in his own country when he offered over 100 contemporary European and American paintings to the Mexican government on the condition that it build a museum in Mexico City. The opposition was generally ascribed to political prejudice, aroused by his steadfast refusal to politicize his art, and to a general notion that his neutral artistic stance was "elitist." His cosmopolitan Europeanized art was, indeed, executed in an internationalist tradition, not a nationalist one. At the time, this aroused popular feeling against him.

As I mentioned earlier, Barbara and I first met Olga and Rufino Tamayo in a Left Bank restaurant in Paris during the summer of 1958. Over casual conversation, dinner and cocktails we dashed off an agreement on the back of a menu securing the right of the New Art Center Gallery to be Tamayo's exclusive agent for graphics throughout the world—for the life of the contract. Knoedler handled his paintings.

That agreement was duly executed several months later, on November 3, 1959. Between that day and May 1961, Tamayo delivered, pursuant to our agreement, 609 original lithographs, for which we paid Tamayo just over $20,000, in seven installments.

From that first meeting, my intuition told me that Olga Tamayo might well turn out to be trouble. She made it clear that as far as she was concerned, her "genius" artist husband was little more than putty in her capable hands. She had long since forgone the pleasure of performing as a professional pianist for the benefits of acting as her husband's agent-manager in all matters calling for a hard business head.

I knew only too well that many artists feel that commerce is crass and that art dealers are all crooks and thieves. My personal experience has been that this attitude often makes a tendency toward greed on the part of the artist which frequently manifests itself in a willingness to breach contracts whenever possible, for the reason that it might maximize their personal income.

Olga handled the minimal negotiations required to make the arrangements for the sale of the graphics to us. For our part, we endeavored to promote Tamayo's graphic production by advertising

our exclusive worldwide agency extensively, arranging to list Tama-
yo's graphics in the catalogue of the Ketterer Gallery in Stuttgart,
Germany—one of the leading, if not the leading, galleries of graphic
art in the world—and generally doing what we could to promote
Tamayo as a graphic arts master. Our chief promotional effort
involved donating a fair number of these lithographs to museums, a
practice generally acknowledged to increase their value to collectors,
particularly if the museums display them or put them in their per-
manent collections. Thus, the American market for Tamayo graphics
was, to a great extent, built up by us. Still, Olga Tamayo constantly
pressed us to pay more for the work and, in particular, to sell it for
more money. When I attempted to remonstrate with her, she replied
testily, "Why should my husband sell for less than Picasso?"

I knew Picasso and Tamayo had known each other in Paris, and
that Tamayo had once spent a week as Picasso's guest at his villa.
Tamayo was clearly jealous of Picasso's immense popularity and
prestige, because he constantly expressed in the press his belief that
Picasso was jealous of him.

In any event, our real schism started in late 1960, when we received
a letter from Tamayo announcing his intention to execute three new
lithographs in editions of 75 rather than the customary 100.

The prints were all numbered in the artist's own hand, 1/75 to
75/75, indicating that the lithographic stone had been destroyed
after 75 copies had been run off. But when the titles were shipped
the cover sheet from the lithographer indicated that 101 copies had
been made. Tamayo had no satisfactory explanation for this disap-
pointing discrepancy; he swore that only 75 copies had been made,
and that there had been no artist's proofs.

In Paris, Tamayo had executed four famous lithographic studies
entitled "Four Horsemen of the Apocalypse" as illustrations for a book.
Tamayo insisted he had made 25 copies of each, all of which he had for-
warded to us pursuant to our agreement. But in early 1969, addi-
tional copies of these lithographs started turning up for sale at various
galleries around the country and, for all I knew, around the world.

As I knew only too well, one of the greatest problems in securing
an exclusive agency is enforcing its restrictions. Exclusivity is all
very well if both parties scrupulously agree to keep their side of the
bargain. But too many artists fall prey to the temptation of trying to
evade their obligations by selling directly to customers. The cus-
tomers, for their part, too often consider it a coup. Everyone likes
eliminating the middleman except, of course, the middleman.

On several occasions during 1962 and 1963, Barbara and I saw
the Tamayos socially. On each such occasion, we were repeatedly

advised that Rufino would make no more lithographs—that he wanted to concentrate on painting. I had mailed a letter dated October 3, 1963, to Tamayo, giving notice of my intention to exercise my option to renew under the provisions of our contract. I would have mailed it to the address in Rue Conde, in Paris, which was supplied on the contract, if I hadn't learned that the Tamayos had moved in December of 1960 to Castillo de Miramar, Lomas, Mexico, the address on his last letter to me.

Later that year, on December 19, 1963, I sent a second letter confirming my renewal as stated in the last letter. This one I mailed to an address supplied by the Knoedler Gallery, which represented Tamayo's paintings. Later that month, Barbara and I made a point of dropping in on the Tamayos in Mexico to confirm my intention to renew the contract. The Tamayos were superficially cordial, even going so far as to drive us back to our hotel after cocktails, all the while assuring us that it was his intention not to make any more lithographs.

I had no reason to doubt his word. But unbeknownst to me, a year later, in October 1964, Tamayo accepted a fellowship to execute 28 new lithographs at the Tamarind Lithography Workshop in Los Angeles. However, 678 of these lithos were released to Tamayo for sale or distribution by him. While he was actively informing us that he had no intention of making any more lithographs he was, in fact, selling these on the side.

I found out about this deception when one of my customers confronted me with a copy of a press release circulated by Tamarind, which openly stated that the Tamayo graphics rendered at Tamarind could be purchased at the Matisse Gallery in Beverly Hills and the Misrachi Gallery in Mexico City.

A collector of Tamayo graphics came to me with a lithograph called "Howling Wolves" which he had bought in June 1966, from Bretano's for $145. He had been told it was an "artist's proof" and wanted to know from us, as Tamayo's "exclusive dealer," how many artist's proofs had been made. I was forced to tell him that, as far as I know, none had been made. Tamayo himself had stated to us on numerous occasions that no artist's proofs had been made. Moreover, he complained that he was insulted that we didn't trust his word as a gentleman. Nevertheless, we had in our possession this lithograph marked in the artist's own handwriting E.A. which means "Epreuve d' Artiste" and signed "Tamayo."

This was not only a clear violation of our contract, but also proof that he was willing to go to illegal lengths to make money, thinking that he would never be caught or pursued in Mexico.

The client, meanwhile, had in effect accused me of misrepresent-

ing myself as the "exclusive agent worldwide for Tamayo graphics," as I had explicitly advertised in brochures and circulars. I was livid. All the Tamarind graphics had been executed prior to the expiration date of the first five-year term of the contract, which in any event included an option for me to extend it until November 3, 1969.

Based solely on the commissions I would have received for 678 Tamarind lithos my attorney, Mrs. Philomene Gates, calculated my losses at $43,280, plus interest. That did not take into account the considerable damage to my reputation incurred by having to defend myself against charges of "misrepresenting" my exclusivity. Mrs. Gates further calculated this "anxiety and embarrassment" and injury to my reputation at around $25,000.

"It is time to make an example of such a case so as to indicate that the dealer is not trying to cheat the public," I wrote to Gates in indignation. "The rich, money-hungry artist will screw his own client."

By April 1965, the Supreme Court of the State of New York compelled both parties to proceed to arbitration. The major issue before the arbitration panel was whether Tamayo had, in fact, received notification of my intention to renew the contract or whether, as Tamayo argued, that he had gone ahead and distributed the Tamarind graphics under the mistaken impression that I had not intended to renew. I had taken the precaution of sending my letter to him in Mexico return receipt requested, and, in due course, I had received a receipt with Tamayo's signature. Further complicating matters, and weakening my case, was a Mexican passport produced by Tamayo carrying what appeared to be a valid customs stamp indicating that Tamayo had been in Paris at the time of the delivery of my letter.

I had first met Mrs. Gates in the early '50s soon after her husband, Samuel Gates, had arrived in New York to take up a position with the law firm later known as Debevoise, Plimpton, Lyons & Gates. She had pushed a baby carriage into the gallery and handed me a number of her husband's extremely impressive-looking diplomas for suitable framing. She glanced through my stock and mentioned that she had recently seen a poster by Toulouse-Lautrec, "La Revue Blanche," at a local gallery but it had been too expensive for her and the gallery had refused to let her pay for it in installments.

I immediately offered to buy the poster for her at a good price for which I would gladly accept payment in installments. This was, after all, a good way to gain new customers. I later heard that some of Mrs. Gates' church-going friends were shocked to find that she was buying "indecent" art by that naughty Parisian, Toulouse-Lautrec.

In any event, once her children were a little older, Mrs. Gates began, in her words, "to slip slowly back into practicing law." She had

been a lawyer when she met her husband, and suspended her practice after having her first child.

Mrs. Gates was and is a superb lawyer. She had the good sense to retain Albert D. Osborne, the noted "Examiner of Questioner Documents," as his letterhead reads, to train his expert eye on Tamayo's signature on the receipt. Mr. Osborne, who had gained fame as the expert called to testify on the authenticity of the famous Whitaker Chambers "Pumpkin Papers" during the Alger Hiss trial, examined the signature "Tamayo" on the return receipt and compared it to other Tamayo signatures. He then took a photograph of the questioned signature and made a 5″ by 7″ negative. He enlarged the image so that it could be easily compared by the untrained arbiters' eyes, and he testified at the hearing. The two signatures were clearly executed by the same hand. Osborne's testimony to this effect was utterly devastating to Tamayo.

The passport, moreover, was found to have been doctored, most likely by the sort of fellow anyone can dig up in Mexico. The clear conclusion was that the great Rufino Tamayo had been willing to perjure himself, under oath, so as to do me out of my compensation.

The Commercial Arbitration Tribunal of the American Arbitration Association rendered its decision in January 1967. It found that Tamayo had in fact breached the contract, and it awarded me $30,000, plus an administrative fee. This was a complete vindication of my position.

Tamayo managed to evade payment for a time until he had a large show at the Perls Gallery at 1016 Madison Avenue in New York. He had cleverly put all his paintings in his wife's name; the contracts for the exhibition were all made between Olga Tamayo and Klaus Perls. Rufino ostensibly was not involved. We were successful in obtaining a court order barring the sale of paintings from proceeding until we collected the debt due us.

Gates pursued the Tamayos by civil suit in Mexico, first trying to hire the largest firm there, Goodrich & Dalton, which declined to take the case on the ground of "conflict of interest." It was more a matter of not wanting to take on a national institituion. Gates retained instead a younger, cheaper but equally competent attorney who did a fine job, and succeeded in obtaining a satisfactory settlement.

Tamayo was clearly not pleased at this outcome. He did his best to wreak a suitably Latin revenge. Shortly thereafter, I received an agitated phone call from a dealer in San Francisco who had purchased a beautiful boxed book of Tamayo graphics which included a framed original drawing by the artist.

When the dealer heard that Tamayo himself was executing litho-

graphs at the Tamarind Lithography Workshop — the same establishment where Tamayo had churned out graphic work in blatant defiance of our exclusive agreement — he took his signed, original Tamayo drawing to the Master himself for verification of authenticity.

Tamayo looked at the drawing, nodding appreciatively at his own handiwork, until he turned it over to check the label on the back. When he saw the hated label "Weintraub Gallery" his face contorted into uncontrollable rage, and he proceeded to begin to smash the drawing over his knee, clearly intent on destroying it. The gallery owner intervened, declaring, "Maestro, it is not your property."

Thinking better of it, Tamayo instead carefully slid the drawing out of its frame and wrote across its face, "Fake" — signifying that he disavowed it. This is considered an artist's prerogative, although not if the drawing is in fact genuine. Examining the work "Fake" scrawled by Tamayo, the owner said, "Maestro, the word you wrote looks like 'Cake.'" And so, Tamayo, ever the scrupulous artist, corrected his drawing on the drawing.

This clearly put the owner in an awkward position, as the drawing and book I had sold to him for $1,200 was now virtually worthless. When he called me to demand his money back on the grounds that Tamayo had disavowed it, I felt I had to refuse his request. But the entire situation put us both in an awkward position. When I checked with my attorneys, it became clear that it's not easy to prove that an artist would go so far as to deface his own work in pursuit of a purely personal vendetta.

■ ■ ■

A similar story is told of Picasso, who upon being shown a painting by a collector for verification, insisted that it was a fake. Fortunately, the owner possessed a valid invoice from Picasso's own dealer, the great Henry Kahnweiler, certifying its authenticity. Picasso, of whom Tamayo was always jealous, showed his true stripes as a gentleman upon this occasion.

After examining Kahnweiler's invoice, and taking a second look at the painting, he had to concede that even he had been wrong. Shrugging philosophically, he said to the owner: "Yes, this is a fake, but I painted this fake."

To make amends for the stress suffered by the owner, Picasso gave the owner a second painting for free. No hard feelings there.

■ ■ ■

We had better luck with a possibly greater Mexican artist than Tamayo: David Alfaro Siqueiros, who in the early '60s had been found guilty of "Communist rabble rousing" and sentenced to five years' confinement in Mexico City's notorious Black Palace prison.

Long an admirer of Siqueiros' work, in late 1963 I traveled to Mexico City to visit him in confinement.

An international appeal was just getting under way to have his sentence commuted. But the traditional appeal for leniency and/or clemency from the president of the Republic was unlikely to be granted, considering that one of Siqueiros' acts of "rabble rousing" had been to call the notoriously corrupt president a crook, and then refusing to retract the charge.

After he had served four years' time for "social dissolution," the prison warden had at last let him paint. He inscribed these works with the initials "CP" after his name, which signified that they had been painted in his "Castillo Preventivo."

Siqueiros' family provided me with food to take to him in his cell, where the 67-year-old painter discussed his various methods for keeping sane. These included organizing a prison-yard baseball team with himself at first base. He worried that his eyesight was growing weaker in the dim light of the cell, where he continued in the lyrical words of a *Time* magazine article, to "wield a dancing brush that creates images somersaulting and swirling far from the prison courtyard. In keeping with the size of his studio, the paintings are small; their message is that the great talent, having been put in the cooler, is frozen."

Still, as Siqueiros told *Time*: "My painting has always been that of a free man. Even though my painting is that of a man in jail, I break my prison bars by painting landscapes and beautiful days."

Siqueiros and I agreed, right in his prison cell, that the New Art Center Gallery would organize a large exhibition of his work later that month in New York. This would undoubtedly help to call worldwide attention to his plight as an imprisoned artist. On February 21, 1964, *Time* magazine noted that "Manhattan's New Art Center Gallery is showing 16 Siqueiros paintings, ten of them done in his 15′ X 7′ home...in prison." I purchased one of the pieces with CP after the signature for my private collection.

I was relieved when he was finally set free, and I was proud to have played a part in gaining the international publicity he needed to put pressure on the Mexican government.

The only aspect of the experience that left a sour taste in my mouth came when I was criticized for lending support and succor to a "known Communist." I didn't care if he was a Buddhist, or an Atheist or a Communist. He was a great artist and should never have been jailed for his beliefs. That he had been was in its own way, one of the great artistic misdeeds committed by a sovereign government. That is the worst kind of artistic fraud.

TIME

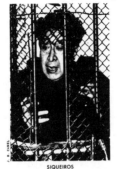

SIQUEIROS

"DANCER" (1963)

Breaking the bars.

Paintings from Prison

Mexico's patriarchal painter, David Alfaro Siqueiros, found guilty of Communist rabble rousing during some 1960 riots, is serving his fourth year in prison, with at least two to go. But locking up Siqueiros in a cell in Mexico City's Black Palace prison does not mean locking up his energy. Carrying out an old ambition, he has organized a baseball team, with himself at first base, which plays in the prison yard. And he steadily paints little pictures that sell at $1,500 apiece. This month Manhattan's New Art Center Gallery is showing 16 Siqueiros paintings, ten of them done in his 15-ft. by 7-ft. home.

Though he says that his eyesight is growing weaker in his dim cell, Siquei-

ros still wields a dancing brush that creates images somersaulting and swirling far from a prison courtyard. His jail-made *Dancer* wishfully wraps a cape of anatomy around a vaulter's pole. His forceful, lavender-colored *Mother and Child* casts the swaying shadow of a madonna into a posture of freedom. In keeping with the size of his studio, the paintings are small; their message is that the great talent, having been put in the cooler, is frozen.

Nonetheless, the work serves Siqueiros' purpose. "My painting has always been that of a free man," he says. "Even though my painting is that of a man in jail, I break my prison bars by painting landscapes and beautiful days."

Buying Siqueiros paintings from the artist while he was in prison, Mexico, 1964.

■ ■ ■
The Public's Right to Know
In April 1986 the Metropolitan Museum of Art displayed Rodin bronzes from an American collector. Over some years the collector has donated thirty-two Rodin sculptures to the museum, which was the first time that the Met had accepted posthumous casts in the collection.

In my gallery I sell only casts of sculpture done during a sculptors's lifetime. That has always been my policy, and I have stated that in advertisements in *The New York Times*. I feel, as do many others—including the artists themselves—that these are the most authentic examples of an artist's work. Henry Moore told me that he stipulated in his will that no cast could be made after his death, and that if any works remained unfinished at the foundry, they could only be completed with approval of his wife, Irina, or his trusted adviser, a sculptor himself, Bernard Meadows. On the other hand, I know that some other equally famous sculptors had no objection to posthumous casts of their work. Rodin, for example, left instructions in his will which allowed the Rodin Museum in Paris to make as many casts as necessary in order to provide funds to meet the cost of maintaining the museum. In the spirit of Rodin's will, Mrs. Cecile Goldscheider, the director of the museum, made sure to get approval from the French government for the production of these posthumous casts.

Because of a continuing controversy in the art world about the posthumous casts made by the Rodin Museum, the French government decreed on March 3, 1981 that there would be no more than twelve casts of any sculpture produced—eight to be commercially available (numbered 1/8 to 8/8) and four only for museum purchase or donation (numbered I/IV to IV/IV), and that each work be stamped with the copyright of the Rodin Museum, the mark of the foundry, and the date of the cast.

Thereafter, on November 18, 1993, the General Association of French Foundries published a code of ethics with the support of the Association of Sculptors, the National Chamber of Auctioneers and the Committee of Art Galleries.

The question of posthumous casts is a complex one. Like Henry Moore, I feel that the production of large numbers of casts of Rodin's well-known sculptures has served to diminish their esthetic value. They become overexposed; trivialized; clichéd. Moore prevented this from happening to his works by carefully limiting the number of casts to be made. In fact on principle, he felt obligated to ask permission of the owners of a particular edition to create an additional cast. Thus, if an edition of six existed, the seventh cast would need the approval of the other six owners. I don't know if Moore ever actu-

ally carried out this intent, but I do remember that when Nathan Cummings asked Moore if he would make a large number of casts as a gift to his guests at his 80th birthday celebration, Moore declined to do so.

I am disturbed that many museums display posthumous casts of famous works, without identifying them as such. As in the case of the Metropolitan Museum's Rodins, the labels give the date that the piece was modeled and the date they were cast, but they do not indicate that the casts are posthumous. Although I have no objection to the display of these casts, and in fact applaud museums for enabling the widest possible public to enjoy great works of art, I feel that a disservice is done by not clearly alerting museum-goers to the fact that the cast they are viewing was never seen or approved by the artist. A simple attribution on the museum label, such as "posthumous cast" beside the date of casting, as the French government and the Rodin Museum have done, would clarify the situation. It would also be the responsible action of a museum to the public, as well as to collectors who have invested tens of thousands of dollars for lifetime casts.

■ ■ ■

Auction Houses

A number of dealers and collectors have been discussing the role and conduct of the auction houses. Having observed the activities of most major auction houses for well over forty years, in the United States and abroad, I find that many things have improved greatly, while still others might perhaps be streamlined.

There was a period of time when the auction houses posed a severe economic threat to the galleries—those were the boom years when prices at auction routinely exceeded the amounts gallery owners were able to pay for works of art, or obtain for their consignment customers. This has not been true for several years.

However, there are still some areas which continue to cause unhappiness in the art world. The auction houses in their eagerness to obtain good inventory for their sales tend to go overboard on their pre-auction appraisals. Of course the day of reckoning comes when the owners are pressured a day or two before the auctions, to lower the reserve prices in drastic measure. Moreover, the real trouble occurs when the items fail to sell, even at the reduced reserves. That goes for maybe one out of four pieces in the catalogues.

Second, I feel the auction houses should put their researchers to work before the catalogues go to press, so as to establish the most complete chain of provenances possible as well as thoroughly examining the works for restoration and retouching. This search for fuller documentation of the background and condition of the works might

well eliminate unsatisfactory, not to mention dubious, items and increase the integrity of their catalogues.

I have not heard many complaints of late about the so-called "Rings"—collusion between competing bidders. This may very well be due to the greater alertness on the part of the auction houses. Unfortunately, instances still occur, where in order to keep an artist's prices high, dealers and artists, working separately or together, will offer a collector an extra work gratis if he will buy the piece at auction. This may not be the auction houses' fault but, aware of the situation, they should work toward the termination of this sort of manipulation of the market.

The industry might well be served by the creation of an "ombudsman" whose rulings would be respected by all houses, so as to avoid costly and embarrassing lawsuits. This would show dealers and collectors that the auction houses are not willing to be manipulated and that they are dealing on a higher level.

Complaints have often arisen because auction houses buy collections outright. I would suggest that when such an occasion arises, the auction house form a joint venture with a suitable dealer to sell the collection. If the dealer cannot sell the work over the period of a year then the auction house would be free to auction it.

Finally, since the press over-reports failures of sales, to almost the same degree it used to over-report every new sales record, the auction houses might well be able to correct the adverse impact of "bad" sales, by publishing a report of how many items ultimately do find a market within a few weeks after having failed to sell at the auction.

The Calder Saga

A genius whose art for years gave me nothing but pleasure and profit has, in the years since his death, given me little but trouble, hassle, and anguish. Dealing with the estate of the late Alexander Calder I sometimes wonder whether Calder is laughing at us from the grave — or possibly, sharing my pain and frustration with his tangled legacy.

Calder's impressive body of work has long fascinated me, particularly his marvelous, whimsical mobiles and stabiles that strike me as so quintessentially American. Having trained as an engineer at Stevens Institute in Hoboken, New Jersey, Calder exhibited none of the pretensions to grandeur of the European artist. Instead, he regarded himself as more of a hands-on man in the rough, rugged American tradition. And what is more, dressed and looked the part.

Calder was the scion of three generations of sculptors, a dynasty launched by his grandfather, Alexander Milne Calder, the son of an Aberdeen (Scotland) stone-cutter, who emigrated to America at age 22, having completed a course of study at Edinburgh's famed Royal Institute. In 1868, Alexander Milne settled in Philadelphia, where he continued his artistic education under the great Thomas Eakins at the Pennsylvania Academy of the Fine Arts. Calder sculpted skillfully in the grand, classical style of the time. The apex of his career was a monumental 37-foot bronze statue of Pennsylvania founder William Penn that still graces the Philadelphia City Hall tower.

Alexander Milne's son, Alexander Stirling Calder (1870–1945), a graduate of the Pennsylvania Academy of the Fine Arts and the Ecole des Beaux-Arts in Paris, followed in his father's footsteps as a successful sculptor in the heroic 19th century mode. His monumental classical sculptures, including the figure of Washington atop New York's Washington Square Memorial Arch, inhabit countless municipal sites and monuments across America. When a large white mobile ("Ghosts") by his son, Alexander Calder (1898–1976), was recently installed in a stairwell at the Philadelphia Museum of Art, the city's residents wryly referred to this local triad of sculptures as "Father, Son and Holy Ghost."

The Alexander Calder we know and love was born in 1898, near

Philadelphia. In 1906, his family moved west in search of a cure for the elder Calder's heart disease. By 1910, they had moved back to New York, where Alex (known to his close friends as Sandy) attended local schools, and displayed high artistic ability and mechanical facility from an early age.

During World War I, Sandy Calder rebelled against the genteel Beaux Arts traditions of his father and grandfather and decided to study engineering at Stevens. There, he developed his curious hybrid talents and interests, combining the mechanical facility of the engineer with the aesthetic goals of the fine artist.

After graduating from Stevens in 1918 (having written his senior thesis on "Stationary Steam Turbines") he set up shop in New York. He worked for a few years as an artist drawing crime-scenes for a local tabloid, and continued on his private quest to transform himself into not only a truly American artist, but an artist of the 20th century. His studio looked more like a machine shop, "deep in steel shavings, wire, nuts, and bolts, and bunched sheet metal," than the traditional sculptor's studio filled with armatures and plaster casts, according to one awestruck visitor. The visitor compared the young Calder not to his fellow artists but to those other mechanical geniuses who shared his interest in flight and motion: the Wright brothers.

Like the inventors of the airplane, Calder felt a strong spiritual affinity with the great 20th century conquest of inertia, with setting bodies in motion, often at high speed. Like the Wright brothers, Calder's greatest love was of "simplicity, perfection of motion, and economy of means."

As a boy, Calder was fascinated by the works of San Francisco's noisy cable cars. In adulthood, he maintained a passionate interest in creating Rube Goldberg-like contraptions. Given this natural bent, it's scarcely surprising — indeed, inevitable — that so many Calder sculptures move. Though Naum Gabo is regarded as the first sculptor to create so-called "kinetic" (moving) sculpture, Calder's influences can be felt in the cool abstractions of Mondrian, and the colorful whimsey of Fernand Léger. Calder knew both when he lived in Paris in the late '20s and early '30s only returning to the United States with the deteriorating political climate in Europe.

Calder first showed his now-famous mobiles at an exhibition at the Galerie Louis Carré in Paris in 1946. Existentialism was in vogue, and its primary exponent, Jean-Paul Sartre, was asked to write an introductory essay for the catalogue.

"A mobile," Sartre wrote, "is a little private celebration, an object defined by its movement and having no other existence." Waxing even more poetic, he continued, "It is a flower that fades when it

ceases to move, a pure play of movement in the sense that we speak of a pure play of light ... It is a little jazz tune, evanescent as the sky or the morning. If you miss it, you have lost it forever."

Calder's machines are made for laughing, capturing a young boy's open-eyed, childlike wonder at the magic of a noisy trolley car. Calder himself cheerfully identified his mobiles as "abstractions which resemble nothing in life except their manner of reacting." And he later said that he created his mobiles out of a feeling that the art of his time was "too static to reflect our world of movement."

What the horse-and-rider was to Marini, and mother-and-child to Moore, the moving solar system became the mark of Calder. In engineering, he had learned about kinetic energy as it relates to bodies in motion. Part Thomas Edison, part Picasso, part Mondrian, his work epitomizes the modern fixation on objects in motion. With a subtle sense of humor, Calder fashioned metal machines with a human face.

I began seriously buying Calders in the early '60s, beginning with a horizontal polychrome mobile called "Boomerangs" (1950) which I purchased at the old Parke-Bernet at a benefit auction for the Artists' Fund of the American Chess Foundation, a charity supported by a number of artists and art-world luminaries including Peggy Guggenheim and other members of her family.

It now hangs above the piano in our living room, and every time I enter the room it makes me smile — capturing a whimsey as evanescent, as Sartre might say, as a summer breeze. Throughout the '60s, I sold quite a number of small Calder stabiles to a growing group of Calder aficionados. As a Calder dealer of increasing importance, I was invited by the artist to break bread with him at a restaurant near his home in Saché, France. His long-time New York dealer Klaus Perls once said of Calder, "He is a man of 100 percent goodwill." Considering myself a "100 percent kosher" man, I found this assessment to be right on the money. We dined at the famed Colombe D'Or in St. Paul de Vence, a favorite artists' haunt. The restaurant's extensive art collection would in later years become a target for art thieves.

Calder turned up wearing his signature red L.L. Bean chamois-cloth hunting shirt, carrying under one arm a large portrait of himself. It was a gift to us, which he signed in honor of Barbara, with the famous signature: AC (with the A inscribed inside the C, which was his logo). He was not accompanied by his wife because, he explained, she might not approve of his ordering a second bottle of wine, which he proceeded to do practically before finishing the first.

While Barbara and I drank cocktails, Calder grew progressively more charming, as he spoke of his principled stand against the Viet-

nam War, that was just drawing to an ambiguous close. I had no idea that he was not well, but he died at the age of 78 in 1976, just a year or so later, his detested war in Southeast Asia having finally ended for good. At which point, my troubles with Calder began.

By the early '70s, Calder had switched his New York gallery from Perls to Knoedler, and I began buying Calder mobiles in earnest from Knoedler, as well as from Perls when he had them. Before Calder's death, I never had a single problem with Calder. Every Calder I bought I showed to Klaus Perls, the reigning expert, and if he OK'd it, I felt no hesitation whatsoever about buying it.

My posthumous problems with works by Calder recall the famous case of Madame Léger, who, after the death of the great Fernand Léger, represented herself as the world's greatest expert in her husband's work. She may have been a wonderful woman, and for all I know, a wonderful wife, but she was not an art expert — not by a long shot. Still, she insisted upon passing judgment on every Léger bought or sold after his death, and created a situation in which dealers didn't feel that their Légers were bona-fide unless granted Madame Léger's seal of approval. Unfortunately, a number of dealers who owned or were trying to sell perfectly good and authentic Légers found themselves in the awkward position of having their reputations — not to mention their Légers — tarnished by the failure of Madame Léger to authenticate their paintings. A number of justifiably irate dealers took Mrs. Léger to court. The French court sided with the dealers and forbade Mrs. Léger to pass judgment on her deceased husband's work.

Serious problems often arise in connection with the estates of artists. The problem lies simply in authenticating the works. Frequently records are not kept properly; details of acquisitions may have been kept only in the memory of the deceased collector; and those family members who have become responsible for attesting to a work's legitimacy may not be knowledgeable enough, or may have been too far removed from the process to make credible determination.

As I mentioned in the case of Rufino Tamayo, who strictly due to a personal vendetta with me was willing to disavow his own work, once a painting or sculpture has been pronounced (or denounced) as a fake by an acknowledged "expert," doubts can hover over a work, destroying not only its integrity, but often the integrity of the dealer — not to mention his bankbook. The public is often afraid to purchase the work by such an artist. The vexing issue of authentication has been the bane of many dealers' existence, and seems destined to inhabit a permanently gray area in the murkier shoals of the art world. It's not surprising that many curators and other aca-

demics refuse to get involved in the business of authentication and appraisal. Unfortunately, someone has to do it. But the opportunities for abuse, mistakes and misunderstandings are many.

All this uncertainty is only, of course, compounded after an artist's death. I strongly believe that the legal profession should join forces with some certified body such as the Art Dealers Association of America to set up a commission to nominate recognized experts of a deceased artist's work, who will be free of the special interests of heirs, relatives, and surviving spouses. A commission, in other words, that would be truly impartial.

In the absence of such a duly appointed body, most prominent artists leave this task to a foundation, often made up of the artist's heirs, and a retinue of hangers-on, relatives, and self-styled experts — usually academics and dealers who have distinguished themselves as authorities in the artist's work. The purpose of a foundation is typically to draw up a definitive catalogue raisonné of the artist's entire oeuvre, so that the fakes and the forgeries can be weeded out.

All this, in principle, makes perfect sense. When the system works, as it has with the Henry Moore Foundation, it works admirably. I consider it a testimony to an artist's integrity when his death does not launch acrimony among competing heirs and interests in his legacy. Henry Moore remains in this regard a paragon not only of an artist and a man, but of an outstanding legatee. After all, when an artist is gone, what is left to represent him but his work? And if his work is permitted to suffer from confusion arising from questions of authenticity, the artist suffers even after death.

Moore took scrupulous care during his lifetime to extensively document and record down to the slightest detail everything about every piece he turned out. No detail was too small to escape the eye of the redoubtable Mrs. Betty Tinsley and her aides, consultants and experts on Moore that are affiliated with the Moore Foundation. In the years since his death, little controversy has ever erupted over fakes and forgeries of Moores, because the Foundation keeps such a tight rein on the body of work in question.

I was contacted by the Calder Foundation about the "Boomerangs" mobile I purchased in the early '60s for my private collection. I was told that there was no record of the piece in Calder's archive and it would not be included in the catalogue raisonné unless I could supply additional details. Fortunately I was able to find the 1961 catalogue from the American Chess Foundation Auction, and there it was in black and white: lot 70. Boomerangs: Horizontal Polychrome (1950) Donated by the Artist, Courtesy of the Perls Galleries.

This is only one example of the difficulties I have encountered

with the Calder estate; unfortunately, I know it won't be the last. Before Calder's death, if Klaus Perls was unavailable to render an opinion, as in the case of the 1950 Calder "Mask," I had only to pick up the phone or write to Sandy Calder if there was any lingering doubt.

Dueling Museums

The National Gallery, Washington, versus the Metropolitan Museum of Art, New York.

For the fiftieth anniversary of the National Gallery of Art in Washington, D.C., in 1991, teams of top curators scoured the galleries of the nation as part of what the museum described as "an all-out gift-giving campaign." One of the most valuable single donations — a 17th century Flemish still life by Frans Snyders — was given by a noted New York Old Master dealer, Herman Shickman, who felt proud to give a "gift to the nation."

"I feel I'm paying an immigrant's debt to this country," Shickman told *The New York Times*. And as a good giver, he was invited to the donors Fiftieth Anniversary gala dinner where, according to the *Times*, "hundreds of donors are to be wined and dined and given a good look at the works before 320 of them go on public display."

Grace Borgenicht, another Manhattan dealer, explained her donation to the gallery of drawings by Marsden Hartley and André Derain to *The New York Times*, saying she liked the attentions paid to donors by the museum. "You get invited to a dinner, your gift is hanging there, and they reproduce it in the catalogue."

I had known J. Carter Brown, the former director of the National Gallery, for many years. He introduced me to the head curator, Charles Moffett, who came to our home to see my private collection. We had a most enjoyable meeting in which I described the beginning of my career with the German Expressionists and I shared my stories of Kollwitz and Kirchner. Later in 1992, while on a visit to the Holocaust Museum in Washington, Bronka mentioned that she had never seen the Barnes collection. The collection was on exhibition at the National Gallery, for the first time outside of the Barnes' Museum in Merion, Pennsylvania. I contacted the National Gallery to arrange to see the collection for a few hours. Not only did they oblige with tickets waiting for us so we did not have to stand in line but they also offered to have a staff member guide us through (which I declined as I wanted to be Bronka's guide).

In contrast to the National Gallery's gracious attitude, and the respect they show their donors and the works given, the Metropolitan is somewhat arrogant.

I was told by a donor who gave a painting to the Met that he failed to see it on display in the museum. He called the 19th century department to ask why his gift was not hanging on the museum walls. The answer was "we have a better example," thus turning his formerly prized possession into back room museum inventory.

Grace Borgenicht noted in the *Times* that she and her husband had given works to the Metropolitan, the Modern, the Whitney and the Brooklyn museums, but no one else made as much of a fuss as the National Gallery.

Where, I ask, is it written in stone (perhaps on certain museum facades) that it is unseemly to "make a fuss" over donors?

I always think of that article in *The New York Times*, March 11, 1991, in which the National Gallery's "Hard Sell In Kid Gloves" approach is examined, when I reread the 1988 letter from New York's Metropolitan:

"Dear Jacob,

"We have begun to catalogue our drawings by Jackson Pollock, and I think now would be a good time for you and Bronka to give us yours. I hope you agree. I enclose for your convenience an Offer of Gift form as well as a stamped and addressed envelope."

That was it. I don't blame anybody for writing this letter. After all, enclosing a stamped and addressed envelope was generous. But I do mind the attitude that simply says "give" without asking "why?" "Why give?" In truth, I have mellowed considerably over the years, even though at times I regret that I have mellowed. The point that letter missed is that the small Jackson Pollock is worth more than money or prestige to me. In painting his dreams, Pollock also painted my dreams. Sometimes, my dreams, like his, were nightmares.

Thomas Hoving, the former director of the Metropolitan Museum of Art, in his recent memoir, *Making the Mummies Dance*, maintains this high-handed attitude when he attacks old and dear friends as well as clients of mine, such as the late industrialist Nathan Cummings. According to Hoving, Cummings committed the cardinal sin of demanding a "huge splash" in connection with a show at the Metropolitan that included a number of his Impressionist paintings.

In his ad hominem attack, Hoving maligned the reputation of a dead man who cannot defend himself. "Nate was affectionately called a 'diamond-in-the-rough' by his friends and a 'vulgar bastard' by those who had been bested or shafted by him in business," Hoving wrote.

"Cummings yearned to have his collection shown at the Metropolitan. But when he approached me, I told him bluntly that he had some fine Impressionist paintings, but not enough for a show at the Met."

The National Gallery Is Really Making Out Like, Well, a Bandit

By GRACE GLUECK

"They came into my gallery, pointed to an Annibale Carracci drawing and said, 'That's it.'" David Tunick, a New York dealer in Old Master drawings and prints, was not describing a robbery but a donation — to the National Gallery of Art in Washington, which is waging an all-out gift campaign for its 50th anniversary. Mr. Tunick, who has a long dealer-client relationship with the National Gallery, had been tapped, and coughing up the Carracci was his contribution.

Unabashedly soliciting collectors, dealers, artists and well-wishers around the country and even its own staff, the gallery has raked in some 550 works of art, many of them major, an act that most museums would find exceedingly hard to follow. But as the Federal Government's official art showcase, the gallery has plenty of clout. Donors are told that they are making "gifts to the nation," a patriotic persuader that gives heartburn to officials of less well-connected institutions.

"I feel I'm paying an immigrant's debt to this country," said Herman Shickman, a New York dealer in Old Master works who came from Europe in 1938. After a visit by National Gallery curators, Mr. Shickman — who has also sold to the museum — forked over a still life by the 17th-century Flemish painter Frans Snyders.

The gifts — the gallery suggests that each donor give works worth at least $50,000 — range from a magnificent Cézanne, "Boy in a Red Waistcoat," contributed by Paul Mellon, the gallery's prime patron, to a 10-foot bronze by Ellsworth Kelly, given by the artist himself, to Wayne Thiebaud's 1963 Pop painting "Cakes," a delectably gooey rendition bought especially for the anniversary event/ by several gallery support groups.

A Party for Donors

To celebrate its bounty, the National Gallery has scheduled a gala on Thursday at which hundreds of donors are to be wined, dined and given a look at the works before 320 of them go on public view in a three-month exhibition, "Art for the Nation: Gifts in Honor of the 50th Anniversary of the National Gallery of Art," opening Sunday.

The high-powered gift campaign began five years ago, after a successful fund-raising drive in the early 1980's brought in $56 million. "We saw that there was an enormous reservoir of good will out there," said J. Carter Brown, the gallery's director. "And so for our 50th anniversary, we came up with an idea for a campaign that wasn't just another fund drive. We decided we'd ask for works of art."

As the nation's showcase, of course, the National Gallery did not want just any works of art. Its curators, like all curators worth their salt, are not only grabby but also know where the right stuff is. Spreading their net carefully, they went to "a number of our close friends," said Andrew Robison, senior curator of prints, drawings and sculpture, who is curatorial coordinator for the anniversary gift campaign and the exhibition. "We asked them to consider making commitments for gifts specifically in honor of continuing to build the collection."

In anticipation of the 50th anniversary, curators began drawing up want lists for their departments.

Continued on Page C16

"Hard Sell in Kid Gloves."

C16

From National Gallery: Hard Sell in Kid Gloves

Continued From Page C13

Then teams of curators and trustees or other gallery associates made plans to visit potential donors. The gallery's friends in various cities were tapped to give dinners, luncheons and cocktail parties at which fervent pitches were made by gallery officials. And there were bashes at the gallery itself.

The Tasteful Hard Sell

One of the most active canvassers has been Mr. Brown. Mr. Tunick, the New York dealer, admiringly described a soiree he attended in New York several months ago in the director's honor. "It took place in an apartment across the street from the Met-

How a museum plucked up 550 artworks for its 50th anniversary.

ropolitan Museum," he said. "After dinner, Carter stood up and gave a speech about how he'd like everyone there to give something for the gallery's anniversary as, he pointed out, my wife and I had. This was even before the gift was formalized. It was pretty hard sell, and right in the Met's front yard."

Mr. Brown seems to enjoy the role of pitchman. "John Walker had a different kind of life, having lunch with Mrs. Bruce occasionally," he said, speaking of his predecessor as director and of Ailsa Mellon Bruce, one of the gallery's chief patrons, who died in 1969. "But it turns out to be a lot of fun, meeting these wonderful people." Stumping the country, Mr. Brown and his aides are highly skilled at conveying the impression that the gallery is America's premier museum, although it is much younger than many major urban institutions and lacks their encyclopedic range.

Asked how they felt about the gallery's incursions on their home turf, Met officials, who have had their rivalries with the gallery over the years, played it cool, refusing to comment.

Several local collectors, however, made clear that they felt more wanted at the gallery than at the Met. "It's such a pleasant place to visit and so friendly to deal with," said Peter Josten, a New Yorker who presented

Mellon Collection

Among the gifts to the National Gallery of Art is Cézanne's "Boy in a Red Waistcoat," contributed by Paul Mellon.

the gallery with a drawing by the 16th-century Italian Federico Barocci. "You call Carter Brown or Andrew Robison and they call right back. The Met is so huge and so hard to connect with."

Grace Borgenicht Brandt, a Manhattan dealer in contemporary art, gave the gallery drawings by Marsden Hartley and André Derain. Her generosity was prompted in part, she said, by the fact that the gallery had set up a special room devoted to Milton Avery, whose estate she represents.

What's more, she added, she likes the gallery's attentions to donors. "You get invited to a dinner, your gift is hanging there, and they reproduce it in the catalogue. We've given things to the Met, the Modern, the Whitney and the Brooklyn Museum, but no one else has made this much of a fuss."

How It Started

Though it opened its doors in 1941, the gallery goes back to the mid-1930's, when Andrew W. Mellon, the Pittsburgh financier who was then Secretary of the Treasury, decided to give his collection of Old Master paintings and sculptures, then valued at $50 million, along with $15 million in cash, for a national art gallery. He chose the architect John Russell

Pope to create a classical extravaganza but died shortly after ground was broken in 1937. As Mr. Mellon planned, the gallery receives its operating funds from the Federal Government, but its building and acquisitions funds come from private sources. Private citizens outweigh Government officials 5 to 4 on the gallery's 9-member board.

Mr. Mellon's son, Paul, and his daughter, Ailsa, have in their o' n right given money and objects worth hundreds of millions, and because of this the National Gallery has had to overcome the perception that it is a one-family museum. In recent years, at Paul Mellon's urging, the gallery has broadened its sources of patronage, setting up several support groups that draw members from all over the country.

Gallery officials insist that gifts made to the anniversary campaign do not siphon donations from other museums. "For this campaign we've made it very clear that we really are asking only for one thing from each collector," said Mr. Brown. "We encourage them to be loyal to their local institutions, but giving one thing is surely sustainable."

A Tax Coup

Pointing out that most donors were heavily involved with museums in their own cities, Mr. Robison acknowledged that "things could get sticky" if local museums wanted a specific object that the gallery was after. "Sometimes we've worked out joint agreements," he said. "If a local museum is desperate to have a particular item and the gallery could take something else, we do it to be congenial."

The gallery does not rely solely on its prestigious position as the nation's showcase to attract gifts. A not inconsiderable draw is the fact that unlike many museums, it never sells works of art. "Once a work comes in the door here, it will never go out again, never appear in an auction," said Charles Moffet, senior curator of paintings and curator of modern paintings at the gallery. "It's one of the reasons donors feel comfortable with us."

Gallery officials also say they helped re-establish another powerful lure, good for 1991 only. It's the so-called "tax window," a one-year restoration of tax deductions for the full market value of donated works of art. Such deductions were curtailed by the 1986 Tax Reform Act, resulting in a flow of high-quality artworks to auction houses and dealers rather than museums. The new provision was pushed through the Congress by Senator Daniel Patrick Moynihan, Democrat of New York, with the support and encouragement of the gallery and other museums.

Mr. Robison, who himself has donated a little something, a woodcut by the 16th-century Italian Antonio da Trento, said, "We've tried to persuade people that the gallery has a long life, a collector has a short life, and the best thing in the long run is to give it to us."

Cummings was one of the great conglomerate architects of the '70s. He founded the company now known as Sara Lee, and was a large stockholder in General Dynamics. Hoving rightly calls him, "along with Norton Simon, the symbol of the '70s tycoon." Except that Hoving also portrays Cummings as a craven, selfish liar and a bully, and as one unholy "prima donna" to boot.

When Hoving discovered that Cummings was sending out his own press releases about the upcoming show, which included works lent by other collectors, Hoving exploded, upbraiding this "symbol of the '70s tycoon" who "collected art because it was de rigueur" as a "duplicitous son of a bitch" whose only goal was to "use" the Metropolitan to increase the value of a "lousy" collection.

Attack the man, but not his paintings! The people who painted them knew nothing of Cummings. Hoving, in passing, mentions that after telling off Cummings, he "never heard from him again. The museum received none of his paintings, nor Henry Pearlman's either."

Henry Pearlman, who made his money selling tanker-refrigeration equipment, was popularly known in the art world as "The Cézanne King." Along with his close friend, Colonel Samuel Berger, he helped me get my start in the art world. All the collectors Hoving attacks committed the same supposed "crime," namely to ask for a little something in return—maybe a little party, or some official recognition—for lending or donating art that cost them millions to buy.

Hoving's underlying assumption, of course, is that we poor self-made men (I note, strictly in passing and without comment, that the wealthy collectors he attacks in his book for being craven and crass in their excessive demands for "recognition" were all self-made and at the time of his writing, all dead) should be thrilled to have the great Metropolitan, bastion of high culture and Western civilization, deign to accept the proceeds of our ill-gotten gains.

Well, I don't agree. What, I ask, is so terrible about being successful in business, or in "trade," that the owner of a Picasso or a Cézanne should be made to feel as if his hands will be "cleansed" or purified by forging a connection to a great museum?

It is interesting to note that the Met was created and the majority of its greatest works given by "self made men." Unlike the Louvre, the Met was not created from Royal collections but was created by the "70s Tycoons"—1870s that is. These, men known as Robber Barons, were not unblemished by controversy in their business dealings.

The true story, by the way, is often quite different. The value of the art being shown at the museum appreciates due to the prestige of a "name" museum being prominently attached to it. The public, pre-

sumably, gets a good show put on for its benefit. The curator also benefits handsomely, through added prestige for putting such a show together.

I can remember when I was dealing in graphics in the '50s a gentleman came into the gallery and asked for a Felixmüller. I asked him if he knew Felixmüller's work. He said no but a curator of the museum told him he should buy one because Felixmüller was a good draftsman and a teacher of Paul Klee.

Very often advice such as this has nothing to do with the current market. The client should have listened to me, the dealer, and bought a Klee. I am not saying that Felixmüller was a bad draftsman, only that Paul Klee was the better investment. Curators may know a good drawing but not necessarily a good investment.

Many times during forty years in business I have heard the words; "my adviser, whom I pay, is a curator in a museum." I don't think curators should be advising people about investing in art. Curators could have a conflict of interest, recommending works that fill gaps in their museum's collections, and hoping their advice might lead to a museum gift.

Unlike Mr. Hoving, I do not intend to name names — living or dead. The point is that curators are not in my view a higher class of human species than dealers. As a survivor of the Holocaust, I remain forever suspicious of any social scheme that seeks to place one class of individuals above another.

As for that "selfish bastard" Nate Cummings, I had known him since the early '60s when he became a client of the gallery. I always knew him to be absolutely fair and aboveboard in art. While paying a call on him at his penthouse in the Waldorf Towers one day, I chanced to spot a lovely Marino Marini that I liked very much. I asked him if I might buy it from him. He told me that he had bought the painting directly from Marini himself, who gave him a "dealer's price," $16,000. This being between friends, he was willing to sell it for what he had paid, $16,000.

"Nate," I said, " I have bought works from Marini, and he would have sold me that one for $10,000. Nevertheless, I'll give you what you ask." I paid the $16,000. Cummings, as a fair man, promised to go through his books and find out what he had paid for it. His memory, he conceded, was far from infallible.

I left with the Marini, and a few days later received a little note from Cummings: "Jacob, you were right. I paid only 10K for the Marini." Enclosed was a check for the $6,000 difference. I later sold that Marini to the film producer Joseph E. Levine ("A Bridge Too Far"), for $16,000.

So why shouldn't the Metropolitan have given Cummings a party? If a man gives a work of art to a museum, instead of enriching himself through its sale, is it too much to ask that the museum treat him like the art patron he is? Hoving seemed to think it is too much.

The current administration of the Metropolitan has not diverged very far from Hoving's high-handed ways. They appear to look down on many of those with new money. To which I say, if you want to run a prestigious art museum, you can't always deal exclusively with the Old Money club. Many an Old Master is owned by someone with New Money. Hoving betrays the same snobbery that in Yiddish we call T.H.G., the "Tate Hot Gelt" club — literally translated, "Father has money."

After I agreed to lend my Magritte to the Metropolitan's recent traveling exhibition, I wrote asking for a few extra tickets to the donors party, for some collectors who were coming from Orlando, Florida, whom I had invited to dine with Bronka and me at the Lotos Club.

I received this tart letter in reply:

"Dear Jacob:

"At the risk of sounding ungracious, I must point out that you have already received four invitations to the Magritte exhibition. Also, the lenders toast by Phillippe de Montebello was for lenders only, hopefully a small but congenial group.

"There are 87 lenders to the exhibition. If each had made similar requests — fortunately, no other has — the size and the cost of the special event would have at least tripled, a largesse the Metropolitan could ill afford. We are, however, pleased to oblige you."

With this grudging concession, and the sound scolding, I received my four extra tickets. I didn't write back but if such an occasion rolls around again, I can assure you that as we live directly across the street from the museum, I shall be sure to offer to bring our own liquor. Far be it from one such as I to demand "largesse the Metropolitan could ill afford."

In my success story, I have always been grateful to the money people. I became successful, thanks to them, "OPM" men, "Other People's Money." Mr. Hoving became a star with "OPA," "Other People's Art," and should, I feel, show gratitude.

As a friend and neighbor of the Metropolitan Museum of Art I would like to convince the people running the museum to change their attitude. Greet your donors with a smile and give them a party.

After the Boom

After two years of the art world's worst slump in four decades, the auction houses were still struggling to stay above water in the spring of 1993. "If the boom of the late 80s had never happened," wrote Carol Vogel in *The New York Times*, "then the offerings wouldn't seem so slim at Sotheby's and Christie's.... But those heady days when catalogues were thick as telephone books and estimates hit the double-digit millions weren't so long ago. They still haunt the art world."

Across the board, prices for art had fallen 30 to 50 percent since hitting their peak in the summer of 1989. That year I bid $1.6 million for a single great work by Marini—my personal high as a sculpture buyer.

At the peak of the '80s art boom, every art dealer was a genius. You could double your money right and left, throwing other people's money around at auctions as if there were literally no tomorrow. Fortunately, by the '80s as art prices peaked, I was no longer dependent on credit to buy art. I was free of the burden of owing large sums of money. My old friend Dr. Nathan of Zurich, who warned me as a young man not to be "too desperate to sell," would have been appalled at the pressure art dealers operated under during the '80s, when a combination of sky-high rents and stratospheric art prices conspired to turn us all into high-stakes gamblers.

If I were writing "How to Succeed in Business in the Art World while Really Trying," the first rule of thumb would be: learn something about art, then get your hands on some money; then follow your instincts, and hope for the best.

I succeeded, as so many other entrepreneurs have before me, by persuading people with money to risk some of theirs with me. But luck came into play when, time and again, I had the frequent good fortune to meet the right people at the right time.

However, not everyone and every encounter was so lucky. I personally witnessed the rise of a private art dealer, whose evolution is illustrative of a route directly opposite to my own. In the late '60s, I sold a Toulouse-Lautrec to a wealthy man who insisted that I accompany him to help him install it in his sprawling apartment on Central Park South. As we approached his front door he knocked and listened closely for any sound within. After waiting a few seconds to

satisfy himself that the apartment was empty, he opened the door. We were discussing where to hang the Lautrec to the best advantage when the door to a back room opened and a woman emerged who looked exactly like a Toulouse-Lautrec model. "You again!" she shouted at him, "why don't you get out of here and take your painting with you!"

In some embarrassment at having been caught buying art, and committing the crime with a dealer no less, my client introduced me to his wife, who acted as if I was little better than an accomplice in this "art conspiracy." Shortly thereafter, the man died. It wasn't long before I heard from her. Now, she greeted me like an old, long-lost friend.

She had just sold the Lautrec, she announced, as if relating one of the world's great financial coups, for $60,000. This was roughly twice what her husband had paid for it. Having doubled her money (or, rather, his money) in under a year, she had decided to set herself up as a private art dealer. "If he can do it, and he wasn't so smart, I figured I can do it too," she said.

"An art dealer!" I exclaimed, "and a private one at that!" I extended my sincere congratulations. She told me that as one of her first deals she proposed to sell me the bulk of her husband's collection. But when I asked her to supply me with provenances, she told me to do it.

"But madam," I said, "you are the seller. It is your obligation to supply the provenances to me." She sounded shocked. I never heard from her again. But I heard through the grapevine that she had printed business cards with her home address, billing herself as a "private art dealer."

This story is instructive not because the woman lacked credentials, but she lacked knowledge learned on the job. She didn't even appreciate art. She loved money. Harold Kaye and Marvin Small, and for that matter Imre Rosenthal, indeed all my joint venturers, have a high regard for money. As do I. But having come to America with nothing in my pocket, and no experience whatsoever in the art business, I had to bide my time, and wait for my luck to turn. Sheer luck, after all, produced the absurd misunderstanding that sent me into the art world in the first place.

The other ingredient to any success story is the protagonist's unwillingness to settle for second best. Settling for second best often involves overvaluing one's personal security. If I hadn't met my old friend Meyer Klein on the street in Berlin, and accepted his invitation to meet Rabbi Shubow, who made it possible for me to enter this country, I might just as easily have remained in Berlin as the owner of a movie house on the Alexanderplatz. In time I would, once again, have been forced to live under a rigid totalitarian regime.

If the Holocaust had never taken place, I might have done perfectly well by taking over my family's small book-publishing firm. I might have prospered in a very different Poland, possibly becoming a lawyer. In this country, I could very well have remained at Erich Hermann's, perhaps rising after a good many years to take Kurt Dishman's position as junior partner. Perhaps even, if the gods smiled upon me, inheriting the business or part of it as some sort of surrogate son and heir.

But what would I have gained? — an art-reproduction business, at a time when the reproduction business was soon to go out of style. I might have done perfectly well if, after leaving Erich Hermann's employ, I had accepted the offer of a job "with growth potential" at the art publishing house of Raymond & Raymond.

Instead, I struck out on my own, to set out in search of fortune, and possibly fame. Luckily, I didn't end up drilling a dry well. The world holds unforeseen futures in store for us, any one of which can change one's life in the blink of an eye.

A case in point: buying that massive collection of German Expressionists from the gentleman in Queens was a great opportunity, an opportunity to establish myself as a major player dealing in German Expressionists. I could just as easily decided I was too tired to go out to Queens that evening. Alternatively, I might not have stayed at their home in sight of the collection, waiting until the next morning to close the sale. By which time the seller might well have changed his mind.

I might not have pushed Marvin Small into the deal we ultimately hatched, an unusual deal for the time, if I hadn't had the chutzpah to ask him to lend me the money to invest with him. Joint venturers weren't uncommon in the art business in those days. What made our deal different was that I refused to accept pieces on consignment, the typical method of conducting such joint venture arrangements. I felt that the consignment system didn't give me a large enough piece of the action. When I came to cut the deal with Small, I had to summon up the temerity not only to demand a fifty-fifty share in the profit, but also to ask him to lend me the money for my portion. That request rocked him back on his heels. But after a moment's consideration, he saw the logic of it, and agreed to go ahead on my terms.

Like Marvin Small before him, Harold Kaye took a risk on me, as did Imre Rosenthal in later years. When I thought of moving to better quarters on Madison Avenue, luck again played a role in bringing me to Ian Woodner. Twenty years later, when it came time to move again, I met Jean and Julian Aberbach, two entrepreneurs from the

music business who'd branched out into art dealing and collecting, but were considering selling their gallery. But it was actually only after Jean Aberbach suffered a heart attack that he persuaded himself to sell his gallery to me.

At each step of the way, land mines lurked: with Rosenthal, for example, I bought, or rather rented, his money at a substantial rate of interest. If I had taken a few false steps, I might well have seen half my art repossessed. That fate has befallen many a customer who did manage to persuade some impetuous soul to put up the money to finance a series of art purchases, only to find that when the market turns, the art is worth less than the money. You owe the difference.

The '80s were a great party, albeit filled with hidden dangers. If, when dealing with Japanese clients, I hadn't insisted upon getting the entire purchase price up front before shipping a work, I might today be stuck holding the bag for a multimillion-dollar Moore held by a Japanese bank, waiting to get paid some small fraction on the dollar. Instead, I can afford to watch my Marini, for example, sit in my gallery and wait patiently for prices to turn, as they inevitably will. My good fortune is that I don't have to be in a hurry to sell.

I had enough financial reserves to survive through lean times, as if in some biblical parable. It takes a certain cushion to get through the months when not much sells, particularly when overhead costs easily top a million per year. Throughout the '90s, I've kept up my advertising in *The New York Times*, the communications vehicle of choice if one seeks to reach a discriminating art buyer. Sometimes I take out full-page ads on Sundays advertising my current inventory: Sculpture by Master Works of the XXth Century. I retained a top-notch art photographer to take pictures for an ad showing works by Botero, Moore, Marini, Manzù and Calder. Sunday, May 8, 1994, I became the first art dealer to have a color ad in *The New York Times*.

I've made a point of continuing to support and promote the works of my living sculptors through lean times as well as fat. They are not yet masters, but well-established artists: Sergio Dolfi, Masami Kodama, Stella Shawzin, Florence Teicher.

In 1990, we celebrated our fortieth anniversary in the art business. Another full-page ad in the *Times* marked the occasion, announcing "Sculpture and Painting of the XXth Century." Listed alphabetically, our extensive inventory included Archipenko, Arp, Botero, Calder, Chagall, Degas, Léger, Lipchitz, Manzù, Marini, Moore, Morandi, Picasso.

Not a bad roll call of 20th century masters. Somehow, having acquired these works seems like quite an achievement in itself. And selling them? Well, all the better.

On our fortieth anniversary, we received letters of congratulation from friends, clients, and colleagues all over the world. Many expressed ongoing astonishment that the Weintraub Gallery continues to function almost like a small private museum of works by the greatest artists of the 20th century.

In a letter I circulated to most of the people on our overflowing Rolodex, I wrote: "Your praise is music to our ears. We have always strived to create an atmosphere where our clients could come in and enjoy great works by Modern Masters of the 20th century."

I still retain a special fondness for the German Expressionists. For their vision of the world I feel a special affinity, largely because it was born out of the unique cauldron of pressures that existed in Europe between the great wars. In April of 1991, I received an engraved invitation from the trustees of the National Gallery of Art, requesting the pleasure of my company at a reception and preview of the exhibition: "Käethe Kolliwitz and Ernst Ludwig Kirchner."

This celebration of the great work of two of my favorite artists confirmed my long-standing faith in the endurance of the German Expressionists. "On this occasion," the trustees wrote, "you are invited to preview both 'Käethe Kolliwitz' and 'Ernst Ludwig Kirchner: Paintings, Drawings, and Prints.' Organized by the National Gallery of Art, these two exhibitions coincide with the German Cultural Festival taking place in Washington during the Summer of 1992 at the Kennedy Center, the Library of Congress, and many other Washington institutions." These were the same two artists whose work I sold to Marvin Small thirty years before, on whose shoulders I first built my reputation and career.

I naturally attended the preview and opening. But few present there could have read my feelings of gratitude that at long last these great artists, whom I had championed thirty years before, had won deserved appreciation in the United States.

That same month, April 1991, I was privileged to attend the Annual National Civic Commemoration of the Days of Remembrance as an invitee of the United States Holocaust Memorial Council. "From the dead and the living we must bear witness," reads the slogan of the committee. At the Memorial Candle Lighting, I shared that honored task with Senators Frank Lautenberg and Joseph Lieberman, and Representatives Tom Lantos, Ronald Machtley, and Susan Molinari. After a moving commemorative address delivered by the Honorable George Mitchell, then Majority Leader of the United States Senate, we listened to a gentle gypsy rhapsody composed by Stefan Moise, a Romani survivor of the Transistra camp where he was interned in 1942.

"We are together now, and we are thankful to be alive," Mr. Moise wrote. "But every time I play my violin, the music is still bittersweet."

What music is to Mr. Moise, art is to me. Whenever I gaze upon certain tortured works of art — from the dark works of Francis Bacon, to the controversial prison works of David Siqueiros to the small early Jackson Pollock that I acquired directly from the son of his psychiatrist, who encouraged Pollock to paint his dreams — the haunted images of these artists remain to me bittersweet.

I think of being held hostage by the Nazis as the nightmarish Warsaw Ghetto was being cruelly implemented. I think of the members of my family whom I have lost, and wonder at times if there was more that I could have done for them.

At a recent exhibition of iron sculptures of the 20th century held at the Guggenheim Museum, the curator made the point that the artists—Picasso, Giacometti, Gonzalez, Calder, David Smith—deliberately decided to work in iron and steel because they were the materials of war, which evoked the massive destruction and violence of World Wars I and II.

In choosing to champion the great artists of the 20th century, I have chosen to emphasize the greatness of our century in triumphing over rampant evil. I could have chosen to stress the violence, deprivation and misery of so much of our world. But the works of the artists I love stress life, not death, and the sweetness of life in the face of death.

As an art dealer, I don't create art. I merely help to distribute it, and to raise the public's awareness of it. The achievement of which I'm most proud, in retrospect, is that in my own small way I helped to elevate the taste of the American public by imparting to them some of the sophistication of a Europe I had fled out of deprivation and distress.

I wanted to bring the best of the Old World to the shores of the New. In the '50s, those were the German Expressionists, whose work had been declared by the Nazis as the degenerate output of "excessive Jewish intellectualism." In the '60s, it was graphics, paintings and small sculpture by the great modern masters, many of them survivors of some of the most cataclysmic events of our tumultuous century. In the '70s, we continued to promote and support the works of modern masters, while mounting a number of exhibitions of less established artists. We worked mainly with foreign artists, because the point was to emphasize the commonality of our world. During that decade, I discovered and rediscovered that other Promised Land, Israel, and in the '90s Bronka and I dedicated a sculpture garden to our great late friend Aliza Begin, wife of the late Menachem

Begin, in whose memory we continue to labor. We proudly dedicated the sculpture garden in Israel, in the summer of 1993, donating ten monumental sculptures by major contemporary artists.

Now, as I write, *The New York Times* has lately confirmed what my instincts have been telling me: the art market is bouncing back. On March 24, Leslie Wayne's Market Place column carried this rousing headline: "The art market is getting livelier and Sotheby's shares are rising."

"Sotheby's stock," the *Times* reported, "has been trading lately with all the madness of an initial public offering." The earnings for Sotheby's reflect "a simple fact of economic life—that the market for art, which peaked in 1989, is coming back." The more bullish believe that Sotheby's earnings will double in 1994. Auction sales have enjoyed 17 percent growth, which encourages sellers to bring more art to market, which in turn attracts buyers. Although the market has clearly picked up, I view with relief the welcome news that "speculators who fueled auction prices in the late 1980s still appear to be on the sidelines." I've never been a great fan of buying art for speculative purposes. It makes more sense to buy art for love than money, and then pray the market will agree with your taste.

Looking back, the most important thing that an art dealer can do is to lend the art market the support of his unflagging honesty. That is why a certain letter from my friend the late Nate Cummings, whom Thomas Hoving attacked for being an S.O.B., means more than money:

"Dear Jacob:

"I've known you for a number of years and thought this is a good time (August 1978) to let you know that I am very satisfied with the business deals we have consummated. I know a good many art dealers—and I'm happy to say I place you in the group I really trust. Not only is your integrity without question, but you have a broad knowledge of the art world. It takes a long time to build up a reputation and, according to my standards, you have done a good job. With warmest regards, Nathan Cummings."

Illustrative of Nate's point, two decades back a female collector and a long-term client asked me to appraise a large sculpture by Henry Moore that she had bought a few years earlier. She intended to donate the sculpture to a museum or cultural institution, and wanted, of course, an appraisal that would maximize the permissible tax deduction.

After conferring with a number of other major Moore dealers, I gave her my honest appraisal: $160,000. A few years later, I had a visit in the gallery from my client's new husband, a judge, accompanied by the managing partner of one of the Big Six accounting firms

and a well-known tax attorney.

The purpose of their visit soon became clear. They intended to persuade me to revise or adjust my appraisal in view of the fact that a certain Moore, which they regarded as similar, had recently sold at auction for $260,000—$100,000 above my initial appraisal. They asked me, point-blank, to give them a new appraisal, or a letter certifying that in my expert opinion, my original appraisal had been out of line.

I refused. My refusal ended up subjecting me to a grueling two-hour meeting, during which they did their best to convince me to change my mind. At one point, the attorney leaned forward and murmured, as if in total confidence, that if it was a question of $20,000 or even $25,000, they could easily make it up to me. This was not an out-and-out bribe, but it came close. It was strongly hinted that if I cooperated, the judge and his wife would buy from my gallery at a higher level than before. Still, I refused to budge. On their way out, the attorney, who was clearly acting in his professional capacity as the heavy, told me that I had just lost a good client.

"I have to be true to myself," I replied, "and stick to my principles."

The attorney was right. I did lose a good client. I didn't see either of them, the judge or his wife, for two years at least. Then I attended the opening night of a Martha Graham dance concert, and at the reception afterwards I found myself seated at a table next to the one where the judge and his wife sat. The judge made a point of coming over to me and greeting me warmly.

"Jacob, do you know who I am?" he asked, sitting down in an empty seat beside me.

"Of course," I replied, "you're a judge."

"I am a presiding judge," he corrected me gently. "And do you know how many other people have said 'no' to me before you?"

I had no idea.

"Just one."

I had a smile on my face, thinking of the one other person who had had the guts to stand up to him.

"Jacob, let me tell you something else. I've been meaning for two years now to write you a letter of apology, because I admire what you did—sticking to your guns. But now that I've got you here, I have a way of making amends that I think will satisfy you more."

I nodded, waiting for him to continue.

"If we had more people in this country like you who could say no to people like me, maybe we would never have had a Watergate."

"Judge," I said, "you're right. This does please me more than any dry letter of apology possibly could have."

He shook my hand, and we parted friends.

I hope it was this quality that Rabbi Shubow saw in me when he invited me to realize my dreams in this country.

Index